Feelings Are Facts

The MIT Press Writing Art series, edited by Roger Conover

Yvonne Rainer

Feelings Are Facts

A Life

MIT Press
Cambridge, Massachusetts
London, England

WRITING**ART** SERIES

MIT Press books may be purchased at special quantity discounts for business or sales promotional use. For information, please e-mail <special_sales@mitpress.mit.edu> or write to Special Sales Department, The MIT Press, 55 Hayward Street, Cambridge, MA 02142.

This book was set in Minion and Scala Sans by Graphic Composition, Inc. Printed and bound in the United States of America.

Library of Congress Cataloging-in-Publication Data

Rainer, Yvonne, 1934–
 Feelings are facts : a life / Yvonne Rainer.
 p. cm. — (Writing art series)
 Includes index.
 ISBN 0-262-18251-3 (hc : alk. paper)
 1. Rainer, Yvonne, 1934– 2. Dancers—United States—Biography. 3. Choreographers—United States—Biography. 4. Independent filmmakers—United States—Biography. I. Title. II. MIT Press writing art series.
GV1785.R25A3 2006
792.8'092—dc22
[B] 2005053429

10 9 8 7 6 5 4 3 2 1

For Ivan, who came running . . .
and Audrey, who laughs . . .

Other books by Yvonne Rainer:

Work 1961–73
The Films of Yvonne Rainer
A Woman Who . . . : Essays, Interviews, Scripts

Contents

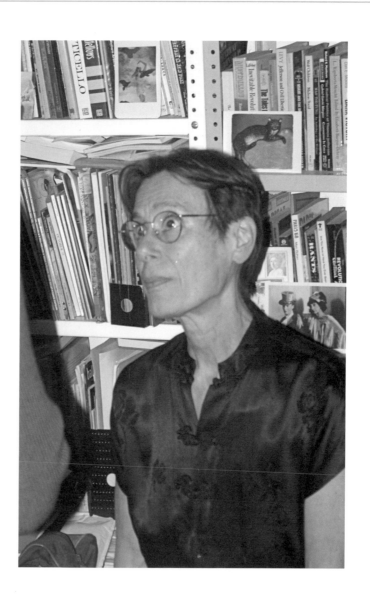

Yvonne Rainer, 2004. Photo: Andrea Geyer.

Acknowledgments

This book owes much to friends, family, and those individuals with whom I reconnected in the course of its writing.

Doris Casella was especially helpful, not only in sharing her memories of our lives in New York in the late 1950s but also in making suggestions for organizing my manuscript. Her interest in writing, plus her delightful sense of humor, made for a number of pleasurable encounters. Other friends and partners from long ago were equally forthcoming with memories and facts: Ronald Clark, David Diao, Nancy Grossman, Al Held, Jill Johnston, Joan Jonas, Robert Morris, Annina Nosei, Irving Sandler, Shirley Soffer, Grace Stein, and David Vaughn supplied information that had disappeared in the fog of my memory. I owe thanks to Audrey Goodfriend and Joi Grieg for their generosity in lending photos from their family archives. My dear brother, Ivan Rainer, not only allowed me to ransack his house and dismember the family album but also dug my long-winded letters to him in the 1960s out of his files and mailed photocopies of precious items I had overlooked in my rummaging. To John Bottomley goes my gratitude for his cooperation in supplying details of the period I spent with him in 1953.

I am also appreciative of the adventurousness of Sid Sachs, director of the Rosenwald-Wolf Gallery in Philadelphia, in initiating the exhibition "Yvonne Rainer: Radical Juxtapositions 1961–2002." The catalogue that accompanied that show proved an invaluable resource and greatly reduced the time and tedium of wading through my badly organized files.

I am most indebted to those who read large chunks of the memoir along the way. Sara Bershtel, Stephen Koch, and Ira Silverberg read an

early version and offered illuminating commentary on the ways and wiles of the publishing business. Sara's and Stephen's criticisms were instrumental in my rethinking and revamping the manuscript at an early stage. John Erdman and Ruth Rainero cheered me on with their warm and provocative responses. Ruth's editing acumen, brought to bear on the close-to-finished manuscript, was invaluable in ferreting out previously undetected grammatical and syntactical infelicities. The encouragement of Gregg Bordowitz, Rosalyn Deutsche, Lynne Tillman, and Bob Ubell, following their reading of various chapters, has been important to this project, as has their ongoing friendship. Over the years Lynne's tart literary intelligence has pushed me to be less timid. ("Make your jokes more wicked," she cajoled me after reading my last script.) It was Lynne and Su Friedrich who played loving gadflies when I balked at writing about my life past 1972 and persuaded me to expand the epilogue.

Not to be underestimated is the interest of Douglas Crimp, Thyrza Goodeve, Simon Leung, and Peggy Phelan—not only in this memoir but also in my total oeuvre, for courses they have taught—and that of Carrie Lambert, who has written extensively on my stuff. Their scholarly regard gave a tremendous boost to my ego (always vulnerable to self-doubt) and by rekindling my own interest in aspects of my career that I had undervalued or overlooked, furthered the shaping of chapter 17.

My old dance pals, Deborah Hay and Steve Paxton, contributed candid impressions and incidents remembered from our heady camaraderie of forty years ago. Besides quoting copiously from Steve's entertaining correspondence, which peppers my paper and e-mail files, I wish to thank others whose letters or quoted material I have used: Trisha Brown, Bill Davis, Barbara Dilley, the late John Bernard Myers, Diane Wakoski, and Peter Way. The inimitable Valda Setterfield regaled me with memories of working with me thirty years ago, and during my infrequent lunches with another "old dance pal," David Gordon, I was

buoyed by his pungent takes on the intersection of our youthful experiences and art-making and life in general.

I might not have embarked on this project at all had it not been for Steve Anker, who approached me in 2002 on behalf of the Pacific Film Archive to write an essay for a book about the formative experiences of Bay Area filmmakers. Chapter 5 was the result, the writing of which was instrumental in launching the larger project.

I am more than grateful to Roger Conover of MIT Press not only for accepting this work but also for his initial enthusiasm, which made me feel I had produced something of more than passing interest.

Barbara Moore over the years has bent over backward to supply me with photos and the rights to their reproduction in journals and catalogues. I am indebted for her cooperation in once again coming through with her time and amazing archive for *Feelings Are Facts*. Without the photographic work of the late Peter Moore, this book would have been less lively. Additional thanks go to other photographers for granting photo rights: Stephanie Berger, Mary Hottelet Giese (for the late Al Giese), Warner Jepson, Babette Mangolte, and David McCabe. While I have made good-faith attempts to contact all the photographers whose work is reproduced in these pages, some have proved impossible to find. I hope in those cases that the credits beside their photos convey my sincere appreciation and desire to acknowledge their work.

I close with two special notes of indebtedness: When needed over the last twenty-five years, Nathan Stockhamer has been a steadfast professional witness to my emotional ebullitions. And I reserve my most fervid gratitude for my significant other/partner/girlfriend/lover, Martha Gever for maintaining the impeccable standards that kept me from indulgence and prolixity during the writing of this memoir, for her infinite patience in dealing with my chronic computer hysteria, and for her unflagging, unstinting support.

Prologue

I started this memoir because I was stumped, caught up short, at a loss. On September 11, 2001, American Airlines Flight 11 roared close enough to my building in lower Manhattan to seem directly overhead. For most of that day I sat in a stupor, watching the horror unfold on TV along with countless others. I live four blocks below Canal Street, about a quarter mile from the World Trade Center. Three days before the attack I had attended a dance concert on a stage nestled in the space between the towers. On looking up at the two structures looming over the audience, I noted to myself that I had never before observed them from this dramatic vantage point. My perspective gave new meaning to the word *soar.* The day before the attack, a Monday, I had had reason to walk across the same plaza on my way to the Department of Motor Vehicles branch further downtown. For my everyday life in New York City, the World Trade Center towers served as beacons that invariably marked my position in the Manhattan grid. Though I had been astonished at the view from the roof of the north tower twenty years before—more akin to the view from an airplane than a skyscraper—from street level I had long since taken the towers' hubris-fraught mass for granted.

On September 11 I was planning a half-hour videotape that would incorporate fragments of dance with printed texts dealing with art and politics during the decline of the Austro-Hungarian Empire. Completing the tape in the spring of 2002, I called it *After Many a Summer Dies the Swan: Hybrid.* At the same time, engrossed in the news reports of the Bush administration's machinations as it prepared for war, I began to spend more and more time at my computer transmitting information

by e-mail to a list of over two hundred friends and acquaintances. In the ensuing months, in a state of appalled apprehension and disbelief, we marched with millions of others throughout the world to protest what proved to be a fait accompli.

Everyone I knew believed that an invasion of Iraq would intensify and activate Mideast antagonisms rather than abate them, and that has indeed come to pass. Meanwhile, as I stated at the outset, I was stumped. Our current regime surpassed any in living memory for meanness and blatant disregard for social good. I found the present situation overwhelming. I could not begin to envision dealing with it in terms of an art practice. It curdled my imagination, stopped me cold. My *Swan* tape made indirect analogies in situating the Austrian bourgeoisie of a century ago in a similar state of paralysis by way of numerous quotes from Robert Musil's *The Man without Qualities:* "It was a remarkable time; you could move neither forward nor backward, and the present moment was quite unbearable."[1] My films, at least from 1980 to 1996, had dealt more directly with the "big" social issues—racism, sexism, homophobia—that had embroiled film, women's, queer, and postcolonial studies and independent film production for the last quarter century. It was "the present moment" that, for me at least, seemed an insoluble obstacle to creative rendering.

My art-making response to our own "remarkable time" has been to follow the example of *Swan* and look to the past, in this case my personal past, and I set out to trace the development of an individual consciousness through a maze of cultural, familial, and historical events. In the interests of supplying varied angles of access to my life, this memoir includes letters, journal entries, occasional program notes from perfor-

xiv

1. Robert Musil, *The Man without Qualities,* Volume 1 (London: Pan Books, 1979).

mances, and, where relevant, excerpts from my film scripts that are fictionalized versions of autobiographical material. All of this constitutes a methodology that very much resembles the mosaic-like construction of my work in general—spanning over forty years, back and forth between dance and film—with its juxtapositions of texts and images culled from a wide variety of sources.

I have stated what propelled me toward writing a memoir, but I am still a little uneasy about my motives. Why do I seek to make myself known when I have already accomplished this in performance and film? Do I wish to make claims to a hearing and in so doing seek, in Peter Brooks's words, "a catharsis of confession"? The very question suggests guilt and a need for expiation. As he points out in *Troubling Confessions*, in our talk show saturated culture "without confessional talk [we] simply don't exist."[2] No, I must remind myself that my existence does not depend on some kind of secular redemption through self-exposure. Though it may prove no more reliable, rather than confession I prefer to think of this enterprise as a more guilt-free kind of testimony: to a life, to the products of that life, and to its public and private interplay.

Another hope I have for this book—outside of its more familiar demonstrations of personal resilience—is that it will offer a détente between the confrontational and absolutist pronouncements and questions of my youth and the more measured perceptions of my imminent old age without undermining the progressive political convictions that by the mid-1970s began increasingly to infuse my films. At the same time I must remind my potential readers that, though older and wiser, I can't make a claim for objectivity, nor would I want to. Each stage of life defines a

2. Peter Brooks, *Troubling Confessions* (Chicago: University of Chicago Press, 2000), 140.

different set of prerogatives and imperatives. I find myself recognizing with no little amazement those that have surfaced in all their prismatic variations from my reckless past. (If I begin to sound like Hollywood movie titles from the 1940s—*Out of the Past* and *Reckless Moment* come to mind—it is because the juvenilia of my diaries and my early mid-life melodramas lend themselves to such analogy.) If this book produces for the reader even a particle of that amazement, I shall be gratified.

Feelings Are Facts

The autobiography is a covertly anti-intellectual genre, designed for those who are more interested in what Tolstoy had for breakfast than what he thought about Plato.
—Terry Eagleton, review of Eric Hobsbawn's *Interesting Times: A Twentieth Century Life* (*The Nation*, September 15, 2003)

If you're interested in Plato, you're reading the wrong book. If you're interested in difficult childhoods, sexual misadventures, aesthetics, cultural history, and the reasons that a club sandwich and other meals—including breakfast—have remained in the memory of the present writer, keep reading.

Burgeoning Sexuality

SEPTEMBER, 1952: Having coffee with Jack Warn and his friend George in a Market Street luncheonette. Jack is showing us 8 × 10 black-and-white glossies of Jayne Mansfield lying on the floor, mouth open in an ecstatic expression while a guy goes down on her and people look on. Jack carefully folds a napkin and places it between his cup and saucer to absorb his spilled coffee. It is the first time I have seen anyone do that.

I have been having occasional sex with George, an artist from New York who is trying to save money to go to Paris. He is staying in a sleazy hotel in the Tenderloin. I try to rush past the desk clerk on my way upstairs. He bellows, "Where do you think you're going?" "Up," I retort.

Jack and George are making a meager living cajoling passersby on lower Market Street to visit a second-floor photo studio. In their early thirties, they feel very hip and love the hustle and bustle of the nighttime weekend crowds. Newly dropped out of college and liberated from parents, I sometimes go downtown on a Saturday night and watch from a distance as they work groups of sailors. "How's the action?," they

challenge their fellow hucksters on the street. One weekday evening I spend time with them in the closed photo studio as they try to take provocative—they would have called them "artistic"—photos of me in the nude. I have just come from a big dinner at my parents' house and have a protruding belly. They are obviously put off by this as they fuss to rearrange my poses. I am not the model they had in mind.

The year before, while still living at home, I had enrolled at San Francisco Junior College (now City College). I started dating Wilbur Bullis, a navy vet in his mid-20s going to school on the GI Bill. I didn't really know it was dating; I mean, he was the first guy near my age who seemed to want to hang around me. While I was in high school the anarchist friends of my older brother Ivan, all quite a bit older than either of us, had shown furtive sexual interest, like Dave Koven, who encouraged me while I was still in high school to take life drawing classes at San Francisco State and had paternalistically discussed "the female body" (in response to my provocative questions, let me add) while driving me home. Comparing my small breasts to those of the model we had sketched, he told me mine would probably grow bigger as I matured. At that point I knew what fucking was, but what led up to the act was still almost as unimaginable as a desire for the pastel cashmere sweaters worn by my wealthier high school classmates. Wilbur was openly admiring and seemed just as uncertain and green in matters of social decorum as I was. He was always rattling on about his previous sexual adventures ("I was sitting on the couch with her and I swear, her vagina burped"), and I was too inexperienced or too oblivious to recognize he wanted to get into my pants. I took him to his first Chinese restaurant, Yee Jun, off Grant Avenue. He was very nervous and after a first sip of tea pronounced with his big wide innocent grin, "This'll put hair on your chest!"

Wilbur had a car. One night he drove me home and parked outside my house. We kissed for the first time. An odd thing happened: my underpants were suddenly all wet. I didn't connect the two events but was so alarmed that I hurriedly said good night and ran upstairs. It must have been a couple of weeks later that we sat in his car out at the beach and started to pet. He nearly got in. Sitting in the front seat with him crunching and straddling me and running off at the mouth—"See how easy it is? . . . See how easy it is?" over and over—I panicked at the last minute and threw him off. Looking back I can attribute the physical discomfort in part to my lack of limberness, but the truth was I didn't quite trust him. He could at least have set us up in the back seat (could the car have been a coupe?). Poor Wilbur—we never did make it. I last saw him when he attended a screening of mine at Pacific Film Archive in the late 1970s. He had become a lab technician and had the same appealing sheepish grin.

The previous summer I had trusted Frank Trieste, one of the older anarchists with whom Ivan hung around, enough to allow him to deflower me. It was the August after I had graduated from high school. I had biked the six miles over to Duncan's Mills from our summer place in Camp Meeker. Shirley and the kids were away. As the day passed he grew strangely intense. I asked him if he was familiar with Dada, which I had recently encountered in a *Life* magazine article. Yes, he knew all about Dada. By this time it was quite late. While he was inside he asked me how I felt, I guess because I was just lying there. I said it felt like pins and needles all over. Was that what I was supposed to feel? After he pulled out—he said he hadn't come—we discussed what I would tell my parents when I returned to Camp Meeker the next day. I wanted to lie and say the family had invited me to spend the night. He thought that

was a bad idea. What if they found out Shirley was in San Francisco? Better to tell the truth. When I got back I told them Shirley and the kids hadn't been there. My father knew instantly. He knew these guys. He was ready to kill. Several years later, when I was living in my third two-room apartment in the Fillmore, Frank came to visit and we had sex on my Murphy bed. Referring to the earlier event, he said, "Better me than someone else." My missionary was twenty-five years older than I.

During my year at San Francisco Junior College I studied all the time, taking a full schedule of courses in psychology, philosophy, European history, intermediate French, English literature, and geology. French was a nightmare; I could read and write but couldn't speak or understand anything that was said to me. I found the readings in philosophy from Plato to Locke the most interesting, although the conceptual intricacies were difficult. At the final exam I was the last one to finish, struggling with the questions in the empty classroom for two more hours. Much to my surprise the professor, a sardonic fellow always ready to make fun of students' presumed indolence—". . . of course I know you'd rather be drinking a double-thick, double-chocolate malt in the cafeteria . . ."—gave me an A in both courses. The following summer (1952) I was accepted at the University of California and moved across the bay.

Now at age seventeen, I had my first encounter with liberation. I moved into a cubbyhole in Berkeley, wildly excited at the prospect of living on my own for a whole month before attending classes at the university. It was absolute heaven. "I am alone. I am in Berkeley. I am in my own house. I am unheard, unobserved," I wrote in my diary, but immediately amended with "I deny the above lines," as though I was not entitled to the pleasure that such unequivocal plain speaking suggested. The apartment, so to speak, was a tiny annex attached to the back of the main house, with its own private entrance. Squeezed into it were a very nar-

row bed, a minuscule desk, a sink, two gas burners perched on the drain board, and a few hangers. To bathe and go to the toilet required going outside and entering the back door of the main house. It cost fifteen dollars a month, which my parents provided. In the main house lived a family with a teenage daughter and another lodger, a young woman with a southern accent who took a special interest in me. Had I been more urbane, I might have thought of her as white trash, but I welcomed her curiosity and attentions. She urged me without success to "arch" my eyebrows and later was astonished when I told her that Jack Warn had come to visit and we'd had sex. What surprised her most was that he had gotten in and out undetected by anyone in the main house.

Nell, [age] 26, from Arkansas, grammar school education, hates to read, can't stay home at night, liked me the first time she saw me, thinks I'm the strangest girl she ever met because "you don't fix up," is kind-hearted and innocuous, is not very happy and knows it, doesn't want to get married and be burdened with a family. She knows nothing and is noble in her ignorance, while I, who aspire to supreme knowledge, find myself growing puny and insignificant as my increasing awareness of internal putrescence, far from leading to greater clarification, understanding, and acceptance, draws the walls of fear and hate closer about me. I am suffocating. I pity and hate myself.

(Diary entry, September 10, 1952)

While browsing in a Berkeley bookstore, the most beautiful woman I had ever seen struck up a conversation with me. Tim Courtney was twenty-five, a graduate student in psychology at Berkeley, and bisexual.

She took me to her house, told me her life story, talked about her conquests. I fell in love. Tim was worldly wise, wore Navajo jewelry, had studied modern dance, could discuss anything and everything, had an IQ of 165 (so she said), and long flowing black hair. (I had chopped off my hair bowl-fashion shortly after falling in with some socialist Zionists from Hashomer Hatzair in my third year in high school.) Although we slept in the same bed, she refused to make love to me, her reason being that she didn't want the responsibility. I confided to her that the woman in my sexual fantasies looked like Marilyn Monroe or Jayne Mansfield. She said that a woman like that would probably want someone more butch than me.

Tim shared a house near the campus with a shy, bespectacled young man who was doing graduate work in physics and, like me, was infatuated with her. He and I would talk about science fiction, agreeing that the genre was interesting because of the ways it reproduced earthly social dilemmas. Tim was having an affair with the TA in one of her classes, a guy. She had had a difficult childhood and adolescence; her parents had been addicted to heroin, and Tim was making up for lost time by working extra hard in grad school. She said she always sat up front in her classes, ignoring everyone but the professor, which is probably how she seduced the TA. Her gaze was irresistible. One day while cleaning the house she performed for us by dancing madly from room to room, furiously wiping surfaces and screaming like a Freudian banshee, "Getting rid of guilt, I'm getting rid of all this guilt!" She knew people I knew, like the painter Ronnie Bladen, in fact had had a "sweet and tender" affair with him. The last time I saw her was in 1954 at Mike (Mel) Grieg's "Poets' Follies," where I introduced them. Tim and Mike coolly appraised each other. By that time, in the middle of a love affair

with Mike, I had confided in both of them. (Mike: "She's not as beautiful as you described." Tim: "Is that him?")

I met Jack Warn while hanging out in North Beach, or rather he had approached me as I was listening to Tim sing folk songs while accompanying herself on the zither at Vesuvio's. I had gone there with some Trotskyites following a political meeting focused on the Rosenbergs, who would be executed the following year. The anarchists I knew never talked about the case, at least not in my presence. They hated the commies. After all, hadn't Emma Goldman and Alexander Berkman been disillusioned when they visited Russia in 1919? (Anarchist Audrey Goodfriend had given me a first edition copy of Emma's *Living My Life* for my sixteenth birthday.) The Bolsheviks had betrayed the Revolution. Both the Trots and Fellow Travelers were kidding themselves in thinking otherwise. I was carrying Nikolai Chernyshevsky's novel, *What Is To Be Done?*, which probably gave me the right credentials in my new acquaintances' eyes. ("Seventeen years old and look what she's reading!") Planning to take a course in pre-Revolutionary Russian literature at Berkeley, I had also been reading lots of Tolstoy and Dostoyevsky. At Vesuvio's Jack came over and offered to buy me a drink. Of course I accepted and before the evening was out gave him my Berkeley phone number. Far from being complicit with the myth of women's sexual power over men, I was about to embark on a desperate odyssey in search of love.

I feel very different now. Yes, very different from the first time. No, mommy, I dint have no orgasm but it was fun nice. It was great, man. It was the most. I talked to myself, to him, to the world. And I heard and he heard, and the world heard and understood. It feels square

almost, to the touch, But then it slides in and is snug, very snug and comforting and all. It is all him-me-the-world. It beats masturbation. No, the earth did not move. He moved up and down in a steady pulsating pattern. It was pure rhythm. And I moved with him. Up and down, back and forth. Sometimes hectically, sometimes very calmly and gently. And I talked. He had talked all afternoon, but in bed it was my turn. I talked words pure words and thoughts and dreams and phantasies. I talked as I have never talked before. Not compulsively nor frantically, but peacefully, for I was in a great womb and he was in mine. I knew security. Perhaps I knew love. My vagina is still sucking in his penis—the beautiful, solidly grand appendage suspended from his groin. What an implement! I like it I like everything about it. I do not say "him," because, although I realize that his part in the act as an individual, as "Jack," was most important in causing me pleasure, I'm not sure, I don't know if it was all "Jack" or was in part due to the mere fact of being next to a body, feeling its warmth, being intensely aware of comfort and tenderness and enveloping security. I am nuts. These things were all Jack, were all he and he alone. I was lying next to *him; his* arms embraced me; comfort and the rest emanated from *him*. Yes, he. With Frank it was a far more restrained, impersonal thing. And with reason. But last night there were no reasons, no logic, no boundaries, no fear, no nothing. It was simply something and everything that were there.

And, of course, I now find myself filled with awe at the intricacies, or lack of them, involved in this experience. A chance encounter, an intent stare, a hand clasp, a running after, a sitting down, a weird, hesitant oral intercourse, a visit, an exploration of bodies, a venturing out at dusk, an extended, more intimate conversation, a decision, a stealthy return, and a glorious, abandoned night. Glittering life,

8

you contain much that is inexplicable and much that is deceptively simple. And all is very, very wonderful. Full of wonder-inducing things for me. The fullness remains in my vaginal passage. A fullness full of awareness, of knowing. A conscious fullness, soothing and compassionate. A fullness that knows and accepts itself.

(Diary entry, August 25, 1952)

This afternoon I was musing over some of my conversations with Jack and remembering that he had said half-seriously, "You'll do great things, kid. I expect to hear about you later." At the time of the actual conversation I had replied that he would probably hear of me in an unfavorable way (what modesty!), but in my imagination I changed my response to "Yes, I'll be listed in the papers as the 632nd person to commit suicide off of the Golden Gate Bridge." 632. I didn't hesitate for an instant. 632 was right there waiting for me. Having just completed Freud's *Psychopathology of Everyday Life,* I was naturally on the lookout for psychic experiences of my own corresponding to those explained by Freud. But now I have struck a blank wall: What do all of these apparently unrelated associations signify as a whole? I'll be damned.

(Diary entry, September 1, 1952)

I lasted a week at the University of California. I bought all the textbooks and attended all the classes. One was a course in physical anthropology in a 400-seat amphitheater. The textbook was a thick tome by

Alfred Kroeber. The course I was most interested in was the one on pre-Revolutionary Russian literature. The professor unsmilingly delivered the ground rules to the small class at the first session. It sounded like a judicial sentence: so many papers, deadlines, assignments. At San Francisco Junior College I had written only one paper, and that consisted mainly of quotations. The teacher had remarked on this but for some reason gave me an A nonetheless. After a week attending classes on the vast Berkeley campus I panicked. I couldn't understand anything in the Kroeber and was totally intimidated by the Russian lit professor.

I am going to force myself to write grammatically and coherently tonight; I am going to try to think the thing through.

Saturday I wandered down Market to 6th St., vaguely wondering whether George would still be working there. I saw him standing at the curb. Then he saw me and said, "Oh, hello. There he is." "He" was Jack, who was just emerging from a cigar store. I was surprised, for I had not expected him to return to this "pitch." We had some coffee and chatted and avoided my moroseness. I mean we skirted around it. But it was there, very much alive, turning down the corners of my mouth at regular intervals. I hated myself with him, I hated myself on the train, I hated myself as I opened my anthropology text in my room and discovered that it was impossible to follow Kroeber's turgid style. And then I knew that I could not go back to school. Why? All in alternating anguish and guilt and resignation and defiance I have asked myself why. I have thought of a few elaborate intellectual scruples, which I would like to have as reasons preventing my return, such as an objection to the impersonal and oft cynical relationship between instructor and student and to the superficial scope of the

curriculum. I am all too aware, however, that my motives are far removed from such objections, belonging to the same emotional category as all of my difficulties with myself and other people.

First of all, I was unable to concentrate on the assignment and realized that this term would be worse than the last as far as studying was concerned. I refuse to go through again what I experienced last semester at SFJC—the ferocious combat between fantasy and comparatively vapid text and my more industrious and conscientious self. The real feelings underlying my resolution were still more tenuous. In fact, I know that I am going to encounter the same difficulties in attempting to describe them here as I did at the clinic last week when I became so mad and flustered while trying to describe similar feelings. My thoughts on that Saturday afternoon roughly followed this sequence:

I cannot concentrate on this. It is dull. I do not want it to be dull. I am very interested in cultural anthropology. I want it to live for me as it did when as a child I read avidly about primitive cultures. I want it to be alive. But it is dull. The style is difficult to follow. I do not understand the author's ideas. No, no! I must not admit this; I must never admit this even to myself. I understand, I do understand, I must understand. There are others in that class of 200 who understand very well. There are some whose IQs are higher than mine. IQ 178, IQ, IQ, IQ. They are all threats to me. The competition will be too great. A term paper is required in the Russian lit course. I cannot write papers. I won't be able to write that paper. Others write papers very well. They can elaborate; they know what they think; they are able to coherently and logically and smoothly express what they think. I cannot. I do not know what I think. I have no ideas. Philip would write a wonderful paper in that course. I cannot. I have no

ideas, no ideas. I cannot compete. They menace me—all of those hundreds and hundreds of students. They sit next to me—they are all around me—they intend to suffocate me, crush me with their brilliant proximity. They will destroy me in my dullness, because they can talk about many things. In the French class there are duller ones. I know my French better than most of them, but there is one girl who can already speak very well; she picked it up someplace. I don't want to hate her. She is a friendly girl. Yes, I had better not go back there again. I don't want to hate all those people. I don't want to feel competitive. I don't want to feel that everyone is threatening me by being more intelligent than I. When I am in school among them, all the hostility overwhelms me. When I am alone I do not feel it. If I were to force myself to go there day after day, soon it would be the hate and fear, rather than the people, that would destroy me. I shall not go where I must expose myself to my own means of annihilation. Alone I shall eventually arrive at some kind of understanding and tolerance of myself; my two selves shall reach an agreement; then, when I am no longer warring with myself, I shall go out among them once more and shall not hate.

I have captured it at last! This is the egoism with which I live. This is the egoism that is wringing the last drop of love and sympathy out of my writhing soul. This is the egoism that threatens to obliterate the last traces of gentleness and true spiritual generosity within me.

(Diary entry, October 3, 1952)

I dropped out, hid out in my cubbyhole on Roosevelt Avenue, read Thomas Merton's *The Seven Story Mountain,* and finally spilled the beans

to my parents. This took place in our living room: I was sitting on the rose-hued upholstered chair, and they were standing like two cigar-store Indians in front of me, my very tanned mother in one of her cotton house dresses with arms folded across her small-breasted chest. They were surprised, didn't seem especially shocked, and asked me what I wanted to do. I started to cry. I couldn't bear the idea of moving back in with them and was deeply ashamed. They stood there, a captive audience to my overflow of feeling. It was exactly like when I was eleven years old, just home from an appendectomy, in bed and crying while the two of them looked at me nonplussed from the foot of the bed. In the hospital I had received tons of affection from a maternal nurse, and now I was back in this gloomy house with these two helpless people. Why is she crying? Poor folks, they hadn't a clue then and were clueless now. I was finally able to stammer out a proposal: I wanted to get an apartment and look for a job. Relieved, they agreed to pay for the apartment and give me an allowance until . . . Anything to get rid of this misery.

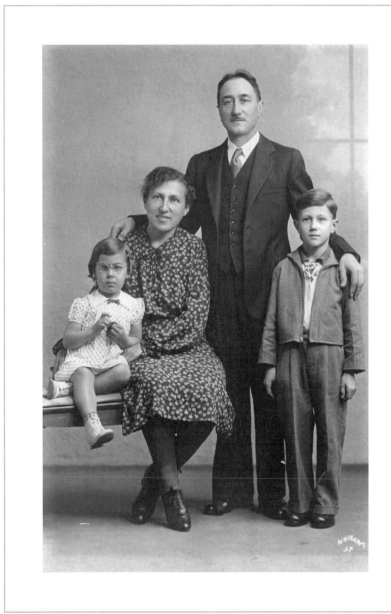

Yvonne, Jeannette, Joseph, and Ivan, ca. 1938

2

A Bay Area Family

IT WASN'T THAT they wanted to get rid of *me*. . . . Just the misery that somewhere deep down they knew they had had a hand in creating. If only the misery of their miserable daughter would go away. . . . They were, of course, still very concerned about me. Unbeknownst to me— Ivan knew but never told me—they had been reading my teenage diary from its beginning, all the fantasies about jumping out the window, all the anguish and guilt and ambivalence over trying to separate myself from my doting father, all the erotic circumlocutions as I began to date Wilbur Bullis. "The cock crows in a loud voice" must have sounded the alarm that propelled my mother into my room one morning while I was still in bed to demand, "Well, are you pregnant?" They were so concerned that when I was sixteen they consulted Anita Day Hubbard, the self-help columnist of the *San Francisco Examiner* who persuaded them to send me to the Mt. Zion Psychiatric Clinic for weekly sessions with Barbara Eppstein, a psychotherapist, the first of many. Daddy was dubious: "She should hear our side of things also."

In their own way, ever since they had allowed my brother and me to come home from Sunnyside, the last of the foster homes to which we had been previously banished, they had done their best to take care of us. Mama shopped and cooked and washed and ironed and darned, and duly taught me these and other things she knew, such as how to parse a sentence and later how to write a check. She had been a crack stenographer, dropping out of high school at age 16 to attend business school, knew Pittman shorthand, and could parse a sentence with the best of them. My father retired from being a house painter and contractor around 1940, after FDR's Social Security legislation took effect. In the presidential election of that year they even voted for Republican Wendell Willkie in protest against the new "red tape" imposed on small businesses. Mama, who kept Daddy's books, didn't want to be bothered. As we shall see, she didn't want to be bothered by a lot of things, including taking care of her young children. After retiring Daddy went every weekend to be the handyman in the Marina apartment building they bought in the early 1940s. He loved to putter, and in the absence of steady work after retirement he found things to do. Once I went with him and met Mrs. Rich, the elegant, proper "grass widow" (1940s' lingo for "divorcée") who managed the place and wore expensive looking knit dresses. (Although Mama had dressed like a "fashion plate" when she first came West around 1923, by this time she wore only cotton housedresses.) Right after the War, persuaded by Mr. Werth, a real-estate man who brought us Christmas presents every year, that a postwar economic debacle was in the offing—I can still see the book he gave them lying around the living room, its dust jacket blaring *The Coming Depression!*—my parents sold the Marina apartment house for $65,000. Mr. Werth must have made a nice commission. When I was nine they bought a run-down summer place nestled with other houses in the middle of a redwood forest,

seventy-five miles north of San Francisco, near the Russian River. A two-story wooden structure with open porches rambling around three sides, it was the most dilapidated house on the road and would probably have tumbled down the hill before another summer came around. I was with them when they drove up there to take a look. It was ostensibly to be "for the children." The local community dammed up the creek every summer to make a long swimming pool, and there were Saturday night amateur hours in the nearby scooped-out "bowl." They got the place for a song, but I always suspected the real reason for the purchase was so Daddy could get away from the family for weeks at a time during the winter while he completely revamped the place, closing in the porches, adding rooms, and lovingly rebuilding the stone retaining walls. He was a master stone mason and never forgot the craft to which he had apprenticed in the foothills of the Italian Alps from the age of eleven. The Camp Meeker rehab was a purposely endless endeavor.

JOSEPH AND JEANNETTE Rainer's adventures in real estate began shortly after they started living together. (They didn't get legally married until after Ivan and I were born.) Jenny Schwartz had begun her trek West following an escapade with a man while she was still living at home on Hinsdale Street in the East New York section of Brooklyn. At that point there were four grown siblings—Philip, Irving, Minnie, and Jenny—all American-born and living with their parents, Sam, a former tinsmith, and Lina, both of whom had emigrated from Warsaw in the 1880s. It must have been a turbulent household. Jenny's older brother Philip, a policeman, was banished by their father after brandishing a gun during an argument. Philip left for Los Angeles and was never heard from again. And because she had become a strict vegetarian—refusing, to her mother's chagrin, to eat her cooking—Jenny was no longer menstruating and was afraid she was pregnant after a one-night stand. When I was in my teens she told me this cautionary tale: Several of her girlfriends belonged to a social club that organized dances and excursions for working girls. Once a big group took a ferry out to Long Island somewhere. It was supposed to be a day trip, but a man she met on the ferry persuaded her to stay behind when everyone left. They went out on a lake in a rowboat and he told her that women with thick ankles are very sensuous. That night they went to sleep in separate tents. She became so aroused she went into his tent and they had what she described as "a sexual relation." She always blamed the chaperone for allowing her to stay behind.

Around 1923 Jenny left home to work as a secretary for the Lindlahr Sanitarium in Chicago. Several of her girlfriends had hitchhiked west and wrote enthusiastic letters to her about the California sun and all the Italian bachelors they were meeting. After a bitter winter—she cried from the cold, and the wind blew so hard from Lake Michigan that

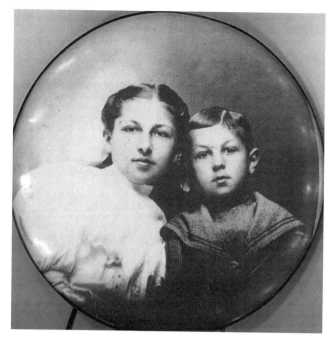

Jenny Schwartz with younger brother Irving, ca. 1908

Lina Schwartz, my maternal grandmother, ca. 1908

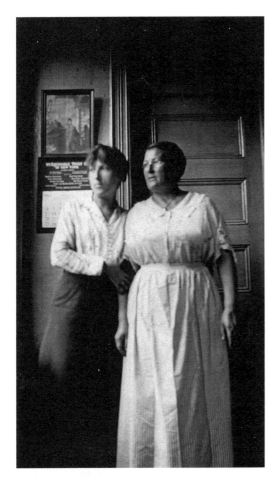

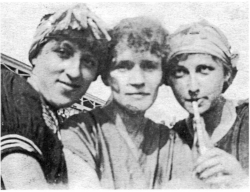

Jenny with mother Lina, 1916

Jenny (left) with two girlfriends at Coney Island, ca. 1916

they had to string ropes along the sidewalks on Michigan Avenue—Jenny boarded a train for San Francisco. I suspect it was the climate more than the Italians that beckoned her. The Italians she knew from Hinsdale Street "belonged to the Black Hand and stored coal in their bathtubs."

As far as I can make out, my father, Giuseppe Rainero, arrived at Ellis Island in 1911 and went directly to Hoboken to catch a train to Chicago. His sojourn in that city, though brief, was momentous. He was so repelled by a visit to the stockyards that he then and there stopped eating meat. He also became involved with some gun-toting mafiosi. Never a bomb-throwing sort himself, he decided this was not the right place for him and took off for San Francisco. I only recently learned of the soap opera–like circumstances surrounding his earlier departure from Vallanzengo, the Piedmontese village of his childhood, northeast of Turino.

Several years ago Ivan's daughter, my niece Ruth Rainero, visited Daddy's sister, my Aunt Maria Rosa, then eighty-five years old. Twenty years younger than my father, she was living in the very same house in which they had both been born. Ruth ultimately learned from a second cousin, living near Lyon, that when Giuseppe's mother became pregnant with Maria Rosa, his father in a drunken stupor accused him of being the inseminator. Giuseppe left, so I'm told, on the next boat for America. My father never talked about his father, only about his mother and grandmother, and he never even hinted at this story, so it may not be entirely true. I do know that he was impulsive and head-strong. (Looking at the photo album with pictures of Daddy as a young boy, Mama always remarked, "He looks mean.") As he told it, already a rebel in grade school, he "hid the nuns' books" and later took an overdose of quinine to get out of the army during one of Italy's Ethiopian campaigns. He spent all of World War I in Baja California avoiding the U.S. draft, which,

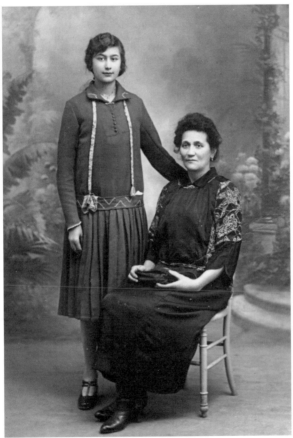

22

Aunt Maria Rosa with Ruth Rainero, in Vallanzengo, 1996

Aunt Maria Rosa and my grandmother, ca. 1925

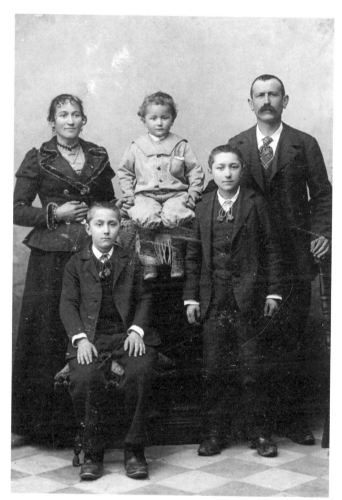

Giuseppe Rainero (lower right) with brothers and mother, Teresa, and father, Giovanni, ca. 1902

Giuseppe Rainero in the Italian army, ca. 1910

during that war, did not exempt foreigners. There he fished and had some narrow escapes in storms and quicksand. I asked for these stories at regular intervals throughout my childhood. They never varied: the burro that looked at him accusingly after saving him from the quicksand, the storms, the struggle with the capsized boat and the heavy boots. He said that thoughts of his beloved grandmother always saved him when his life was in jeopardy. Although he sometimes talked about returning to Italy—with me, if not with Mama, who refused to sleep in "strange beds"—he never returned and never met his sister or saw his two younger brothers again.

My mother and father met in a "raw food dining room" in San Francisco's North Beach. (Not "vegetarian restaurant," "South Indian Cafe," or the like, the setting was always referred to as somebody's—alas, I can't remember the name of the "Somebody"—"Raw Food Dining Room.") Sharing interests in radical politics and vegetarianism, they immediately took to each other. Joe helped Jeannette move to a new flat with his Tin Lizzie truck. One day during a picnic with some anarchist friends in the countryside, they went out in a field and made love. The earth must have moved, because that was it for my puritan, virginal father. When Jeannette a short time later remarked that she was glad of her previous sexual experiences because now she could appreciate Joe even more, he became so enraged and obnoxious that she made arrangements to take a secretarial position in New Orleans in yet another vegetarian sanitarium. As she was packing he came to her flat very contrite and implored her to stay. When I was in my late teens she told me that he was driving her crazy with his jealousy after a recent walk in the park during which a man passed them who resembled a former lover of Jeannette's from those long-ago days. "Are you still seeing him?" Daddy inquired. What a guy.

I don't know when they changed their names. For my mother "Jeannette" sounded more refined than the low-class "Jenny," and my father changed "Giuseppe Rainero" to what he thought was the more American-sounding "Joseph Rainer," when in actuality people took it for German. Jeannette's father, Samuel Schwartz, who, my mother was wont to declare, "had the map of Jerusalem written all over his face," had moved with wife Lina to Los Angeles in the late 1920s. After my grandmother died there, he remarried, evidently into a bit of money. Sam and Rose, his new wife, loaned my parents the down payment on a small house situated on a few acres in Torrance, then a sleepy town southeast

Giuseppe (center top) with buddies, ca. 1922

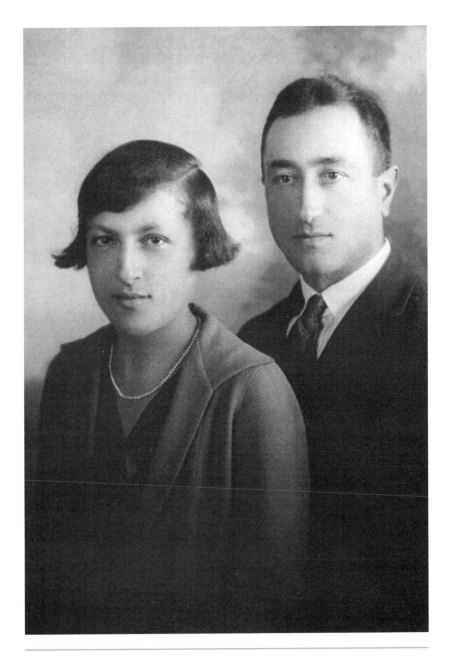

My mother and father, Jeanette and Joseph, ca. 1925

of Los Angeles. Joe fancied himself a farmer and grew vegetables for the first year, haranguing my mother into helping him, but, as Mama would later recount—with no little sense of vindication—"he never had a green thumb." Over the years they sold off parcels, including the one with the house on it, until nothing was left but a small wedge that would be leased to Richfield Oil in the late 1940s for a gas station. I never understood how they could buy property during the depression, but property values must have been so depressed that even if you had a small amount of cash you could swing something. Mama remembered that the worst it ever got for them was when they had only twenty-five dollars

27

Samuel Schwartz, my maternal grandfather, ca. 1935

in the bank. From Torrance—where Mama developed a craving for milk and would sneak out to buy the forbidden substance from the passing milkman—they moved back to the Bay Area, where my brother, the cause of her craving, was born. As far as I know there was one more attempt at farming, this time overseeing an orchard of plum trees near Gilroy. One of my earliest memories—I might have been barely three—springs from visiting them in this place: I am sitting and teetering precariously on the flat wooden surface of an old two-wheeled farm cart. It moves ponderously forward as Ivan heaves mightily behind the iron bar at one end of it. It is one of those rare moments of synergy

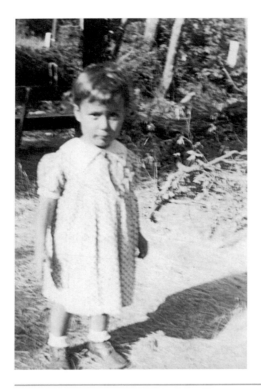

YR, ca. 1936

between us. It is a big cart for a small boy to pull, but I am not afraid. Though it feels very dangerous to be balancing like that with nothing to hold on to, I have total confidence in my adored older brother's judgment and strength. For Ivan, this was only a visit, an all-too-short reprieve from his exile from home. My own exile was either in the offing or had already begun.

The biggest mystery of Ivan's and my lives has always been why Mama "gave us away" and how Daddy could let her do it. Over the years I tended to blame him more than her, but as they say sometimes happens in therapy, "You go in blaming one parent and come out blaming the other." Sunnyside was only one of the various—what shall I call them: foster homes? orphanages? boarding schools? child depositories?—places to which we were sent. Located in Palo Alto, it was the only institution of this kind that housed both of us at the same time and of which I have vivid memories.

I was born on November 24, 1934, four years after Ivan, at 7421 Geary Boulevard in the Richmond district of San Francisco, out near the beach. Mama was 38. She always claimed that immediately after my birth she went into menopause, which must have been a very precipitous event indeed because I emerged quite unexpectedly eight weeks early when Mama got up to go to the toilet in the middle of the night. Ivan remembers a commotion in the house and a feeling of fear. His mother disappeared for some days, and then, much to his astonishment, came home with me. The family photos before the event reveal a smiling happy little boy. A year later it was a different story.

In short, our mother couldn't cope with a new four-pound, cross-eyed baby and a very upset, angry son. He may not have been any more pissed than any other kid totally lacking in preparation and coaching for such an event. What was unusual was the degree of incapacitation,

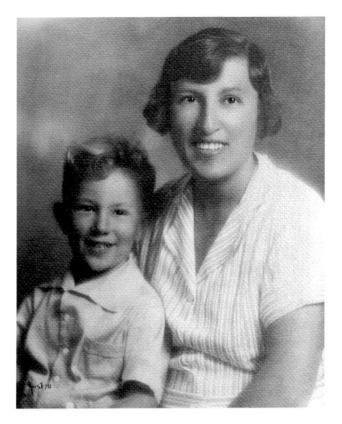

Ivan and Mama, ca. 1934 (before my birth)

Mama and I, ca. 1935

mental and physical, of our beleaguered mother. To this day, when I speculate about the roots and details of her difficulties—the death from scarlet fever of a beloved younger sister, an overbearing older sister, a mother who spoke only Yiddish, a deep shame about her *greena,* or so-called greenhorn, parents, an overly sensitive neurological and psychic nature, a physical self weakened by years of eating only fruits and nuts, two permanently swollen elephantine legs, then called "milk leg," in-curred during her pregnancy with me, all of which may have grossly eroded her self-esteem—I still can't completely fathom the draconian measures that she and my father—in passive acquiescence—felt they

31

Ivan, ca. 1935 (after my birth)

had to take. I know that she suffered some kind of nervous breakdown either before or after my birth. Could it have been postpartum depression? She sometimes referred to a hospital stay during which she thought they were trying to poison her by serving potatoes and tomatoes in the same meal.

Tears drip from the disheveled bedclothes. The carpet is strewn with fragments of torn fingernails and flesh peeled off in a mad fervor. Tears from bloodshot eyes lubricate the blue rings beneath them, and their pupils roam up and down in quest of relief from the burning tears. My mother told me how she fainted twice in succession in the presence of a helpless old woman. I fought to restrain the tears. My mother told me about her hallucinations of persecution due to malnutrition. I was losing. My mother told me how she had to hold her mind intact with both her hands. I lost. My mother did not tell me that she is lonely now that we who have sapped her strength mewl no longer. I wept and shrieked and tore my hair. My mother smiled sadly. I fled, loaded with guilt.

(Diary entry, December 17, 1952)

Something had to give. Ivan was sent away to the first of a series of private foster situations that they found in the yellow pages of the phone book or classified section of the local newspaper. They told him he was being sent away because he was "bad." ("When he walked up the stairs with you he knocked your head on every step," Mama told me.) I was occasionally farmed out to a Mrs. Stein next door, who, incidentally, suggested my given name. Mama tried to recover by resting on the couch.

By the age of two and a half or three I too was being put out to pasture on a more permanent basis. Years later my parents made bitter fun recounting a Sunday visit to one of these places. As they approached the outdoor patio on which a number of children were playing, they heard a single voice sweetly singing midst an eerie silence. The voice was mine, as I sat in the middle of a group of deaf-mutes, as they were then called. They took me out of there the same day.

Ivan and I were taken to Sunnyside at 1055 Forest Avenue in Palo Alto in 1938, at ages seven and four. Ivan may already have been there when my parents arrived with me during lunchtime. I held Daddy's hand as we looked into the dining room containing two long tables, one for the big kids and one for the younger. Sunnyside was a private concern, housing primarily the children of divorcées or working mothers whose husbands were in the military. Ivan and I were the only kids with an intact set of parents. It was owned and operated by two women, Mildred Howard and Irene Burlew. Mrs. Howard was a widow with one son Ivan's age named Philip, who was given to running around in his mother's cast-off clothes. She wore her dark hair in carefully marcelled waves flat against her temples. Miss Burlew was a spinster who always wore Hawaiian print shirts tucked neatly into her creased slacks. Maybe I'm remembering the shirts from photos, but I am sure she always wore pants. Both women were in their early forties when we got there.

Everything at Sunnyside was regimented and systematized. If you had a sore throat they doled out castor oil and spearmint gum and sent you to bed. If you had a bloody nose you got castor oil and spearmint gum and were sent to bed. If you vomited in your plate because you were afraid you would be punished if you didn't finish everything on it, you got castor oil and spearmint gum and were sent to bed. You had to stand in line to take your turn on the toilet every morning after breakfast, and

after you succeeded in moving your bowels Mrs. Howard or Miss Burlew would make an inspection. If you weren't successful you received a tablespoonful of castor oil. They thought our shit was more important than we were.

Even the punishments were regimented: We are lined up—all fifteen of us—to administer the spanking to my brother, who is lying over Mrs. Howard's lap with his pajama bottoms pulled down. I'm not sure what his infraction is, but he is to receive the standard ritualized punishment. When it comes my turn I don't refuse. I hit his bottom like all the rest. And of course feel terribly guilty.

Ivan and I at Sunnyside, ca. 1938

In the middle of the night I get one of my nosebleeds. In the dark I feel my way out of the room on the second floor I share with Matilda and another girl, grope down the hall to the bathroom, and stand over the toilet until the bleeding stops. In the morning there is hell to pay. Blood is everywhere, all over the bathroom, in a zigzag trail leading down the hall into my room, and into my bed, where I lie cowering midst my bloody pillow and sheets. I have disrupted the smooth workings of the institution and am given castor oil and must stay in bed for half a day.

If you were caught lying you got a bar of soap shoved into your mouth. (Try it sometime; the residue stings for hours even after you spit and spit.) Ivan remembers Sunnyside with more fondness than I do. I mostly remember the humiliations, some of them brought on by a complicit streak on my part, no doubt, such as the time all the little kids are getting into their swim suits in Mrs. Howard's and Miss Burlew's room: I undress as slowly as I can, knowing the ax will fall. Finally, the inevitable cannot not be forestalled and I tell Mrs. Fisher, Sunnyside's part-time housekeeper, that I don't have a swimsuit. Big commotion, loud rebukes, someone has to go somewhere, maybe into town, to get me a suit. Meanwhile, no one gives me permission to put some clothes on while I wait, so I stand there naked while the other kids snicker.

Children brought up in similarly callous circumstances know all too well at an early age who among them are "different" and have the least means of self-protection. I was that person throughout my childhood, even into high school. At the bottom of the pecking order, perhaps at first due to my crossed eyes and pronounced lisp, I was the outsider, the scapegoat, the compensatory clown, the object of ridicule, and the one who supplied her tormentors with the weapons of her own destruction. I told them I had been born in the toilet; I told them I didn't

believe in God; I told them we were anarchists and my parents had been vegetarians; I told them my father was a World War I draft dodger.

My pitfalls have not always been of my own making, however, but once marked as a digger of one's own grave, you receive plenty of shoveling assistance from the social world. One night, early in my stay at Sunnyside, we have jello with whipped cream topping for dessert. Out of the blue I am snatched from the little folks' table and thrust roughly into a highchair in the corner. Miss Burlew then smears jello and whipped cream all over my face. "That'll teach you not to play with your food!" What? What have I done? Did they give me a warning that I had ignored or hadn't heard? My tears stream down in rivulets through the mess on my face. I couldn't have been more than four or five years old.

I am now savoring a memory of solace: on returning from school I take my afternoon snack—an orange crescent of gumdrop candy dispensed in the big kitchen—through the back screen door and out to the distant swings. All alone, drifting in dreamy happiness, I suck on the candy to make it last. No one can bother me while I am in possession of this magical combination: the sun, the solitude, the candy, and the seamless arc of the swing.

Sunnyside was a beautiful place in some ways. The rambling three-story wooden house fronted a few acres surrounded by hedges that enclosed a playground, an airy "summerhouse" straddling a creek, a big open space for bonfires, and sheds out back where we made mud pies. White nasturtiums peeked through the hedges bordering the horseshoe-shaped front drive. When they were in bloom you nipped off the end of the flute and sucked out the elixir. The little kids were driven to Lytton Elementary School every day in Mrs. Howard's station wagon, while the big kids got there on their bikes. In the summer there were picnics, bonfires, marshmallow roasting, swimming, and running through the

sprinkler, and in the winter there was the big Christmas tree and a roaring fire at one end of the huge living room. I was especially fond of Dusky, the black cocker spaniel who bore several litters while we were there. The attic of the house was filled with trunks of old clothes and shoes that were made available to us for dress-up. On rainy days we spent hours up there prancing around in the schmattas. When my mother found out I was playing in high heels she told Mrs. Howard to put a stop to it.

The little kids have to take daily naps. We lie on top of the coarse yellow bedspreads in our clothes. I share my nap room with a boy somewhat younger than I. As I lie on my stomach and start to masturbate, I tell him to look the other way. I work up a sweat which stains the bed cover. Later, I know enough to stonewall when they interrogate me about it. Playing with myself down there is another source of relief and escape. No one is going to take that away from me, even after my sleep is disturbed one night by someone pulling my arms and hands away from under my chest where I have folded them before falling asleep on my stomach.

Our parents visit every Sunday afternoon and take us out in their new 1938 Pontiac sedan. Daddy lets me sit between his legs and steer the car as he controls the accelerator and gear shift. Palo Alto in those days still had some bucolic spots. We sometimes go to a secluded foresty place that Daddy calls "Shady Nook." It is right by the railroad tracks and at least once during the afternoon a train roars by. When it has passed we recover the flattened pennies we have placed on the tracks. I love and pine for those visits. Do my tears fall into the Sunday supper—chunks of white bread soaking up sugary milk—as I watch the blue Pontiac exit through the front gate?

I am five or six when my mother enrolls me in a dance school a few blocks from Sunnyside. After being taken to the school several times, I

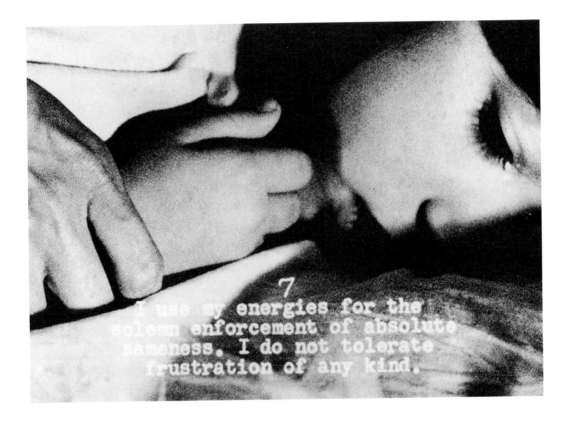

Film About a Woman Who . . . (16mm, 1974). Sarah Soffer

am expected to walk there by myself once a week. The trouble is that I have to choose between two streets that converge at Forest Avenue. One day I take the wrong one and, after walking for what seems like too long a time, realize that I am lost and am overcome with terror. Managing to regain my wits, I backtrack, find the other tine of the fork, and reach the building that houses the school. But the dance school itself is a source of continual anxiety around performance. All the little girls are able to touch the backs of their heads with their toes. It seems to me that I am the only one who can't. As I lie on my stomach one of the teachers struggles with my recalcitrant body by pulling my shoulders back and grabbing my ankles in a vain attempt to introduce them to the back of my straining head. It's hopeless. Once, in this undignified position, I fart, much to the amusement of everyone but me. These trials continue for the next two or three years, even after my return to San Francisco.

We spend parts of summer vacations with our parents. Once we take a trip to the Feather River, where smashed mosquitoes leave big blotches of blood on the inside of our white tent, and riding on the up-turned back of a saddle behind my father is so uncomfortable that I plead to be let down and find my way back to the campsite by myself. We make several trips down to Los Angeles. It is the beginning of World War II, and long columns of army trucks fill the roads. My father becomes so irritated at having to lag behind them that he impulsively speeds up and crosses over the raised median into oncoming traffic that veers out of his way before he manages to cross back over ahead of the convoy. They are amused that during this hair-raising maneuver I kept patting his shoulder from the back seat, where I sit beside my mother. It may be on this trip that they complain that I'm always asking questions. Once in LA I sleep on an inflated mattress on the floor of the little house they still own in Torrance. We spend hours in the blazing sun on the

beach. I remember Daddy taking my hand as I play languidly in the sand and leading me to the shade of a nearby arcade. It is on this trip that we eat at a restaurant where I have a club sandwich for the first time. (It is small pleasures such as this that, in the midst of an overriding dread, have left their indelible marks on my memory.) At the end of the trip they decide to leave very early in the morning while it is still dark. It will be an eight-hour drive north to the Bay Area. I am awakened by a sensation of sinking as Daddy lets the air out of the mattress.

On the drive back to Sunnyside we must pass the Tanforan Racetrack, where all the Japanese people live. I can see children my age clinging to and peering out from the other side of the cyclone fencing that surrounds their compound. I don't remember my parents' explanation. At some level I know these kids are like me: exiled and excluded.

IN MY LAST few months at Sunnyside Miss Burlew began driving me once a week to the Greyhound Bus station, where she put me on a bus to San Francisco. There my mother would pick me up and take me to see Dr. Brumbach, an ophthalmologist who was treating the strabismus, or crossed eyes, with which I had been born. The treatment, such as it was, consisted of sitting me in front of various stereoscopic machines that required me to change two waving American flags into one. That I was completely unsuccessful at this feat was yet another source of humiliation. A more drastic treatment was in the works. During one visit, after Dr. Brumbach dilated my eyes, I refused to close them and sit quietly in the waiting room as I was supposed to. My mother said, "If you close your eyes, you can come home." I closed my eyes. Shortly thereafter I was hospitalized for cosmetic surgery that would more or less straighten out my left eye (but not give me binocular vision). In the days that followed, I screamed so relentlessly for my mother that they sent me home early to get rid of me.

"Home" was an entirely new house in the Sunset, an unfamiliar neighborhood of white protestant working class families. No Jews or Italians in sight. They had bought the three-story set of flats at 1249 Seventh Avenue at the end of Hugo Street in 1941, some months before I arrived, and were still fixing up our five-room quarters on the second floor when I came home from the hospital at age seven with a bandage and black patch over my left eye. Ivan would come later. (The diary he kept in Sunnyside proclaims on December 7, 1941, "Rode my bike to school today. WAR IS DECLARED!," which tells me his release took place about five months after mine.) Daddy, who had studied interior decoration while still in Los Angeles—at some point Ivan dug up his certificate of completion from the decorating school—had stained all the moldings in our flat a faux ocher wood grain. I'm sure it was his idea to use "old

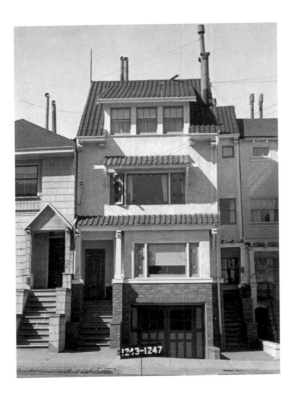

rose" as a color scheme in our house. Old rose floral curtains, old rose carpets, old rose sofa slip-cover and old rose overstuffed armchair.

Obviously they had been planning to bring us home for a while but had been waiting for the right moment to tell us. The ophthalmologist's office offered, in my case, the perfect trade-off. Shut your eyes (and your mouth?) and you can come home. It took me a while to shut my eyes and turn the other cheek. I had been through too much deprivation and wore the wounds of my first seven years on my sleeve, which I couldn't immediately let them forget. For the next year or so they had to contend with my tantrums. Under constant threat of banishment, I nevertheless

 42

1247–49 Seventh Avenue, 1941

persisted in being "bad." The specifics have mostly vanished from memory, replaced by images of physical struggles with my parents.

One time I am screaming in the presence of Mary Ellen, one of the black cleaning ladies who helps my mother with housekeeping once a week. Mary Ellen is a most fastidious person, carefully cutting the crusts from the sandwiches that my mother prepares for her lunch and leaving them on the plate. Mama, who never allows us to leave food on our plates, thinks Mary Ellen is "putting on airs." Submerged in feelings of social inferiority, my mother knows the state of things all too well. If her own position of white, lower-middle-class housewife is implacably fixed, what right has the black cleaning woman to mime the upper crust?

My father drags me kicking and screaming into their bedroom, tears off my clothes, forces me into my peach colored cotton knit pajamas, and throws me onto Mama's bed. When he has slammed the door I jump up and down on the bed and yell "I hate Mary Ellen! I hate Mary Ellen!" I know how to embarrass the pants off them.

Another time I am on my back on the floor of the kitchen, my mother looming over me trying to get at my bottom with the Sherwin-Williams paint mixing stick that always stands threateningly behind the kitchen clock on the corner shelf. I manage to roll from side to side and thwart her efforts as she lurches and swings, beside herself with fury and frustration.

I didn't remember what may have been one of the last of these familial melodramas until I was in psychotherapy with the late Magda Denes in 1968. I had been invited to teach dance at Goddard College for a month, my first out-of-town gig. The day of my departure is imminent and I am still unable to figure out the cause of the deep depression that has plagued me for the previous month. Sitting across from Magda in a leather chair with my arms resting on its stainless steel armrests, I begin

to feel a peculiar warmth in my right forearm as she says "You're depressed because you feel like you're being sent away." At which I burst into such convulsive sobbing that she bolts from her chair to hold me. I have become at that precise moment my traumatized seven-year-old self, standing in the kitchen of my childhood home with my right forearm on the sideboard, sobbing in terror as my mother in the adjacent living room dials a number she has copied from the classified ads for a new "boarding school." "I'll be good, I'll be good," I scream over and over. Mama hangs up the phone. They have won the unequal contest. From that day I embark on a willful crusade to "be good," which means, if I am to survive, I will have to change my MO. I will have to shut my eyes to my aggrieved sense of justice and keep an eye out for the vagaries of my neurasthenic mother. A familiar template: The child becomes the vigilant one, keeping watch on the unpredictable parents. The toll will be paid by me for years down the line, in shrink fees and more melodrama.

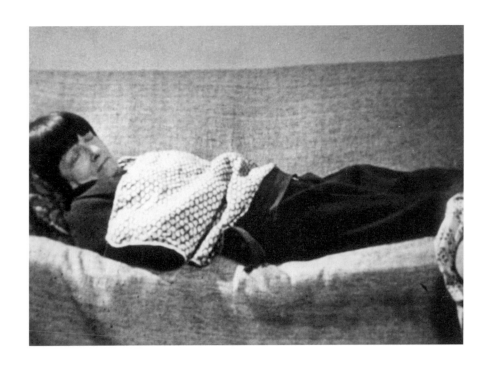

Kristina Talking Pictures (16mm, 1976). Lil Picard

3

School Years and Incidentals

A PIVOTAL IMAGE: My mother lying on the couch, her rickrack-edged apron pulled over her folded arms for warmth in our chilly flat. In that position she rests from her household labors, listens to Gabriel Heater deliver the evening news and to Fred Allen, Jack Benny, and Fibber McGee and Molly with William Bendix on weekends. From that recumbent position she calls instructions to me in the kitchen for preparing a complete Thanksgiving meal, including turkey and all the trimmings. I am nine or ten. I am well acquainted with Mama's debilitated states. When I come home from school she is lying on her bed listening to radio soaps. When it is time for me to go to bed, I kneel beside the couch and hug her unmoving body until she has had enough and orders me to say good night to Daddy, who sits in the big armchair. He is always sitting, she lying down. He is the epitome of forcefulness, she of faintness. Her swollen legs and feet dictate many of her priorities: keep them elevated as much as possible; buy yet another Ace bandage or pair of elastic stockings or molded shoes at Hittenburger's on Market Street. Diagnosed

as phlebitis, the condition of Mama's legs never changes. Years later, perhaps motivated by my moving out of the house at age seventeen, she buys a pedometer and walks ten miles a day at such a fast clip that she leaves my panting, plaintive father behind.

In my eight-year-old mind, however, their positions are reversed. Mama is the exhausted, retiring, self-effacing, timid one. He is the resourceful, energetic, confident one. I sit on his lap and try to pry open his fist. He is too strong. Although the outcome is invariably the same, we're both always up for the game. One night I am awakened by much screaming and commotion in the kitchen. I run down the hallway. Mama is cowering in a corner while Daddy flails around in the last stages of putting out a fire. It seems that he has hung a cleaning fluid-soaked dress of my mother's on a rope stretched across the kitchen. Exasperated with her fearful remonstrations, he has thrown a lit match into the pail in which he had soaked the dress, yelling in a fit of bravado, "Look, it won't even catch fire if . . ." Of course, it did and immediately spread to the dripping dress on the line. One thing you could say about my father, his reflexes were as quick as his impulses. He tears the dress off the line and stuffs it into the pail, smothering the conflagration and burning all the hair off his arms. A similar event occurs in Camp Meeker when Mama absentmindedly throws a burning match into the matchbox rather than into the receptacle reserved for it. The matchbox explodes in flames. Mama reflexively opens the adjacent door, as if to escape, and the resultant rush of air fans the flames even higher. Daddy runs over and snaps the matchbox shut. End of story.

As soon as I come home from Sunnyside, I begin to take piano lessons with Miss Anderson, who lives downstairs with her aged mother. The lessons are an essential component of my tantrum MO. The poor woman has no idea what role she plays in the contests going on upstairs

between me and my beleaguered mother. Miss Anderson and her mother wear very heavy powdery make-up, which Mama often comments on, always disparagingly, as she herself never deigns to add anything to her tanned face, even lipstick. Mama has a somewhat sallow, olive complexion that, when exposed to the sun, makes her look like a "Red Indian," as my father is wont to put it, although it is more on the ocher side than red. After six months of tantrums upstairs and down—I refuse to practice unless she is at my side—during which time, as Mama will repeatedly claim, half her hair falls out, the piano lessons cease.

As my tantrums abate, they are replaced by more clandestine acts of "badness." I embark on a secret life of small transgressions, like bending Mama's soft gold brooch, or scratching the celluloid what-not tray on her dresser with a pin, or breaking the bar of ivory soap, or tearing the wings off a fly, or crumbling the block of cheddar cheese, all the while writing and rewriting a personal Ten Commandments of good behavior that I secrete behind the 1925 photo of my parents. I test the limits of danger and secrecy, see what I can get away with. (On the inside of the Seventh Avenue garage door can still be seen my childish scrawl, "Don't write on here, bad girl.")

After ostensibly going to bed, I wonder, can I open the door of my room without making a sound and sneak down the hall and listen to my folks' conversations without being detected? I do this fairly often and am never caught. The content of their dialogue is not important. It is my own delicious secrecy and fear that matter, not what they discuss. On returning to bed I glide into sleep with fantasies of my bed sailing out the window, high above the rooftops, past the full moon that smiles into my room. On weekend mornings I open their bedroom door very quietly to see if they are awake, and am sometimes invited in to snuggle under the covers of Mama's bed and bask in her musky warmth. They still sleep

in twin beds in one room. Later Daddy will move to a daybed in the foyer because of Mama's snoring.

For a short while I come under the influence of a "bad girl" who goes to St. Anne's, the Catholic school further out in the Sunset. We fiddle around at a Coke machine at the corner gas station before she tells the attendant that it doesn't work. When he comes over and puts a nickel in, a bottle of Coke drops down. We share it while he watches us suspiciously. My folks are appalled when I foolishly tell them about it, as outraged at my having imbibed Coca-Cola as having committed thievery. On another occasion this same girl and I, having spent some of our allowance on Hostess cupcakes and a dozen miniature Hershey bars, sit on the steps of my hallway and consume the whole lot, she with greedy and I with guilty pleasure. Again I confess the heinous deed to my parents, who react with their accustomed censoriousness about unhealthy food consumption. I am not allowed to see this friend again.

Running parallel with these traces of our parents' former food fanaticism are many gustatory pleasures, some grudgingly condoned by Mama and others not—like the occasional vanilla soda accompanying the grilled American cheese on white bread with potato chips at Edie's Soda Fountain on the corner of Seventh Avenue and Irving Street, cherry Cokes at the corner drugstore counter, and the treasures of Ma's Candy Store across the street from Laguna Honda School, operated by an ancient wrinkled woman whose wares run the full gamut of icky-sticky kid stuff: red wax lips and tiny wax bottles that you bite the top off of in order to get at the colored sugary liquid inside.

A less secretive pleasure is the slice of buttered toast that Daddy dunks in his bowl of sweet milky coffee. After carefully turning it until all sides are properly but not overly saturated, he hands it quickly across the table to my waiting hands and mouth. It is a gift of love, ingrained

forever in my passion for dipping bread in wine and soup. Once in a while Mama roasts a spring lamb with onions, potatoes, and carrots soaking up the juices in the big oval speckled enameled roasting pan. Daddy occasionally cooks a great platter of pasta with garlic, olive oil, and chopped parsley or, my favorite, a rabbit stew loaded with fresh rosemary that grows wild in our backyard—and which sticks in one's teeth—served on individual portions of polenta that he has cut with a string from the big slab laid out on a wooden board. He loves to bring special treats home from North Beach after visiting some of his old Italian comrades who still live there. Sometimes they are big coconut macaroons, but more likely a loaf of panettone and always a gallon jug of red wine, which he decants into green liter bottles. When he makes rabbit stew we are allowed to imbibe from delicate little green glasses filled half with wine and half with water. Mama shouldn't drink but does, complaining every time that it makes her arms feel heavy. Daddy inevitably teases her about this: "Oh she always says that!" addressed to anyone else in the room. We have almost no "company." Aside from the annual Christmas visit of the realtor Mr. Werth, the only people who visit us are Daddy's friend from house-painting days, Al Spadini, and his wife Angela. When they come, the newspapers are removed from the round black metal-and-glass deco stand in the living room, and a bottle of sherry is placed upon it along with the delicate green glasses.

There is no love lost between Mama and her older sister Minnie, but Mama tries to be hospitable when in 1944 Aunt Minnie and Uncle Harry Resnick come to visit from Bayonne, New Jersey. It is an election year, and they have brought us painted wooden animals. Mine is a brown donkey, Ivan's a gray elephant. When we place them on a slanted surface they wobble forward unsteadily on their hinged legs. Although Harry and Minnie are staying in a hotel—we have no room for them—and

aren't around that much, Mama has no kind words for her sister. She complains repeatedly that Minnie leaves the bathroom door open after going to the toilet and that when eating the duck that she has cooked, Minnie "got grease up to her elbows." Mama thinks she has risen above her provincial background and feels superior to her uncultured sister. In reality, she has retained a good deal of the bigotry with which she was raised. When Ivan wants to go out with Dolores, who lives on Hugo Street, our parents forbid it because Dolores is Mexican. In contrast, we younger neighborhood kids adore Dolores and her mother, who launched a spirited defense of our right to draw the big colored hop-scotch in front of their house as a neighbor tried to wash it away. Dolores and her mother are heroines in our eyes.

When Ivan and I arrive at Seventh Avenue in 1941 the ice man is still coming around to make deliveries from a horse-drawn wagon. The neighborhood kids surround him as he shaves slivers of ice for us from 25- and 50-pound blocks. Garbage is collected once a week in tall dark green trucks by bands of Sicilians who, with heads swathed in bandannas, upend our garbage cans onto brown squares of burlap laid out flat on the ground. After tying the corners together they haul the ballooning sacks out to the trucks, then clamber up the sides like pirates swarming up the masts of a schooner. Before being used again the sacks are untied, their contents dumped and spread out atop the other free-floating refuse in the trucks. Then there is the rag-and-bones man in another horse-drawn wagon who announces his arrival with a peculiar sing-song chant. Ivan and I drive Mama to distraction one day by refusing to stop parading around the kitchen table while belting out our rendition of his refrain: "oo ah aw; oo ah aw." Ivan leads the way; I follow.

During the war we patriotically flatten tin cans, collect newspapers and fat, and buy stamps for the "war effort." I take a wagon around the

neighborhood to collect other people's newspapers and bring them to a depot in the Laguna Honda schoolyard. I spend secret hours at the corner drugstore poring over racks of forbidden war-splattered comic books, the covers of which show little yellow men with buck teeth torturing skimpily clad white women tied to big wooden wheels. We have ration books, and instead of butter we use Nucoa, disgusting tasteless white stuff that comes in a sealed transparent packet with a capsule of red dye in the center that you knead into the glutinous mass until it reaches a credible approximation of the color of butter. Daddy packs up CARE boxes with canned goods, soap, writing paper, and other stuff for his brothers in Italy. He also sends money to his beautiful younger sister, Maria Rosa, whom he has never seen except in photos. She and her husband and two boys are in dire straits during and after the war. In the photos they look a little underfed. One day in 1945 Daddy sits by the living room window crying quietly as he reads the letter from Maria Rosa announcing their mother's death. For years afterward she sends us an annual Christmas card.

One Saturday around 1946 I go downtown with my mother on the N streetcar. As we wait to get off at the Emporium Department Store, I feel a peculiar sensation on my behind and freeze, then move forward, but the rubbing hand comes with me. Again I move forward, pressing close to Mama ahead of me. Again the hand follows. I dare not turn around. Mercifully, the streetcar stops and the motorman opens the mechanical gate. I escape into the street. Furtively looking back I see a man at the gate staring at me as the streetcar rumbles off. When I tell the folks that evening about the molester they are aghast. "Why didn't you say something?" And from Daddy, "Why didn't you turn around and kick him?" How can I tell them that my kicking and screaming days are over? How could I oppose what an adult, especially a man, wanted of me?

A happier excursion takes place just before Christmas when Ivan and I ride the N downtown to the Emporium and buy presents: a short-sleeve "union suit" for Daddy and a silk scarf for Mama. It feels like an adventure to me, to be spending money with my big brother, just the two of us, without parents, in the vast department store. I feel very privileged when Ivan takes me under his wing. Sometimes we go down to the garage and listen on the car radio to "The Whistler" and "Inner Sanctum." It is spooky and thrilling to be there beside my brother in the dark, with only the faint light from the car radio painting our faces.

But the idyll with my brother is soon shattered. Our intermittent sibling squabbles unnerve Mama. One day she rushes from living room to kitchen wringing her hands. "I can't stand it anymore," she wails. "I'd rather they not speak at all than have all this fighting!" This is Ivan's cue to initiate a long-running drama, both fanatical and obsessive. For the next three years, until he leaves for college, he refuses to speak to me. Literalizing Mama's frantic plea, he will be at once the obedient son and vengeful brother. He has the will for it, and the perversity. From that moment, if he looks at me it is with disdain. Otherwise he averts his eyes, passes me in the street or the narrow hall of our flat with a stony face. In later years he will confess to me that he arrived at his decision after I had come into the bathroom while he was taking a bath and blurted out "Ivan, what a big penis you have!" Whether my outburst precedes or follows Mama's desperate imperative is unclear, but evidently both events are crucial for Ivan. I am about nine, he thirteen.

54

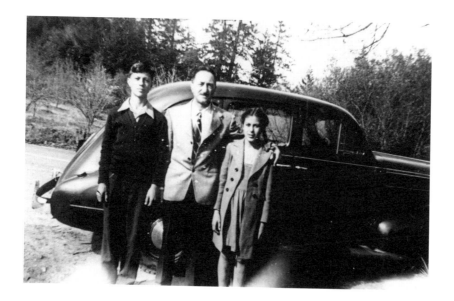

RUTH NITTLER AND I are after-school buddies, tomboys in our passion for physical activity. We love stilt-walking, jumping rope, and reckless skating down her Sixth Avenue hill. Our ball-bearing four-wheel skates are clamped to our shoes and tightened by a skate key hung round the neck on a string. Faster and faster we go. The corner rushes toward us. Will someone suddenly appear and collide with me? My heart pounds with excitement. At the bottom of the hill I swerve out to the edge of the sidewalk and make a perfect skates-in-line arc around the curb. After school in front of Ruth's house we tenaciously practice throwing a ball overhand like the boys are able to do without ever practicing. We are proud of our ultimate mastery of this skill.

55

Ivan, Daddy, and YR, ca. 1944

Fifth grade photo, 1945. I am in the upper left corner, my future nemesis, Carl, below me.

I am possessive of her, jealous of her other friendships. At a birthday party at her house we play a game that requires the loser to crawl through the legs of a column of girls while each paddles her on the behind. I am (naturally) one of the losers, but protest when I feel the paddling goes too far, especially from Ruth, and storm out of the house. Halfway down the block I change my mind and go back and ring the bell. When they open the door I burst into tears and am tenderly welcomed back into the bosom of the group.

My social encounters do not always end so felicitously. I remain an outsider, sometimes naively contributing to my pariah status, and am

Ruth Nittler and YR, ca. 1946

always taken by surprise. In the fourth grade Ruth and I are judged smart enough to skip high fourth grade. We are escorted down the hall and introduced to Miss King's fifth-grade class at the beginning of the semester. The sun pours into this classroom in the afternoon. It is here that I meet Veronica, a girl nearly crippled with arthritis who takes an inexplicable dislike to me. During softball practice everyone makes allowances for Veronica's disability; no one ever tags her out. One day I hear her say with utter scorn, "I'm up after that Yvonne thing."

In seventh-grade sewing class I suddenly become aware that all the girls have gravitated around big Geneva Emerson, the class bully and my nemesis, at one end of the long cutting table while I sit alone at the other end. "Was it fun?" Geneva wings my way. My heart sinks. "What?" "Was it fun in the toilet?" They all giggle with malicious glee. "I don't remember." Too eager for a closeness that might lighten the weight of my secrets, I have been betrayed by my best friend Ruth. Or was it her friend Lynne Jackson to whom she transmitted the fatal information and who then spilled the beans?

That same year I have some run-ins with Geneva's younger brother, Carl. He has caught the torment-Yvonne virus from Geneva and frequently taunts me after school. We roll around on the ground pummeling each other and several days later he lights a wooden match and throws it at me. My mother is incensed when I report the incident to her, and the very next day she marches me up to school and into the office of the principal, Mrs. Harris, a tall imposing woman in her forties who wears heavy jewelry and bright red lipstick. Carl is duly reprimanded, perhaps suspended for a few days. My teacher, Miss McCarthy, comes over during class to comfort me. "I didn't know he was bothering you. It won't happen again." I am of two minds about the whole thing, relieved that Carl will leave me alone, embarrassed about the fuss and

Mama's intrusion into my public life. I am unable to appreciate her sense of justice, which had roused her from her couch-bound debilitation to defend her progeny against the delinquent hooligan.

Another threat that incites her maternal wrath and causes me embarrassment takes place at the corner of the apartment building across from my house. A cocker spaniel has grabbed my shoelaces and refuses to let go. I cling to the bricks and struggle with the dog. Suddenly I hear screeching and look up to see my mother charging across the street like a berserk banshee, brandishing the Sherwin Williams paint mixer. Startled, the dog releases my foot and flees. Though frightened by the encounter with the playful dog, I am even more shaken by Mama's theatrics. The occasion hardly warranted such an overwrought display. I sheepishly return to the flat with her, and she returns the paint mixer to its usual place behind the kitchen clock where, although it is no longer deployed by either parent to punish the antics of their unruly children, it still serves as a hedge against bad behavior.

A combination kangaroo court and colloquium takes place on a Hugo Street front stoop after I reveal that I don't believe in God. My defense is that there is no physical evidence. "But He just is; you've GOT to believe in Him" seems pretty lame to me, but I am outnumbered, the only one with any doubts. Nevertheless, for about six months I attend Sunday school at the Presbyterian church up the street because my friend Ruth does. I don't last long. Jesus remains an abstraction and gains no hold over me. The catechism teacher remarks on the meticulous braiding of my hair. "It shows you are much loved," she says, which pleases Mama to no end when I report this to her. Because I am dark-skinned I am frequently asked about my parents' ancestry. They advise me in no uncertain terms to insist that we are "American." Our parents' paranoia around their "foreign" status never quite dissipates. Despite

my father's heavy accent, the word "Italian" is to be used as sparingly as possible in the presence of non-Italians, and the word "Jewish"—applying to my mother—not at all.

The street life of the neighborhood kids is intense. Roller-skating, Kick the Can, Hide and Seek, Capture the Flag, Heat, One Foot Off the Gutter, jump rope, handball—the games sometimes range dangerously over a five-block area. Some of the older boys own "Flexies," sled-like wagons that go faster the more weight they support. I have the special privilege of sitting behind Charles Sicorra's older brother on a thrilling ride down the Fourth Avenue hill while someone stands at the bottom to warn of approaching cars on Hugo Street with a stentorian "TIM-BERRR!!" When the street lights crash on, Mama bellows out the window for us to come in.

Riddles like "Ef you see Kay, teller I wanna meet 'er" produce much merriment among my street friends. My bewilderment persists even after I figure out the cipher, F-U-C-K. There is consternation in our house when I ask what the word means. After much discussion out of my earshot Mama finally comes into my room with an explanation: "It's a word that low elements use to refer to the way babies are made." For the moment my curiosity goes no further.

In 1946 I hang out with a precocious bunch of pre-teens during summer vacation in Camp Meeker. My special friend is Joan Flynn, whose parents rent a cottage down the road from us. We dress in the cool teen fashion of the period: "Sloppy Joe" cardigan sweaters two sizes too big and big white dish towels worn with the knot at the tip of the chin like an infantry-man's helmet. Ivan, who is still not talking to me, shows his disapproval in contemptuous looks. After washing and drying the sweater, Mama has a fit as she tries vainly to pull its unblocked bulk into a respectable shape on my body.

The summer kids sometimes have contact with the ones who live there all year round. The latter are a different breed, more withdrawn, wary, and, of course, poorer. I am ordered by my folks not to see Karen anymore after telling them that some boys had yelled at us from the bushes, "Roy asked Karen to do it and Karen did it!" I have only a vague idea of what "it" is, but Karen is very upset and vehemently denies "doing it." On Saturday nights a special bus takes Camp Meeker people to Monte Rio five miles north to go to the movies. The best part is sitting in the theater waiting for the double bill to begin and listening to Beethoven's Emperor Concerto. They always play the Emperor Concerto before the picture starts. I fall in love with Tony Curtis in *City across the River,* in which he plays a member of the Amboy Dukes. I have a crush on Roy's younger brother. On the ride back to Camp Meeker on the crowded bus I stand very still beside him, almost touching him. The hairs on my left arm feel funny.

We attend all the Saturday night shows in the Camp Meeker Bowl, which consist of stand-up comics, acrobats, singers singing "Danny Boy" and similar chestnuts, usually people who are passing through or are friends of the summer residents. My parents are always urging me to play my Hawaiian steel guitar for the few visitors who stop by in Camp Meeker, which I reluctantly do. Having fallen for the blandishments of a door-to-door salesman, for the past year or so I have lugged the heavy instrument onto the N streetcar to attend group guitar lessons given by Mr. Eddy in a garage out in the avenues. Now the time has come for me to perform on one of the Bowl shows.

On the appointed night and hour I stand in the wings waiting to go on. My turn comes, and someone brings out a chair for me. I place the instrument across my lap and begin to play "Home on the Range." To my horror strange sounds rise up as I pluck the strings and slide

the steel bar around. The chill night air has made it go out of tune and I am unable to tune it. (I never did have a musical ear or gift.) I call helplessly to Mrs. Lawrence in the wings, "It's out of tune" and make a hasty exit. I am inconsolable for days. This incident is my swan song as

a musician.

When I am twelve Ivan and I help Daddy terrace the hillside beside the Camp Meeker house with stones he has dragged up from the creek and deposited at the bottom of the hill. We fill his old five-gallon metal paint buckets with rocks and haul them up the steep incline to where he is building one of his retaining walls. It is heavy work in the summer sun,

Stone walls, terraces, and stairs at Camp Meeker

and he berates me when I begin to falter. Later he is very apologetic after Mama tells him I am menstruating. "I'm sorry, Kiki [one of his special nicknames for me], I didn't know you have your period."

My first menstrual period had been a big event in our house. One afternoon in my seventh-grade classroom I felt wet and when I got home found blood in my underpants. I called my mother into the bathroom. She grabbed the garment and, brandishing it aloft like a banner, rushed into the living room to make the triumphant announcement to my father: "Twelve years old and her first period!" Only then did she return with a Kotex pad, safety pins, and belt to instruct me in their use. I was doubly mortified. My childhood, misshapen as it had been, seemed definitely over.

On a June day in 1950 there is a commotion down on the road below our house in Camp Meeker. My father is standing with some neighbors while one of them recounts what he has just heard on the radio. "I can't remember the name of the country, but we're at war." Who has ever heard of Korea? On this summer day in the redwood forest in northern California, Korea is as far away as the moon.

AS I WRITE, it seems odd that when I began to menstruate I still didn't know about fucking. I knew how babies *weren't* made. Hadn't they told me how the "unfertilized" egg in the womb is released every month to produce menstruation? How it got fertilized was the untold story. I thought I knew everything and pedantically described to Ruth Nittler the anatomical details, which didn't elicit the $64,000 question from her either. Then I went home and recited for the folks what I had told her, congratulating myself on the knowledge that Ruth lacked and on having parents who, unlike hers, had so enlightened me. Yet no further information was forthcoming from either parent. It wasn't until I was about fourteen that I acquired the essential information from Ivan. I don't remember how it came up. Ivan and Mama were in the kitchen. I was warming my behind at the gas heater in the living room. I could see Ivan look at Mama incredulously. "You mean you never told her?" "No," Mama weakly admitted. So he told me explicitly how the sperm gets in there to "fertilize" the egg. I use quotation marks to indicate my adolescent familiarity with the technical term in the absence of any real understanding.

Following the advent of menses, girls in those days were not supposed to be active at that time of month. You could always tell who had "gotten it" when she sat out during organized sports. At this time I began to sit by myself at recess when I had my period. I couldn't stand being with the gaggle of giggling girls who just yesterday had been playing jump rope and jump ball. Once when we were let out for recess I ran to one of the basketball stanchions and swung way up and around in exuberant abandon. Standing nearby, Mr. Kermoian, my eighth-grade teacher, rebuked me, "That isn't a lady-like thing to do." "Why not?" I challenged him stubbornly. "Well, your skirt went way up and your underwear showed. You're too old to be doing those kind of things."

Mr. Kermoian didn't know much about grammar. During class he asked us to name the parts of speech of a sentence he had written on the board—"We were well on our way before the sun had risen"—and when I claimed that "way" was a noun because it was the object of the preposition "on," he insisted that it was an adverb. My grammar-sharp mother backed me up on that one.

Mr. Kermoian was a tall, darkly handsome twenty-six-year-old ex-GI fresh from teacher's college. New to the school and anxious to get off on a rigorous footing, he read us the riot act of permissible and impermissible behavior. No gum chewing, no talking without permission, etc. He was the only male teacher in the school, also the youngest. All my other teachers were so-called old maids, the most formidable of them skeletal seventy-year-old Miss Pepina of the sixth grade, who I once saw hit a boy with her recess bell. Before the stanchion-twirling incident, I had developed a crush on Mr. Kermoian and made efforts to shine in his eyes, like keeping my girl scout shoes as fanatically polished as his always seemed to be. Mama made fun of me when she realized why I was suddenly so concerned about my shoes. She also made fun of Ruthie and me, calling us "Mutt and Jeff," two characters in the daily comics who were absurdly different in height and girth. Ruth was a tiny sprite who still had some growing to do, while I had reached my adult weight and height by age twelve.

WE LIVED ELEVEN blocks from a public library. At age eight I hauled four Oz books home and read them all in one weekend—the 1940s' version of Harry Potter. Later it would be Louisa May Alcott and Albert Payson Terhune. When Daddy caught me reading Nancy Drew mysteries that I had borrowed from Ruth, he accompanied me on my next trip down Irving Street to help select more educational reading matter. Two of the books he chose were *The Story of Money* and Fabre's *Life of Insects.* I didn't finish either of them. My father was self-taught, educated by all the Haldeman-Julius "Little Blue Books" that encapsulated histories of everything. During my childhood a bunch of them were still stacked up on a shelf in the living room cabinet. By age twelve I was roaring through Jack London, Charles Dickens, Mark Twain, Booth Tarkington, William "makepeace" Thackeray, and James Fenimore Cooper. I was in love with Smike, the downtrodden character in *Nicholas Nickleby,* and wove elaborate fantasies about defending and running away with him. Nickleby was nowhere in my picture; I had taken his place. By my mid-teens I was reading the novels of Somerset Maugham, D.H. Lawrence, Alberto Moravia, Sinclair Lewis, William Faulkner, and Thomas Wolfe, most of which I found in Ivan's growing collection of paperbacks and Penguin classics. At sixteen I read Emma Goldman's *Living My Life,* given to me by Audrey Goodfriend, and also the travel books of Richard Haliburton, the adventurer who disappeared while sailing a Chinese junk across the Pacific on his way to the 1939 World's Fair in San Francisco.

66

When I entered Lowell High School I reluctantly hung up my roller skates. Continued to lisp. Played softball with the Girls' Athletic League. Took Latin for three years because Ivan had: three hours' homework every night translating thirty lines of the Aeneid. Miss Whitaker, the Latin teacher, was disappointed that I didn't continue for a fourth year. Joined the Writers' Club. Wrote a long prudish short story about a boy who read too many comic books and ended up a juvenile delinquent.

The teacher urged me to write about subjects more in keeping with my own experience. I had no contact with boys while still in high school. My two best friends were Martha Krauss—at 4 foot, 8 inches, 85 pounds, with a mouth full of clamps and rubber bands and screws from which she spent a great deal of time picking her lunch every day—and Betty Helmsdoerfer—at 6 feet, 180 pounds, already experienced with men, getting picked up by sailors in Market Street bars. When I last saw Martha, maybe around 1952, she was trying to gain 20 pounds so she could join the WACS and leave home. The last time I saw Betty was when she came over for a visit to my Berkeley cubbyhole in 1952. I think she scared me. Her sexual exploits, much in advance of mine, made me uneasy. Although being loved by men would be central to my life in the coming years, I was not going to go down the tubes because of it, at least not yet. She was the "bad girl," not I.

Yesterday I went to an assembly in 306. A girl sang "Come come, I love you truly" from *The Chocolate Soldier*. As she sang I began to feel the most peculiar sensations. Cold shivers were wracking my entire body. Clammy currents ran all over me. I thought I was sick, but when she had finished, the shivers left me. Very often these sensations come to me when I hear or read of some outstanding human experience of bravery or perseverance, or a story of great emotional appeal. Sometimes these stories are absolutely corny or excessively melodramatic, like the one Louise Utis told in Oral English the other day about a GI who corresponds with a girl whom he intends to marry as soon as he returns from the war. His face is left badly scarred, and he is also crippled after a battle. The day before his ship is to dock in the U.S. the girl is hit by a car. She suffers a serious brain injury which results in blindness. There was some dramatic closing which I can't

remember. At any rate, during the last few sentences I had the chills. I really fight against them because basically I reject such stories for their contrived nature and unreality. Intense drama is always so removed from my own life that it leaves me with an empty feeling. I was also irked by the melodramatic manner of delivery . . . Then what in God's name do those damned shivers mean?

(Diary entry, April 27, 1951)

Even during my third year in high school my mother still insisted occasionally on "helping" me shop for clothes. Though I had earlier gotten away with some far-out purchases like the "Sloppy Joe" sweater and even a pair of unsupportive brown-and-white saddle shoes, she could be tenacious, especially when it came to color. She was drawn to bright reds and magentas as a bee to a rose. Also to flowers. For my attendance with my class at a performance of *Der Rosenkavalier* at the Geary Theater she chose a flowered cotton dress with billowing skirt and Peter Pan collar. I had wanted a dark blue affair with short jacket. "Too gloomy" she pronounced. The dress revealed the small round orbs of my breasts for the first time. This surprised me and was much appreciated by Mama. The last straw came when she insisted on buying me a flaming scarlet wool jacket—I had wanted the dark blue one of course—which I wore with my tail between my legs for a year until I won the right to choose two new coats—a long one and a short one, both in unobtrusive beige.

68

The tears are here again. Brush them away. Something just happened. Mama just finished listening to one of those one-hour dramas, a real tragedy. She said, "I shouldn't listen to those stories, they really move

me too much. But I don't know what else to do with my time." And the tears came. Sometimes I feel an overwhelming tenderness for her. I don't know if it's love. Right now I am being strangely moved by my feeling for her. Daddy is away. I am relieved when he goes away, yet I often pity him. I look at the picture of them on my dresser. I have always loved that photograph. He was 34 and she was 29. They were young once and joyous together. What happened?

(Diary entry, September 28, 1951)

Another crisis came in art class when I heard a girl whisper to her friend, "She stinks." I had no doubt she meant me. The only deodorant on the market at that time was Mum, a white paste that you smeared into your armpits and which had a smell all its own. Another malodorous by-product of female adolescence was the Kotex pad. Because I had a very heavy flow every month I wore two at a time, throughout the school day, resulting in badly chafed thighs that healed just in time for the next menstrual period. It was out of the question to carry an extra pad to school; disposing of the soiled one would have meant having to carry it furtively to a trash receptacle in the girls' lavatory. In fact, disposing of them at home also posed a challenge. For some reason I couldn't simply put the bloodied ones in the garbage; they had to be burned in our old stove, which required standing there and wielding a poker at the unspeakable stinking object until it was totally consumed. O misery, thy name is adolescent female in the time of the proscribed tampon.

This morning I went to the Victor Equipment Co. for Junior Goals Day. I was the only girl among thirteen boys. I found that I was not

interested so much in the machines as in their operators. I can't imagine myself living like that. All day long they stand there, turning something here, pushing something there, and on and on and on. The roar of the machinery is deafening. Then the women who work over the small and delicate pieces—they sit in a dingy room, all wearing hair nets and grimy aprons, pushing and inserting and cutting and placing. They could probably do it without looking. And the girls in the offices—I met one in the ladies' room. She said, "They give me things to type, and I don't even know what they mean." Even if all the paper work could be dispensed with, someone must do the work with the machines. But all one's life, all day long? What a terrible existence. And that fat president, sitting back in his swivel chair and laboriously telling us what a democratic organization he has. According to him, all of the office workers share his pride in his company. Poor slaves, they are all properly servile to him. In their starched white collars and pressed pants and hairless, washed-out faces. Ugh. What do they think? Do many think of what actual good they are producing for man's existence?

(Diary entry, May 17, 1951)

How hard I try to convince myself that man is intrinsically good. If this were not so, what would be the use of trying to be good oneself? I think that by a good person I mean one who does not feel compelled to satisfy the demands of his ego. Such a one will be at peace at least with himself and will be able to accept himself as

he is. Only then will he be able to love others. It is only with the conviction that his love will arouse the Good that lies dormant behind every soul's façade of hypocrisy and selfishness that one should seriously try to eradicate the querulous cries of the ego. For hypocrisy is itself hypocrisy, murky water that obscures the face of the seeking self.

(Diary entry, November 18, 1951)

THERE'S A WAY in which the psychobabble that colored so much of my juvenile logorrhea has continued to inform my writing and critical thinking. Beyond the anguish of relentless ambivalence and emotional insecurity that is revealed in these diary entries, I can see a more solid skepticism about self and society being formed. I see not only an emerging social conscience (already instilled by early exposure to anarchism) but a kind of critical introspection that would ultimately go beyond my personal dilemmas and both weather and elude the more conforming and conventional aspects of all the psychotherapy to which I would be exposed in the coming years. This is not to downplay the effectiveness of such therapy—it ultimately saved my life and made it intelligible—but simply to paint a more complex picture of personal struggle.

I kept this diary from 1950 to 1953 between the ages of fifteen and eighteen. It now seems clear that my adolescent obsession with goodness stemmed directly from those earlier dire consequences of being "bad." Some of the diary's more poignant aspirations, like "I will learn to love myself; then I will love humanity," can be traced to the influence of Ivan's idealism, which was partly the reason he himself gave up college for an apprenticeship as a carpenter. It was an ethos that affected many Bay Area bohemians, intellectuals, and nonconformists of the period. Some turned to art and the construction trades, others to political activism—even spending time in World War II detention camps for conscientious objectors. For Ivan and me, the combination of a confused idealism and childhood trauma would be deadly, though in very divergent ways.

During Ivan's last year at Lowell High, our parents sent first him, later me, to the Johnson O'Connor Human Engineering Laboratory on Filbert Street. There, in a strangely barren flat, we took what were called aptitude tests, administered by a businesslike woman who may have just

gotten her M.A. in psychology. Ivan's tests resulted in his going off to the University of Cincinnati at age sixteen to study business administration, despite my father's qualms. "What about his interests, all the model airplanes he's built?" Ivan's meticulously glued and strutted airplanes had floated at the ends of wires tacked to the ceiling of his room for as long as he and I had lived in the Seventh Avenue house. My test results are revealed in a priceless letter from Mama to Ivan in Cincinnati, dated January 19, 1947:

> Yvonne took the second half of her aptitude test last Saturday. She is decidedly objective, high creative imagination, low accounting aptitude, 75 percentile English Vocabulary, high structural visualization, extremely high in Tonal Memory, Pitch Discrimination, and Rhythm Memory, above average in Finger Dexterity, and very high in Proportion Appraisal. The administrator said it was difficult to combine her aptitudes into one calling, but made a few suggestions, viz.: Interior Decorator, Radio Advertising, Music Teacher. My suggestion would be work in a music establishment in an advertising or publicity capacity. However, it is a long time before she is ready to go out into the business world; in the meantime she can prepare along the lines in which she is most fitted.

For poor Ivan the authority of the "human engineers" ruled the day. Daddy accompanied him by train to Cincinnati and deposited him in a Jewish fraternity house. I was more fortunate. By the time I was graduating from high school, Ivan had dropped out to become a carpenter, and the certitudes of human engineering no longer held sway, at least not in our family. On further thought, I cannot entirely dismiss Johnson O'Connor's scientistic prognostication for me. There is an eerie echo of

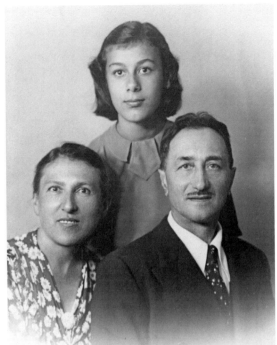

their recommended "interior decorator" in the title of a dance I would choreograph in 1972: *Inner Appearances!*

By age sixteen I was chronically depressed, no longer spending an hour every night putting my long hair up in pin curls. Mama kept complaining that my hair hung down "like a curtain." One day I put a bowl on my head and cut around it. Following my mother's lead and brother's inferred disapproval, I had never worn lipstick, even in my pre-teen precocity, and I didn't care that boys on the street stared at me and shouted "Smile."

74

Ivan's high school graduation picture, 1947

Jeannette, YR, and Joseph, ca. 1947

75

YR, ca. 1950

YR, ca. 1950

In my last year at Lowell I met some kids who belonged to Hashomer Hatzair, a Zionist socialist youth group. Being half Jewish (though in name only, as Mama had just about forgotten everything she ever knew; she couldn't even make chicken soup), I was accepted into their milieu. These were the first bohemian oddballs of my own age I had met; they were intelligent, politically radical (relative to the time), and, most important, accepting of me. Though I went to their meetings and folk-danced with them, I resisted becoming totally assimilated—for instance, I refused to trade my given name for a Hebrew one, as they had all done. The high point of this association was a two-week trip to the San Bernardino mountains during a Christmas vacation. Here the parent organization was sponsoring a series of seminars, offering daily Stalinist indoctrination sessions and arts and crafts classes. The best thing was hitchhiking around LA afterward with my friends, Chaim, Rina, and Lea. We went to museums and Oliveros Street and Pershing Square, where we listened to soapbox orators and were rounded up by the police and told to leave because of the "perverts." Daddy would later say that this trip was the cause of all the trouble he and I began to have.

Actually, I had already begun to mount a resistance to his inability to let go of his "little Cookie." A new phase of rebellion had erupted, this time directed more at my father than my mother. Sexual and ideological challenges now replaced tantrums. "Yes, on the bus ride home I laid my head on Chaim's shoulder." And, "What kind of anarchist are you? You own property!" To all of which he responded, "After all I've done for you, how can you talk to me like that?" and sat on the couch holding his head in his hands. The waters would continue to be troubled. John and Judy, the beautiful twins who lived in the big modern house on Clayton Street and had introduced me to the Hashomer crowd, took me folk dancing. Mama gave me twenty dollars to buy a blue-and-white-striped

dirndl skirt and white peasant blouse for the Friday night excursions. When Daddy found out, he was outraged at what he considered an exorbitant expense. He also blew up when he discovered that on Dave Koven's suggestion I had bought oil paints and was painting imaginary landscapes in my room: "What does she need to do that for?" Daddy had very clear ideas about a woman's place, and painting and frivolity did not belong in his picture. (His response may also have been due to competitiveness. He painted trompe l'oeil roses on his tool boxes in the garage.) I must say that Mama defended me, and he rendered an apology, but his outbursts had already added momentum to my general withdrawal from him.

I spent Easter vacation that year at Camp Meeker with my father. It mostly poured, so I stayed in my room reading and writing in my diary. When the weather cleared I helped him take apart a decayed roof overhanging a rear porch. We were both working on the roof when I heard a crash behind me and, turning, saw my father lying still on the ground eight feet below, an ax beside his head. "Daddy! Daddy!" I screamed as I climbed down and knelt beside him. His voice was weak, "Just let me lie here a minute." He eventually got up and seemed to be okay, but I was shaken for the next couple of days. Later he would tell me he had been surprised at my concern, so convinced was he of my complete alienation from him.

Another bone of contention now began to roil my house:

Conditions in this house have become progressively more intolerable for me. Hardly a day has passed in which M. & D. have not discussed in their petty and querulous way Ivan's "affair." I suppose, as Ivan asserts, that there is no justification for *my* being upset and

bitter about their quibbling, trivial, and, at all times inconsistent complaints and cynical childish remarks. Day in and day out it continues: Mama waits until I come out of my room to eat and then begins to insinuate, complain, and prophesy until I find myself shouting at her in rage and even inner shame at being humiliated so by being made to hear all of her misdirected ire and petty grievances against a brother. At least Mama seems to have something to complain about, or, as I should say, tries to find something more or less solid or tangible to fume about: either the uneaten greens or Ivan's secrecy. But D.'s talk infuriates me even more because it is so utterly groundless and stupid. I try to tell myself that the very stupidity and senselessness of what he says should be sufficient to prevent my taking him seriously and being angered. It doesn't work that way at all. The more I hear the more incensed against the two of them do I become.

My parents' disapproval of and obsession with Belle was based partly on the fact that she was eight years older than their son, but also on her physical condition, an extreme scoliosis that she had lived with since adolescence and which they were afraid might be transmitted to any children she might have with Ivan. Belle, a psychiatric social worker, born in Brooklyn, educated at Berkeley, had met Ivan at the weekly lectures held at the Workman's Circle. They were immediately attracted to each other, my virginal and inexperienced brother especially smitten with Belle's beauty and polish. Unlike the anarchist women, Belle loved fashionable clothes, was always well decked out, in contrast to the more popular "peasant" attire of their friends. I too was smitten with her. A few years later she would be a role model for my developing tastes in

79

Belle Zabins and Ivan, ca. 1951

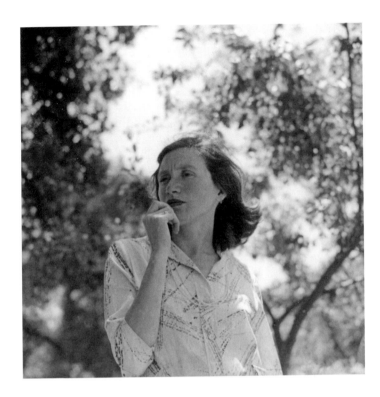

clothing, kitchenware, and furniture, from Capezio shoes to silk blouses to chinoiserie.

Around this time Ivan discovered that Philip Howard, whom he had not seen since Sunnyside, was living a few blocks from us with his mother, Mrs. Howard, and Miss Burlew. Philip was a habitué of gay clubs and sometimes took Ivan along on his excursions. He was strikingly handsome, tall with delicate features, and, it must have been obvious, though not to me, that he was attracted to my hunk of a brother. If there was any attraction on Ivan's part, it was more on the level of curiosity and "research," as he had already embarked on the first and only

Belle, 1958

love of his life with Belle. Philip had worked in Mexico with a Quaker organization. On one of his visits to our house he gave me a Mexican necklace made of interconnected scrolls of silver and turquoise.

(*Image of a woman touching a necklace at her throat*)—This? Oh, this was given to me by a friend of my brother's when I was 15. He and Ernie had practically been raised together. Then I didn't see him for a long time until my brother discovered that he was living with his mother only a few blocks from us. He started showing up at our house. I guess he always had been homosexual. I remember him as a very young boy running around in his mother's nightgown with pears stuck in the bosom. By the time I saw him again he was extraordinarily handsome. Then he went to Mexico. And brought this back with him. It must have been the very first necklace I ever owned. I had a huge crush on him. I would cast long, lingering looks his way. He was very gracious about it, although I remember that when he presented me with the necklace his hand trembled slightly as he withstood the ardor of my gaze. Ernie saw him very infrequently during the next four years, and only when he invited him to his house. By that time my brother was married and had a baby. Sometimes I would be invited to dinner and he would be there. I remember—it might have been the last time I ever saw him—we left my brother's place one evening. [pause] He told me that by the time I was thirty I would probably be a very beautiful woman.
(*Film About a Woman Who . . .*)

Wanting to earn some money I answered an ad for an "artist's model" by sending my photo and phone number to an address near

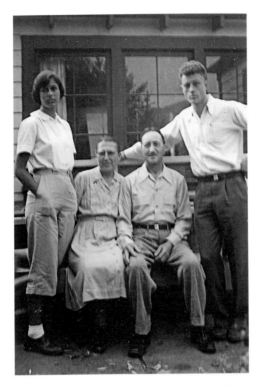

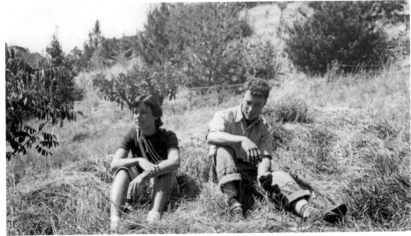

82

Rainer family at Fritz Gerstaker's in San Anselmo, ca. 1950

YR and Ivan, ca. 1951

Chinatown. An old Chinese man opened the door and told me to follow him. We moved past members of his family, who eyed me impassively, and proceeded downstairs into his basement studio. He asked me to remove my clothes so he could see my body. I seemed to please him, so we made an appointment for future work. A big ruckus ensued at home, and I was persuaded to cancel the appointment.

In my last year at Lowell, on Ivan's suggestion, I sent away for brochures from Reed College and Black Mountain College. The photos of the deadly serious faculty at Black Mountain scared me off. They all looked like Nazis to me. At the end of the 1951 spring term I needed only a few credits to graduate, so I took Music Appreciation and Chemistry II in summer school and, by the end of July, had my diploma. I refused to attend the graduation because, as I told the administrators, "I don't like ceremonies." At first they threatened to withhold the diploma unless I attended, but then backed down. I was sixteen years old, the same age that Ivan had been four years earlier when he went away to the University of Cincinnati. I was equally unprepared for what lay ahead.

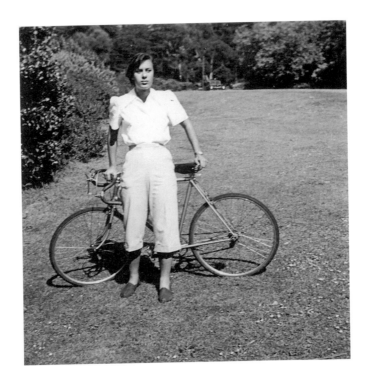

Me and my Raleigh, ca. 1950

4

Burgeoning Sexuality 2

AFTER A YEAR at San Francisco Junior College and one week at Berke-
ley, I dropped out toward the end of September 1952. As I sat in the old
rose overstuffed chair sobbing in grief and shame, my parents stared at
me in helpless perplexity. It wasn't that they wanted to get rid of me
again, just the misery that somewhere deep down they knew they had
had a hand in creating. If only the misery of their miserable daughter
would go away . . .

On second thought, maybe they did want to get rid of me again. I
was almost eighteen years old and maybe they had had their fill of me.
A few months later as I was leaving the house after dinner, Mama said,
"You know what you want." At this moment as I quote her I hear a plain-
tiveness in her voice that matched my own longing. But as she closed the
door on me still standing in the hallway, her words had a chilling effect.
She seemed to be fobbing off an image of a self-reliant daughter so she
wouldn't have to be bothered with me anymore. (As she declined into
Alzheimer's following my father's death in the late 1950s, a frequent

expression was "I can't be bothered.") For the time being we perused "Rentals: Furn Apts" in the classifieds. Then they drove me across town to look at two sparsely furnished rooms on the third floor of a house at the corner of Clay and Pierce that had once been a private mansion but was now broken up into one- and two-room apartments with a shared bath on each floor. It was on the downscale side of Pacific Heights.

My place had a kitchen, but I shared the bath with a Swedish girl across the hall and a couple in their forties who had two rooms adjacent to my kitchen. All that separated me from them was a thin tongue-and-groove wooden partition. When the taxi-driver husband came home in the evenings I could hear their conversation.

One night I left my room to go to the bathroom. It was locked. On returning to my room I glanced through the open doorway of the Swedish girl's room and saw her boyfriend sitting up in bed. Barely a minute later the wife from the end of the hall left her place to go to the bathroom. It was still locked, and apparently she got the same glimpse of the boyfriend that I had just gotten. She barreled back to her husband lickety-split, shrieking about what she had just witnessed. They both rushed out past my closed door. The husband went down to get the manager while the wife loudly upbraided the young woman, who had now emerged from the bathroom, for her immoral conduct. She countered as valiantly as she could in her own defense. "It's none of your business" and "We aren't bothering anyone," etc. By now the husband had returned with the manager, a kindly sixty-year-old woman of whom I was very fond. She was no match for the vituperative couple, who continued to demand that justice be done.

I was now hardly hearing anything, so frozen was I with anger and fear and indecision. It was like a nightmare of confused, unpleasant noises outside my door. Even when the harpy's voice filtered through

and I heard "*She* wouldn't do such a thing," even then I couldn't bring myself to tear open the door, as if on cue, and scream "That's not true; I have men up here all the time!" But I couldn't move. The horrid pair stayed there until the boyfriend left. I remained still, stunned by what I had heard, appalled at my loss of nerve.

The partition is like paper: I can hear them laugh and talk in the next apartment. Every night the man comes home from driving a taxicab and regales his wife in a gruff, humorous way with the events of the day. They sit down to dinner, then wash the dishes. Afterwards they play cards or listen to the radio. They never quarrel; they never speak harshly or rancorously to one another; they never engage in discussions about religion or philosophy or politics or art or literature; they never cry or sulk. Who are these people? They seem to be content—without education, knowledge, erudition, insight; without swarms of friends, without constant distraction outside of their domicile; without intellectual stimulation. Radio, cards, newspapers, the dog, trivialities encountered in housework or at job, the wife, the husband, the bed, the passage of time as each day fuses into another—this is life. What do I want? WHAT MORE DO I WANT? Why do I want more? And is there more than this—the life of the man and woman next door? . . . Can it be that the more you seek things, the more you cram your head with lore, and the closer you come to an intellectual or spiritual understanding of the esoteric, abstruse facets of life—then the more the bare act or fact of living and being eludes you? . . . Why do I attach a feeling of banality to the aspects of life that pass before us in a steady, perennial procession? Sleeping, awaking, dressing, eating, crapping, working, copulating, bathing? If such things are not a

part of living, what is? Jesus Christ! Why do I want more than this? Who am I that I should feel entitled to more from life? Or is it that I feel entitled to more from myself? I expect more from myself in extracting things from life and in contributing things to life than they do. Things, unknown, vaguely luminous, with shifting, hovering shapes. Things that sometimes mock me with their maddening flitting and capricious whims for alighting with a shock of recognition and then as suddenly vanishing into a cloud of forgetfulness, a black, angry blur of frustration.

(Diary entry, November 25, 1952)

In fact I did begin to have men up there, if not exactly all the time, then enough to have satisfied my censorious neighbors' criteria for indecency. There was Shamim, the Indian journalist from Bombay who propped a pillow under my hips in "the Indian way" and had premature ejaculation. When I decided he wasn't for me, he still came around in the middle of the night and howled out my name from the street below. I kept the lights off and lay low. Most of my time I spent reading, going to my shrink, and looking for work.

During an interview for an apprentice position at a bookbinding firm, the plump middle-aged man behind the large desk asked why I wasn't living at home. I said I didn't get along with my parents. Oops. "If you don't get along with your parents, how will you get along with us?" I didn't get that job, nor the apprentice editing position at a film production company on Howard Street. For a while I sat at a card table every day on a corner of lower Market in the freezing wind giving away advertising flyers.

Yvonne, you're making things unnecessarily difficult for yourself:
You've just got to face the facts: PEOPLE IN THIS SOCIETY DON'T
WANT TO HAVE RELATIONSHIPS WITH PEOPLE, DON'T WANT TO
WORK WITH PEOPLE, DON'T WANT TO EMPLOY PEOPLE, DON'T
WANT TO BE SEEN WITH PEOPLE WHO DON'T LOOK LIKE ALL
THE OTHER PEOPLE.

There! I have written the heinous truth in bold letters. The prob-
lem has by now grown to ridiculously over-sized proportions, crop-
ping up in all my conversations with Eppstein, Ivan, Mama, and now
with Belle and Philip. Everyone knows: I know. Yes, I can no longer re-
ject or make light of this heinous truth, for I know. Oh yes, I knew it
throughout high school, but not as I know it now. I had become so
accustomed to avoiding situations in which an acquaintance would
be embarrassed (and, hence, I too) by my not appearing in the proper
mask and materials that I rarely questioned my behavior. I simply
knew that I would go to this place or that place alone, and I went.

And now? What accounts for my present struggle? Am I willing
at last to grapple with the problem solely because no one wants to
hire a weirdy like me? Or am I finally beginning to realize that I might
be much more comfortable in looking like the crowd, that some of
my insecurity would disappear, that I would cease to be tormented by
extreme self-consciousness, that, relieved of the constant necessity
to protect myself from possibilities of the rejection and disapproval
that my appearance might incur, relieved of the need to harbor an
attitude of indifference or defiance, and free from the tremendous
tension that has resulted from these self-protective devices, I might
direct my latent creative energies down new channels away from

self-concern, but leading ever to a greater realization of my self and what I am? . . .

Despite my sharpened insight into this matter, I am no more prepared to bedeck myself with all the adornments of the modern female than I was before. First I must bask in the heat of my new found perspicacity and enjoy the peace of mind, however temporary that is the inevitable accrual of it. I am sure that the bedecking aspects of the experience will begin in due time. Of course, there are innumerable difficulties attendant to this earthmoving reversal of mine: matters of taste and money and uneasiness. I still experience the twinge of shame when I must confess to M. that I would like money for this or that article of apparel; I will have to suffer the embarrassment of choosing things (lipstick) and searching for things (shoes), of being seen by acquaintances and strangers alike, and having to explain to Ivan, parents, David, Audrey, Belle, Phillip, Jack, George, etc. etc. Although such discomfiture will not last, it will probably be more intense for its duration than any feelings of embarrassment I am now experiencing. But that's all part of the experiment.

(Diary entry November 15, 1952)

In December of 1952 I landed a temporary job drying photos in a storefront lab on Polk Street. It was owned and run by Henri, a large taciturn man in his forties.

I am at present employed for a period of only three days in a little shop downtown that prints stationery and picture postcards for

ships. The fellow who runs the place is about 40. Just before quitting time today we began to talk somewhat haltingly, and he told me a bit about himself. He acquired this business in 1937 and has been in it ever since except for the four years he served in the army in the Pacific during the last war. He showed me a slew of depressing photographs he took of war-wracked Iwo Jima, where he was stationed for some time—torn, gutted landscapes, split corpses, crusty, mud-caked instruments of war. He doesn't speak as Jack and George do, who defend World War II as a "war against fascism," for he hates war and doesn't believe that any conditions can justify it. Married and divorced once, he is now alone with his business, of which he speaks with a trace of sadness, as if he wishes the cold, devitalizing thing could be transformed into something warm and fulfilling. In fact, he almost said as much. I am sure that he was able to say as much as he did because he knew or felt that my attitude toward him was a positive one of sympathy and warmth. He asked me at length if I wanted a drink and brought out some bottles of scotch and ginger ale. I drank a little of the stuff and then said that I really had to go, as I had been invited to a Christmas dinner (at Fritz's). He didn't want me to leave; he grasped my arm tightly, saying I'm really sorry to see you go, Yvonne, you're pleasant company. And there was something infinitely wistful and pleading in his voice, which moved me even though he was pulling at my arm and behaving for all the world like a man who is in the initial stage of seducing a woman. But this too was a part of his loneliness; so I cannot feel resentful or even hesitant to return for a final day's work on Friday.

(Diary entry, December 17, 1952)

Following a day of work at Henri's photo shop, I went to Fritz Gerstaker's Christmas party on Delores Street. Marie Rexroth was there, the willowy soft-spoken former wife of Kenneth Rexroth; also Grace Clements, a former wife of Frank Trieste; along with about a half dozen other dinner guests. I may be confusing this gemütlich evening with several others I spent in Fritz's flat with soignée young men and . . .

Max, I heard you died. In the park, a cruiser's death. What quirk of fortune brought you to that trashy end? After all, you were my first access to the finer things: a reproduction of the Sistine Jehovah and Adam, André Gide, tall Nuremberg bureaus, Tom and Jerries at Christmas never equaled since, Chinese rugs, fresh herring, Parsifal, soignée young men who spoke of axiology, cast-off wives of virile poets who wept on your shoulder and graced your parlor. The parties in your long flat inundated my impressionable vision like a gilded freight train in endless and singular passage. One night you described in meticulous detail Cocteau's *Orpheus*. I waited patiently, knowing my time would come. At last you paused and asked "Have you seen it?" "Four times," I said. At which you roared your Teutonic lion laugh. Later you were to say of me, "All she needs is a kick in the ass." Your old-world nostrum for new-world adolescent psychic ills. But you did teach me the finer things. And came to a trashy end nonetheless.
(*Kristina Talking Pictures*, 16mm, 1976)

Several years are compressed in the above paragraph. Fritz gave a number of parties to which I was invited, sometimes with Ivan and once or twice with my father, who knew Fritz from the Workmen's Circle evenings attended by anarchists and poets. I saw *Orpheus* when I was

sixteen and was eighteen when I worked in the photo lab in 1952. The axiology bit probably occurred in 1951 during my first semester at San Francisco Junior College. When one of Fritz's dinner guests was momentarily stumped in the middle of an arcane philosophical discussion, fresh from my philosophy course I was able to supply the missing category: "Axiology!" The guests were impressed. As for "the finer things," my mother had already given me a head start in that department by taking me to Italian opera from the time I was nine or ten. "Nuremberg bureaus"? I made that up. At one of the earliest parties I attended a young man asked me, "How can someone as young as you enter a room with such aplomb?" It was like performance years later: I had nothing to lose, or was oblivious to what I might have to lose.

FRITZ GERSTAKER WAS born in Munich. He was about fifty and teaching culinary arts at San Francisco Junior College when he became a self-appointed mentor to Ivan, then in his early twenties. According to Ivan, all that ever happened sexually between them was a bit of frottage. Sometimes while I was still in high school Ivan and I would ride our bikes across the Golden Gate Bridge, down into Sausalito, and then on to San Anselmo, where Fritz had a small house on several acres, crowned by a spreading oak at the crest of his hill. Ivan would go over there to help him out with carpentry work and gardening. Fritz was effusive about everything. While the three of us lay on his deck on one of those

94

Ivan and Fritz Gerstaker in San Anselmo, ca. 1951

crackly dry Marin County days, the peppery smell of oak and manzanita heavy in the Indian summer air, he evaluated my sixteen-year-old feminine attributes. Patting my chest above my breasts, he said "She's a little too flat here." In the late afternoon I left Ivan there and took off on my bike, girding my loins and mind for the long haul back to the foggy Sunset district. The Waldo Grade just before the bridge was especially daunting with powerful headwinds ripping off the bay. I had a five-speed Raleigh touring bike, but the struggle with hills and wind could leave me with thighs like water after finally dismounting at the top of our driveway. In the mid-1960s I heard that Fritz's body was found in Golden Gate Park with his skull smashed in. A trashy end.

At the end of my next workday at Henri's, I accepted his invitation to have a drink in the closed-up shop. He seemed almost too friendly and played boogie-woogie on the upright piano in the back room. We ended up on a make-shift couch. It was the last day of my period, so I knew I was safe.

It has happened just as I had anticipated: Henri fucked me tonight. What matters is not that I fuck so readily with anyone congenial, but that tonight especially, knowing the painful complications that have resulted from previous experiences with men, I allowed myself to be in a situation in which there was nothing else to do *but* fuck. I talked for a long time about my scruples and anxieties related to promiscuous sexual activity. And I was really able to talk sensibly about these feelings, for, thanks to Eppstein, I have by now a fairly clear conception of my sexual "status," at least as far as active sexual behavior with other people is concerned. Yet even while I spoke, I was fully aware that we would have sex before I left, if for no other reason than

that I would follow the line of least resistance, knowing that whether there was sexual intimacy or not, the problems attendant upon the close relationship which has been developing through much talk and mutual unarticulated understanding—and the problems connected with being intimate with someone in any context, sexual or otherwise—would still exist. I think that it is very unfortunate that the situation was predetermined in this way. Henri was eager to copulate, but understanding what I was telling him and having a great deal of respect for the way I think, he wasn't aggressive. The truth is, however, that he succeeded in exciting me and was simply waiting for events to follow the only available course open to them. If I had expressed a desire to leave (which I had no inclination to do) he would have restrained me.

I saw what was coming, but went to work today regardless. . . . During the morning Mrs. Bright, Henri's regular assistant, phoned to say that her new teeth were giving her so much trouble that she couldn't come to work all day. Henri and I would be alone the whole day. I saw more clearly what was coming. During the day we worked together, communicated, struck more chords, drew closer. . . . Another thing about which he was quite relieved was my complete frankness in speaking about my sexual feelings. Our conversation had led to the subject of homosexuality and thence to sexuality in general after which there was a loaded pause. Then I said heatedly "Oh, yes, we talk about sex so rationally while we sit on this bench side by side, you with your hand on my shoulder and both of us torn by our own strong desires." It was sometime after this that he remarked about my openness, contrasting it with the attitude of frivolous girls he has known. I replied, "My God! I can't be cute about sex. It's too big a thing in my life, too big a thing in everyone's life." I re-

peat these fragments as examples of the spontaneity and positive-
ness which pervaded most of my conversation with Henri and which
are so unusual in my conversations, especially when they concern
topics about which I have exceptionally strong feelings.

(Diary entry, December 26, 1952)

I never went back to the photo lab. Around this time I got a yeast
infection and found a gynecologist who gave me a prescription for sup-
positories but refused to fit me for a diaphragm after delivering a moral-
istic lecture. Later I found a more sympathetic and sensible doctor. By
then I had a job south of Market operating a machine that stuffed coupons
into envelopes. There was another operator nearby, a big rollicky white
girl who had to come over repeatedly to help me out whenever my ma-
chine jammed, which was often. One day out of the blue she bellowed
"I smell a roach!" Julie was a real party girl. I admired her. I admired any
woman who had guts and expressed them.

Jack Warn never visited me on Pierce Street. I went to his place off
Divisadero, a makeshift apartment with concrete floor that had been a
garage. He showed me some tattered pornographic postcards and asked
me which ones turned me on. One was of a woman hanging onto the
back of a chair while the man supported her outstretched legs in a kind
of bridge while entering her from behind. Maybe it was the athleticism
that aroused me. Jack also showed me his wire recorder, an exotic ma-
chine in those days, the only one I've ever seen. He talked about the war,
the "big one," and was proud of having graduated from the University
of Chicago on the GI Bill. Sometimes when I'm drying myself after a
shower I think of Jack Warn. He was the first to point out the hollow of
my throat, "the place that everyone forgets to dry." He always wore the

same suit with open-necked white shirt and sandals. He knew Chris MacLaine and was a character in MacLaine's underground film "The End." One day I watched them shoot a scene on the steps of Alta Plaza Park, which I could see from one of my dormer windows. Fifteen years later I saw the completed film at the Filmmakers' Cinemateque in New York. And there was Jack, ambling around Russian Hill and Pacific Heights in his suit and sandals.

And finally—regarding the people in my life while I lived at Pierce and Clay—there was Bott. John Bottomley, unlike the other guys who had previously "occupied" me, did not belong in the category I call Masters of Women. He was too self-defeating, too substance-abusing, and too self-absorbed to make the effort to bolster his ego at the expense of the opposite sex. Out of the memory fog of interrelated people and events that belong to that winter of 1952–53, Bott just suddenly appears: tall, lanky, with a drinker's nose and thick shock of straight black hair, he must have shown up in a group that I had stumbled into that consisted of a few Chicago expatriates and their assorted girlfriends. Frank Adams was one of them, and Bott was another. Jack Warn may have been the connection, but by the time I was carousing with this bunch, Jack was out of the picture. Getting drunk on booze and out of their minds on grass and Seconal and barbiturates seemed to be their main activity and interest, and for a short time I joined them in the boozing and pot-smoking, having too great a sense of self-preservation to ingest the other stuff. But the boozing and pot-smoking were extreme. I remember an all-night party in the fancy part of Pacific Heights that culminated with three of us—me, Frank Adams, and Mutt Nielsen, whose flat it was—in bed, unable to pull off anything sexual because we were stoned and wasted and laughing so uncontrollably under the covers.

Bott had no place to live, so he moved in with me. We had to be careful because of the terrible neighbors, so we never had any conversations in the kitchen and closed the door between kitchen and bedroom when we weren't in there. I don't know how we got away with it; Bott stayed with me from January to March of 1953, and we were never caught. We even upped the ante by letting Frank Adams occasionally stay over. (Did he sleep on the floor or in the queen-size bed under the eaves with Bott and me?) I remember creeping around the kitchen early in the morning before going off to my factory job, trying to make breakfast as quietly as possible. Frank, who had worked as a short-order cook, watched my pitiful efforts at cooking eggs with a baleful eye. "If you fold it over it might be an omelet," he whispered dryly. He was wearing a suit and hat for his first day with a financial firm. He wanted to make a lot of money and retire early. Some years ago John wrote me that Frank had committed suicide. Bott was the first man I had an orgasm with, which probably accounted for a stronger emotional tie than I had going with his predecessors. He too had been in the war, had seen active duty in Saipan, one of the bloodiest battles in the Pacific. When he came home he studied painting at the School of the Art Institute of Chicago but somehow got derailed. Just before I met him he had a job operating a forklift but couldn't keep it because of his addictions. He loved cars and had bought, or inherited from a friend, a Model A Ford that had only one intact window. He drove it all over San Francisco, sometimes to my consternation. Imagine going down the Broadway hill in an antique like that, or getting stuck trying to climb it. One day a bunch of us emerged from a restaurant in North Beach, Bott floundering around, drowsy from downers. Mutt looked at me sternly and said, "YOU drive." Me drive that thing? Impossible. We compromised. John sat in the driver's

seat commandeering the gas pedal while I steered. Somehow we got back to Pierce Street unscathed. There was a charm about him—in spite of his blatant snobbishness and anti-Semitism—and a childishness which played on some weird and recessive maternal instinct in me. Even he admitted that his obsession with cars was a symptom of "arrested development." Shortly after his eightieth birthday John sent me his latest newsletter. In it he wrote: "A couple of days ago we heard Terry Gross on PBS interview a priest from out East who is gay. He said, 'I can't believe in a God who would give me the gift of sexuality and then forbid me to use it.' My sentiments exactly. I cannot believe in a God who would make me want a convertible and then not give me one." In a more recent letter John generously supplied more information:

> Am not sure but believe Mutt Nielsen's real first name was Harold. He made the news one day while we were there [San Francisco]. Stole a boat and headed for the open sea. Drunk, of course. Coast guard got him. Later he went to Vietnam where he piloted a river boat and got a disease that rendered him blind. For all I know he's still alive. His home was Logan, Utah. Frank Adams was mostly a junkie—though very smart and made some dough in the stock market. However, he and the woman he loved ended up spending YEARS in Synanon. I knew the girl . . . used to see her around Berkeley . . . she palled around with the Black Panthers. She's dead now . . . but she's the one who told me Frank had OD'd.

Bott had become bored with San Francisco and was waxing eloquent about the allures of Chicago. "In Chicago the water tastes like cherry wine" or something like that. San Francisco was for yokels. These sentiments began to surface after I brought him to dinner at my parents'

house. Neither party was very intrigued with the other. My father recognized the wino as soon as he went for a third glass of red, and Bott looked down his nose at my déclassé family who ate in the kitchen. His roots were upper-class Anglo-Saxons who had lost their money in the Great Depression but still pretended they had it, whereas mine were working-class European immigrants who were embarrassed about the money they had made after the Depression and lived as though they didn't have it. They looked down their noses at people who showed off with their Magnavoxes and matching mahogany dining room sets.

Bott was determined to flee in the Model A, head south to avoid the northern winter, and ride old Route 66 because he loved the song by the Andrews Sisters. I persuaded myself to go with him and asked my parents for $300. At first they refused but as we were packing up the car on the day we planned to leave, my mother showed up on Pierce Street and solemnly handed over $300 in cash. I hurriedly kissed her goodbye, and she watched us drive off. Later she would say that she expected never to see me again. Mama was fifty-eight years old, John Bottomley was thirty, and I was eighteen. We headed south in March of 1953.

5

Past / Forward Interlude: More Bay Area Cultural Memories

IT WAS AROUND 1950. I was a moody, solitary, unsocialized sixteen-year-old who sought frequent relief at the Clay and Larkin, the only commercial theaters in San Francisco that showed foreign films. I had long been familiar with the breed. From the early 1940s my father, an Italian-born French- and Italian-speaking émigré, would take me to the Sunday afternoon screenings at the Palace of the Legion of Honor out near the beach. I can still induce the chillies by invoking images of Falconetti's huge face and shaven head in Dreyer's *The Passion of Joan of Arc,* which I saw there around 1944 at the age of nine. I can only speculate that my fascination, then totally unconscious, with Falconetti's, or Joan's, suffering originated in my own early childhood deprivations. The setting itself was magical. Before the lights faded in the baroque, perfectly round basement theater, gilded like a jewel box, I craned my neck to study the swirling panorama of Cupids, angels, nymphs, and horses that cavorted and plunged on the glowing ceiling. The low murmur of voices, of adults and children alike, matched the subdued

lighting emanating from the wall sconces, to create an ambiance of pleasurable anticipation.

So it must have been on a summer afternoon in 1950 that I sat by myself in the Clay's soothing gloom and watched—*devoured* is more apt—Cocteau's *Orpheus*. Afterward I walked down Fillmore Street in a state of rapture, my mind suddenly unburdened of the adolescent dread that habitually engulfed me. Reaching the end of Fillmore, I turned in at Waller and rang the doorbell of Dave Koven and Audrey Goodfriend. I needed someone to bear witness to my trance-like state. I remember Dave saying, "You really liked it, huh?" The following week I saw the film three more times and haven't seen it since. I doubt if hearing "the bird sings with three fingers" would now have the same effect. At the time, however, this recasting of the Orpheus myth in modern dress opened a door to possibilities of imagination that, unbeknownst to me, marked a new chapter in my internal image archive. I was swept away by the dissolving mirrors and abrupt transitions from sun-drenched everyday life to the slow-motion agonizing of the turbid underworld. And of course I would not have been able to tell whom I found more attractive: Maria Casarés or Jean Marais.

It may be of interest to note here that, during an earlier period of my life, Hollywood films were a source of entertainment during Saturday afternoon family outings. I saw *How Green Was My Valley* in 1941 while sitting on my father's lap in a packed downtown theater. Nearby spectators repeatedly shushed me as I plied my father with questions about the plot and characters. ("Why is the man lying under that rock?") We used to go to the Golden Gate Theater and see a cartoon, newsreel, short, and feature, all followed by a stage show. The one that has stayed with me was a Loie Fuller–like concoction of nymphs swirling swaths of diaphanous material under colored lights while a live orchestra played,

perhaps Debussy's *La Mer* or Ravel's *Bolero*. After the show we sometimes walked further down Market Street to Foster's Cafeteria, where I would be allowed to choose a big slab of lime jello with peas embedded in it, and when I couldn't finish it my mother would say, "Her eyes are bigger than her stomach." She was also wont to comment that Rita Hayworth's mouth was too big.

Still later, with friends or my brother, I would traipse eight or nine blocks on a Saturday afternoon to the local movie theater (the Irving on Irving Street and fourteenth Avenue, now a supermarket) and pay a dime and a penny to see a "serial," or cliff-hanger, and double feature. Here I must have been exposed to innumerable Hollywood melodramas, images from which were undoubtedly stored in my internal archive until I was to immerse myself in the same films forty years later for ostensibly more highfalutin reasons. My fifth feature, *The Man Who Envied Women* (1985), would deploy clips from a number of Hollywood noirs like *Double Indemnity, In a Lonely Place,* and *Clash by Night* to stand for my male protagonist's cultural unconscious.

When I was nine or ten I saw a Hollywood movie that I've never been able to identify. In it was a scene of two women being totally bitchy to one another. Was one of them Dorothy Lamour or Betty Grable? They were wearing identical gowns, and one woman had ripped the other's dress off. I stayed in the movie theater long after my friends had left until that scene came around again. I laughed louder than anyone else. And I must have felt guilty about it, because I never told anybody, not even my mother. Perhaps the scene replicated for me my earlier physical struggles with my mother. The combination of eroticism and rage was irresistible. As a number of feminist film theorists would note in the '70s and '80s, men were not the only ones to be enthralled by such scenes.

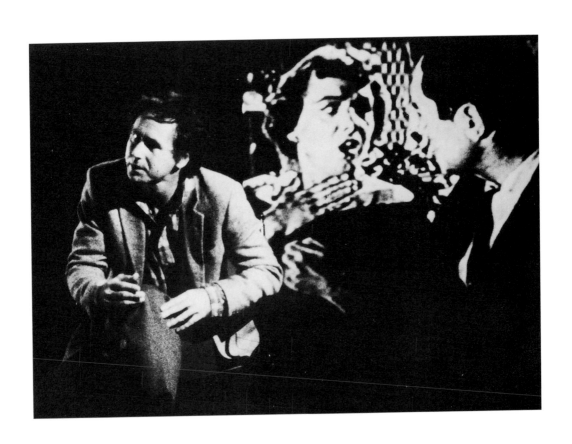

The Man Who Envied Women (16mm, 1985). William Raymond in front of *In a Lonely Place*
(d. Nicholas Ray, 1950)

If my father introduced me to art-house movies, it was my mother who introduced me to opera and ballet at a very young age. Born in Brooklyn to Jewish immigrants from Warsaw, she had working-class aspirations to cultural refinement, or, as she put it, "the finer things," which had already led her to enroll me as a reluctant student in several "tap and acrobatic" dance schools from ages five to eight, until I finally prevailed on her to allow me to stop. She took me to the San Francisco Opera to see old chestnuts such as *Carmen, La Traviata,* and *La Bohème.* We also regularly attended the crowded outdoor Sunday events at Sigmund Stern Grove, where we saw excerpts from *Swan Lake.* Around 1950 I bought a single ticket to Roland Petit's Ballet de Paris at the Curran Theater. Jean Babilée and Zizi Jeanmaire were performing in *Le Jeune Homme et la Mort,* but I was most impressed by a female dancer (Jeanmaire?) dressed in bright yellow, shod in matching yellow ballet slippers, who promenaded, or turned very slowly, on one straight leg, unassisted, in a complete circle in a flat-out arabesque, arms stretched wide. That I could and might one day enter this field did not cross my mind, even fleetingly, at that time.

FROM MY EARLY childhood my parents had taken Ivan and me to the Italian anarchist picnics and *festas,* one purpose of which was to raise money for anarchist periodicals, such as the British *Freedom* and New York/Italian *L'Adunata dei Refrattori,* and for prosecuted and imprisoned comrades in Italy. Every year the September picnic took place on a farm owned by Joe and Augusta Piacentino near Pleasanton. It was a jolly all-day affair, with much barbecue and pasta and red wine laid out on long tables under trellised grape arbors; much dancing to polkas and fox trots accompanied by banjo, fiddle, and guitar; much boccie and walks around the farm to look at cows and vineyards. In the cool gloom of the cellar of the main house hung dozens of salamis, and here the older anarchists congregated to gossip and drink. My most vivid memory is of wandering forlornly in the Indian summer torpor among the tombstones in the cemetery across the road. As a teenager I attended the winter *festas* that took place in the evening in a rented ballroom on Potrero Hill. My introduction to one of these events was momentous, as it was the first time that I had worn a garter belt and nylon stockings. My prepubescence was definitely over, and I was not at all comfortable in this new role of sexually attractive young woman.

From the age of twelve I had also been exposed to the heady commingling of poets, painters, writers, and Italian anarchists who gathered at the Workman's Circle in the Fillmore district every Friday night to hear the likes of Kenneth Rexroth, Kenneth Patchen, Herbert Read, and George Woodcock read poetry and socially critical essays. Although they were all nominally anarchists, heated exchanges would sometimes erupt between the more free-thinking speakers and the Italians, who were for the most part older and morally more conservative. Emma Goldman with her doctrine of free love was not a popular figure among the latter.

By the early 1950s I was working as a figure clerk for the Hartford Fire Insurance Company on California Street, near Chinatown, and starting to socialize in enclaves in which I was totally out of my cultural depth. For instance, one evening I found myself in the company of culturati who were discussing someone named Merce Cunningham. Thinking they were talking about a woman, I naively betrayed my ignorance. They looked at me in disbelief. The date who had brought me there never called again.

More kino epiphanies: In 1954 the late Michael Grieg, then in his early thirties, started the San Francisco Cinema Guild. A native New Yorker who headed out to San Francisco after World War II with his wife, Sally, and fellow anarchists Goodfriend and Koven, Grieg was to become a well-known Bay Area poet, novelist, and journalist. He modeled the San Francisco Cinema Guild after the Berkeley Cinema Guild started by Ed Landberg (then married to Pauline Kael), and installed it on weekends in the Green Street Theater, a former live burlesque house in North Beach where half-naked female caryatids still supported the proscenium arch. I was hired as the ticket vendor. (I remember reading Ernest Jones's *Life and Work of Sigmund Freud* between sales in the outside booth.) After selling my last ticket, I would go upstairs and watch the films. It was here that I first saw the films of Jean Renoir, Jean Vigo, and Buster Keaton. Mike always accompanied the silent films with music that he chose from his collection of LPs. Thus *The General* was accompanied by an orchestral version of *The Threepenny Opera* and was projected in this way three or four times on one weekend. I sat through every screening, mesmerized. To this day I cannot look at *The General* without hearing the *The Threepenny Opera* themes in my head.

Mike also rented and operated the single 16mm film projector himself. An unsettling event occurred one weekend when the projectionists' union picketed the theater to protest his non-union status, resulting in very poor attendance, as in those days people took picket lines very seriously. I don't remember how the situation was settled, but Mike continued to run the projector until he gave up the venture a year later.

Through Mike Grieg I was introduced to the Art and Cinema programs at the San Francisco Museum of Art, where I saw Maya Deren's *Meshes of the Afternoon* and *At Land.* The impact of these films was not apparent to me until 1960, when they were screened at the Living Theater in New York. It was there that I absorbed them for real, especially *At Land,* the editing techniques of which would affect the way I cut segments of my third feature, *Kristina Talking Pictures,* sixteen years later. Mike also took me to a private screening—I can't remember where— of Kenneth Anger's *Inauguration of the Pleasure Dome.* For all my familiarity with bohemian lifestyles and political radicalism, I was a bit shocked by the go-for-broke decadence of all those people lying around eating jewels.

I also remember meeting Frank Stauffacher, the director of Art and Cinema, and his beautiful wife, who was wearing a camel colored wool skirt and creamy silk blouse (don't ask why this sticks in my memory fifty years later). Stauffacher, about to endure the throes of terminal cancer, was gauntly handsome. To an unsophisticated and extremely shy nineteen-year-old these people represented the height of cosmopolitan élan. I also met Mike's friend, Weldon Kees, the poet and painter who disappeared off the Golden Gate Bridge several years later. Mike reported to me that Kees was incredulous that I didn't know what a "heavy" was. Though I had seen any number of Hollywood noirs, I apparently hadn't read many film reviews or criticism.

In 1954 Kees and Grieg produced an event called "The Poets' Follies" at the Theater Arts Colony on Washington Street, since torn down. (It was there in 1946 that my father, brother, and I had been the sole audience for a production of Maxwell Anderson's *Winterset*.) The sensation of the evening was a professional stripper from Oakland who read her favorite poetry by Edna St. Vincent Millay. She was a statuesque platinum blond with milky skin, decked out in a strapless black gown and long dripping stole of white fox. I remember Kees and Grieg fawning all over her. Once again I was the ticket vendor.

As a result of seeing all the films Mike screened at the Cinema Guild, I enrolled in a course in 16mm filmmaking at the San Francisco Art Institute. The instructor showed us how to load a Bolex, and I wrote a short treatment for a documentary about Crystal Palace Market, replete with detailed descriptions of shots, dissolves, and framing. Under a great glass roof that arched over innumerable stalls selling everything from produce and meat to steam beer, Crystal Palace Market, at Market and Eighth, was one of my favorite haunts in San Francisco. It was one of the treats of my childhood to accompany my father on a Saturday afternoon to Joe's lunch counter for spaghetti and meatballs and listen to them talk in Italian (which, because it had never been spoken in my house, was incomprehensible to me). Joe's was an oasis of calm amid the smells and clamor of that vast expanse. It was criminal that it was torn down in 1959 to be replaced by an apartment block.

When the Cellar opened around 1955 in North Beach, it became a popular hangout for bohemians of all stripes to hear Rexroth, Patchen, Lawrence Ferlinghetti, and others intone, rant, and declaim their poetry to the accompaniment of cool jazz. As it was a short walk from my small three-room house above the Broadway tunnel, I could be found there several times a week. Even then the atmosphere seemed somewhat

overblown in its macho self-importance, but it was a great place to get drunk and pick up men. It was there that I met the painter Al Held, with whom I would live from 1956 to 1959. In 1955 Al was working as a carpenter on the San Francisco freeways, and I was working during the day as a figure clerk and typist for a wholesale shoe company south of Market and studying acting at the Theater Arts Colony in the evenings. I introduced Al to the painter Ronald Bladen, and he introduced me to artists Ernest Briggs, Milton Resnick, and Ed and Edie Dugmore, all New York natives who, like Al, were living in San Francisco. Dugmore and Briggs were disciples of Clyfford Still; Resnick, an abstract expressionist working in the style of de Kooning, was temporarily teaching at Berkeley. Edie was a warm, maternal woman who was supporting their teenage daughter, Linda, and not-yet-successful husband. The model of devoted artist's moll was one that I would inadvertently emulate during the next few years before striking out on my own. All of us had just read *Waiting for Godot* and had a great time summoning the title as we lolled on a North Beach bench on a warm Indian summer afternoon.

In October 1955 Al, Ronnie Bladen, and I attended what would become one of the epochal cultural events of the decade: a poetry reading at the Six Gallery on Fillmore and Union. It is interesting to note that of all the readings heard that evening—by Michael McClure, Gary Snyder, Philip Lamantia, Allen Ginsberg, and Phil Whalen, with Kenneth Rexroth playing the MC—it is only Ginsberg's performance of *Howl* (more than a reading, it was an incantatory performance) that made a lasting impression on me. Wearing a black suit and white open-necked shirt and brandishing a half-empty gallon of rot-gut red, he chanted and howled out the haunting lines beginning, "I saw the best minds of my generation destroyed by madness." It was a little too bombastic for my aestheticized sensibilities of the moment. I remember being critical in a

subsequent conversation with Audrey Goodfriend, who was there with Ivan. She had loved it.

In August 1956 I followed Al to New York to begin another life. I was not quite twenty-two years old. What is striking as I reread this chapter is the paucity of women in roles other than wives, mothers, or performers and the total absence of gay culture and people of color. It was indeed a different world, a world that was about to undergo vast changes, or at least make a great many of us painfully aware that it should.

Chapter 5

Past / Forward

Interlude

I'm goin' to Chicago
Sorry, but I can't take you
Yes, I'm goin' to Chicago
Sorry, but I can't take you
Cause there's nothin' in Chicago
That a monkey woman can do.
—Based on blues lyrics by Ida Cox

6

Chicago

LETTER FROM JOHN Bottomley, dated Tuesday, September 2, 2003:

I must have seemed like a snob but I didn't feel like one. My family was never rich and after the depression we were very poor—often unable to pay our rent or utility bills. We had one car, briefly, in 1935 or so. A great old Packard (1924) as tall as a stage coach . . . But I do recall that your family were all Bolsheviks—anarchists—that sort of thing. I know I was (and am) vaguely anti-Semitic . . . but I don't know why or where I got it. All my dad's business associates were Jewish. (He did advertising for wholesale garment manufacturing) . . . half my friends were/are Jewish. . . . The Model A Ford I bought for $35 from friends of my sister who lived in Berkeley—it had no starter so we had to always park on a hill . . . That insane trip from SF to where we conked out in Grant, New Mexico, was a real nightmare. The rod bearings went out on the car, for one thing—we had them replaced, and they went out

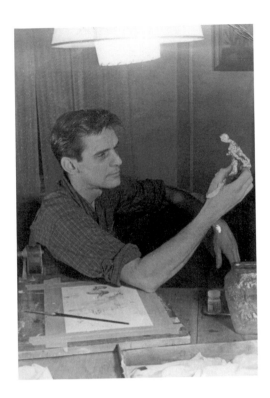

again! Top speed about 40 mph . . . took forever . . . Also you had a ton of stuff with you. Pots, pans, etc. I think we may have been able to send for that box later on.

From San Francisco Bott and I headed south, past the furrowed fields outside Fresno, on to the California/Arizona border. From one of the hottest places in the world, Needles, California, we crossed the Mojave Desert and began climbing. Bott hadn't bargained on cold weather along Route 66 in mid-March, and as we climbed higher into the southern Rockies, the frigid air penetrated the three broken windows of the

John Bottomley, early 1950s

Model A. He was beginning to be ill with a kidney infection, which was diagnosed after we reached Chicago. Even under these circumstances I was awed by the brooding power of the mountains. I particularly remember the truck-stop breakfasts at dawn. When we got to—and here I differ with Bott—Flagstaff, Arizona, the weather turned stormy. We found a motel and collapsed. In the morning the blizzard had passed, filling the interior of the car with snow and freezing the engine. A garage mechanic took it off our hands free of charge. I phoned home for funds in a phone booth in the Greyhound bus station. I had to shout because of the bad connection. Rejoining Bott I found him slumped in his chair, feverish but also angry at me for making a spectacle of us. As though my ravaged companion wasn't already a spectacle! True to my origins I was fanatical about nourishment and brought onto the bus, along with other foodstuffs, a package of unshelled walnuts. Almost immediately the package burst, sending a pound of walnuts scurrying all over the floor of the bus. For the next two days those walnuts rattled down the aisles and under the seats with every lurch and pitch of the vehicle. It drove my battered boyfriend nearly out of his feverish mind.

LETTER TO MY brother in San Francisco from Chicago, dated Saturday, March 28, 1953:

Ivan, I feel inclined to say that Chicago is the ugliest and dirtiest city in the world, its only redeeming visual feature that I have yet seen being the lake. Naturally, the state of mind I was in when we left the depot colored my impressions a helluva lot. I was fairly despondent and exhausted in the first place, after that arduous journey, and then on top of that the noise and hysteria of the heart of the city weighed down upon me like a jagged piece of lead. You may have read the letter which I wrote to the folks containing excerpts from the journal I kept on the trip. Needless to say I omitted personal details that I thought would cause them too much anxiety . . . [like] the relations between John and myself: the terrific strain and tension between us, partly due to mutual anxiety and John's sickness at the end of the trip. It all emerged in nagging, snapping, meanness, sarcasm, petty wrangling, and hysterical weeping on my part and finally a complete rejection of every idea I expressed on his. . . . So you can imagine how we felt when we got into Chicago. It was bitterly cold. John was still a little feverish. We had less than a dollar in our pockets. Try to visualize how we looked: both of us in coats spotted with grease and dust and other dark designs accumulated during 7 days; faces tired and worn; hair matted with dirt and disheveled; John pounds lighter, carrying a book; I clutching a draw-string cloth bag *[which I had made in 7th grade sewing class from a dish towel]*, literally loaded with filth, and that black leather bag of mine. We left the depot to go to John's father's office, which is also downtown. People rushing along, scam-

pering along crowded streets; faces faces blur of faces approaching receding; windows, food; and the BUILDINGS—filthy, grimy, ancient black piles of masonry soaring up up up, spreading out sideways like ungainly frozen lumps of lard. And sound noise—that's what gives me an impression of hysteria—We passed under an elevated platform—the most hideous structure I ever saw: fat rusty old (everything's so goddamn old here) girders supporting a platform overhead that makes a tunnel of the street below it. A train roared past—and they are long trains—the noise went on and on and on inside my shattered head. . . . Even after the thing had passed, the world rocked and swayed with a reverberation of that noise. I plodded behind John. But he, HE was in his element. His face brightened, became more alert; his step quickened so that he was once more walking with his peculiar prancing gait. I met his father, an emaciated, tall, nervous-fingered man wasting away from cancer. He gave John the key to their home on the northern fringe of the city. We took the subway, oh Jesus God! I thought the El made a lot of racket. The roar of the subway is enclosed in a tunnel and vibrates through every bone in your body. But John was "swinging" with it all, with the sounds, the hectic movement, the idiotic snapping open and shut of centrally controlled train doors; the hurtling, the turn-stiles, the glaring billboards plastered end to end on the walls of every station, with the hordes rushing in and out of doors doors doors [that] open, close, click, snap, [and the train] rushes away again through a mole-tunnel hurry hurry. It took us an hour to get to his home. The train eventually emerged from its tunnel and, climbing a platform, became an El. Now came an endless scene of rickety wooden back stairways littered with trash, dirty, stunted brick flats (old, of course, old

as Methuselah), and grimy, flapping clothes. Miles and miles of splintery, winding stairs, overflowing garbage cans, and ancient brick with the El roaring past second-story windows.

Today, as I was traveling the whole length of the city, coming up from the South Side, I thought of a word that epitomized my feelings about Chicago. GRAY. It is a gray, gray city. Gray in the sense of being colorless—its filth, its squalor, its meaningless frenzy are for me all incorporated in the adjective gray. Its fat skyscrapers, its squat brick residences, its very air, are gray. San Francisco's fog was never as gray as this. The former is colorful and romantic by comparison. It is graceful and gentle, but not harsh, not menacing.

I remember the foggy Sunset district where I grew up as infinitely depressing. So much for romance! But please keep in mind that this was my first exposure to a great Midwestern metropolis in the throes of winter. San Francisco seemed downright pastoral, if not tropical, in comparison.

Letter to my brother (continued):

What about John? I hardly know where to begin to analyze the situation: In the first place, as I have already mentioned, the trip caused a kind of stubborn rift between us. And now we are on edge, partly from the temporary arrangement of living with his parents, extremely reserved, restrained, polite, "correct" people who pity me something awful, because "John is bad medicine for any girl."

His mother told me in no uncertain terms that she didn't want to be responsible for me. And, again, from John (September 2, 2003):

> We arrived in Chicago with about 35 cents between us. We had some macaroni and cheese at a cafeteria and then went to my folks' apartment. (I may have gone to my dad's office and gotten a couple of bucks from him.) My mother wouldn't let us sleep in the same bed, but you snuck out on the sun porch one night and gave me a blow job. Oddly enough it was the only blow job I've ever gotten from a woman.

Letter to my brother (continued):

> We went to the South Side (where the University is located) last night, and I met some of his friends. A lot of yukking and laughing, John the center of the stage (he is one of the prima donnas of the group, which he himself admitted is a vicious, back-biting crowd). Most of the conversation taking place between the fellows, the "chicks" sitting around like parts of the scenery, trying desperately to be "cool," poised, and sophisticated. In fact, the men speak of them as *"my* chick" and *"your* chick," seeing them as hardly more than appendages of the bed. And, of course, there was dope on the scene. I was so unnerved by it all that I was ready to expire on the spot. Terrifically insecure people, sympathetic in their own way, but impossible at least for *me* to communicate with on their own terms. . . .
>
> Shit! The same old factor keeps popping up: BOREDOM. John once told me he drinks out of boredom. And I have seen him restless and fidgety, unable to become absorbed in anything. I heard the talk

of some of the females of this group: Nothing was "doing." One of them for a while had been sleeping 16 hours a day because there was "simply nothing to do." But get high. Enjoy life more! I want to enjoy life all the time, goddamn it, not just when I'm "high" (I have never yet been "high," so don't worry). And I think the strongest reason for my not being attracted to "junk" is the fact that I am not bored. I can honestly say that I am never bored. As I wrote to Eppstein, I think boredom is far more pernicious than my indulgence in weeping and self-pity. . . .

But in my relationship with John I have discovered such disturbing qualities that I would never have dreamed I possess. The only one I feel easy about describing to you is that I am a nag. Remember the way Mama used to nag us: about food, rest, clothes? I behave in this same manner (when I nag) with poor John. I nag him—no, I *used* to nag him—I have reached the point where I say "Let him do what he wants" when on the verge of nagging. It is quite a strain to exert this self-control, but I manage it more easily as time goes on. I used to nag him about his drinking, his dope-taking; on the trip when he was suffering horribly from wracking chills and a raging fever, I needled him about eating and dressing more warmly until he was nearly out of his head with suppressed rage. He told me that never in his life has he spoken more harshly to anyone than to me. Going by what I've heard from Daddy all my life, this is hardly harsh, but still each managed to hurt the other pretty severely on this trip.

I have left some loose ends: We both got jobs 2 days after we arrived: I work in an enormous modern warehouse in Evanston, just north of Chicago, as an order filler. I must walk about 20 miles a day (roller skates are available there; I think I'll use them when I get used

to the job) filling orders for everything from link belts to toy pistols. John has the same type of job in a nearby plant that handles machine parts. He makes $1.33 per hr. and I $1.17½ an hour. Nearly all of the 50 or more girls I work with are Negroes. The one who is training me has somehow taken a liking to me. She comes from a higher-class northern Negro family that "used to have servants." She applied for factory work rather reluctantly, much preferring white-collar work, because "you meet such a low class of people in factories." But factory work pays more, and she needs the money. I didn't know there were snotty Negroes. She was describing the conflict that she thinks exists on the job because of the three types of people who work there: Those who are too stupid to do anything else, those who have the brains for office work but not the will or ambition, and those who have the brains but need the money. She put herself in the third group. Anyway, she has me squirming: She's trying to interest me in joining some nation-wide club called the F.A.R.T. for the Parturition, Procreation, Promulgation, and Propagation of Racial Equality (or something like that), which consists of every race under the sun. I can imagine few things more contrived and irrational than a deliberate throwing together of races. In fact it's nauseating even to visualize a mob of people representing different races, all smiling so benevolently, tolerantly, and broad-mindedly upon each other that it makes one's head ache from an overdose of security. Phoo! If my friends happen to be Negroes, Jews, Orientals, etc., fine! But I'll no sooner join a club to meet the same than take dancing lessons to meet Caucasians. I fear that my vehemence may cloak more than I would like to admit.

Like the fact that I was an unreconstructed anarchist individualist. Racist? At least not overtly, but still not cognizant of my own white privileged status. I had parents who could get me out of there at any time. I don't remember any of my coworkers' names.

Bott's generous response to my recent inquiries mentions a number of names that summoned up more memories of the raucous parties on the South Side, from which I would drag him half-comatose to the El for the forty-five-minute early morning trip to the housekeeping room we eventually rented on North Pinegrove on the near North Side. Sometimes, as we approached our stop, I would have to slap and shout him into semi-wakefulness in order to heave him through the doors before they shut. From the El station we had eight long blocks to stagger. Bob Howie and Jim Saibert were dissolute buddies who would come around North Pinegrove a couple of hours after we had gone to bed and create such a drunken racket outside our ground-floor window that Bott would feel obliged to get up and go out to carouse with them some more. Obviously he couldn't hold a job on that regimen.

But Bott was not the only one who was passing out. "Jimmy's" was a bar on the South Side where we met our friends and drank ourselves silly. I drank because I was uncomfortable, sometimes to the point where I was able to pretend to pass out. This tactic proved to be an effective way of competing with the clever iconoclastic repartee. It produced the attention I desired, putting an end to whatever conversation I felt left out of by making it necessary for my companions to carry my seemingly senseless body out of the tavern and into a car. I performed this maneuver once or twice when the parties took place at the apartment of Karl and Valerie Sokoloski, both University of Chicago drop-outs. I remember "passing out" by the threshold of their front door. The revelers had to step over me to get out. After everyone had left and Valerie and Bott

had gone to sleep (Valerie to bed, Bott slumped somewhere), I lay on their couch as Karl, a former psychology major, sat on a chair near my head and played "psychoanalyst" to my venting "patient."

Valerie was the most appealing person in the group. A lovely, dark-haired woman with strong domestic inclinations, she taught me to dance the Lindy. She and Karl moved to San Francisco in 1954, bought a bookstore on Haight Street and lived in the apartment in back. I lost track of them, then heard that they had split up. Belle reported seeing Valerie with a young child in Berkeley in the 1960s. Bott wrote me some years ago that Karl had committed suicide.

One of the preoccupations of the group was daring each other to remove their clothing. At a party in our place I finally tired of the childish palaver and stood on the bed and took all my clothes off, at which everyone followed suit. Bob Howey was so drunk he went naked down the hall to the shared bathroom to pee and on the way back encountered the landlady, who started pounding on the door. We all hustled into our clothes, and when everyone had fled, John and I had quite a time explaining the rude behavior of our guest. Somehow, in spite of her outrage that Howey had "waved it" at her, we managed to appease her.

A somewhat marginal player in this group was Jim Gail, a semi-professional photographer. He drove Bott and me home from the South Side one night, Bott raving and thrashing. We hauled him into our little room. I sat and watched quietly while Jimmy stood over him as he vomited into the corner basin. Jimmy remarked how unperturbed and calm I seemed in the face of such sordidness. I said I was used to it. But in truth, I was embarked on a serious mission to "not be bothered." Like Mama. A curious side-light to my Chicago adventure is revealed in the following quote from a dance I performed in 1972, called *Inner Appearances,* that involved printed texts projected on a back wall:

The rain makes her think of when she was eighteen years old, spending a summer in Chicago. She was sitting by an open window in a room with five other people. It had started to rain heavily. A woman on the other side of the room was talking about her baby sitter. She said, "I hope the stupid girl has sense enough to close the windows." Without a second thought she reached over and shut the window. A stunned silence fell on the room.

By the end of August the real crisis came after Jim Gail took photos of John and me having sex in our room. A week or so later John borrowed someone's car and rammed it into a bus in Oak Park. The police found photos in the glove compartment of me giving Bott head and jailed him. I heard about this in a phone call from Jimmy in which he cryptically warned me not to "go out there." I didn't get it, and was so concerned that I took the El and a bus out to Oak Park Police Station. Soon after I was ushered into a room, they brought out the haggard Bott, who sat dejected and silent beside me. As I tried to have a whispered conversation with him I noticed that the room was gradually filling up with very large uniformed and plainclothes cops who stood and stared at me. Only then did I realize the seriousness of the situation. I was an underage girl involved with pornography. They let me go on my way. John's father interceded for him and he was eventually transferred to a veteran's mental hospital in Danville, southern Illinois.

I spent a final week at Hibbard, Spencer, and Bartlett confiding in my coworkers. They had psyched out my unhappiness and gathered around at lunch time to hear my tale of woe. These black women from the ghetto knew all too well the vicissitudes of living with wayward men. They were an unexpected and deep source of comfort.

I had already applied for admission to the University of Chicago, and assuming that I would be admitted, quit my job and moved to a room on the South Side after taking the entrance exam. The landlady had it painted forest green for me. A week later I was asked to come in for an interview. A grad student in psychology asked me a few questions, then popped the big one: "Of all 500 applicants taking that test, why were you the only one who didn't return for the second half in the afternoon?" Huh? I wasn't admitted.

During this interlude I hung out with Jimmy now and then. Once we both discovered we had forgotten our money as we finished a meal at a restaurant—no one I knew had credit cards back then—and had to sneak out without paying. It was he who suggested that the best thing for me would be to return to San Francisco. I made one trip down to Danville to say goodbye to John. He was sober, sad, and reflective. "You're the least phony person I've ever known" was his parting tribute. I wouldn't see Jimmy Gail again until he came through New York around 1963 and took photos of me dancing in my studio. The last time I saw him was prior to a screening of my film, *The Man Who Envied Women,* at the Chicago Art Institute in 1987. He was standing by the entrance to the theater, a big imposing man, balding, with the same style of aviator glasses he used to wear. I had a so-called senior moment and couldn't immediately retrieve his name, so I said simply, "I know you." He had had a stint as a 35mm cinematographer in Hollywood but was now retired and living in Chicago. I heard from John that he died some years ago. Despite his voyeuristic proclivities Jimmy was a less desperate character than the others, with a caring side to him. Actually the last time I saw him was following that same Art Institute screening as he pushed a woman in a wheelchair across Michigan Avenue.

Dearest Yvonne:

I forgot to tell you how we met.

It was at the party at Mutt's where we tried to have group sex. (Although all I remember about that is Frank Adams hopping in and out of bed with you—unable to perform. Too wasted.)

I probably walked you home so I knew where you lived. Not long after that I showed up at your door. "And there you were," you said.

I don't remember the bits about having to be so quiet . . . nor do I remember a kitchen. I remember milk on the window sill.

I do recall that one night Jack Warn showed up very drunk and put the blade of an open pocket knife at my throat . . . lay down and passed out. I guess he was your first lover. He later said something like, "I found her in Vesuvio's and she looked like she needed it."

I got a job in the shipping department of a place that imported rattan furniture. Waited a month for my first paycheck, then got rolled on my way home. (Stopped in a bar to drink with coworkers.)

Two reasons for going to Chicago: Frank had gone back, and I think Mutt was gone too. You had an idea that you'd attend the University of Chicago.

That spring and summer in Chicago were nightmares. You remember that you were in a submissive phase . . . but I was a total wimp myself. The guys we hung out with used us mercilessly. Climbing in our windows if we didn't answer the door. There was a lot of that trying to get up enough nerve to take off our clothes.

Bob Howey got naked and ran to the bathroom down the hall. The landlady saw him and we had a lot of explaining to do. Bob and Jim Saibert both tried to fuck you when I was away and of course Jimmy Gail did that photo number.

It was funny. We were headed for the South Side, but you said, "Let's not go, I'm horny." So we stayed . . . and Jim stayed.

He was married to Marney Schwinn, an heiress, and getting caught with the photos led to his immediate divorce.

The guys were trying to get me into the Vets hospital in Heinze, but left me in the car with the keys in the ignition. The rest is history. I drove off—crashed into a city bus. The trunk flew open and the photos spilled out.

Cops all eyeing you lasciviously when you came to see me in jail. My dad and Marney had to buy us out of that scrape.

I remember you crying as you looked up at my window in Cook County Psycho. It must have been a ghastly time for you . . . alone as you were, surrounded by predators.

Also I was generally pretty awful to you. Lotta passive aggression. Sneering, etc.

The worst of it is, Yvonne, that that was just the beginning for me. I went downhill from there for the next 20 years—didn't begin to get well until I hit fifty.

I lucked out . . . that's all there is to it—borderline miracle. Smart shrink took an interest in me. I was able to stay with my mother until I married Anne and got my gardening business going. Anne has been through a lot with me too.

Love and best wishes,

Bott

Letter to my sister-in-law, Belle Zabins Rainer, dated Friday, September 25, 1953:

Dear Belle—

I would be sending you only a postcard if I had one at hand, for my only real reason for writing to you at this time is to tell you to change back the flight you had on the way to NY. You see, I have decided to return to SF. as soon as possible, and it would not only be a waste of time for you to stop over in Chicago, but also a disappointing and barren experience since I, the sole object of your visit, will have already fled from the city. I hope you won't be too disturbed by my not clarifying anything, but at this time I don't feel like making any sharply defined explanations and speculations about the circumstances surrounding my behavior—at least in writing. Let me say simply that I am in a state of repose that I have never known before and deep within myself have an awareness and certainty of what I am doing that I can't really convey verbally—an awareness that exists even while I am in a strange kind of limbo, knowing for sure that they will let me in to paradise, but not knowing the exact location of the gates.

I can't feel too guilty about leaving you bewildered with this inadequate note, Belle, for we shall see each other so soon—not in the detested Chicago, but in SF.

Love,
Yvonne

A postscript to the Bottomley saga: In the early 1990s I had just started a Q & A after a screening of my film *Privilege* at the Pacific Film Archive in Berkeley. A hand toward the back shot up. It belonged to an elderly man with a thick shock of straight white hair. I recognized him instantly. "You know that part in the film where she talks about dreaming of meeting a former lover from forty years ago on the street? Well, that was me!" I said, "Looking good, John! Next question?" I didn't want to engage with him. His letters over the years had been obsessive and salacious, sometimes nasty when I didn't respond. When he came up after the Q & A I brushed him off. I have since made amends, I hope, and am grateful for John's contributions to this chapter.

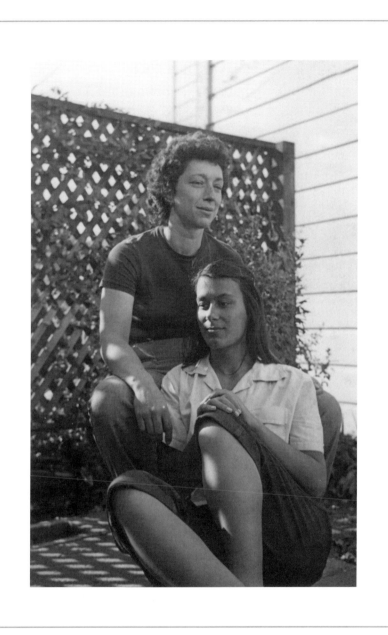

Sally Grieg and YR, ca. 1954

7

SF Maturation

I FLEW BACK to San Francisco in September 1953, newly confident in my hard-won independence. This time I intended to exploit my touch-typing skills, which I had taught myself while still in high school, and apply for office jobs. I went downtown to the Emporium, bought a pink wool suit with a straight skirt and boxy jacket—"It's not really pink, but dusty pink," Belle had observed approvingly—and showed up for my first interviews in that and new Capezio low-heeled black suede pumps. The folks helped me get settled in a former rooming house on Oak Street. The two furnished rooms were separated by a public hall, bath-room, and kitchen on one side, bed/living room on the other. It was a tad more upscale than the Pierce Street place in that the furniture was brand new Danish modern, with added decor of fox-hunting wallpaper and an orange shag rug. The kitchen too was wallpapered. When I turned on the light I could hear hundreds of cockroaches scurrying to safety behind it. A merchant marine lived down the hall. He had been all over the world, his tiny apartment stuffed with his trophies. Carved

wooden furniture from the Philippines, Javanese shadow puppets, Chinese vases, a Japanese ivory-inlaid screen. I managed to keep my distance from his advances.

After three or four futile interviews, I landed a job as a clerk at the Hartford Fire Insurance Company, figuring premiums on a cumbersome mechanical machine with a handle. The firm was on California just above Grant Avenue, so I began to spend my lunchtimes exploring Chinatown and spend my paychecks on clothes and jewelry and books. I also returned to weekly sessions with Barbara Eppstein. One of the turning points in my therapy hinged on whether or not I was going to wear lipstick. Therapy for a young woman in the 1950s often equated the acceptance of social conventions with emotional maturation. But on one item she was certainly correct: my new grooming was key to finding a white-collar job. One day I sailed into her office in a newly purchased Dior-like black wool suit with flaring skirt and nipped-at-the-waist jacket. The wonder of wonders was my mouth, painted with Germaine Montieul ruby-red lipstick. I was duly commended. It was like getting a gold star.

For the next two years my social life centered on the household of Mel (later calling himself Mike) and Sally Grieg and their two young children, Joyce and Bart. They became my surrogate—and eventually incestuous—family. In their rented house on DeHaro Street on Potrero Hill I was occasional live-in babysitter, friend, confidante, and—despite Eppstein's warnings against it—lover to Mel.

Mel was a Til Eulenspiegel kind of figure—a verbal trickster and provocateur, at once mischievous and skeptical, either fence-sitting or contrary when he sensed which way an argument was going. I remember a discussion in which he criticized the idea of medical progress in disease prevention by citing resultant population explosions in the

Third World. I wasn't quick enough on my feet to point out that birth control was also a product of medical science. But that would have been typical of him: to appear to prefer disease rather than science and education as a brake on population growth, all for the sake of argument against liberal positions. Although he encouraged my writing and was the only one of the anarchists to treat me as an equal rather than a troubled teenager, he could be critical of me, for instance in bed, comparing my "style" in a disparaging way to that of Sally, who would always be the love of his life.

My desperate needs for closeness and physical warmth meshed with the tensions in the Grieg household. Sexually frustrated and willful, Sally was having an affair with Dave Koven with the full knowledge of Mel, who proceeded, partly in self-defense, to get involved with me. Sally was aware of it—even encouraged it—to justify her own affair. Also, in some lopsided way, Mel was her gift to me, the outsider to whom she herself was attracted. In another instance of irrational logic, Mel embarked on his affair with me to please Sally. For me, she was the familiar combination of mother and avenging angel, while he was the big brother who showed me the world. The more I think about it, the more complicated and Dora-like that situation seems, only with me, unlike Freud's famous patient, a willing role-player. Sally had a formidable temper and drive that made her the centripetal force in the family. While baby-sitting one night, I ran to Joyce's room after she awakened screaming from a bad dream. Sally at that moment came home and took over. From the dining room I could hear her voice ratchet up from a soothing purr to fury as the child remained unconsoled. Sally beat her into silence. I was in no position to protest or criticize. This was my chosen family. The central tragedy was Bart, the angelic baby born with club feet who spent his infancy and early childhood in plaster casts and braces. I

suspect he was also given pain medication, which may have contributed to his heroin addiction in later life. Sally was great with him, very affectionate and matter-of-fact. I remember him crawling around on the floor, a metal bar connecting his shoes to keep his feet in line, and Sally chortling "Bartie Boy" as she lifted him high into the air. For a while Sally was the family's economic mainstay, bringing home the bacon from her job as a bookkeeper while Mel kept house and worked on his novel. This was before he started the San Francisco Cinema Guild and before he went to work for the *Examiner* as a cultural reporter.

Sally loved Dave Brubeck and loved to dance. She and I would go to the Blackhawk and listen to Brubeck's jazz group while making our two-drink minimum of whiskey sours last for two sets. Once we went to a dance hall in North Beach, where we sat around waiting to be asked to dance until Sally got fed up and whirled me across the floor. Immediately two middle-aged Italians cut in and separated us. Although women at the anarchist *festas* danced together, here it just wasn't done. At parties, if she danced alone, Sally moved like the Ginger Rogers she adored during her depression-era adolescence. Upper arms held close to the body, hips and parallel forearms swaying, face swooning with pleasure. Sally had pungent opinions of people. She once exploded about Arthur Berecke, a poet who lived up the street whom I was considering dating, "He's no prize package!" She single-handedly put up drywall to make an extra kid's room in their house and made beautiful pottery on the wheel in their basement. She was also very handy as a seamstress, sewed all her suits and dresses for work and altered the stuff I was buying. She eventually went back to school and obtained a degree in clinical psychology.

In 1954 I moved to the Steiner Street apartment with the Murphy bed, finally ensconced where I didn't have to venture into public space to reach the bathroom or kitchen. Daddy brought over his old drop-cloths

136

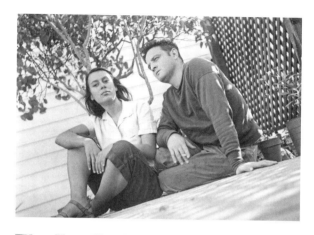

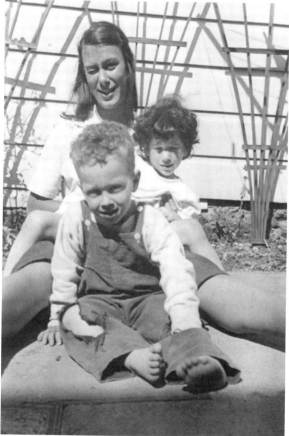

137

YR and Mel Grieg, ca. 1954
YR with Joi and Bart Grieg, ca. 1954

and brushes and painted the kitchen yellow and the living room a deep salmon. I still had dinner with the family once a week, often joined by Ivan and Belle, now with tiny daughter Ruth in tow. The first time we took our parents to Chinatown Daddy made jokes about finding a finger in the soup, and once he splurged on dinner at Jack's, the venerable steakhouse in the financial district. If I recall correctly, the bill was $20 for the lot of us. During this period I initiated an argument with a young Jehovah's Witness on a Fillmore Street corner about the existence of God and naively gave him my phone number. When he called a few days later I agreed to have him over, but then thought better of it after he rang the bell and was on his way up to my apartment. He knocked and, getting no response, poked open the little window in the apartment door and called my name. Out of his sight, I held my breath. He finally gave up. Why had I given him my number? Because he admired my "deep dark eyes"?

In that year, 1954–55, I went everywhere with either Sally or Mel or with the two of them. We saw *The Oxbow Incident* (resulting in heated argument about justice and betrayal), *The Earrings of Madame De* (protracted discussion about morality), *Day of Wrath,* and *Dead of Night* with Michael Redgrave as the mad ventriloquist. At the end of *Dead of Night* I was so unnerved and speechless that Mel had to steady me on my feet as we left the Union Street Theater. We attended numerous plays at the Interplayers on Stockton Street. I saw Joyce Lancaster in *The Madwoman of Chaillot* and my first Pinter play. For weeks after, whenever serving something to eat, Sally quoted the shrilly repeated line from *The Birthday Party,* "IS IT GOOD?!" Eventually the *menage à cinq* at the Grieg house imploded when Mel fell in love with someone else and left all of us. I remember sitting at their dining room table crying my eyes out

while Sally tried to comfort me. She knew, as far as she was concerned, he would be back.

Sally died of cancer at age 55 in 1978.

(*Image of two women dancing together*)

Doris: Why did it happen to me? Sometimes when I'm cooking I think of Sally. She was the one who told me about using wooden spoons in metal pots. She used to say, "Your pots will last longer." And sometimes when I enter a subway car I hear Roberta saying, "My mother taught me never to ride in the first or last car." She never was in a subway accident. And Sally's pots outlived her. Breast cancer got both of them.

(MURDER *and murder,* 16mm, 1996)

SOMETIME IN 1955 Sally invited me to accompany her while she inquired about the possibility of designing costumes for a little theater group that occupied the old Theater Arts Colony on Washington Street. They didn't need a costume designer, but the guy behind the desk (it's funny, but I don't remember a single name connected with that outfit, not even the name of the outfit!) asked me if I had ever acted. Then he gave me this come-on about his drama school, and I decided to join up. What the hell. The place was run by two guys on-the-run from New York who did a lot of talking about epic theater. And—luckily for me—there was a speech teacher there. Remember, I was still lisping; my tongue shot halfway out of my mouth with every sibilant. One night he asked me, "What other kind of 's' can you make?" I showed him. He responded, "What's wrong with that?" I said, "It sounds funny to me." And he said, "There's nothing wrong with it. You just have to get in the habit of doing it." So for the next two weeks I slowed my speech by half, no matter whom I talked to: boss, parents, friends, pets—and spoke with no other "s" but that new "s." And by the end of two weeks I had it licked! Twenty-one years old and my first triumph! I was intoxicated with success. The other good thing that happened there was that they let me be on stage. They were doing *All the King's Men,* and I was cast in two parts: a member of an incited mob and—better still—the mother of the judge. In the latter role the lights came up on me sitting on a raised platform in a filmy peignoir screaming at the top of my lungs, "You killed him, you killed him, you killed him!" I loved it. There was no doubt about it; I had become stage-struck.

Working around little theaters was not entirely new to me. Even before going to Chicago I had pulled the curtain for a production directed by Martin Ponch at the Beach Street Playhouse at the foot of Mason Street. It had not been a very enjoyable experience. Evidently I

was rather slow in picking up my cues, which several times caused short-tempered Martin to lose patience with me.

But now I was older and wiser. Several times a week I sat down on a stool in a greasy spoon on Polk Street to eat dinner (soup? hamburger?) before going to my acting class at the Theater Arts Colony. The prongs of the gas burners were caked with old grease and a small TV monitor was suspended over one end of the counter. We had never had TV in our house, so it was a novelty to watch the $64,000 Question. The contestant was Dr. Joyce Brothers, whose specialty was boxing. The show was probably rigged, like "Twenty-One," which had its downfall in the Charles Van Doren scandal some years later.

As noted above, my most notable success at the acting school was overcoming my lisp. I also remember delivering a long monologue in class as the mother of Richard II, which the instructor criticized as "monochromatic." What most impressed me about the place was the friendliness and camaraderie of everyone involved, from office personnel to director to instructors. New to me was the male homophile ambiance, which manifested itself in the special attention given to handsome male students and in sexy outbursts. "GONNA GET THOSE COLORED LIGHTS GOIN'!" the chubby box office guy would shriek at the drop of a hat. (Need I cite the source, *Streetcar Named Desire*?)

It is all refreshingly new to me. Late at night, with my head teeming with ideas from the class, I head up Broadway to the crest of Russian Hill and am shocked into sentience at the shimmering spectacle below. A full moon hanging low in the sky irradiates the bay with a milky glow. I can still be thrilled by the stunning views afforded by San Francisco's topography. Crass commercialism, which may have spoiled much in this city, has not been able to blight its exquisite affinity of land and water.

In the summer of 1956 another student and I were both leaving the drama school for greener pastures in New York. She was a glamorous white turned-up nosed celestial creature who would eventually land a job as a showgirl in a Broadway musical. I was a stage-struck, not very talented, aspiring actor, told by the director, "We're sorry we couldn't find a bigger role for you here," and riding the coattails of a New York-bound lover. But whoa: in my haste to bring closure to my stretch at the Theater Arts Colony, I'm getting ahead of myself.

In late summer of 1955 I moved to a three-room house above the Broadway tunnel in North Beach. It had been the home of poet and playwright Holly Bye and painter David Ruff, both of whom I had known for some years through my connections to the anarchists and the Workman's Circle meetings. They were friends of poet Kenneth Patchen and operated a printing and etching press in the basement, where they published limited editions of poetry and graphics. Dave Koven had introduced me to the etching process there while I was still in my teens. Holly and David were moving to New York. The printing press was gone, but Holly's rainbow striped floor boards remained plus a few pieces of furniture, including a round oak table that had belonged to Ronald Bladen and his wife Barbara when they had previously lived in the house. The table ended up in Ivan and Belle's house in Berkeley where it remains to this day. There was another little house in back of mine occupied by Betty Keck and Dickie Mills, a freelance jazz trumpeter, and Betty's daughter, Kimrie. I still have *The Joy of Cooking* that Betty gave me almost 50 years ago. They were extremely warm people. I would never have known that they were heroin addicts had I not been told.

During this period and before, I frequented the Black Hawk, sometimes with Sally and Mel, sometimes alone. In addition to the San

Francisco–based Brubeck, whose group was a standby at the club, we thrilled to Chet Baker, Lester Young, Thelonius Monk, and Miles Davis. I went alone to hear the Chico Hamilton Quintet. Hamilton's group at that point consisted of an unorthodox mix of flute, cello, bass, timpani, and guitar, with Hamilton on drums. At the end of their last set I brought the whole group home to my little house where we improvised a meal, which included a big can of V-8 juice, to which Chico was addicted. I subsequently dated Buddy Collette, who played sax, clarinet, and flute and wrote some of the songs. He took me to a funky club in the Fillmore where I proceeded to get loaded on stingers, a powerful mix of crème de menthe and brandy, then went on to a dance club where I met a guy I knew (whose name I haven't been able to retrieve and who later was involved with the media group USCO) and danced with him. Was I innocent, oblivious, or perverse in playing off these men, one black and one white? I ended up at Collette's apartment and reluctantly had sex. Like so many young women I let myself go along with the game until it was too late to turn back, easier to give in than to resist. Afterward he said, "Well, I got more than he got." I wish I could say that times have changed, but I know that sexual ambivalence is a transgenerational phenomenon for young women, as is sexual conquest for men, whether or not complicated by race.

Shortly after I moved into the little house I was awakened by a loud altercation. Two broken down people—a man and a woman—were sitting opposite each other on my front stoop. In voices destroyed by alcohol and hard living they enacted the all-too-familiar tropes of the lovers' quarrel. "You don't love me" . . . , "You're always saying things like that" . . . , "If you loved me, you would . . . ," "You've never loved me," and the like. I stood in my dark hallway a few feet away from them,

just behind the curtained glass panel of my front door, riveted by the uncanny drama unfolding in the middle of the night. I would adapt this dialogue eight years later in a duet called "Love" with William Davis.

Ronnie Bladen, separated from Barbara, began to visit me every Friday night. I eagerly awaited his ring and the sight of his lean slouching shape at the door. Ronnie was a romantic figure, originally from Vancouver, thirty-six years old, working at a factory job and making Blake-inspired paintings in his spare time. Reticent, gentle, slightly withholding, and mysterious, he had a way with the ladies and a quiet self-confidence about his talent and attractiveness that dovetailed with his assumption that I would be at home when he rang my bell every Friday. I invariably was. I loved the guy, but it was *my* assumption, without asking, that the relationship could go no further than our weekly trysts. It wasn't until years later that I learned my error.

I MIGHT NEVER have gotten up enough nerve to leave San Francisco for New York had I not met Al Held.

In the fall of 1955 I ran into Mutt Nielsen in the Cellar and was sitting next to him along the wall opposite the bar, sipping my drink and listening to the live local jazz combo. A burly young fellow came up to me and started a conversation. He would later say that he wouldn't have approached me had he thought that I was with Nielsen. His name was Al Held. He was an artist, recently arrived from New York, living and painting in a North Beach flat. He made his living building wooden forms on the rapidly spreading San Francisco freeways. He had joined the merchant marine in the last year of World War II, afterward studied at the Art Students' League and in Paris. His presence in San Francisco was the aftermath of a recent break-up with his wife, with whom he had fathered a daughter. I didn't take him home that first night, but we very soon became involved. I introduced him to friends and family. When we had dinner with my folks at Trader Vic's on Columbus Avenue in North Beach, my father seemed to like him. His response to Al's thick impasto abstract paintings was to suggest that Al could save a lot of money on pigment if he used cement and then painted over it. The ethos of the abstract expressionist painter's "heroic" manipulations of paint was lost on him. Al bought a funky secondhand car, and Mel Grieg taught him to drive. We started living together at Al's behest because he was tired of running back and forth between our houses. He set up his studio in the basement where the printing press had once resided and immediately got to work. He was painting in black and white then. In my mind's eye I can still call up the long horizontal painting of a strung out white image that evoked the Golden Gate Bridge.

In a proud possessive way Al was definitely in love with me. Though not the "very beautiful woman" of Philip Howard's prediction,

I had learned to groom and adorn myself, with Belle as my model, in ways that made me attractive to men. I was beginning to have my own opinions about cultural matters, although at that point I knew little of recent American art. My collection of clothes, jewelry, and books was growing. We bought a tiny record player and several LP records—Billie Holiday and Mozart clarinet concertos. As for *my* feelings about Al, there was the irresistible lure of being wanted—a powerful aphrodisiac and ensurer of my worth. Dave Koven had his own summation: Al was an ideal lover for me, he said. "He's an artist, he's from New York, he's Jewish." Everything seemed to be going smoothly. But then I fucked up.

The acting school gave a party in someone's big flat. I got very drunk with a young actor I knew. We went into a back room and I went down on him.

The next day I was taking a bath and having a conversation with Al, who sat companionably on the closed toilet seat. When I casually mentioned my adventure of the previous night, he looked at me aghast. I was taken completely by surprise. Why was he so upset? The incident hadn't meant anything to me. I simply "did it" because the guy had wanted me to and it was expected of me. Or, more accurately, I expected it of myself. I had internalized the expectations of all the men I had known. My first New York therapist would tell me several years later that I was the most compliant person he had ever met. If I was compliant, I was also aggressively so. A kind of inside-out predator against myself, but with a modest exterior.

Al went kind of berserk, was ready to leave me and San Francisco. Ivan interceded, arguing that I meant no harm, I was inexperienced and didn't know what I was doing. Al was somehow appeased. Without making a moralistic judgment, I can affirm unequivocally that I was never

146

again unfaithful to anyone I lived with, or, for that matter, to anyone with whom I was sexually involved. However, beyond my reasons for acting out a "meaningless" adventure, a question inevitably arises: why did I tell Al about it? What that confession points to is my long standing mania for "telling." Telling my parents about things of which I knew they would disapprove. Telling friends embarrassing secrets that might be turned against me. Blurting out my opinions about others. I live with a weird compulsion to betray myself, to reveal everything, under the guise of a disingenuous "openness." Ha! And now I find myself entangled in Peter Brooks's "catharsis of confession," which I so nobly disavowed in the prologue to this memoir. It's time to switch gears.

(*Image of middle-age woman talking to man on the other side of a desk, his back to camera*)

Patient: He had the biggest hard-on I had ever seen in my life. I admit I had been indiscreet, but you have to realize how young and innocent I was then, I did whatever anyone wanted me to do. My friend—this guy I had gone to the party with—we got very drunk and it just seemed like the most natural thing in the world to go into the back room and . . . and then it seemed perfectly natural to tell the guy I was living with about it the next day. After all, I told him everything, didn't I? Well, he got pretty mad, but that very night he also got such an enormous erection as I had never seen the likes of. It scared me half to death. What in God's name had turned him on like that? It couldn't have been *me.* Shall I now subsume history under memory, confuse memory with dreaming, call dreaming seeing? Or push for some cheap theatrical effects and simply reverse at a moment's notice?

(*Journeys From Berlin/1971*, 16mm, 1980)

Already set in motion by our crisis, Al shipped off his paintings and preceded me to New York. We both assumed that I would follow. Ivan commented that my decision was based on "the usual emotional reasons." In his characteristic rationalist scheme of things reason and logic trumped feelings. I sold off or gave away most of the furniture, some of it to Roberta, Al's younger sister, who was doing graduate work in psychology at Berkeley. In August of 1956 Linda Dugmore, Edie and Ed's seventeen-year-old daughter, and I boarded a plane for New York. I was wearing my black linen sheath and gun-metal Capezio sandals. (People dressed up for plane trips in those days.) I had no way of know-

Jeannette, granddaughter Ruth, and Joe, August 1957

ing that I would never see my father again, and on the plane I read a *Life* magazine report on the death of Jackson Pollock. This time, in contrast to my Chicago interlude, I would have a more trustworthy Virgil as my guide in this new urban inferno.

At this point in my narrative it behooves me to say something about the role of alcohol in my sexual escapades. Being drunk enabled me to suppress anticipation and a natural wariness, override intuition, disavow emotional consequences. It wasn't that "being drunk made me do it" when if sober I might not have. Alcohol allowed me to hone my willfulness and desire to be free, to be unencumbered by all the miseries and constraints and embarrassments that my early life continued to produce. To use an anachronism, my life was like a runaway Xerox machine, reproducing its contents ad infinitum. I can't say "the miseries" have ever entirely disappeared. While writing this memoir one will occasionally worm its way up from the depths and erupt out of my mouth in a barking "Aaaaa!" like the creature wriggling out of the astronaut's belly in *Alien*. But then it's over. Although I've never looked to art to exorcise my demons, I can attest that, sapped (or zapped!) by art-making and other resources, they eventually quieted down.

YR in the 21st Street loft, ca. 1957

8

New York in the Late 1950s

FROM KENNEDY AIRPORT Linda and I took the airport bus to the First Avenue Air Terminal at 36th Street. As we stepped off the bus into a surge of humid air, we were met by Al and Linda's mother Edie, who whisked Linda away. Al stashed my suitcases in a locker and proudly proceeded to show me his Manhattan. First stop was the automat on 42nd Street and 3rd Avenue. I was duly impressed by all the nickels and the elegant brass spouts and handles that dispensed coffee and the little gated windows which you could see being replenished by the hands of moving figures even as you withdrew your selection. We then boarded a downtown IRT (Interborough Rapid Transit) and got off at 8th Street. From there we walked west across Washington Square Park to the tiny walk-up apartment on Bank Street that Al had sublet for the month of August from the abstract expressionist painter Hyde Solomon, who was away at an artists' colony. I had to pick my way carefully in my low-heeled sandals over the cobblestones that then dotted West Village Streets. Arriving at the apartment we made love, after which I slept while Al went off to retrieve my luggage.

By the time he got back it was early evening, still hot and steamy. Al then took me to Times Square. I had put on a peasant-like cotton print dress that Sally Grieg had given me. We stood at the corner of 7th Avenue and 42nd Street, Al pointing out the sights. The huge Camel cigarette billboard exhaling smoke through its open mouth and the cacophony of traffic and hawkers remain vivid. I rested my arm on a mailbox. On removing it I discovered my forearm was covered with black soot. This had never happened in San Francisco. The air smelled of bus exhaust rather than sea-borne fog. We had dinner at Hector's, the sprawling cafeteria on 42nd Street. I was pleased to see they offered steamed broccoli.

Al found a 2000 square foot loft on the second floor of 5 West 21st Street, and we started to fix it up and paint the whole place white. At $75 a month it was the usual vacated manufacturing space, with two toilet stalls and unsanded filthy plank flooring. A previous occupant had already transformed one of the toilets into a shower. In those years such spaces were quite illegal for habitation, and Al cautioned me repeatedly not to answer the door unless I knew who was there for fear it might be the "loft squad" coming to kick us out. Al's boyhood friends from the Bronx, John and Nicholas Krushenick, gave us a few pieces of furniture—some multicolored homemade kitchen cabinets and a kidney-shaped wooden table. Other accoutrements were a sink supporting a corrugated porcelain drain surface propped up on its other side by a two-by-four. Next to that was a basin, a definite luxury that eliminated having to brush one's teeth in the kitchen sink. Al covered the floor of the back third of the loft, where we lived, with red linoleum, and from a 3rd Avenue secondhand store I hauled some dark blue velvet curtains with which we draped the two big rear windows. With the addition of a four-burner gas stove, a clothes closet with sliding hollow-core doors

that were always coming off their tracks, and a bed made from a hand-me-down mattress on a 4 × 8 sheet of plywood sitting atop six dowel legs, we were all set. The front two-thirds of the space, with its rough exposed planks and partially separated from the rear by a dry wall partition, was reserved for Al's studio. While still living on Bank Street, Al complained that I never worked at painting the new place unless he was there with me. I took him seriously and went up to the loft one night alone and finished rolling the last coat onto the remaining wall. By the beginning of September we had moved in. During the day 21st Street seethed with the tumult of trucks, workers, horns, and yelling. At night and on weekends

Al Held, ca. 1957

it was an abandoned city, desolate and silent. In the winter we had steam heat until 6 pm, and in the summer no air conditioning.

My first three years in New York are a blur of impressions, excitement, events, and activity. For that first Thanksgiving in 1956 I offered to make dinner for the Dugmores, sculptor George Sugarman, and Ronnie Bladen, who had just moved to New York from San Francisco and was staying with us until he found a place of his own. With the help of my trusty *Joy of Cooking* I did the whole thing. Everyone, including Al, arrived punctually from the Cedar Bar just in time to eat. They had evidently been regaling each other with all the things that might go wrong

George Sugarman, YR, and "Lily," ca. 1957

due to my inexperience, like a totally white turkey. (I hadn't thought to reassure them with the tale of my mother-on-the-couch, ten-year-old cooking exploit.)

One of the first people I met was Al's friend Jaakov Kohn, a small wiry Israeli who made jewelry in a shop he rented on St. Mark's Place. Jaakov lived with his wife and five children in a railroad flat on the East Side. He hired me for several weeks to polish jewelry. On the first day he seemed obsessed with my breasts, sneaking frequent looks. My breasts also became an issue for Al one day as we walked down a street in the Village. He suddenly exploded with "Okay, that's enough. You're going to

Ronald Bladen, ca. 1957

buy a new brassiere!" It seemed that my bobbing appendages were eliciting stares from passersby, of which I was completely unaware. (Carolee Schneemann once told me that when she first met me I looked like Gina Lollobrigida.) We popped into the lingerie shop on 8th Street, east of 6th Avenue, where I bought a firmer harness to hold them in place.

Our lives soon settled into a routine. Every Sunday we picked up Al's four-year-old daughter Mara and drove up to Crotona Park North in the Bronx to visit Al's parents, Harry and Clara. Harry still worked as a jeweler on West 47th Street. On one of these occasions there were a number of distant relatives also visiting, some of whom Al had never met. Harry introduced everyone by name followed by his or her relation to himself. "This is so-and-so, my wife's second cousin; this is Al, my son; this is x, my nephew's wife," etc. He completely passed over me. Since I was neither a blood relative nor his son's legal wife, he had no way of identifying me.

We both had part-time jobs. At first Al delivered furniture for the Door Store on Greenwich Avenue, shortly thereafter buying a second-hand station wagon and starting his own moving business. Also working at the Door Store was a young sculptor, David Owens. His wife, Rochelle, would eventually become known as a poet and playwright, her plays staged at the Judson Poets' Theater in the early 1960s. I typed for a small firm on 23rd Street that dealt in mailing lists, later landing a better-paying part-time office job at the University Settlement on the Lower East Side. In that first year I did all the grocery shopping and cooking, lots of hamburgers and frozen lima beans, as I recall. After dinner three or four times a week we walked down to the Cedar Street Tavern on University Place, between Eighth and Ninth Streets, and nursed 15¢ beers or 50¢ glasses of wine with Al's friends and acquaintances. Besides the Krushenick brothers, we often met up with painter Bernice Dvorzon,

aspiring pianist Doris Casella, Ronnie Bladen, and Al's friends from Paris—George Sugarman and painter Shirley Kaplan—and when he was in town, the painter Sam Francis. To get to the booths in back you walked past the bar and its habitués, the most renowned of whom were duly pointed out to me: Franz Kline, Willem de Kooning, and the lesser-known writer Fielding Dawson, who had attended Black Mountain College and would much later write a biography of Kline. The place was always brightly lit, the walls painted an institutional green and hung with paintings of fox and duck hunting. The energy of the Cedar originated not in pounding pop music but in the steady buzz of voices locked in intense conversation. I remember asking Bernice who Alexander Calder was and embarrassed Al by asking John Krushenick why he had a Brooklyn accent and his brother didn't. But mainly I listened, as the cornucopia of artists' names, many not yet—or never to be—canonized, and their champions spilled in desultory torrents from the mouths of the ardent discussants. In addition to those previously mentioned, I heard for the first time the names Harold Rosenberg, Clement Greenberg, David Smith, Mark Rothko, Philip Pavia, Nicholas Marsicano, Alfred Barr, Sidney Janis, Martha Jackson, Robert Motherwell, Thomas Hess, Nicolas Calas, William Baziotes, Philip Guston, Earl Kerkam, Adolph Gottlieb, Ad Reinhardt, Herman Cherry, Aristodemos Kaldis, Hans Hofmann, Peggy Guggenheim, Norman Bluhm, Richard Stankiewicz, and other names either attached to bodies passing through this soon to be fabled saloon or hanging in the smoky air to be appraised, reviled, awarded or dismissed by those who uttered them.

I had already schooled myself in a cursory way in the broader outlines of early twentieth-century European painting, but the roster that was to constitute the New York School was a new kettle of fish. There were few women mentioned—Grace Hartigan, Joan Mitchell, Elaine

de Kooning—and usually only in passing or dismissively. Somehow the sculptors Louise Nevelson and Marisol fared better. The tenor of the times can be gauged in the frequently heard disparagement, "She paints like a man," meaning, of course, that "she" had no business doing so and was too ambitious and/or too successful for her own good. A comment by Lil Picard, lover of Alfred Jensen, exemplifies another side of the rampant, if unconscious, sexism: "I always choose geniuses for my lovers." Though not yet famous, Jensen's putative genius enhanced Lil's own psychic/social position.

Every Friday before decamping to the Cedar Bar we attended openings at the 10th Street cooperative galleries lining the block between 3rd and 4th Avenues. The Krushenicks had started the Brata Gallery, also the frame shop in the back that provided them with a livelihood. Next door was the March Gallery and across the street the Tanager, the latter managed by painting exegete Irving Sandler. My impression was that the Tanager was the most prestigious. Al considered it a coup when his beautiful black-and-white *Bridge* (my private title) was accepted for a group exhibition there. What also stood out for me in that show—could it have been because they were women?—were a pointillist abstraction by Sally Hazelet and a figurative landscape with cows by Lois Dodd. Dodd in particular was not accused of painting like a man. The mind-body/male-female dichotomies were constantly rearing their heads in some form or another. A parody of this biologically deterministic mindset might read: "Men are from abstraction (mind) and women are from cows (body)."

As you might imagine, some of these impressions emanated from my macho mate but could not begin to be crystallized or questioned by me for another fifteen years, not until the second wave of feminism broke on my shore. Nevertheless, I owe whatever knowledge I have of

the painting of that period to having become an avid student of Al Held's ideas and working process. By this time he was using color, a muted palette of ochres, siennas, dark reds, blues, and greens, which he mixed from dry pigment and linseed oil. The thickly slathered strokes were applied with spatulas and trowels to unprimed canvas, an abstract expressionist vigor (virility?) and bravado clearly in evidence. I loved those paintings. I watched him work and spent hours poring over them when he was not in the studio. I also absorbed the hours of talk about "space," the "picture plane," "flatness," "the edge," "figure-ground," "behind and in front," and "depth." Cubism was still a key referent. Frequent topics of intense discussion between Al and George when they met for breakfast every morning were the differences between Picasso and Matisse and who of their—Al's and George's—contemporaries were or were not indebted to Cubism. ("Everyone is," claimed George.) George had a small studio on West 23rd Street, so it was convenient for both of them to bring their respective copies of the *New York Times* to the Paradise Cafeteria at 6th Avenue and 23rd. Equally passionate about art, they ate their bagels, drank their coffee, read their papers, and talked art from 9 to 10 or 10:30 A.M. (In 1974 I went up to the Whitney Museum to see Al's retrospective. Rounding a corner of the third floor, I was knocked for a loop. The room was filled with the paintings he had made during the time I lived with him on 21st Street almost twenty years earlier, and I knew every stroke like the back of my hand.)

Even before we moved into the loft, Julie Krushenick, Nick's wife, herself an aspiring actor, advised me to enroll at the Herbert Berghof School of Acting, then located on 6th Avenue in the 20s. I attended a scene-study class taught by Lee Grant, whose acting career was still on hold due to the Screen Actors' Guild blacklist dating from the heyday of Joseph McCarthy and the House Un-American Activities Committee

hearings. Her usual outfit consisted of a sweatshirt and pearls. A very young, snub-nosed, golden-haired Sandy Dennis was in the class, obviously everyone's favorite and being groomed for greater things to come. I was a total washout. Grant commended my "intense concentration" but criticized my enactment of a scene from *No Exit* as "too cerebral." I could no more assimilate the "Method" and its sanctified interpretations of Stanislavky's writings than walk through the eye of a needle. And when I started to go to auditions for on- and off-Broadway plays, I was more than once told to try auditioning elsewhere for "American Indian" parts. My olive complexion, dark hair, and strong features marked me as useless for 1950s Americana by the likes of Inge and Chayevsky. I had a similar experience at Paul Mann's Actors' Workshop the following year. While trying to fulfill a "sense-memory" assignment, I pantomimed walking along a riverbank and retrieving a stone from my shoe. The response was "We don't believe you." I couldn't generate the proper illusion. The spectacle of someone *trying* to create an illusion was not, of course, interesting to anyone, not even me. I was frustrated and confused. The fact of the matter was—is—that I am not a gifted mimetic actor. What I had going was a strong presence, which would serve me well in the kind of dance and performances that I ultimately created. But as a convincing actor in the conventional sense? Forget it. Which is exactly what I would soon do.

In the summer of 1957 Shirley Kaplan and her husband, Bill Hunter, a Scottish physician interning at Bellevue for his U.S. license, invited us to spend a few days at the old farmhouse they were sharing with Doris Casella in East Hampton. It was pristinely unrenovated, with a pump on the kitchen drain board. I woke up at dawn and was so thrilled at being in the country that when I couldn't figure out the latch on our second-floor bedroom door, I tied a sheet to the bed leg and shimmied

160

down it to the ground. Walking past a cornfield, devouring corn right off of the stalk, I was reminded of my mother's memories of the sweetness of the corn she had picked in the New Jersey cornfields of her youth. We spent most of the next few days at the beach. Sam Francis was in the Hamptons having a red-hot love affair with Naomi Levine (later to become an underground filmmaker and famous for being one of the performers in Warhol's "Kiss"). We caught glimpses of them as they zoomed around in Sam's red MG, occasionally coming to rest at our corner of the beach.

Shirley Kaplan, Bill Hunter, and Doris Casella, East Hampton, ca. 1957

A SLIGHT DIGRESSION: The ocean waters relieved the swelling of my feet and ankles, an annoyance and embarrassment that had begun to afflict me the instant I stepped into New York's summer humidity. Unlike my mother's "milk leg," however, the condition disappeared when cool weather arrived and was later alleviated by dancing and still later ended with the advent of menopause. My mother's anguish over her swollen legs was never far from my thoughts during the summer, resurfacing in my own self-consciousness as a socially sanctioned stigma. Legs, along with breasts, hair, and buttocks, are parts of the female anatomy that continue to be fetishized by mass culture despite years of feminist resistance and struggle. For me, aging and illness have been sure-fire catalysts, enabling me to jettison whatever internalizing process gave me grief in my younger days around my physical attributes. Now with one breast gone and the other shrunk, my hair shorn to one-inch spikiness, and legs sheathed in trousers, I can walk the streets in dignity. Being addressed as "Sir" is a minor inconvenience. But it was not only aging and breast cancer that hastened such change in consciousness and appearance. Beginning in the early 1980s my association with lesbian friends and culture led inexorably to a weaning from the vanities and bodily obsessions I had absorbed from the worlds of dance and heterosexual social imperatives. But again, I'm getting ahead of myself.

LATER THAT SUMMER Al and I drove up to Provincetown. Too poor to rent a room, we intended to sleep in the station wagon after parking at a beach. Toward evening a storm rolled toward us over the water. As we sat in the front seat it was like having a private view in a Restoration theater. The dark clouds, lightning, and rain paraded like mechanized effects, a divertissement staged especially for us.

Throughout this transitional period the honeyed, heavy, success-and-ambition-and-fantasy-laden atmosphere of the New York art and theater worlds was everything I might have envisioned had I dared to do so in San Francisco. I remember walking down 5th Avenue past Madison Square Park, overwhelmed by an ineffable sense of infinite possibility. Someone else might have described it as a "conquer-the-world" kind of feeling. For me it was simply pure open-ended excitement. Though I had no idea what the future held, it was already signaling with open arms. Reading Kerouac's *On the Road* and Alexander Trocchi's *Cain's Book* around this time may also have contributed to my perfervid state of mind. It was as though everywhere I turned I encountered figures of possibility and liberation. A letter from me to Mel and Sally dated October 22, 1957, delivers a somewhat different impression:

Dearest Mel & Sally—

So here I am writing another letter on the back of another gallery notice *[Group Show, Brata Gallery]*. It is after midnight. Al is drowsing on the bed. All three kittens are asleep with their black sphinx-like mama and I have just finished Jack Kerouac's haunted gabby book *On the Road*. It is the kind of book—irrespective of its literary worth—that I find particularly fascinating. It stirs in me all the slumbering unresolved unrest that still peoples my fantasies—the mad, undirected,

rebelling, the squashed-down explosiveness that takes second place in my present I-know-where-I'm-going-or-at-least-I'm-making-a-grade-A-effort-to-find-out. The book made me so nostalgic—my thoughts stretched out to you "3,000 miles across the sad continent.". . . The book does generate a delicate sad helplessness & inertia. I'm a real sucker for it . . . Have started attending classes at Paul Mann's Actor's Workshop. I find that the guy is a likeable fool, full of large talk and vapid life-ideas.

Every fall for the first three years I sent away for tickets to Broadway and off-Broadway plays. You could get good seats to the former for $2.50, so we went fairly often. On Broadway we saw O'Neill's *Moon for the Misbegotten* and *Long Day's Journey into Night,* Saroyan's *The Time of Your Life,* Brecht's *The Resistible Rise of Arturo Ui,* Ionesco's *Rhinoceros* with Zero Mostel, and Jerome Robbins's *West Side Story.* Off-Broadway there was Schiller's *Mary Stuart* with Eva Le Gallienne at the Phoenix on 2nd Avenue and O'Neill's *The Iceman Cometh* with Jason Robards at Circle-in-the-Square in a basement on West 4th Street in the Village.

Doris Casella, or Dolly, as we called her, was one of our closest friends. Dolly had known Al when he was still living with his wife Gisella, and had been around during some of the more violent scenes that roiled that marriage, including a fire that burned up their Lower East Side loft and all of his paintings. Slight in build with an elfin grin, Dolly was a feisty, ebullient neoclassical pianist, living alone in a cold-water apartment (freezing toilet in the public hall) while still seeing husband Bobby, a laid-back physicist, from whom she had separated. At the same time she was involved with Lester, her mercurial black lover. When

I knew her she was supporting herself by giving piano lessons and doing part-time "varityping" at night for a printer in the Puck building while studying composition with composer Ben Weber. In 1956 she had taken one of John Cage's famous composition courses at the New School, which would be attended by future luminaries Dick Higgins, Allan Kaprow, Philip Corner, Henry Flynt, Jackson MacLow, Al Hansen, Alison Knowles, George Brecht, and La Monte Young. Dolly was the only woman in the class. In a recent conversation she recounted, "I thought [Cage] was wonderful, but I was feeling out of step and was desperately trying to do the assignments. After hearing a piano piece of mine, he said, 'You have a really good ear, but it's going to be a terrible drawback.'"

We saw a lot of Dolly. I remember part of a conversation I had with her as we stood on either side of my kitchen counter on 21st Street. She had grown serious for a moment and said, "You'll have an easier time than me; you're prettier than I am." I didn't respond. Admitting the rightness of her remark would have been tantamount to saying we were different, and differences of any kind, especially between women, were threatening. Not only that, to focus on the specifics of my future—easy or otherwise—was unsettling. A part of me already knew that my life with Al was temporary.

Dolly introduced me to Tom Tierney, a piano student of hers who was a would-be fashion photographer. He offered to make 8 × 10 glossies for my acting auditions in exchange for using me as a model for some of his ideas. He brought out all kinds of glamorous accessories— hats, boas, cigarette holders, etc.—and took a number of Polaroids that made me look like someone from the boondocks pretending to be a *Vogue* model.

Dolly also introduced me to the music of her loves, Frank Sinatra and Errol Garner, and, more crucially, to the dance classes of Edith

166

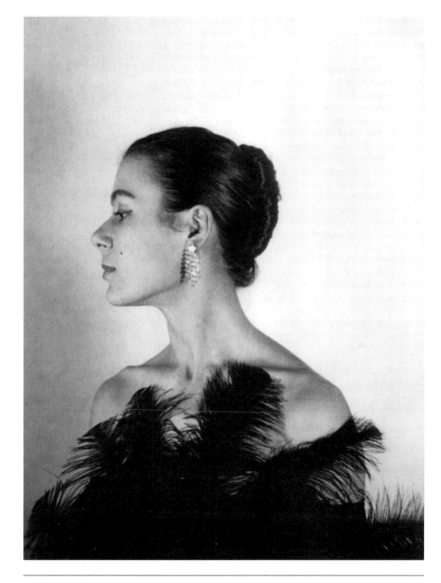

YR, ca. 1957. Photo: Tom Tierney.

Stephen, a modern dancer in her thirties who had a studio in a fifth-floor walk-up on 6th Avenue around 9th or 10th. Edith had studied all the established modern techniques plus African dance with Asadata Dafora. Dolly persuaded me to accompany her to one of her weekly classes with Edith, arguing in the face of my reluctance that actors needed the physical discipline. So I bought a leotard and tights and went to my first adult dance class. Afterward Edith gave me an evaluation. I was strong, she said, but not very "turned out." What she didn't say was something that I would gradually recognize in the next couple of years, that my lack of turn-out and limberness coupled with a long back and short legs would reduce my chances of performing with any established dance company. (When I performed with the James Waring Dance Company some years later, Robert Rauschenberg reportedly commented, "She can't do much but she has terrific stage presence.") Luckily, I was impervious to these portents. All I knew was that I loved running and jumping. I proceeded to absorb everything that Edith dished out, an eclectic mix of Limon, Graham, African, and improvisation. At the end of every class she produced a basket of schmattas and told us to dance. I would take a scarf and toss it around while executing some of the movement phrases she had just taught in the previous hour. "Yvonne uses everything she's learned," mused Edith. In subsequent classes it was from Edith's frequent admonishing that I learned to pull in my belly, a part of myself I had hardly known I possessed. In the spring of 1957 Edith presented our compositions in an informal recital in her studio. Al and George and Ronnie came to see the duet that Dolly and I danced to Webern. None of us took it very seriously.

It was either George or Al who introduced me to Louise Gilks, an African American dancer then living in a huge rough loft under the Brooklyn Bridge with her white sculptor boyfriend. Louise offered to

give me private lessons in African dance. She would put on a conga drumming record and we'd go at it. It was very strenuous, and Louise was an exacting teacher. She was extremely generous. For the price of the fabric she sewed a skin-tight black wool dress for me to wear to the opening of a huge international painting show around 1957 at the Coliseum that included a painting of Al's. I got a kick out of parading around in my heels and sleek outfit. I lost track of Louise, and must confess that when she called me in 1963 for a loan of $25, I refused. I was in a deep depression, had no cash on hand, and would have had to go to the bank. In my abysmal state I was unable to leave the house. Had I not been blind to the consequences for Louise of our racial difference, I hope I might have behaved otherwise.

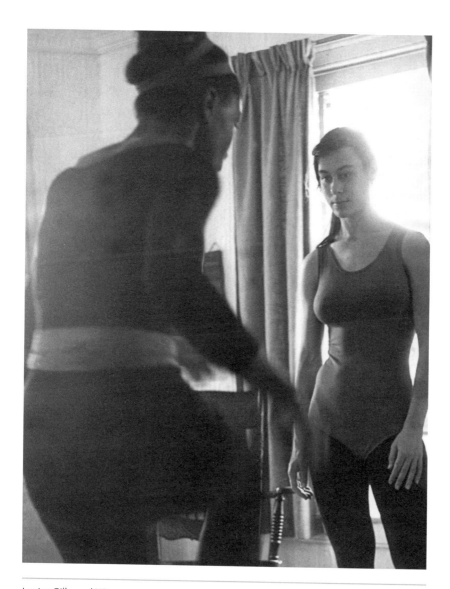

169

Louise Gilks and YR, ca. 1957

WHEN I FIRST came to Edith's I would sometimes peek through the curtains and watch Merce Cunningham gliding around in the studio. At that point he didn't have a studio of his own and was renting hers. It was as though he was on wheels, so smooth and effortless were his movements. However, after seeing a concert of his—it might have been at the Brooklyn Academy of Music—I shared Edith's view that the work was "cold." The Graham aesthetic dominated both the critical scene and my inchoate sensibilities. I was overwhelmed by her *Clytemnestra, Cave of the Heart,* and other dances that I saw around this time at a Broadway theater. The apparent absence of emotion in Cunningham's work, in addition to the disjunction between Cage's music and the choreography, stuck in the craw of critics, who made pejorative comparisons with other modern dance that utilized recognizable—and by now conventional—gestures to express feeling. It was not until I had been through the Graham "factory" and embarked on serious study with Cunningham that I could fully appreciate the heretical notion espoused by the Cage/Cunningham school—namely, the implicit humanity and emotionality of the human body. Before that could happen, however, George Sugarman was another mitigating influence with his memories of Graham in the 1930s and 1940s when, as he said, she was so radical that "she drove them [the audience] out of the theater."

George had a friend, Emile Faustin, who was teaching Afro-Cuban dance in a shabby midtown studio. For a short while Al, George, Ronnie, Dolly, Shirley, and I all attended his weekly sessions. It must have been an amazing spectacle, we rank white beginners struggling to follow the throbbing rhythms of live conga drumming along with a roomful of lithe black dancers. It was unlike any dance class I've ever attended. Exhilarated from our efforts, we would go out for food and drinks afterward with Emile and some of his boisterous friends and laugh and laugh.

In the following years George was an important person in my life. He had gone to City College and worked as a parole officer until he was 35, at which point he quit to devote himself to drawing and sculpture. When I first met him he had a part-time job teaching woodworking to kids in the Little Red Schoolhouse on the Lower East Side. George's private life was something of a mystery: he would show up with a different male or female friend whom he seemed to treat rather casually, even irritably. His living quarters and studio, filled with lumber and storage racks, were scrunched into no more than 800 square feet. He ate his meals on his desk, which first he covered with newspaper. For me George came to represent an ideal of the artist who devotes his life to his passion and doesn't let anything distract him from making art, neither poverty, nor personal relations, nor emotional setbacks. I was not nearly there yet. George died in 1999 at age eighty-seven.

One of George's sisters knew Zero Mostel. George was invited to lunch at her apartment with Mostel and his wife and took Al and me along. Zero and I were seated next to each other at the table. Throughout the meal he kept me in paroxysms of strained laughter as he free associated and used me as a straight man, at moments even grabbing food off of my plate. It was a bit unnerving, and I was glad to get out of there.

I STARTED TO model for life-drawing classes at $2.00 an hour at the School of Visual Arts and for individual artists. One client was a painter with a studio on the top floor of an Upper West Side brownstone. It was furnished like the Hollywood set for *An American in Paris:* Spanish shawls flung over painted screens, a skylight, and traditional wooden easel. He posed me in a chair with a shawl wrapped demurely just below my bare shoulders. After a number of sessions I took a look and couldn't help exclaiming "My god, it's just like Rembrandt!" More like Frans Hals maybe, his carefully applied glazes had produced something definitely not of the last two centuries. After a measured pause he replied solemnly, "Yes, but it is necessary to go beyond what has been done in the past."

In 1957, because Gisella, Al's ex-wife, had gone to court to obtain more child support, claiming that he was supporting a mistress, Al and I went down to City Hall and got married, with a ring from Woolworth's and Dolly and husband Bobby as witnesses. Afterward we had a meal in Chinatown. It was no big deal to me, one way or the other, but not because I did not feel committed to Al. The institution of marriage had never carried any symbolic weight for me. My parents had tied the legal knot some time after I was born, and then only because they had become property owners. (Ivan and Belle, on the other hand, got married after their kids were grown to reconfirm their commitment after a rocky spell.) If Al hadn't gone to Juarez to get a divorce ten years after we split up, we might still be legally married. Call it sloppy anarchism. Although I don't believe the State should meddle in matters of human intimacy, I don't feel justified in disguising my casualness in a cloak of high principles.

In the spring of 1958 Ivan phoned to report that our father had died suddenly from a stroke. He was sixty-seven years old. The previous year Daddy had suffered a concussion after falling from a third-floor scaffold that he had jerry-rigged before starting to paint the back of the house on Seventh Avenue. At that time I wrote him a warm letter of concern. For

years, before losing it, I carried around his four-page reply, written in impeccable old-world cursive. It was full of advice, aphorisms, and poems ("If you hang your wishes on a star, just drop your bucket where you are . . . "). Most important to me were his expressions of surprise at and gratitude for my concern. It seemed that our difficulties were resolved; he was assured of my love, and I looked forward to seeing him again. We thought that his fall might have shortened his life, but an autopsy revealed an advanced stage of kidney cancer. I am sure his daily use of lead house paint for so many years was a factor. Al urged me to fly to San Francisco for the funeral, but I couldn't do it. I hadn't been back for almost two years. It was as hard to leave my new home as it had been to leave the old one. I feel tremendous anguish whenever I call up the image of Ivan and Mama all alone as they watch Daddy's casket being lowered into the grave. Ivan told me that the finality of the scene came home to him when he looked up the hill and saw the two grave-diggers leaning on their shovels, waiting to finish the job.

Equally important during this period was a concert by the Erick Hawkins Company, which I saw at the 92nd Street YMHA around 1957. Hawkins had danced with and been married to Martha Graham. After leaving her company he worked with composer Lucia Dlugoszewski to make archetypal, somewhat mystical dances. I was knocked out by the simplicity and directness of "Here and Now with Watchers." At one point a female dancer leisurely walked, without stylization, from the wings and placed an object downstage center. I had not yet seen such an ordinary walk in a dance performance and was strangely moved. It was as though that golden future was not only beckoning from a distance but was now about to pull me over its threshold.

I went home that night in a state of high exaltation. This had occurred earlier when I saw Robert Rauschenberg's 1957 show at the Castelli Gallery. Immersed as I was in the abstract-expressionist mystique,

Rauschenberg's *Monogram* had opened a window on the future of my own funny bone. I all but rolled on the floor in a convulsion of laughter when I saw the paint-besmirched goat with the tire around its middle. I didn't know who the artist was, but I knew I was witnessing a sensibility at once elemental and authentic. The irreverence of this new art, later termed "Pop," was about to supersede the high seriousness of abstract expressionism. My own creative pump was being primed.

But for now, following the Hawkins concert, Al looked at me approvingly. "It really got to you, huh?" Though I couldn't articulate exactly what I felt, he, having arrived there first, recognized the inspired state when he saw it. In retrospect this was a critical moment. Al's leadership hung in the balance, for my awakening would be followed by more troubling stirrings.

I had already begun to feel burdened by some of Al's overbearing ways. An unnerving incident took place during Ronnie Bladen's stay with us when he arrived from San Francisco. Al became furious when he discovered that I had washed a sweater of Ronnie's. "It would have been different if you had washed one of mine at the same time." What to me was a simple, if disingenuous, act of hospitality—in my mind having no connection to our previous intimacy—exacerbated Al's jealousy, already given an impetus by his knowledge of my history with Ronnie. That night when I resisted having sex because Ronnie was in bed on the other side of the partition, Al raped me. There is no other word for it. I wasn't able to question his sexual dominance until my latent ambitions for an autonomous life in art began to surface. It was these slowly accumulating rumblings that augured trouble in paradise.

On Dolly's suggestion, I sought psychological help from Albert Ellis, a die-hard behaviorist as it turned out, for whom emotions were irrelevant. His most frequent question was, "Why are you so concerned

about pleasing other people?" A reasonable question if it had come from someone with a broader perspective, but not pleasing other people seemed to be his end-all nostrum. Ellis arranged a meeting with his dancer wife, Rhoda, who in turn recommended that I take private dance lessons with a former ballet dancer named Allen Wayne. An engaging, chatty man in his fifties who had danced professionally with one of the Ballet Russe companies, Wayne taught in his apartment on East 83rd Street. My desire to pursue dancing more seriously meshed with Wayne's promises to make me a dancer through an approach that bypassed what he called the "ruinous" techniques of Graham and ballet. I said good-bye to Edith, asked my mother for money to pay for the lessons, and for the next year traveled three times a week to the Upper East Side. (Mama's largesse was simplified, perhaps even made possible, by my father's death. I doubt if he would have been so wholeheartedly generous in sponsoring what he might have deemed so useless a pursuit.) The lessons, which consisted mainly of strenuous yoga-like stretches and small repetitive leg-lifts that zeroed in on precise, and painful, positioning in the hip sockets, cost around fifteen dollars a shot. Under the impression that twenty-four was too old to be starting to dance, I thought the Wayne technique would be a shortcut. After a year I grew impatient and began studying Afro-Cuban dance with Sevylla Fort, who had danced with Katherine Dunham, while cutting down on my classes with Allen. Well past her prime, Sevylla ran a shabby studio just off Times Square that featured her husband playing an old upright piano, two live conga drummers, and a moth-eaten dog that wandered around. She sometimes came over to me during the barre intro and remarked, with her gentle touch and voice, on my progress. I was the most untalented in the class. After attempting a complicated combination across the floor, I heard someone say, "What was *that*?"

By the spring of 1959 I was fed up with Albert Ellis and started going to George's former analyst, John Schimel. I had just read Djuna Barnes's *Nightwood* and told him in the first session that I wanted to be able to withstand comparable sordidness without being affected. (Like Mama, I was engaged in a serious mission to "not be bothered," or to be "above it all.") He retorted, "Then you've come to the wrong place." He also exclaimed, in response to my descriptions of domestic incidents, "How can you live with such a man?" I was startled. As Dolly recently reminded me, Al was like a big exuberant kid. We had lots of fun, with each other and with friends. Weekly excursions to the Apollo on 42nd Street or the Waverly in the Village to see Fellini and Bergman movies, to the Cedar Bar, to openings, to the Savoy and Small's Paradise in Harlem, ferry rides in the wee hours from Washington Market to Paddy's Clam House in Hoboken, innumerable loft bashes, Christmas eves at our place with big pots of mulled wine, New Year's eve parties ending at dawn at the Paris Bar in the Fulton Fish Market. Al's extroverted personality took the burden of social performance off of me. Schimel's question made me realize the cost. It was becoming apparent that our problems were increasing in direct proportion to my awakening aspirations.

I decided to move out, with the understanding that we would continue to see each other. Al's sister Roberta knew someone who wanted to sublet a two-and-a half room, forty-five-a-month, second-floor apartment at 215 East 25th Street between 2nd and 3rd Avenues. I moved in with a couple of suitcases, a long plywood table that Shirley Kaplan had given me, a 6×5 foot mirror that Al had framed with two-by-fours, and Lily, the big white neutered tomcat I had picked up on Orchard Street while working at the University Settlement and carted home on the subway, moaning all the way. The guy from whom I was subletting had gone

out to Hollywood to paint portraits of the stars, leaving a double bed, a small blue round table, and a mural of a blue Islamic-like archway, which I obliterated with several coats of white paint. It didn't look like he was coming back.

Al and I had a date shortly after. He came up to the apartment and wanted to have sex. When I refused, he ripped a drawing he had given me off the wall and left. We've run into each other very amicably maybe two or three times since, once in 1988 at Ronnie Bladen's wake. The last time I saw him was when we both happened to be in Berkeley at the same time. Al came to a screening of my film, *Privilege,* at the Pacific Film Archive and to the party afterward at Belle and Ivan's house. In many ways Al gave me an entrée into New York cultural life. He was the best guide I could have wished for. May he rest in peace.

I was now cut loose, on my own.

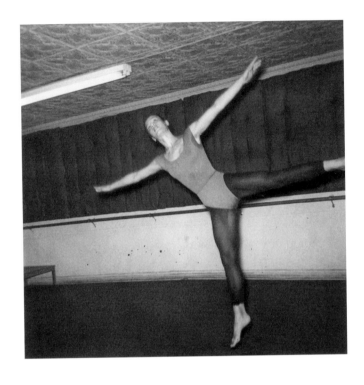

YR, 1960. Photo: Simone Forti.

9

Dance, Girl, Dance

AFTER SPLITTING UP with Al, I began writing my brother long, detailed letters about my life as a budding dancer and therapy patient. An excitement comes through in portions of them, despite my usual rationalism.

Letter to Ivan, dated Friday, July 10, 1959:

It is now 2 AM Sunday morning. The fervor that produced the first part of this letter is not going to help me with this part. I slept into early afternoon today. Got up, ate, puttered around, combed out shedding fat Lily, washed my stinking dance clothes, sat down to read a little more of Paul Gauguin's *Journals*. I've been reading this book for almost 4 months now, in little bits and pieces. In spite of my physical identification with his Tahitians and a fascinated interest in his life that dates back to my teens, this firsthand contact with his

writings and thought is very irritating. I find his arrogance offensive, the arrogance of the "self-made" man. Daddy had some of this, also Al. All 3 take pride in being primitive, strong, virile. Satisfiers of women. Debasers of women. (Too strong? Perhaps.)

Now it is Monday evening. I have just come from a semi-weekly class in Eurythmics which I am taking at the Dalcroze School of Music. It is based on the theories of Dalcroze—to enable musicians, singers, composers to respond *physically* to rhythm rather than rely on counting or a mental relation to a beat. I've always had great difficulty with rhythm, especially since I've been at the Graham School, where every movement must be performed with a strict and accurate timing. I find that I can neither feel phrasing when the accompaniment has a complex rhythmic pattern nor—strangely enough—can I count. It is very difficult for me to tell a 2-beat rhythm from a 3-beat. I think it is largely a matter of listening, especially when in the throes of fighting for balance and "rightness" in a particular movement.

Here I am chattering away, knowing that ultimately I'm going to have to deal with your "easy" questions. Like right now. Like: What does dance mean to me? There are all kinds of ideas that occur to me, each one a small piece of a total picture.

Dance =

1. A way out of an emotional dilemma.

2. A place where the training period is so long and arduous as to almost indefinitely postpone a coming to grips with things like purpose and aesthetic or vocational direction.

3. A place that offers some rare moments of "rightness" (that word again; I think it is equivalent to joy, or "fitness," i.e., things fit).

4. Something that makes my throat fill up sometimes.

5. Something to do every day.

6. A way of life, where most other things in life assume a lesser importance and value.

7. Something that offers an identity: "I am a dancer," also "I am a hard worker, I work my ass off in class in spite of being handicapped by a crazy Rainer body." The virtue of hard work, salvation through sweat, is very important here. I am sure most dancers are martyrs of one variety or another.

You ask about a connection between therapy and dance. Directly, there is none, other than that in talking about dance, as about anything else, my basic attitudes to myself and the world are revealed, and these in turn, in being changed by therapy, will naturally affect my relation to dance. This is, of course, an intellectualization of a process that I really don't feel very articulate about. All I know is that certain basic attitudes *are* being changed, or rather, with the help of the analyst, I am slowly, and at times painfully, changing them.

His name is John L. Schimel. He's a psychoanalyst. Your description of Berblinger could quite aptly fit Schimel, *except* for your word "subtleties." Schimel could hardly be called subtle—ironic, but not subtle. He hits his patient over the head with a hard, blunt instrument and then lets her stagger around in the world until the next session. This man is absolutely unindulgent, but not unsympathetic. He has no ax to grind—as Ellis did—but he at times comes out with statements that seem to be unnecessarily ironic or downright sarcastic. His technique seems to be to say whatever comes into his head; often he sounds unsure, and he never presumes to offer answers, advice, or solutions. As he says, most neurotics come for help with the hope of achieving some kind of grace (be it having their

demons exorcised or coming closer to some personal vision of perfection or whatever). He feels it's one of the analyst's jobs to try to dispel that hope. Well, you can imagine little old vulnerable Yvonne capsizing under the inscrutable gaze of this exceedingly nasty man. Until some things began to make some sense—and even sense is not quite the right word—it smells too much of intellect; it doesn't give the "sense" of a window opening a tiny slit to let some sun into a dark closet. I have already had moments of revelation, warmth, and even excitement there. I mean excitement about life and its possibilities. Mama and Daddy could never have experienced any of this or given us any inkling of it. Work, duty, and an ever-present sense of worry. You and I, we have probably worried and fretted our way through every small thing we've ever done, to say nothing of the large things. And where we haven't fretted, we felt we *should* have . . .

Now it is the next morning (Tuesday)! I went to bed so late last night that I didn't feel like getting up this morning to go to class. But I'll make it up tonight. That's one thing I need plenty of and make sure I get these days—sleep.

I guess it's about time I concluded this wordy letter. Somehow I feel very happy, Ivan. It may sound crazy—because I still have the old problems—isolation, making contact with people, confusion about closeness with people. But maybe in spite of Dr. Schimel's "nasty" dictum, I have hope—not of achieving grace so much as of being able to live with myself with some degree of comfort, and even enjoyment. Perhaps this is the "aloneness" of which you speak.

Yvonne

P.S. I have put off mailing this letter until I had an opportunity to get Belle a belated birthday gift. The Usual Thing.

In 1959, feeling that I should start exposing myself to some of the same training that was producing professional modern dancers, I enrolled in the beginning-level June Course at the Martha Graham School. As in the acting classes, I found myself an ungifted novice. I not only lacked "turn-out" but was also very unmusical, desperately following the person in front of me in order to stay on the beat. One day when Martha herself was teaching the class, she came over to me as I was struggling with a floor stretch and said "When you accept yourself as a woman, you will have turn-out." Prophetic words. Neither condition has come to pass.

It was during this period that I met Nancy Meehan, who was taking the advanced June course at the Graham School. She had grown up eight blocks from me in San Francisco and had danced with Welland Lathrop before coming to New York with the hope of joining the Graham Company. Like me, she had arrived in New York in the summer of 1956 along with an older lover (the late Warren Finnerty, an actor who would later perform with the Living Theater, most notably in *The Connection* and *The Brig*). I admired Nancy's grace and warmth. Though she was much more experienced than I, our mutual interests in dance history, theater, and Graham's artistry drew us close in the following year.

Mike Grieg came to town that summer. His friend Daniel Dewees drove us and Mike's younger brother Jimmy up to Haverstraw to a party given by Harlan McCallum, a former Limon dancer I had met through Mike in San Francisco years before. In the course of the evening Jimmy and I went up to the attic and had sex. I missed my next period, got myself tested and was pronounced pregnant. Again Roberta Held came to the rescue. She knew of a Scandinavian gynecologist on the Upper East Side who performed illegal abortions. I asked Nancy to lend me the requisite $400. At first she agreed to the loan, then later reneged. It seemed

that my situation had brought up painful material in her analysis around her having been adopted as a baby, and her strict Freudian analyst had threatened to discontinue treatment if Nancy complied with my request. Disappointed, I called Sam Francis, then went to the Chelsea Hotel, where he had a temporary studio, to collect the cash that he graciously loaned me.

I arrive for the appointed late-afternoon procedure at the doctor's ground-floor office after his last patient has left. The atmosphere is heavy with secrecy and anxiety. He gives me a local and goes to work. I squeal in pain. His aged Scandinavian nurse tries to hush me, clamps a rubber thing over my nose and mouth, and I start to inhale gas. In a panic I tear it off and hear her say, "Was your pleasure worth all this?" (In my hindsight alternative scenario I retort "Fuck you!") In mute concentration the doctor continues scraping and finishes the job. Fourteen years later, *Roe v. Wade* will save women from such indignities—like this and far worse.

I decided I was fucking around in more ways than one, that I was getting too old to be a dancer, that I had better buckle down. I wrote to my mother and asked her for $5,000 so I could study full-time without having to work, not telling her that it was also to repay Sam Francis for his loan. Five days later she sent me a check for $2,500; the rest came a month later, and in the following two years she must have sent me $10,000 in monthly installments. I could breathe easy for a while and go about my business. I had a little slack and knew I had to make the most of it. In the fall of 1959 I started studying in earnest. Three classes a day— two at the Graham School, one ballet.

ROUTINE, SEPTEMBER 1959 to May 1960: Monday through Friday, get up at 8 AM; take the IRT to 59th Street; walk over to the Graham School on East 63rd; afterward take the crosstown bus to Vim and Vigor on 57th Street for lunch; then across the street to Carnegie Hall to beginning ballet class at Ballet Arts with Lisan Kay (dressed in blue coveralls) or Lynn Golding (who listens to the World Series on a headset while teaching class), later intermediate with Nina Stroganova (impeccably coifed and garbed in pastel blue leotard, tulle skirt, pink tights and toe shoes); watch a bit of advanced class taught by Vladimir Dukadovsky, Stroganova's husband (who looks like a dashing matador); sometimes late lunch at the Automat on 57th, west of 6th Avenue or in the garden of the Museum of Modern Art; sometimes attend 2:30 PM movie in the museum (Chaplin, Keaton, Keystone Cops, Laurel and Hardy, Eisenstein, Welles, Lubitsch, Rossellini, René Clair, et al.); do a little clothes shopping at Bloomingdale's before heading for 6 PM class at the Graham School on East 63rd Street; home to meager dinner, washing of tights and leotards, to bed by midnight; weekends shop for food, take sheets to laundromat, go to 92nd Street Y or Henry Street Playhouse or Cooper Union to see modern dance concerts (Merle Marsicano, Midi Garth, Annaliese Widmann, Jose Limon, Erick Hawkins, Pauline Koner, Alwin Nikolais, James Waring, Aileen Passloff, Myra Kinch, Jean Erdmann, Katherine Litz) or sneak into City Center at intermission to see Ballanchine and Robbins ballets (*Agon* with Diana Adams and Arthur Mitchell, *Serenade* with Patricia Wilde, *The Cage* with Melissa Hayden) or go to Ballet Theater at the old Met Opera House for Tudor ballets (Nora Kaye in *Pillar of Fire*) and *Giselle* with Alicia Markova, the only person for whom I've ever waited outside a stage door. During this period I read Mailer's *Advertisements for Myself* and several of his novels, Shirer's *Rise of the Third*

Reich, Karsavina's *Theater Street,* and stand for hours in bookstores perusing photographic histories of ballet and early modern dance.

I see quite a bit of Nancy (our recent contretemps overlooked, for which she has since apologized profusely), who is also studying at Ballet Arts. On our first day with Stroganova, as we await our turn for the diagonal leap-run-run that traditionally ends the class, Nancy gleefully challenges me, "Okay, Yvonne, let's show them our stuff!" and we both fly across the space. Though our *glissade-assemblé* may be unpolished, we sure can leap with the best of these would-be Giselles. During the barre Stroganova comes over to me, straightens my head (my monocular vision, always favoring my left eye, positions my head off-center to the right), and says, "I like the way you work." She is undoubtedly referring to my concentration and not my technical finesse. I recall making dinner in my apartment for Nancy (broiled pork chops topped with peach chutney). I recall telling her over lunch on 57th Street about my childhood. With no particular affect I recount the story of being sent away—to me it is just facts—then watch with dawning anxiety as her face registers amazement and dismay. It is the first time I have had to think of my childhood as damaged. The years of therapy have not impressed on me the reality of my early life as powerfully as this expression on my friend's face.

In the summer of 1959 I rented a room for a weekend in New London, Connecticut, while attending the American Dance Festival at Connecticut College. I saw the much touted Sibyl Shearer from Chicago and was not impressed, also a work by the late Jack Moore, in which Nancy Green (then Lewis, who ten years later would become a member of the improvisation group Grand Union) stood downstage and pawed her open mouth in a Marilyn Monroe fit of feminine narcissism. Her bit was a knock-out. But it was Cunningham's stuff that blew me away. I seem

to remember seeing *Antic Meet* and *Changeling* that weekend. (The Cunningham archive states the program as *Antic Meet* and *Rune.*) What impressed me was that, although these two dances were still somewhat theme-based in a literary sense, as had characterized much previous modern dance, their combination of intellect and formal rigor was on a par with their emotional intensity and humor. Merce would continue to be a *persona non grata* to the modern dance establishment. As William Davis, just beginning to dance with Merce, wrote me in the summer of 1962:

> I can see that I will now appreciate *Rune* for the first time. Merce talks about it being such a difficult dance because the movement is so dry and has such abrupt and extreme shifts of tempo. He said he was terribly angry that summer with "those bastards at Connecticut," and he was determined to make a dance that they just couldn't look at. (!) He feels it demands so much concentration to watch because "there's nothing in it to look at but stark movement" . . . no sensuousness, no flow, no "expressionism," no psychology, etc. . . .

It was at the American Dance Festival the following year that I spent a little time with the inimitable Bob Rauschenberg—who had already designed decor and costumes for Merce and was about to become his lighting designer—and began to get the hang of his boozy charm. You either played a kind of straight man to Bob or bucked his unpredictable waves to maintain your own buoyancy. In a few years he was to become an important and beguiling figure in my life.

By the end of 1959 my attention was shifting more wholeheartedly to the Cage-Cunningham nexus. I approached Merce and Carolyn Brown at a Christmas party/benefit for WBAI and sheepishly explained that I

wanted to study with him but was still tied up at the Graham School. He looked at me with his singular wry, half-cynical, half-mischievous expression and didn't say anything. I continued my two-Graham and one-ballet daily regimen through May, and out of a feeling of incompletion took the intermediate Graham June Course, but in addition signed up for the beginning June Course in the evening at the Cunningham Studio. Within the limits of my physical structure I had become relatively competent in the rhythms and phrasing of the Graham technique, able to handle the more difficult whiplash-like combinations and no longer having to follow the person in front of me. I was pleased with my progress, but had my fill of Graham's mystique and pretensions. I was ready to move on.

HOUSED ON THE top floor of the Living Theater building on the north-east corner of 6th Avenue and 14th Street, the Cunningham studio was brand new in June 1960, and there was a feeling of excitement and an-ticipation in the air. My first classes with him seemed very quiet. *He* was so quiet and unemphatic. He just danced, and when he talked it was with a quiet earnestness that both soothed and exhilarated me. His phys-ical presence—even when involved in the most elusive material—made everything seem possible. It was truly the beginning of a zeitgeist. You just "do it," with the coordination of a pro and the innocence of an am-ateur. My early impressions of him remain: the way he danced with such

Merce Cunningham, ca. 1965

unassailable ease that made him look as though he was doing something totally ordinary. I knew I would never dance like that. The ballet part of the shapes he chose I could only parody. But that ordinariness and pleasure were accessible to me. I knew there were specific things I could copy and other things I would absorb by watching and being around him. But mostly it was that mysterious ease of his—which he may even have tried to account for when he would say, "down, down, down,—get your weight down." Now I am not really sure if he actually said that or if I *saw* it: him rooted in space, so to speak, even while in motion. I can still see him in my mind's eye sailing and wheeling and dipping and realize that it is always in the studio on 14th Street that I see him rather than in later studios or in performance. That was where I saw him best. "You must love the daily work," he would say. I loved him for saying that, for that was one prospect that thrilled me about dancing—the daily involvement that filled up the body and mind with an exhaustion and completion that left little room for anything else. Beside that exhaustion, opinion paled. And beside that sense of completion, ambition had to be especially tenacious.

Through Nancy Meehan I had met Simone Forti, then married to Robert Morris and newly arrived in New York after performing with Anna Halprin in San Francisco. Simone was taking the 1960 beginners' June Course at the Graham School. During July the three of us—Nancy, Simone, and I—rented rehearsal space at Dance Players on 6th Avenue to improvise together. One day Simone took some Polaroids. Nancy recently told me that after Bob Morris observed one of our sessions he said the best moments were when we weren't dancing. I thought he was a strange duck. At dinner in their loft on Avenue A one night Simone and I talked while he said not a word the whole evening. She seemed completely unperturbed.

191

Nancy Meehan, 1960

YR, 1960

Photos: Simone Forti.

Simone and Bob planned to return to the Bay Area in August, she to take Anna Halprin's summer workshop, he to go down to the University of Southern California to check out a filmmaking course. At that point he was a lapsed abstract expressionist painter. Intrigued by Simone's descriptions of working with Halprin, I accepted their invitation to drive across the country. We took a Greyhound bus to Bob's parents' house in Kansas City, Kansas, where he borrowed a car, and from there we set out for California. Some memorable parts are watching a distant tornado in Kansas, having lunch in a diner in a small midwestern town with everyone staring at us (Bob complaining *sotto voce* that his tuna fish

Robert Morris and Simone Forti, ca. 1957. Photo: Warner Jepson.

sandwich tasted like cat food), and riding a ski lift in the Rockies. After three days on the road—Bob doing all the driving—we pulled up at my brother's house on Alvarado Street in San Francisco. The prodigal sister was very excited to be returning. I had seen Ivan and Belle and my niece Ruth on their several short trips to New York, but I had not been back to the West Coast since leaving in 1956, nor had I seen the latest arrival, my nephew Leo. It was still important to me to impress big brother and Belle, especially Ivan, with my "progress" toward independent adulthood. My new friends and evidence of an incipient career were to be the ticket this time around.

The month in Anna Halprin's workshop in Kentfield, Marin County, was filled with stimulation and activity. Mornings were devoted to exercises on the outdoor deck, sometimes led by Anna. I was surprised at how Graham-like they were. I remember Trisha Brown spreading her legs 180 degrees and putting her belly on the floor. In the afternoon we worked on short projects and assignments involving objects, tasks, fragmented speech or vocal sounds. I remember Anna—then as now a powerful, radiating presence—running while holding a tree branch. (The deck was surrounded by beautiful red-barked madrone trees, later to be decimated by an epidemic.) Also Trisha pushing a wide brush-broom with such force her body was catapulted horizontally into the air. For one week composer La Monte Young conducted explorations of John Cage's scores and vocal and nonvocal sound production. I made a score for three performers titled "Sonata for Screen Door, Flashlight, and Dancer." The squeaky screen door to the indoor studio beside the deck was the source of sound. Someone else created a mélange of sound while sawing through a milk carton. Each evening of free improvisation was my favorite part of the day. I ran amok, that is, until the end of the first week when I slipped on the deck and seriously sprained my ankle. Thereafter

194

YR and niece Ruth at Half Moon Bay, 1960

Ruth and Leo, 1961

my activities were severely curtailed, although I continued to participate by making pieces that did not require me to move about. I performed something with vocal sounds while pulling objects one-at-a-time from my bag, including a tampon in its paper wrapping. Trisha recalls being shocked at the exposure of this unspeakable object. Remember, we were barely out of the 1950s. Other participants who went on to forge careers in choreography, teaching, and healing arts were Ruth Emerson, June Ekman, A. A. Leath, John Graham, and, of course, Simone.

On returning to New York I continued with ballet and Cunningham and got involved with Robert Dunn's composition workshop. Dunn, a musician and follower of John Cage who often provided piano accompaniment for classes, had been persuaded by John to offer this weekly course in the Cunningham studio. There were very few of us at the beginning: Steve Paxton, Marni Mahaffey, Paul Berenson, Simone, and I. Bob spent a lot of time showing us and explicating the chance scores used by John Cage for his *Fontana Mix* and other pieces and analyzing the time structure of Satie's *Trois Gymnopédies.* The idea was that we might be interested in combining them in some way. In the studio on Great Jones Street that I shared with Simone and Bob Morris, I worked on the movement phrases I would use in *Three Satie Spoons,* my particular resolution of Dunn's assignment. I also rehearsed with Simone and Bob Morris on her *See Saw,* which she was about to show at the Reuben Gallery. Around this time I saw Simone do an improvisation in our studio that affected me deeply. She scattered bits and pieces of rags and wood around the floor, landscape-like. Then she simply sat in one place for a while, occasionally changed her position or moved to another place. I don't know what her intent was, but for me what she did brought the god-like image of the dancer down to human scale more effectively than anything I had seen. It was a beautiful alternative to the heroic posturing

that I felt continued to dominate my dance training. (At the Graham School I had been told to become more "regal" and less athletic!)

The Reuben Gallery storefront on East 2nd Street was used by artists Claes Oldenburg, Jim Dine, Robert Whitman, and Allan Kaprow, all of whom wanted to escape the constraints of static gallery installation and explore a time-based medium. Simone had been invited to present two works at their Christmas show of 1960. Her *See Saw* was on a program with *Rollers* (in which she and La Monte Young caromed and were pulled around in two go-carts) and Jim Dine's *Shining Bed* (Dine lay on a bed and wiped dough along its metal posts). In *See Saw* Bob Morris and I began by sitting at either end of the crude wooden seesaw, then executed mildly athletic moves like walking along it and balancing while making tiny, almost imperceptible shifts in weight. The piece had a climax, the outcome in rehearsal of Simone's throwing a jacket on the floor and ordering me to "Perform that!" at which I had a screaming fit on my end of the seesaw (don't ask why) while Bob read an art magazine to himself at his end. It was the precursor of another screaming fit two years later in a solo dance of my own, *Three Seascapes*. George Sugarman, after seeing Simone's piece, exclaimed enthusiastically, "It's like a Chekhov play!" (The screaming/reading climax now reminds me of the night in Chicago with John Bottomley drunkenly thrashing while I sat in quiet detachment.) One of the most compelling evenings I witnessed at the Reuben Gallery was Jim Dine's *Car Crash,* in which, as a spectral figure in gleaming gray makeup and cloak, he wrote on a blackboard and Patty Oldenburg sat on a high stool intoning catastrophic phrases describing auto accidents.

Yoko Ono's Chambers Street loft was another site of weekly activity during the 1960–61 season. Every Friday evening I climbed to the fifth floor space to see, but mostly to hear, avant-garde composers like La

Monte Young, Henry Flynt, Terry Riley, and pianist David Tudor. I remember Henry Flynt plucking a rubber band next to his own ear and David Tudor crawling around the perimeter of a grand piano while rubbing a window squeegee along its sides. The grand piano was the bête noir of the avant-garde, fair game for all kinds of abusive tactics, initiated by Cage's own "preparations" via paper clips, rubber bands, and other paraphernalia distributed on its harp to create alternative timbres and pitches. When I first heard the expression "prepared piano," I was perplexed. "Prepared for what?" Now it is clear that Cage was "preparing" the way for more violent assaults on the integrity of the classical instrument. There was the young Cage disciple in Sweden who gashed his leg in the process of cutting into a grand piano with an electric circular saw. Another classical victim was the violin, which Nam June Paik massacred in a performance at the Cafe au Go Go around 1964. The worst atrocity—perhaps apocryphal—was that perpetrated by artist Ralph Ortiz, who achieved avant-garde immortality by smashing a live chicken to death against the grand's eviscerated innards. All of these shenanigans foreshadowed the antics of 1970s' rock groups such as The Who, who destroyed their instruments on stage, and also those of performance artists who would still later inflict bodily insult, even damage, on themselves.

The final evening at Yoko's loft was announced as "an event" by Robert Morris. George Sugarman and I traipsed downtown and up the five flights expecting some kind of performance, only to be met, on opening the door, by a three-foot wide curving corridor with seven-foot high ceiling that ended in a pointed cul-de-sac. I was so outraged that I wrote on the wall "Fuck you too, Bob Morris."

At the Hallelujah Gardens, choreographed by James Waring, 1961, Hunter
College Playhouse, February 1963. YR's costume by Al Hansen. YR, Arlene
Rothlien, Diane Munser, and James Waring. Photo by Peter Moore.
© Estate of Peter Moore/VAGA, NY, NY.

10

The Real Deal

I NOW COME to August 25, 1961, and a 4000-word letter I wrote to my brother and sister-in-law about what I had been up to. Its irreverence and details offer a far more trenchant account than were I to reconstruct the period from memory. So here it is—with my bracketed italicizes annotations:

Ivan & Belle:

The immediate reason behind my beginning this letter—sitting me down at 1:00 AM Sat. morning—is that the letter I received from Mama today made me realize that her letters are getting briefer and more cryptic all the time—not only do I get no clear news of her condition, but I hear next to nothing about you folks. The solution is obvious.

First off—about Mama: Quote from her last letter:

My spirits are at a rather low ebb this morning due to the departure to Los Angeles of a very dear friend, but now the sun is out bright & clear & a trip to the flower show in Golden Gate Park will revive me. With usual love & best wishes,

Affectionately, Ma

This completed exactly half a page. Really—how is the old lady & who is the "very dear friend"? *["The old lady" was 64 years old. The YR of this letter was 26. The old lady of this italicized annotation is 69.]* The little I can glean about her reactions to my activities has made

At the Hallelujah Gardens, choreographed by James Waring, 1961. YR, Valda Setterfield. Photo by Peter Moore. © Estate of Peter Moore/VAGA, NY, NY.

Ordinary Dance, KQED, San Francisco, August 1962. Photo: Warner Jepson.

201

me a bit sad—for instance: she "cried with joy" when she heard about the Montreal deal [The Montreal Arts Festival, during which I danced with the James Waring Company]. There is a tone almost of incredulity in her letters (despite my best efforts not to inflate each piece of news beyond what the facts warrant)—as if she could not believe that such "miracles" could happen so close to her. Evidently she is having some kind of difficulty adjusting to the nature of my profession—witness the eerie news clipping that showed up in one letter—concerning the Bay Area dancer who committed suicide in Manila. I know that she was trying to say, "Don't overwork yourself and get depressed like that dancer. It's not worth it." But it is a pretty scathing message to a daughter who is having a ball. Let that be a caution to you, Yvonne! Don't take sleeping pills to Manila! Poor Mama. I have had cause to think quite a lot about her lately—how out of touch with life she has been & how much she has missed.

I suppose it is time I told you just what pastures I am feeding in these days and what horses I am trotting with. The recent events that you are familiar with came about through my association with a strange piece of fruit named Jimmy Waring. As I explained in a letter to Mama—sometime last winter I decided that it was about time that I get involved in dancing in someone's company. It didn't matter whose company it was; it was the experience that mattered. But it happened that I had just seen a concert of a young dancer (about 30) named Aileen Passloff and was very impressed.

[It was a solo, performed at the Living Theater, that really knocked me out. It was called Tea at the Palaz of Hoon. Passloff wore a red velvet dress with a bustle; sat in a throne-like chair; outlined her own features, breasts and nipples with a pencil; kind of 'bumped' around the chair;

202

and did other things that I don't remember. It was very female, funny, robust, and stylish. She also stuck the pencil in her mouth and chattered her teeth.]

In fact, I first saw the concert, then decided that I should be performing. I know the girl's older sister, Pat, who is a painter. So I made a point of going to Pat's opening at the Green Gallery (where Ronnie [Bladen] had a show in May) in order to meet Aileen. Introduced myself, described my background, (lack of) experience, etc. She seemed interested; the question came up about where she could see me dance; she finally suggested that I try James Waring's classes because she would be there on certain days and also Jimmy Waring taught a good ballet class. So I started studying twice a week with Jimmy Waring.

Jimmy Waring is an underground, underdog modern dancer. He is about 40, has worked in the mail room of Time-Life for the last 10 years, somehow manages to put together a concert every year, which is invariably panned by every critic on the scene. He has been dancing since about 1939, studied with Ann Halprin and Welland Lathrop, danced with the SF Ballet. (He was born in Oakland.) After the war he came to NY & became one of the most ardent followers of Merce Cunningham & John Cage, after whom he models his work, not entirely consciously.

Here it is, Thurs., Aug. 31st. Have just purchased a new ballpoint refill. Maybe you'll get this letter before Christmas.

As it turned out (beginning 2nd installment "Y. Rainer: dancer in NY") Aileen Passloff never showed up to take Jimmy's classes. But I did, and quite regularly. I found I was learning a lot from his dry, rigorous balletic approach to dance. Before and during this period I was involved with Simone's stuff—*See Saw* at the Reuben Gallery in

December and her marvelous evening of "stuff" at the Chambers St. loft last May—the latter the last concert in a series, mostly music, organized by La Monte Young (remember old La Monte, the "butterfly composer"?) [*The instruction for one of his compositions was "Turn a butterfly (or any number of butterflies) loose in the performance area."*] and Yoko Ono, a Japanese surrealist poetess and painter who owned the loft. (More about her later.) Was also taking a composition course with a fellow named Robert Dunn, a musician, follower of Cage, husband of one of the dancers [*Judith Dunn*] in Merce Cunningham's company. What proved to be the main virtue of that course—so far as I was concerned—was that Bob Dunn was not equipped or inclined to explore movement content; his sole interest was structure, how to put dances together from related or unrelated fragments of material. So all he did was present various examples of chance operations: mostly chance-derived scores created by John Cage, which could be adapted to dance. I don't know how familiar you are with all this—but no matter. The point is that I was free to discover my own movement tendencies, and after several unsatisfactory efforts I began to realize a kind of direction—and—using the chance devices— a kind of rhythm. So I finally came up with 2 solos. There is a lot of gesture in my stuff—also sounds and sentences—not necessarily related to the movements that accompany them. I imagine what comes across is incongruity, bizarre—maybe odd or eccentric—although I make no conscious attempts at humor. My image sometimes takes the form of a disoriented body in which one part doesn't know what the other part is doing. Examples: A movement in which my head looks at my moving feet, or my gaze follows the upward traveling of wiggling fingers; facing the audience, I walk slowly on half-toe while my fingers twiddle in front of my eyes and I say "I told you

everything would be all right, Harry"; or in the middle of a long continuous phrase, I stop in a very convoluted posture, head upside down, and say "the grass is greener when the sun is yellower."

But to continue the chronology: In Jan. I performed the *Three Satie Spoons* in a *[Cunningham]* studio demonstration involving the other members of Bob Dunn's class. It was on the whole a refreshing collection of work. The best things in it were my solo and a cooperative trio created by Simone, a girl named Ruth Allphon, and myself. The trio was called "Stove Pack Opus" and was really delightful— there is a section in it where we are all off stage barking like dogs. Alas! It is lost to posterity, as Ruth Allphon, a beautiful unstable mulatto girl, has since fled to Calif. *[eventually marrying Chaim, my old chum from Hashomer Hatzair]* and Simone never liked the dance and has all but given up dancing altogether. More of Simone later.

Then along in May I get a call from Jimmy Waring. He wants to speak to me about something important. It turned out to be an invitation to dance in a new work of his to be choreographed for the Montreal Arts Festival. It seems that his regular company was dispersing for the summer, and he was taking whomever he could get. It is still a mystery to me that he asked *me—*

[Jimmy had an amazing gift which—because I was put off by the mixture of camp and balleticism in his work—I didn't appreciate until much later. His company was always full of misfits. They were too short or too fat or too uncoordinated or too mannered or too inexperienced by any other standards. He had this gift of choosing people who "couldn't do too much" in conventional technical terms but who, under his subtle directorial manipulations, revealed spectacular stage personalities. He could pull the silk purse out of the sow's ear.]

—he had never seen me dance except in class, he hadn't even seen the Dunn performance. It is especially mystifying that he asked me to perform work at the Living Theater that he had never seen. He does seem to like me, also my work. I learned a helluva lot from this guy. I started rehearsing with him completely ignorant about working with other people, and secretly harboring the notion that I would never be able to dance in any professional-type company because my technique would never be proficient enough.

I soon enough realized that I was not only able to handle most of the stuff he wanted me to do, but could dance it well. He was actually giving me material that—within the limitations of his particular idea of dance—in some way brought out my own peculiar nature & feeling about dance. In other words, I was able to bring my own personality into play in carrying out his ideas. I think this is one of the secrets of any halfway decent choreography. Somehow the situation—being accepted as a dancer, being accepted as a creative person, being accepted as a likable person—brought out the best in me, and I responded with high good humor and appreciation. It is probably the first time in my life that I have both enjoyed myself and been able to *be* myself in a situation involving people whom I did not completely believe in—and by that I mean people who I didn't think were the "greatest." So I ended up being quite fond of all of them—even the impossibly narcissistic queen faggot named David Gordon,

206

[who shortly thereafter married Valda Setterfield. The above pejorative says more about me than about David. Forgive me, David, for my homophobia. Not to excuse myself, I must point out that this kind of smug stigmatizing was part of many people's baggage in those years (it may even have been yours on occasion). The distance we have come

from the casual sexual bigotry of that period is nowhere more apparent than in the situation of gays in the early 1960s dance world. Though we were in daily contact in our classes and rehearsals with the sensibility, presence, and subcultural campiness of gay men (the women's sexual preferences were far more ambiguous), sexual identity, because it was an unknown or forbidden concept, could be dealt with in mixed gendered settings only in the most oblique fashion. My soon-to-be colleagues Steve Paxton and Robert Rauschenberg were openly living together, but their public behavior was either asexual or at times a heterosexual charade. Granted, some of my colleagues were bisexual. This does not account for the public suppression of homophile desire and attraction that was de rigueur at that time.]

a serious young dancer named Bill Davis and a NY City ballerina-turned-actress named Ruth Sobotka (once married to Stanley Kubrick, the *Paths of Glory* director).

About the dance itself: It is called *Dromenon, a Dance for Music, Lights, and Dancers*. I have come to appreciate Jimmy Waring as a good craftsman, if nothing else. Even though his range of movement is unoriginal—mostly balletic variations with a few Merce Cunningham torso effects and some nondance gestures thrown in—he knows how to put things together, how to weave and overlap solos, duets, trios, and large unison fragments into a constantly moving whole—no mean feat. The piece is 25 or 26 minutes long, has a score for tape & live instrumentalists by Richard Maxfield, a well-known electronic composer in this area. The only relation between score & dance is duration; in fact we didn't even hear the music until the rehearsal that immediately preceded the performance. I found it expedient to ignore the music while performing. This arrangement seems to be

common among the "avant-garde" these days. I can't say that I find it an interesting one.

The very best thing this summer, however, was the July 31st evening at the Living Theater. I suppose you read my last letter to Mama in which I described all my "symptoms" preceding the performance. I literally shat out my guts for a solid week in sheer panic, went around with dripping armpits (not from the heat) and bottomless stomach and choked gorge. The people I worked with were great: Nicola Cernovich—the lighting man—a real pro, the best dance lighter in the business; also Aileen Passloff, who performed on the same program. Several hours before the performance I went over to her house where I met a friend of hers—formerly with N.Y. City Ballet. This gal, Joanna Vischer, spent a whole hour making up my face & explaining the whys & wherefores of stage makeup as she went along. She did a beautiful job.

I find myself running on at the mouth inordinately. It may not seem so to you—I know you are interested in my life here. But I have been sitting with this letter off and on for a week now, and each session entails a great deal of sitting without writing, a great deal of rambling reflection, picturing you people 3,000 miles away, wondering at where I have been and what I have come to, getting up to refuel at the refrigerator-altar, coming back and sitting, listening to the roughnecks outside abusing the street with beer bottles and garbage-can lids. Here I am, and I want to convey to you what it means to be here (that is why I write so rarely: To convey "what it means to be here" somehow requires pages & pages of script and hours & hours of sitting in this rickety cane chair)—but when I find myself getting bogged down with perambulatory details—as in the above paragraph—I get restless and irritated. I get up and pour a glass of beer. It has been in

the 90s for the past week. The beer is already oozing from my pores. I can pick out each droplet on my bare arms. They are bigger on my left arm. I am wearing your brown & white print Chinese cotton dress, Belle. It sticks to my damp neck. There is a minute insect hopping about the *Sunday Times* scattered on the table. It is a dry sound. It must be after 2 AM Saturday night. The street is suddenly quiet.

I try to imagine the sounds outside your house on a Saturday night—the muffled thickness of fog, the darkness, the street lamps, the dark sleeping houses where you know everyone is sleeping. Here there is a raucous retching—a man is vomiting outside my window. There is a sudden outburst of loud voices across the street. Very brief, but when you go to the window you see heads poking out of open dark windows all the way down the block. The shouting dies down. The people remain at the windows. A drunk staggers down some steps across the street. Goes to the curb between two parked cars, rummages for what seems a whole minute in the depths of his trousers, finally finds what he is looking for and begins to pee, holding himself upright between the cars. The heads at the windows titter, louder and louder, shrieks, catcalls. The drunk looks up, bemused, unperturbed, remains stolidly in this stance. Finally assembles himself, zips his fly, and staggers up another flight of stairs and into a building several doors away from the one he had emerged from. The heads gradually disappear. The bomb will remove this street also.

But now I'm getting literary. Ooshy-gooshy. There! No more of that.

Prior to the digression, I had been leading up to what it felt like that night on the stage of the Living Theater. It felt like nothing that I had ever experienced before. It is difficult to find the right words for it—the sense of calm mixed with expectancy as I paced around

backstage while waiting to go on, the standing in place on-stage finally, watching through the transparent scrim as the house lights dim off, the brief moment of darkness as the scrim opens. I have one bad moment of absolute dread—my heart is like an inert stone, a feeling of paralysis. Then the stage lights fade up; I face them, a vague sea of spectacles—the lights protect me—I feel life and energy flowing back. My music begins and I am transported into a very special world. I felt beautiful, confident, knowing, proud, completely carried away by the magic of my own gestures and movements. And best of all my technique did not betray me; I could depend on it. Certain balances that repeatedly gave me trouble in rehearsal were no trouble at all in performance. I had complete control.

Dear Belle & Ivan, I want you to know what a triumph it was for me—aside from the praise of friends and professional acquaintances. When I was 15 or 16 I used to go alone to the Curran or Geary to see various dance events. I remember one moment from a Cocteau ballet performed by what must have been a Parisian ballet troupe, possibly the Paris Opera Ballet (I know I saw Jean Babilée) *[Roland Petit's Ballet de Paris; Le Jeune Homme et La Mort with Jean Babilée and Zizi Jeanmaire]*. A girl in yellow shoes was slowly revolving, unaided, on one straight leg, foot flat on the floor, other leg extended straight out behind her. It took her an eternity to get around in a maneuver that I have since done many times in ballet classes. It is called a "promenade." The body is held rigid, the only moving agent is the foot. It requires phenomenal control to do it slowly without faltering and wavering like a tree in a breeze.

I sat there in a stupor—awed, hypnotized by that girl. I was in the first row of the balcony. I might just as well have been watching her on Mars through the wrong end of a telescope. It never entered my head—

even in fantasy!—that I might be that girl, so closed was my imagination and so ignorant was I of possibilities—in myself & in the world.

To me that dancer was an a priori phenomenon, if I thought about it at all. There she was, a complete entity, no history, no sweat, no tears. She hadn't arrived there; she simply *was* there—not by dint of education, work, experience, but because she was *there*. As I was *here* in my seat and always would be *here*. I couldn't even phrase it as "I will never be *there*" because "never being there" admits of the possibility of "getting there," and it was not within my consciousness that such a thing existed.

No wonder I quit school and flopped around for so many years. I was not afraid of failure; I was simply behaving on the assumption of my irrefutable place in life—uncontested, unassailable "here I am nowhere" & "there they are somewhere"—a state of being that miraculously bypasses the whole question of success and failure, achievement, satisfaction, even pleasure.

Believe me, I am not trying to push some high-powered version of the American success story with its "everything and anything is possible in this happy land" overtones. I am just trying to say that so many more things are possible than I was ever brought up even to suspect that I find myself amazed and appalled whenever I think of my suppressed childhood and adolescence. Yes, I am somewhat obsessed, but obsessed with the wonder of living. Having come so late to see the possibilities of thought and action, I will not soon settle down to taking these things for granted, as "normal" people do. Hardly a day goes by but in some form or other I am overwhelmed with the realization of being one of the really privileged of this earth. And I suspect along with this goes a great responsibility, but I will have to think about all this more fully.

Have just come from a visit with friend Nancy Meehan. She and friends of hers are talking about getting out of NY while the getting's good, that we'll be at war by December. I have had several dreams lately about bombs and nuclear holocausts, but then I have peculiar dreams at times (a series several years ago concerned vast military operations). It is hard to know what to do. Do you join SANE? Organize the Puerto Ricans on your block to protest the resumption of tests? Or continue to live your life in NY until the sirens blow? The last seems to be what I am doing & will continue to do even though reading the newspapers these days is like looking at a well-made horror movie called *Can You Top This?* Talking to the man in the street here is fantastic: I got involved in a conversation with 3 women while waiting on line outside the Met box office for tickets to the Kirov Ballet. One woman spoke of the coming of the bomb as coolly and matter-of-factly as a religious fanatic might speak of the coming of the messiah. Another made heavy-handed jokes about bomb shelters. (Come to think of it, a bomb shelter is a sort of demoniac joke at this time.) Evidently nuclear war is neither imminent nor real for most people. I can't say it is even for me in spite of slight indigestion over the newspapers. An American diplomat at a London soirée is supposed to have caused a furor that was quickly hushed up when he coolly asserted that we would be at war by December. No, it is idle gossip. My life has in a sense just begun—a self-involved life, perhaps even a selfish one, but I am not ready to give it up, even for President Kennedy.

[At first reading I thought the above was a reference to the Cuban Missile Crisis, but on further research I realized that on August 25, 1961, the date of this letter, I was talking about the construction of the Berlin Wall on

August 13, which effectively sealed off West Berlin from the rest of Germany. The Cuban Missile Crisis, an event which has left a stronger stamp on my Cold War memory bank, occurred the following year.]

A funny thing: Just before I received your last letter, Ivan, I had stopped going to Schimel, for a number of reasons. The main one was that I was very involved in making dances at the time, and I couldn't see how he could help me or I could help myself through him in this area, especially after he told me one day that my dancing "denied humanity." In essence I reacted with "Fuck you, Jack," told him I was tired of his disparaging remarks and that I thought I had gone as far as I could go with the analysis bit, and left—with his blessing. It was exactly two years. Six months later I went hurtling back when certain "demons" began to rear their ugly heads. One demon is called "Obnoxia." Schimel once described to me a patient who—when partway through her analysis—said "I'm no longer neurotic, just obnoxious." I was running into tendencies to devour or trample people weaker, more insecure, or stupid than I. Someone told me that I don't have much sympathy for people, and I must admit there is some truth in this. Old Yvonne, after being stripped of her sainthood-striving, love-aspiring, humbler-than-thou pretensions, is just as obnoxious as the next fellow. From "here I am nowhere" to "here I am somewhere" to "man, you're there nowhere, so beat it" is a logical development in the analytic gambit, but where do I go from here? I'm not sure. I've had some great sessions this summer and seem to have a lot of nastiness under control, though controlling it is probably not the point.

I realize I haven't said much about people and have said nothing about men, love, etc. (This is turning into a real compulsive

missile: I have to say *everything* about *everything*.) It's a sort of touchy subject because lately my relations with the opposite sex have been sporadic and inconsequential. Not that I'm looking for a husband—god forbid!—Just something either exciting or "substantial." The affair with the assistant DA, Richard U., turned out to be both, and the fact that it fizzled out can be attributed simply to his being a certain kind of man and my insistence on being a certain kind of female.

[Richard U. was another figure that entered my life in the summer of 1960. (Dr. Schimel's response: "I thought you'd be the last person to get involved with a member of the bourgeoisie.") He had prosecuted a Puerto Rican man, who lived in the building next door to mine and had been charged with assault and battery against my downstairs lesbian neighbor. I have fictionalized this episode, also the ensuing love affair with the D.A., in Privilege, *a 1990 film.]*

Richard is an extremely urbane, competent, well-bred, and well-educated (Harvard) man, paints in his spare time, plays the cello, and pursues women with more gusto than anyone I've ever met. Also appreciates women the way a gourmet appreciates wine and food. Let's say he is a gourmet of all 3. His only failing (in the sphere of womankind) is that his taste is exacting and ultimately limited, for although he seems to be able to enjoy many kinds of women (I'm using his point of view now), he has a very set image of the gal qualified to share his life, and so unconsciously brings this to bear on his relationships. At least he did with me. I guess some people would call him "square." I still see him occasionally, but as far as I'm concerned, there is nothing left to learn or discover from it. I still like him and can at times have fun with him, but there is this insurmountable barrier between us: To him I will always be a lovable nut, a strange fe-

214

male more interested in dancing than finding a husband & making babies. The description is somewhat misleading, implying that to be *more* interested in one is to be *un*interested in the other. Anyway, I'm a nut: You people think so too, don't you?

(Jenny [voice-over]):
To Robert I must have represented some kind of kooky Bohemian plaything. He was still sowing his wild oats and fancying himself an occasional artiste. He had an easel set up in his duplex with a permanently unfinished oil painting on it. We did things I've never done before or since. He took me to a charity ball at the Waldorf Astoria in his mother's mink stole after picking out a ball gown for me. Such *haute bourgeoisie* shenanigans made me ignore things that have since come back to haunt me. (*Privilege*, 16mm, 1990)

[Both the preceding accounts elide a crucial aspect of the affair: that it was Richard who called the whole thing off, precipitating fantasies of suicide on my part. I sat on the edge of my bed for an hour holding a carving knife to my wrist.]

Yet the thing with Richard was one of the most instructive and exciting affairs of my life. In your last letter, Ivan, you say, "I don't know why I can't help sounding like I'm putting him down." Well, goddamn you, you miserable priggish son of a bitch, *I* know. Your head is so chock-full of stereotypes of good guys and bad guys that you respond like Pavlov's dog or like a mindless well-oiled machine when you hear a particular word: like D.A.—bad! Banker—bad! Stockbroker—bad! Probation officer—bad! Anyone who's part of that mythical bugaboo of the anarchists—THE SYSTEM! Right? Especially someone with a little authority. Bank *clerk*, legal secretary, errand boy on the stock

exchange—not so bad! Well, brother, you may not be a *part* of the system, but you certainly are a *slave* to it, devoting your energies to *beating* it and *evading* it. And in the long run you end up as much a part of it as anyone else.

I suspect that I am involuntarily underrating your intelligence and that I may be out in left field somewhere. But you asked for it, Ivan: Your sanctimony is really insufferable sometimes.

If there is one thing I've learned in analysis, it is to appreciate the infinite diversity of human life and that to remove oneself from any segment of that diversity or to avoid experience with it is tantamount to amputating an arm or leg. I started out as a cripple, Ivan, but I'll be damned if I end up as one. *Now* who's being sanctimonious? Your turn, brother.

Now you know what I mean by obnoxiousness. (This is not an apology, just more of that tedious self-analysis.) . . .

Now it is Tues. Sept. 5 *[1961]*—still 95°. This letter must end! But first a few words about non-I people. Simone *[Forti]* and Bob *[Morris]*—through some private masochistic quirk—took summer jobs as dance and crafts teachers in a Vermont camp. Halfway through poor Simone came down with pneumonia, spent 10 days in a hospital. They're back in town, Simone still shaky, but recovered, and somewhat depressed. As early as last winter she was expressing disgust with dance, though nothing seemed to be at hand to claim her lively imagination, except for her evening at Chambers St., a very brief interlude. She has big problems, one of the most creative and imaginative people I know but also destructive. Somehow she keeps cutting off her "life lines" to things. She no sooner experiences a glimmer of satisfaction then she must squelch it and go thrashing about again, bitching, shitting on people, and then finally coming up with some

beautiful revolt-laden idea that actually works—for awhile. She refreshes and enlarges the experience of everyone she has contact with, but then she is gone—leaving, as someone in SF put it, "a troubled wake." I am indebted to Simone for my awakening as a dancer. I can say that my creative life as a dancer began when I met her, shortly before our trip west last year. But it is my good fortune to be an acquisitive, plodding, stubborn, steadfast sort of person. Like an idiot mule I stand at the barre everyday and do what I am told. I slowly enlarge my technique, hoarding each new-found bit of progress like a rare gem. I ape everybody; I am a human garbage dump—the garbage being bits and pieces of movement seen and relished everyday of my life. I have faith in my garbage-disposal system. Everything that goes in, no matter how second-rate, will someday emerge in a personal, perhaps even original, form. So far, in my few efforts at choreography, this has proved to be so.

Simone will have none of this nonsense. She has no patience with technique-building, with the daily drudgery of the dancer. She demands of herself that all movement have an immediate and highly personal and unique character, and she resents having to adapt to the movement directions of anyone else, even for the duration of a class. Strong head, that one. But I wonder how far one can go without somewhere along the line yielding to discipline, joyously. But then there is the question "Must one go far?" Maybe not "far," but "somewhere."

I see Ronnie now and then. He says he is saving his money to return to SF next year for at least several months. I have great love for Ronnie, but there is great distance between us these days. Nothing is really said, but enough gets understood: In Ronnie's eyes I am aggressive and ambitious, and to me, Ronnie is sorrowful and despairing. I

am obnoxious; he is pathetic, a beautiful angel who never learned to fly and never learned to live an earthbound existence.

[For a short time in 1961 Ronald Bladen and I took up where we had left off in San Francisco in 1955. My assessment above is a little off. It's true that Ronnie felt embarrassed before his friends by my being so busy with rehearsals and classes. It's also true that the "pathetic, beautiful angel" was himself a very ambitious artist, as his subsequent work and career would prove. Both of us saw ambition as a character flaw; the onus was especially heavy on me as a woman, which forced me into a kind of dissembling.]

And you, my dear dollinks? How are the fantastic children? (I have to take Mama's word for Leo's uniqueness, as I never got to know him very well.) I sometimes miss Ruth acutely. You see, I know no children here. I hardly think of her as a child—more as a good friend or wonderful mensche.

I wish you an early happy 31st birthday, Ivan, and I want you to write to me and wish me an early happy 27th (good god!) birthday. You said you used to feel that time was running out on you. It certainly is running *somewhere*.

And happy _____ birthday to you, Belle. (You must really be ancient. *[She was 39.]*

Say hello to Mel and Sally for me. I still can't believe that postcard came from Mel in Pago Pago. It must be one of his heavy variety of joke. A weekend in Pago Pago? *The Examiner* goes to a Pago Pago Party? Naaaa-a-a-a . . . Y.

P.S. Good Christ—I'm nearly forgetting to tell you about my future "prospects." Jimmy Waring is planning a big concert for January. He'll do the Montreal piece ("Dromenon") plus another big epic in-

218

volving 12 people, including little old me *[at the Hallelujah Gardens]*.
He is also talking about applying for a $75,000 grant to finance a big
2-week modern dance season, many dancers, at a decent theater.

The other event is a Carnegie Recital Hall concert of Yoko Ono,
the beautiful Japanese screwball (the thought of sending the word
"screwball" 3,000 miles across the continent strangely titillates me)
I referred to earlier (many days ago). She does what might be called
"theater pieces," a conglomeration of her own poetry, improvised
instrumental and vocal sounds, and various kinds of decor. This
time she wants me to work out some dance movement. It might be
interesting.

This is now really the end. I send my tenderest regards to all
of you.

Yvonne

The New York cultural events in the following years have been am-
ply documented in the writings of Jill Johnston, Michael Kirby, dance
historian Sally Banes, and others, also more subjectively in my own out-
of-print volume, *Work 1961-73*. I have copiously borrowed from the lat-
ter for the following account:

In the fall of 1961 I started sharing a new studio with Jimmy and
Aileen above the old St. Mark's Theater on 2nd Avenue, and Bob Dunn's
workshop started up again with more people. There was so much going
on that year that it is hard to sort it all out. The Dunn workshop pro-
duced a huge amount of work, much investigation into chance proce-
dures—I remember Elaine Summers's numbered styrofoam blocks; Steve
Paxton's diagrammed ball, which he spun and stopped with his index

finger; Trisha Brown's dice; Steve's preoccupation with eating. The emphasis on aleatory composition reached ridiculous proportions sometimes. The element of chance didn't ensure that a work was good or interesting, yet I felt that the tenor of the discussions often supported this notion. I don't think this was at all an issue for Bob Dunn, who was happy to see so much activity loosed by whatever means. He seemed as interested in how something was presented as by what method it was made. And, of course, the Cagean idea that chance offered an alternative to the masterpiece was operating very strongly. In retrospect this must have secretly galled me, as I continued (secretly) to aspire to making

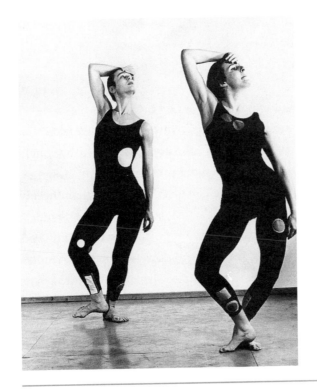

Studio photo of *Satie for Two*, ca. 1962. Trisha Brown and YR

"masterpieces." I completed *Satie for Two,* a duet for Trisha and myself, the last time I would use a formal chance score (again an adaptation of *Fontana Mix*).

In January 1962 I shared a concert with Fred Herko at the Maidman Playhouse on West 42nd Street. My half included my first three solos plus *Satie for Two* and *Grass,* a duet with Dariusz Hochman, a Polish-born ballet-trained dancer. Freddie presented a Waring-like half-hour mélange for a large group. Fred Herko was an extremely gifted dancer. Trained in ballet, he performed in Broadway musicals, with Jimmy Waring, and in some of Warhol's early films. He also taught a ballet class, which I took, in the studio on 2nd Avenue that I shared with Jimmy and Aileen. Perhaps everything was too easy for him. By 1964 he had burned himself out on amphetamines and under the influence jumped out of a window to his death. For years I thought of Freddie each time I executed a particular leg warm-up during my daily barre workout.

It says something about my stamina in those days that I performed all five dances on the Maidman program under the duress of a fever, having been in bed for the preceding five days with the flu. Later Bill Davis told me that for the next week he laughed out loud whenever he thought of the finale of my solo, *Three Seascapes,* with its maniacal screaming and thrashing, the last thing one would have expected of a modern dancer in those decorous times. All of the dances at the Maidman, both Freddie's and mine, received devastating reviews.

By the late spring the Dunn workshop knew it had more than enough work for a concert. A number of us—Trisha, Ruth Emerson, Steve, and I—had auditioned for the annual "Young Choreographers" concert at the 92nd Street Y M H A before judges Jack Moore, Marian Scott, and several others. All of us were rejected. (In the 1970s, as I was watching a dress rehearsal of Nancy Green's rendition of my *Three Satie Spoons,*

which I had taught her, Jack Moore, who was sitting behind me, leaned over and very graciously whispered in my ear, "We were wrong.") I had seen plays presented by the Judson Poet's Theater upstairs in the choir loft of Judson Church—*The Great American Desert* by Joel Oppenheimer and Apollinaire's *Breasts of Tiresias*. So I suggested that we look into the possibility of a concert in the sanctuary. Steve made the contact with Al Carmines, one of the ministers, and set up a date for an informal audition. We actually presented him with a mini-concert: I did *Three Satie Spoons*, Ruth Emerson performed *Giraffe*, and Steve performed *Transit*, in which he executed ballet combinations and then "marked" them. Al seemed pleased, and we agreed on July 6th as the date for our first *Concert of Dance*. Al would later say that he didn't understand what he was looking at, but sensed it was important.

Howard Moody was the radical director/minister of Judson Memorial Church in the 60s. A former marine with a crew cut and twinkly eyes, he made the church into a social and cultural magnet. During his tenure it became more than a haven for experimental art and theater events. Besides running a gallery on Thompson Street that showed work by Robert Whitman, Claes Oldenburg, Allan Kaprow, and other up-and-coming artists, and producing numerous collaborations between composer Al Carmines and director Larry Kornfeld, the church operated a draft counseling service and organized around issues of civil rights, free speech, abortion rights, and the decriminalization of prostitution. Its small but devoted congregation came to many of the cultural events.

The first *Concert of Dance* turned out to be a three-hour marathon for a capacity audience of about 300 sitting from beginning to end in the un-air-conditioned 90° heat. It seemed a very heterogeneous group: Greenwich Village residents, artists, dancers, drop-ins, congregation

members. The selection of the program had been hammered out at numerous gab sessions, with Bob Dunn as the cool-headed prow of a sometimes overheated ship. He was responsible for the organization of the program. It began with a sequence from *The Bank Dick* as the audience was coming in. Judy Dunn stage-managed and also performed in my *Dance for 3 People and 6 Arms* with me and Bill Davis. David Gordon performed his inspired proto-feminist solo, *Mannequin Dance,* in which he wore a blood spattered lab coat and sang all the verses of *Second Hand Rose* and *Get Married, Shirley, Get Married* in his gruff baritone while descending in a slow-motion pivot to the floor. Also on the program were Fred Herko on roller skates with an umbrella; Carolee Schneemann's *Lateral Splay,* in which a dozen or so people scuttled across the space as low and fast as possible; composer John Herbert McDowell with red sock and mirror; Steve Paxton's *Transit* and *Proxy,* in which Steve, Jennifer Tipton, and I performed; and dances by Elaine Summers, Ruth Emerson, Deborah and Alex Hay, Bill Davis, Gretchen MacLane, and others. I also performed a solo, *Ordinary Dance,* during which I recited the names of my grade-school teachers and the streets on which I had lived from early childhood. We were all wildly ecstatic afterward. As the audience enthusiastically applauded at the end, I clasped Judy around the waist, hoisted her in the air as we both exclaimed "It's a positive alternative!" The church would become our home, its basement gymnasium available for weekly workshops and additional performance space, an alternative to the once-a-year, hire-a-hall mode of operating that had plagued the struggling modern dancer before. Here we could present things more frequently, more informally, more cheaply, and—most important of all—more cooperatively. If I thought that much of what went on in the workshop was a bunch of nonsense, I also had a dread of isolation, which made me place great value on being part of a group. As I

A CONCERT OF DANCE

BILL DAVIS, JUDITH DUNN, ROBERT DUNN, RUTH EMERSON, SALLY GROSS, ALEX HAY,
DEBORAH HAY, FRED HERKO, DAVID GORDON, GRETCHEN MACLANE, JOHN HERBERT MCDOWELL,
STEVE PAXTON, RUDY PEREZ, YVONNE RAINER, CHARLES ROTMIL, CAROL SCOTHORN,
ELAINE SUMMERS, JENNIFER TIPTON

JUDSON MEMORIAL CHURCH
55 WASHINGTON SQUARE SOUTH
FRIDAY, 6 JULY 1962, 8:30 P.M.

Flyer designed by Steve Paxton for the first *Concert of Dance*, Judson Church, July 1962

look back, what stands out for me, along with the inevitable undercurrents of petty jealousies and competitiveness (from which I was not exempt), is the spirit of that time: a dare-devil willingness to try anything, the arrogance of our certainty that there was ground to be broken and we were standing on it, the exhilaration produced by the response of the incredibly partisan audiences, and the feverish anticipation of each new review in the *Village Voice* by our champion, Jill Johnston.

Following that first *Concert of Dance* we partied for a while, then a bunch of us—Cindy, Deborah and Alex Hay, Freddie, Phil Corner, and I—and I seem to remember Al Hansen, because he was around quite a bit, much enamored of Cindy—piled into a car and drove out to a Staten Island beach. As the sun came up, the awesome specter of the unfinished Verrazano-Narrows Bridge was revealed, its towers connected by suspension cables, the roadway missing, leaving the vertical cables dangling and unmoored. A functionless ghostly structure, etched surreally in the dawn.

In the following eight months I continued to take two classes a day, rehearse several times a week with Jimmy Waring, and attend the weekly workshops in the Judson Church gym. These sessions were open to anyone who wanted to show work, finished or unfinished. Brian de Palma visited on one or two evenings, and, besides the performers mentioned above, regulars were Arlene Rothlein, Dorothea Rockburne, and Malcolm Goldstein. In 1963 sculptor Charles Ross showed up to propose building two large structures that would be available to us to use in any way we wished. A number of performances emerged from this collaboration. A memorable one was a piece by Carla Blank (*Turnover*) for eight or nine women rolling Ross's ten-foot high aluminum trapezoid-like frame around the sanctuary. As half the group lifted a lower bar of the contraption from the floor, the other half reached for the top bar on the

other side and in the process of bringing it to the ground raised the first four or five performers high in the air. The second group then moved to the other side to lift another part of the structure, thus lowering the dangling ones to the ground. In this fashion the whole configuration rolled crazily around the space. I found it breathtaking to engage in this heavy and slightly dangerous work with a team of women.

The workshop was a place for me to show movement-in-progress that would go into *Terrain,* my first evening-length work. In the fall of 1962 poet Piero Helicser had visited me in my apartment. In the tiny living room I put on a record of Satie's *Trois Gymnopédies* and performed

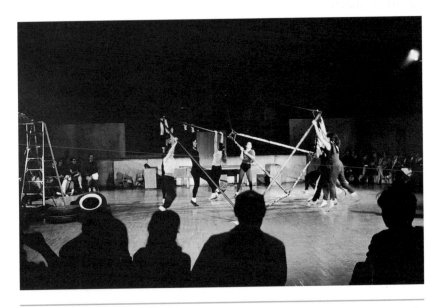

Turnover by Carla Blank, Judson Church, November 1963. Photo by Peter Moore. © Estate of Peter Moore/VAGA, NY, NY.

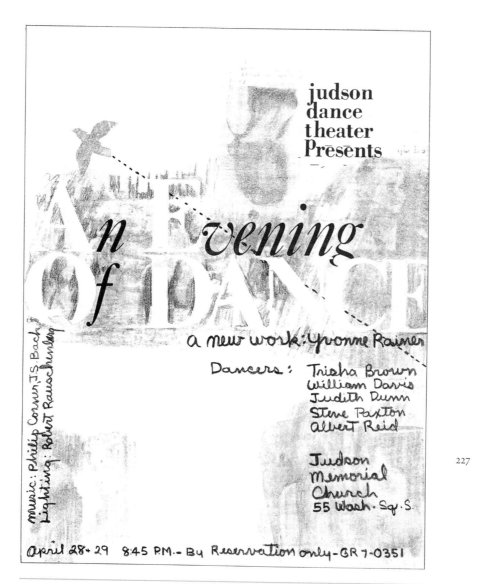

judson
dance
theater
Presents

An Evening
of Dance

a new work: Yvonne Rainer

Dancers: Trisha Brown
William Davis
Judith Dunn
Steve Paxton
Albert Reid

Judson
Memorial
Church
55 Wash. Sq. S.

music: Philip Corner, J.S. Bach
Lighting: Robert Rauschenberg

April 28 + 29 8:45 P.M. – By Reservation only – GR 7-0351

227

Flyer designed by Robert Rauschenberg for *Terrain*, Judson Church, 1963

the whole *Three Satie Spoons* for him. In appreciation he left me a Deutsch Archiv recording of Bach cantatas. As I listened to Dietrich Fischer-Dieskau singing *Ich Habe Genug* my mind began to swarm with dance images. I sat in another state of rapture, this one never equaled since. *Ich Habe Genug* became the accompaniment for the last section of *Terrain*, performed at Judson by Steve, Judith, Trisha, Bill Davis, Albert Reid, and me in April 1963. Rauschenberg designed the flyer and lighting and ran the lights. It was a simple and ingenious design: a downstage stanchion supported a bar that ran directly upstage center above our heads and held the lights in full view of the audience.

"Play" from *Terrain*, Judson Memorial Church, 1963. William Davis. Photo: Henry Genn.

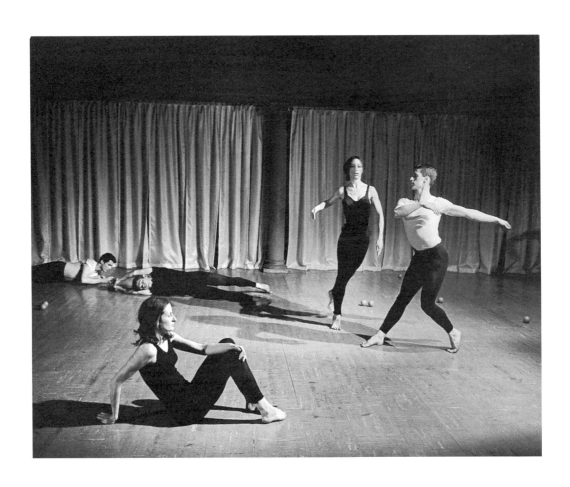

"Bach" from *Terrain*, Judson Memorial Church, 1963. William Davis, Albert Reid, Trisha Brown, YR, and Steve Paxton. Photo: © 1963 Al Giese.

Almost immediately after the last performance I sank into an abysmal depression which affected both psyche and body. I felt like I weighed a ton, could hardly move, much less dance. In *The Master of Petersburg* J.M. Coetzee has described this state incisively:

> He is paralyzed. Even while he is walking down the street, he thinks of himself as paralyzed. Every gesture of his hands is made with the slowness of a frozen man. He has no will; or rather, his will has turned into a solid block, a stone that exerts all its dumb weight to draw him down into stillness and silence.*

"It looks to me like you need a vacation," Dr. Schimel observed. He was treating me like a reasonable person who works hard all year, travels, relaxes, enjoys herself, and recoups. Why wasn't he savvy after all these years to what "going away" signified to me? Why wasn't I cognizant that going away would be tantamount to being sent away? Not conscious that I was stifling my terror, I battened down the hatches and went through the motions of what "normal" people do: I flew to San Juan, then to St. Thomas, went to the beach, tried to ignore the desperately poor people along the way, shopped in the arcades, had expresso and cheesecake on the veranda of poet Tram Coombs's cottage. Then I returned to San Juan, where I spent two days on the twentieth floor of the San Juan Hilton contemplating jumping out the window. In fact, ordered a "last supper" from room service: banana daiquiri, shrimp cocktail, the works. On returning to New York I was so relieved to be home that the depression miraculously lifted. For the time being.

230

* J.M. Coetzee, *The Master of Petersburg* (New York: Penguin, 1994), 52.

Because of the nature of consciousness, Dostoevsky indicates, the self cannot tell the truth of itself to itself and come to rest without the possibility of self-deception.

—J. M. Coetzee, *Confession and Double Thoughts*

11

The Plot Thickens

"LISTENING TO VIVALDI on a Sunday morning."

"I'm not such a bastard as I used to be."

It's odd how a single utterance by a particular person in one's life can seem at certain moments to encapsulate a total sensibility. Composer Philip Corner's love of Vivaldi, sculptor Robert Morris's indirect acknowledgment of ethical transgressions.

Perhaps I should have subtitled this and some future chapters "Caveat Emptor." They have been the most troublesome to write. In trying to avoid the shoals of vindication, revenge, and vindictiveness and in choosing to focus at least in part on my own behavior, contradictions, insensitivities, and complicity, I again find myself perilously close to the sticky terrain of confession with its attendant constraints and inevitable omissions. Another overriding problem in any autobiography is how to deal with facts that may be hurtful, if revealed, to those still alive. Should I then use a pseudonym—call myself "Yvonne Washington"—and turn this into a roman à clef? Or follow an entirely different tack of free association and/or absurdity? To quote from a 1980 essay:

Flitting and dipping are more to my liking than soaring and arcing. Stumbling over the hit-and-run of the quote and the snort is more habitual to my mode of operations than the intricacies of binary logic. . . . The function of the artist is to emerge periodically from the (m)ire of her solipsisms. Yes, that's it. I think I've finally got it: The function of . . . uh . . . memory is selective burial. Disinterment being what it is, i.e., inevitable, seasonal, chronic, it behooves us to engage memory in the service of a perish-the-thought subjectivity mired in (she was never very good at living with) contradictions. Hundreds of seabirds rode the wind. She felt compromised at the drop of a hat: by being asked a question she couldn't answer, by being held in high esteem, by being in the company of two men, by being addressed by one man, a younger woman, a younger man, a peer (to look for the reasons one should not stomp on someone's face is to accept stomping on it), by her irresponsible memory which invariably copped out at the punch line. . . . The fatal glass of beer at this late in the day sees print as harboring fact, and the filmic image as perpetuating representation.
("Beginning With Some Advertisements for Criticisms of Myself, or Drawing the Dog You May Want to Use to Bite Me With, and Then Going On to Other Matters," *A Woman Who . . . : Essays, Interviews, Scripts*)

Since I see no recourse but to stumble on, "the fatal glass of beer" seems as good a place to begin again as any. Robert Morris, my on-and-off lover and partner from 1964 to 1971, loved W. C. Fields as much as I,

and during our first winter together would growl, "It's not a fit night out for man nor beast" at the drop of a hat—or snowflake. Come to think of it, I can imagine him dropping similar comradely bons mots with his brilliant first wife, Simone Forti. As for seeing "print as harboring fact," one way around such an addictive misperception is the non sequitur. So let me confess right out of the gate that I did and said things that hurt him, but sex with anyone other than him during our partnership was not one of them. I mean, not one of the things I did to hurt him, and, but for two exceptions, not one of the things I did at all. Which is another way of saying (while trying to avoid self-congratulation) that for seven years I was involved with a philanderer.

When I wrote "Fuck you too, Bob Morris" on the wall of his 1961 installation in Yoko Ono's studio, it was not only an angry reaction to his wily architectural provocation. It was an indication of my dubious regard for his character. By 1962 he and Simone had split up, and he was living with the poet Diane Wakoski in his Church Street loft. I knew he had slept with others while with her; I knew the people he had slept with. So what else was new? But there was something a little creepy and evasive about him apart from his infidelities.

Our paths continued to cross at openings and other events. They crossed in a peculiar way in his 1962 Living Theater "presentation" in which a rectangular gray column stood for some minutes, then toppled over and lay on the floor for the same duration. The column had originally been constructed and painted yellow by George Sugarman as decor for one of my early solos, *The Bells*, which I had performed on that same stage the previous year. Bob found it in the wings and painted it gray, then in rehearsal made it fall over while standing inside it. He cut his lip on that occasion and in the actual performance attached a string to the column, which he pulled from offstage to effect the toppling. The

transformation of his "primary structure"—from decor to inert protagonist—might add another angle to the roiling debates that would foment around the work of Morris and Don Judd for the next few years. But this early performance of his confirms a basic difference between them: The human body was always implicit in Morris's sculpture in the 1960s.

In October 1963 Morris had his first one-man exhibition at Richard Bellamy's Green Gallery. There he installed gray plywood structures—or "unitary forms" as he called them early on—plus Duchampian objects displayed around the periphery of the gallery. Just prior to the opening of that show, in the same space, I performed an improvisation with a spool of white thread during an installation/event by James Lee Byars consisting of a sea of white cardboard boxes over which paper scrolls were unfurled while a female model stood stock still in a white Balenciaga gown. My crashing-into-walls performance in a black dress and heels was largely affected by my feeling that the whole thing was pretty chichi.

At the beginning of 1964 I attended two memorable loft bashes. The first was a New Year's Eve party given by Irving Sandler at the loft of painter Sylvia Stone (then involved with Al Held). In the words of Sandler it was "[abstract expressionism's] last sign of life."* The other was at Bob Rauschenberg's loft on Broadway shortly thereafter, which, in contrast, might have been called "minimal and pop art's ascendant sign of life." The latter was a huge crowded event attended by everyone who had been seen at "happenings," dance and music concerts, and gallery openings for the past four years. Bob Morris was there, and we danced. I didn't see Diane, and he didn't mention her, nor did I ask. We left together, waited downstairs for a cab alongside Miriam Schapiro. In our

236

* Irving Sandler, *A Sweeper-Up After Artists* (London: Thames & Hudson, 2003), 321.

randy haste we grabbed the first one that came along, leaving Miriam in the cold. We went home to my apartment and made love. The love-making was protracted and astonishing, almost unbearably erotic. Again in the words of J. M. Coetzee (whose books engross me in the year I write this memoir), "About them is an incandescent sphere of pleasure; inside the sphere they float like twins, gyrating slowly." All previous reservations and caveats vanished. I was hooked and so was he.

When I told Judy Dunn I was in love, she said knowingly, "He'll never leave Diane." When I reported my new liaison to George Sugarman, he responded dismissively, "Now you're officially part of the minimalist camp." Bob Morris never returned to Diane Wakoski. And almost from that first night I had a recurring nightmare. Something or someone was lurking menacingly behind the bedroom door. The only way to get rid of it was to wake up. It was the first time I had allowed a sexual partner to embed himself so deeply in my psyche.

Diane called several times in tears, and from the other room I could hear Morris's voice as he tried to console her. In an e-mail response to my recent and much belated apology for having caused her so much pain she wrote:

> Ironically, yesterday I was reading through the essay I wrote almost twenty years ago for a library reference work called CONTEMPO-RARY AUTHORS AUTOBIOGRAPHIES because they've asked me to update it. I came across something that I will surely update, now that I've heard from you. It reads, "Morris left me and asked me to move out of his loft in the spring of 1964. . . . When someone leaves you, especially for another lover, the pain is probably worse than loss through death. It means rejection. And total failure. Real failure. Bob left me for Yvonne Rainer, a woman I have

never stopped hating [sic, I wrote this in 1983!], as oddly we do not hate the lover who rejects us, but rather the men and women who take them away. For many years, I thought Morris would come back to me. It always seemed like we belonged together. But he never did. We do not even have a speaking acquaintance any longer. . . ."

I have long stopped hating you. Actually, I have such a peaceful life that I don't feel hatred for anyone or anything much any more. Possibly stupid university administrators and an occasional ghastly student. But not much else.

Dr. Schimel prophesied grimly, "Well, someday the same thing will happen to you." Sooner than he could have known. But meanwhile my love life and work life were going full tilt. Bob moved into my two-and-a-half room apartment while keeping his studio on Church Street. For the next two years, we were almost inseparable, attending concerts and plays and appearing on the same dance programs. Caught up in the general euphoria over the new flowerings of the so-called Minimalist and Pop Art movements, we showed up at innumerable museum and gallery openings and cocktail parties at the homes of Park Avenue collectors and nouveaux riches. As Minimalism edged toward its zenith in a profusion of exhibitions and publicity, I accompanied Bob one day to a younger sculptor's apartment/studio on West Houston Street. One room was bare, save for a standing wooden square column painted white. We circled the object, mutely studying it. Bob uttered a few enigmatic words, then we managed to beat a hasty retreat. Once outside I blurted out, "Between you and Judd, the two of you have almost single handedly spawned a generation of cretins."

238

I gained ten pounds from our ecstatic domesticity, nibbling on cashews before dinner, smoked oysters after sex, and ice cream for break-fast. Bob was in the middle of making reliefs of body parts for a future exhibition and enlisted me, or rather my vulva, for that purpose. As I was lying on my back in his studio, legs akimbo, waiting for the hot molding material he had slathered on my crotch to cool, I farted. The escaping gas left a gouge in the still soft material. I doubt if anyone examining the object in the exhibition would have been able to recognize the source of that furrow.

We were also experimenting with drugs. One afternoon while rummaging in Bob's refrigerator on Church Street I found two cookies wrapped in foil and gobbled them up. Later that night as we lay in bed in my apartment I uttered some nonsense that had nothing to do with our conversation. We then realized that I was stoned from the hashish in the cookies I had ingested earlier. I began to see rainbows around the curtain rods and free-associated a stream of surreal prose for the next couple of hours.

The Judson dance scene was now beginning to fragment. By early 1964 various changes had taken place. Some of us began to drop out of the workshop following some "splinter" concerts. This was a natural outgrowth of particular aesthetic and social alignments that were both complicated and schism-making. A friend of Deborah and Alex Hay brought some of us to New Paltz Teachers College; Steve Paxton pro-duced a series called "Surplus Dance Theater" at Stage 73; some of us were invited—as the Judson Dance Theater—to the Once Festival in Ann Arbor. And there was another factor: Bob Rauschenberg, whose in-volvement as a designer with Cunningham made him no stranger to our concerns, began presenting work on our programs. The plot thickens.

From the beginning, nondancers had been active in the group as both performers and choreographers: composers Philip Corner, John Herbert McDowell, Malcolm Goldstein, and artists Carolee Schneemann, Alex Hay, and Bob Morris. But there had always been a sense that we were all in it together, that whatever the inequities, they came out of our common cause, a shared present time. Upon Rauschenberg's entry as a choreographer—through no error in his behavior but simply due to his stature in the art world—the balance was tipped, and those of us who appeared with him became the tail of his comet. Or so I felt. It was not something that I ever heard openly discussed, although I was aware of his sensitivity to the *possibility* that this might be occurring. The situation manifested itself in the change in the audiences—the power-oriented critics and dealers and glamour-oriented art stars and collectors came en masse—and Rauschenberg's diligent stroking, both publicly and privately, of each of us. The truth of the matter was that we were simply not in his league as far as previous accomplishment went, and there was nothing anyone could do to make audiences look at our work the same way they looked at his (and vice versa). If Bob raised his thumb it was something very special because *he* was doing it; if I raised my thumb, it was dancing. The situation was every bit as trying to him as it was to us. Rauschenberg's association with us (or perhaps, more accurately, mine with him) was a mixed blessing. We got a lot of mileage out of it both notoriety-wise and gig-wise. And the glitter aspects of being part of his entourage were extremely seductive. Beyond all that, I owed a lot to the inspiration of his daring and humor.

The years 1964–66 were important for Bob Morris's career and for mine. In February 1964 Steve produced four nights of dance that he called "Surplus Dance Theater" at a tiny theater on East 73rd Street. Then living with Rauschenberg and dancing with Cunningham, Steve Paxton was

240

one of my most cherished friends. Charismatic in every respect, on and off stage, muscular and broad shouldered with a long neck and small chiseled head, he looked like a *Saltimbanque* just jumped out of a Picasso painting. In fact, he had been an Arizona state runner-up tumbling champion before coming to New York from Phoenix. Steve and Bill Davis (also then dancing with Merce) were the colleagues (apart from Bob Morris) with whom I had the most extended discussions about art and dance. While performing with Cunningham, Steve still found time to choreograph and produce ambitious programs. His own work was underappreciated by Jill Johnston, who wrote extensively and enthusiastically about others of us in the *Village Voice*. As Bill Davis wrote to me in 1962:

> Here's Jill's Judson review from today's *Voice*. I have sort of mixed feelings about it (I must get over having feelings about reviews at all). But why, for example, devote considerable space to Freddie [Herko], John McDowell, and Ruth [Emerson], and not talk about Steve's work at all?

Steve's was the most severe and rigorous of all the work that appeared in and around Judson during the 1960s, and could most accurately be termed "minimalist." In contrast to my stuff—wildly eclectic, alternately eccentric or formal—or Bill Davis's romanticism, David Gordon's campiness, or Trisha Brown's daredevil "Equipment Pieces," Steve's work stood its ground. Eschewing music, spectacle, and his own innate kinetic gifts and acquired virtuosity, he embraced extended duration and so-called "pedestrian movement" while maintaining a seemingly obdurate disregard for audience expectations. Most significantly, he asked challenging questions about the nature of self-presentation. In *English,* a dance of 1963, he had a dozen of us "erase" our features, i.e.,

soap out our distinguishing facial characteristics, and enter the Judson gym in a lock-step column, some of us walking backwards and some forwards. The idea was not to look like robotic automatons, but rather to call into question received notions of expressivity and how it was delivered in performance. A "tango kiss," which he and I executed in the same piece, brought this home. I don't think many people got it. Steve was equally critical of the orthodoxy of the Cunningham Company's glazed "blankness" (Caroline Brown called it "serenity") and the notion of charisma—in my case conveyed by an intense inner concentration—without acknowledging or taking into account the power of his own performance persona. Early on Trisha was dealing with the same "problem" in another way, through improvisation. As she has eloquently explained:

> There is a performance quality that appears in improvisation that did not in memorized dance as it was known up to that date. If you are improvising with a structure your senses are heightened; you are using your wits, thinking; everything is working at once to find the best solution to a given problem under pressure of a viewing audience. In contrast, at that time, modern dancers glazed over their eyes, knuckling down behind that glaze to concentrate and deliver their best performance—an understandable habit but unfortunately resulting in a robot-look. At Judson, the performers looked at each other and the audience; they breathed audibly, ran out of breath, sweated, talked things over. They began behaving more like human beings, revealing what was thought of as deficiencies as well as their skills.*

* Trisha Brown, quoted in *Contemporary Dance,* ed. Anne Livet (New York: Abbeville, 1978), 48.

I eventually tackled the issue of facial presentation in *Trio A* of 1966 by choreographing special moves for the head that kept the performer's face constantly averted from the spectator's gaze. As a consequence, the face remained unreadable with regard to expression, personality, or quality of engagement. For me this ploy extended the debate by associating "expressivity" with pandering, narcissism, voyeurism, and exhibitionism. I later brought this to a cinematic extreme—under the influence of feminist film theory—in my 1985 film, *The Man Who Envied Women,* via the strategy of eliminating the physical presence of my female protagonist, thus removing her from a sexualizing gaze, both on and in front of the screen.

The question frequently asked or implied by the more conservative dance critics was, "Why are they so dead-set on just being themselves?" The transformations that had been celebrated in previous modern dance—the god-like, the ecstatic, the heroic, and the regal all canceling out the mortal, the pedestrian, the quotidian, and the athletic—seemed very tired to us, used up, effete. My *We Shall Run* of 1963 and Steve's *Satisfyin' Lover* of 1968 were noteworthy efforts in this period of "adversarial culture"—to use Susan Sontag's memorable phrase. Referring to these two dances, Steve and I sometimes joked that he "invented" walking and I "invented" running. Certainly no previous formal choreography had relied solely on running, as in my dance, or walking, sitting, and standing still, as in his. After seeing the first performance of *We Shall Run* in January 1963 in the gym of Judson Church, Jasper Johns remarked that this dance had gone to the outer limits on a scale of possibilities. I was quite flattered, since going out on a limb was a prized aspiration for those of us circling around the ideas of Duchamp and Cage, who themselves were still revamping earlier twentieth-century aesthetic rebellions.

Bob Morris and I both presented work at Stage 73 in February 1964. One of the hits of the series was his *Site,* an homage to Manet and construction workers in which he wore a life mask of his own face (another response to the problem of self presentation) and manipulated 4 × 8 sheets of plywood while Carolee Schneemann reclined nude on a shelf à la Manet's *Olympia.* I performed *At My Body's House,* a solo involving wireless sound transmission of my breathing designed by Billy Klüver and a recitation about an eighteenth-century elephant. I had wanted the device to transmit my heartbeats, but the technology for this wasn't yet possible. (Sarah Rudner used it in a recent dance for Mikhail Baryshnikov.) I also presented *Dialogues* with Lucinda Childs, Judith Dunn, Deborah Hay, and myself. During the performance, three men—Alex Hay, Tony Holder, and Steve—repeatedly ran down the aisles onto the stage and bumped into whoever was in their way. If you were in their path, it was hair-raising to see them coming at you. The "proper" dance for the four women contained dance phrases performed by Judith and me, some sitting and lying around by Cindy, and a zany duet for Deborah and me that had been inspired by a lunch with Andy Warhol and others at a midtown restaurant, during which Andy repeatedly exclaimed "How marvelous!". . . . "Isn't that marvelous!". . . . "Marvelous!" I transformed this into a falsetto "dialogue" between Deborah and myself that spun variations on "That was so lovely . . . Yes, yes, that was so lovely . . . It was so lovely it will make me think about it a lot . . . Yes, it is so lovely to have thinking," etc. *Dialogues* marked the second time I abandoned the modern dancer's bare feet for rubber soled shoes, "to mar the image," as Jerry Ordover commented. The first instance had been *Room Service* of 1963, a collaboration with sculptor Charles Ross. In that situation, shoes were a protective necessity for movements that mainly comprised walking, climbing, and jumping in the negotiation of

244

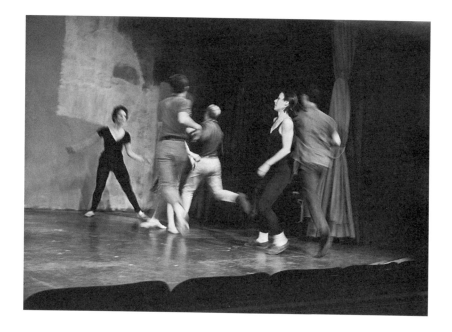

the many objects and obstacles that were strewn about the space. In the much sparer and "dancier" mise en scène of *Dialogues* the wearing of heavy shoes in the execution of dance phrases stood out as a kind of aesthetic affront.

In February 1964 the Once Group, a loosely knit association of musicians Robert Ashley, Gordon Mumma, and Alvin Lucier, artist Mary Ashley, and filmmaker George Manupelli invited Rauschenberg and his entourage to their annual "Once Festival" in Ann Arbor, Michigan. Rauschenberg, Cindy, Alex, Deborah, Steve, and I all presented work, maybe Bob Morris also. My recall of the performances is nil, eclipsed by

The men rattle the women in *Dialogues*, Stage 73, February 1964. Judith Dunn, left; YR, right. Photo by Peter Moore. © Estate of Peter Moore/VAGA, NY, NY.

memories of the still unbanked fires of our passion, expressed in public necking and joyous dancing at parties to the newly discovered Beatles. The mawkish "I Want to Hold Your Hand" was played over and over. We couldn't get enough of it.

I started to work on a duet for Bob Morris and myself in his Church Street loft. It would be called *Part of a Sextet* and ultimately integrated into 1965's forty-three-minute *Parts of Some Sextets* for ten people and twelve mattresses. I worked quickly. It was mildly gymnastic; he was strong and had a natural coordination and skill. "It seems so easy for you," he remarked on my process. Following the initial performance of the duet, he despondently complained that my movements were flowing and graceful in contrast to the ones I made for him which made him look, or feel, like a puppet. This had certainly not been my intention.

Our apparently successful, exciting, active, impervious lives were beginning to show a few cracks. On the domestic front, I felt secure in Bob Morris's love for me. What I couldn't parse, and he was incapable of conveying, once our initial passion cooled down, was the degree to which my intense concentration on work seemed to rule out fulfilling his everyday needs for attention, sex, and affection. I doubt if those needs were excessive—"Is he asking you to fuck in the wings?" Dr. Schimel commented sardonically—but since they weren't expressed and neither one of us was by temperament very demonstrative, I took his love for granted and went about my business. It's true that for me, at least, work usurped needs for affection. Call it sublimation, if you will, the unspoken "contract" would have disastrous consequences. For a while it was a perfect neurotic fit. I could maintain my autonomy and secret "escape option" by keeping him at a distance, which he could then use as justification for his infidelities.

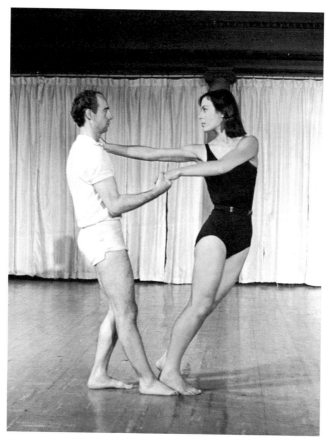

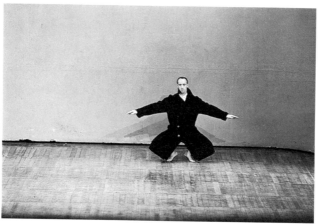

Robert Morris and Y R in *Part of a Sextet*, Judson Church, 1964. Photo by Peter Moore.
© Estate of Peter Moore/VAGA, NY, NY.

Robert Morris in *Part of a Sextet*, Wadsworth Atheneum, March 1965. Photo by Peter Moore.
© Estate of Peter Moore/VAGA, NY, NY.

The first crisis came within four months. At a party around June 1964, at Frank Stella's loft, I noticed that he and art historian Barbara Rose (then married to Stella) were flirting. When we got home, I accused him of having, or about to have, an affair with her. His response was, "Well, *you* don't love me." Which knocked me for a loop. I asked, "Shouldn't you be taking that up with *me*?" and stormed out. I spent the night at the Broadway Central, the flea-bag hotel that would collapse in the summer of 1973. Cockroaches roamed the moldy shower stalls and the place creaked with age, but it was cheap. Morris called the next day, very contrite, and I went home. There were several more face-offs of this kind.

As we lay in bed in my apartment he commented, "She has a softer belly than you," which was not only a pejorative reference to my dance-firmed abdomen but the confirmation of his infidelity. I hit him about the head before rushing into my clothes, this time intending to go down to the new loft we had just leased in the deserted pre-Soho area below Houston Street. Later it would be my 1972 lover, Peter Way, who would compare my breasts to those of his estranged wife, this time in my favor. Outside of *Sex and the City* do women ever tell their male lovers that they are bigger or smaller or softer or harder than previous or current sex partners? It's true I was not above ridiculing the look of Bob's butt in a new ill-fitting bathing suit, and I was probably guilty of similar meanness on other occasions of which I have no memory. My dancer's obsession with notions of the ideal body conspired with my underdeveloped empathy to produce behavior every bit as obnoxious as that condoned by patriarchal sexism. It has taken me years to loosen my grip on these misguided and destructive notions of "fitness" and accept the traumatic, later inevitable, "deterioration" of my body. I put the word in quotes in order to emphasize the way in which the aging process in our culture is

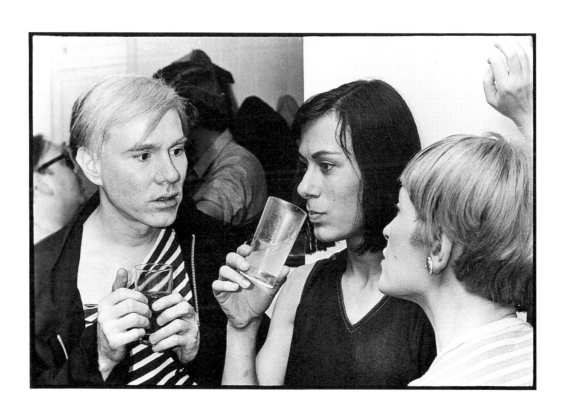

Andy Warhol, YR, and Barbara Rose in Frank Stella's studio, 1964. Photo: © 1964 David McCabe.

normalized as something to be feared and despised. Things got contentious enough so that Bob started going to my shrink, Dr. Schimel.

(Two women walking on a crowded street):
Woman #1: So his shrink says to him, "If you're going to fool around with other women you'd better become a better liar." So he did.
Woman #2: Did what?
(*The Man Who Envied Women,* 16mm, 1985)

"Did what?" indeed. He became a better liar and I became more adept at being unsuspecting of his lies.

I was not alone in a tendency to have periodic depressions. During July I rehearsed with an actor, Larry Loonin, for a collaborative performance—*Incidents*—at the Cafe Cino. I had become transfixed with moving objects around, and the first event of the evening saw us repeatedly asking audience members to move their chairs and tables from one side of the room to the other until they balked and stopped cooperating. (This event had a direct antecedent in Simone's "Herding" in her 1961 concert at Yoko Ono's loft.) In another "incident" Larry read from an FBI dossier while I clambered around on the overhead pipes, finally descending to wrap myself around his body as he continued to read. During the time Larry and I were rehearsing, Bob became noncommunicative, refusing to talk to me. I suspected one of the reasons was jealousy, but he was unable or unwilling to talk about it. My professional involvement with Larry Loonin was one more justification for his philandering. I didn't feel guilty at the time; I didn't think I had behaved inappropriately.

I now can recognize that trait in my character that Bob perceived as rejection: the fierceness of my ambition and work ethic, no greater

than his, by the way, but culturally and psychologically perceived in a woman as "unloving." At a party Richard Serra insulted me by telling me in his tactless way that mine was an ambition that verged on the "suicidal." Calvin Tomkins would later quote Rauschenberg, "She was the most ferocious woman I ever met," this perhaps in response to my bull-in-a-china-shop knocking of him as a "Sunday dancer" as he made his first theater pieces. Both remarks by these men were all the more offensive to me, as I was still in the habit of regarding myself as docile and unambitious. This self-characterization was bolstered by Billy Klüver (with whom, prior to hooking up with Bob Morris, I slept on several occasions), who appreciatively remarked that I was "not aggressive like other women artists." If I were so inclined I could use this moment to make a psychoanalytic pronouncement: "There you have it: the castration anxieties of patriarchy working their contradictions." Since I'm not totally convinced that fear of castration rules the world, I won't pursue the matter. More to the point, all of the above assessments were more or less accurate. My aggressiveness was on display only for those with whom I was competitive.

In August 1964 the Cunningham Company was scheduled to perform for the first time in London, then to go on to Stockholm for a festival of music and dance at the Moderna Museet organized by Billy Klüver and Pontus Hulten. Bob and I were both invited to show work, along with Cunningham, Cage, Paxton, Rauschenberg, Deborah and Alex Hay, and Oyvind Fahlstrom. It was to be our first trip to Europe, and I was terrified (though not acknowledging the fact) not only of going to a strange country but of performing on an equal footing with my famous mentors, Cage and Cunningham. From London, where we saw several Cunningham performances (which wowed the English critics), we took a side trip to Stonehenge. At that time there was no fence

surrounding the site, so you could wander freely amid the standing stones. The pervasive silence of the barren plain, the symmetry suggesting a mysterious—though incomprehensible—reason, the stillness that absorbed the awed murmurs of us milling day trippers spaced like figures in a de Chirico painting—all made for an unforgettable experience.

After four or five days we went on to Paris, staying in the Hôtel La Louisiane on the Left Bank, a flea bag, or more accurately, bedbug bag. Here my terrors engulfed me. I broke down, cried for hours. A side of Bob emerged that in hindsight still surprises me. Though completely perplexed, he showed infinite tenderness and compassion, holding me in my stricken convulsions. The bedbugs in the hotel and the grandeur of Chartres are the most vivid of my impressions of this first visit to France. Photos taken of me later in Stockholm reveal the strain I was under.

Bob and I shared an evening during the festival. Oyvind Fahlstrom translated my eighteenth-century elephant story into old Swedish, which I memorized phonetically for my performance of *At My Body's House.* Bob presented his *Site* and made a dance for forty Swedes called *Check,* which owed something to Simone's *Rollers* in its inclusion of two go-carts that were pulled about with each of us inside. The audiences were educated and appreciative. We were invited back to do a Scandinavian tour the following year (1965) in Copenhagen, Lund, and Stockholm. While still in Stockholm during the 1964 festival, Bob received an invitation from Alfred Schmela to mount a show in his Düsseldorf gallery in October. He decided to accept the offer, and, following the concerts, we took an overnight train from Stockholm to Germany. It was a shock to wake up the next morning and hear German being spoken by uniformed train officials outside the window of our sleeping compartment. World War II was barely twenty years in the past, and the Nazi atrocities were immediately invoked in our minds by the harsh consonants of the German language.

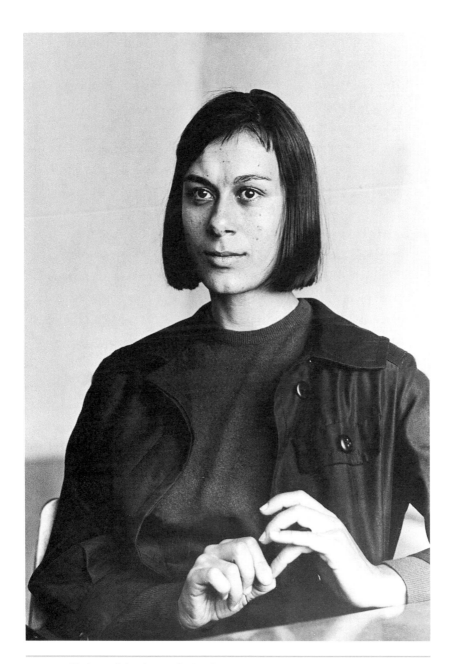

253

YR in Stockholm (with bug bite on forehead), 1964

Herr Schmela, a rotund, affable man whose only language was a German dialect and who spoke not a word of English (we of course spoke hardly a word of German), was married to Monica, an exuberant bilingual mediator and interpreter for her husband. Without her we would have been quite at a loss. One of the first social events was a visit to a nightclub with Herr and Frau Schmela. Lacking the requisite formal clothing, Bob was supplied with a heavy Harris tweed jacket and flashy tie by the management. The music was 1940s swing and the clientele middle-age overweight men and their wives clad in loud silk print dresses. We couldn't help seeing ex-Nazis wherever we looked, fattened up in the postwar industrial "miracle." The Schmelas urged us to dance. We obligingly gyrated around the dance floor as they watched in appreciation.

We spent the next six weeks in strange circumstances, sharing a Bauhaus-like building with Ilse Zwinger, a designer, and her buttoned-down ad-exec partner. The latter frequently baited us by initiating "ugly American" arguments that could be summed up with "We had our Hitler, and you have your Nixon." A chilling comparison, especially in view of the fact that Nixon had lost the 1960 election to John F. Kennedy and in 1964 still had no political clout.

We both were provided with studios, Bob's on one floor of the building in which we lived, mine a short streetcar-ride away. Bob spent his days roaming the town with an English-German dictionary, buying materials and tools that he needed for the preparation of his exhibition, which would consist mostly of remakes of some of the sculpt-metal reliefs and plywood pieces he had shown the previous year at the Green Gallery. His mood matched the gray chilly weather. He was ambivalent about repeating old work. His lover/critic, Barbara Rose, favored his minimalist plywood pieces over the sculpt-metal reliefs and reflexive punning constructions like the "I Box" (a cabinet that when opened re-

vealed a photo of Bob naked and smirking) and "Box with the Sound of Its Own Making." I wasn't aware of any of this until one night after we returned to New York he suddenly erupted in a fit of self-loathing and slammed the lamp off of the bedside bureau. Somehow he felt deeply humiliated by his "lapse" in career acumen by having exhibited the more personal neo-Dada objects, which were already being perceived as not cutting edge.

I went everyday to a tiny sixth-floor walk-up ballet studio in the Altstadt, from the windows of which I could see the Rhine beyond the old rooftops. One day there was a fire in the next block, producing much smoke and activity. I felt like a cuckoo in a Swiss clock observing another intricate mechanized toy go through its paces. All those little firemen and townsfolk seemed wound up as they scurried around in mindless circles. Beyond them, in the distance, was the flat river and green-washed Rhine meadow. The whole scene was decidedly depressing.

Since there was nothing else to do, I worked. Worked mechanically and at times despairingly on movement. It was necessary to find a different way to move. I felt I could no longer call on the energy and hard-attack impulses that had characterized my work previously, nor did I want to explore any further the "imitations-from-life" kind of eccentric movement that someone—I forget who—once described as "goofy glamour." So I started at another place—wiggled my elbows, shifted from one foot to the other, looked at the ceiling, shifted eye focus within a tiny radius, watched a flattened, raised hand moving and stopping, moving and stopping. Slowly the things I made began to go together, along with sudden sharp, hard changes in dynamics. But basically I wanted it to remain undynamic movement, no rhythm, no emphasis, no tension, no relaxation.

We traveled to Berlin a few times. The contrast between East and West Berlin was exactly what the Western powers cultivated: the excess

of capitalist wealth flaunted on the Kufurstendam contrasting with the blank hoardings devoid of advertisements, the empty stores, and bomb-cratered sidewalks and buildings beyond the Wall. Russian tanks patrolled the streets and soldiers armed with rifles were stationed on the S-Bahn platforms. I even thought the sun clouded over when we crossed into the East. Braving the sinister, seemingly joyless, atmosphere, however, was more than rewarded by the glories of the Bode and Pergamon Museums. We stood in awe before the Ishtar Gate and the Pergamon Altar, marveled at the wealth of Babylonian antiquities. All of the buildings' exteriors were black with age and battle-scarred, the Bode especially still bearing its wounds in its battered dome and torn up surrounding sidewalks. The interiors, however, seemed none the worse for war.

Some of the more interesting people we met while in Düsseldorf were Hans Haacke, his American girlfriend, Linda, and Josef Beuys. Hans was eking out a two-year wait before being able to obtain a visa and return to New York. He was making sculpture using balloons suspended above air jets. We visited Beuys at his home, where an eight-foot dried up Christmas tree was a center of attraction. Beuys told us stories of his stint as a Luftwaffe pilot and offered to organize a dance concert for us at the Kunstakademie, where he taught. In fact, he ended up being our stage manager. Our stay culminated in the opening of Bob's show at Schmela's gallery and our shared concert at the art school. As in Stockholm, we were again gratified by the response of a cultivated, knowledgeable audience.

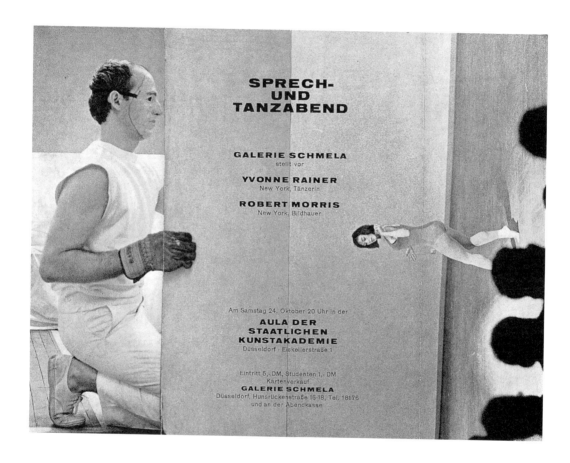

Flyer for Dusseldorf dance concert, 1964

ON RETURNING TO New York, I gave up my East 25th Street apartment—Bob had already relinquished his Church Street loft—and we moved into a 3,000-square-foot space at 137 Greene Street. The previous occupant had been a toy manufacturer, employing at least fifty women who sewed dolls and stuffed animals on his machines. He had followed the general exodus of small manufacturers from the city to find cheaper spaces and lower taxes in New Jersey and elsewhere. In preparation for our living here, I crawled on hands and knees, moving a magnet over every space between the soft pine floorboards. Hundreds of sewing machine needles sprang out of the cracks like maggots, or dragon teeth. The wood itself was so rough and soft that it sometimes inflicted splinters in feet, knees, or buttocks. At first I took the front half while Bob occupied the back next to the minimal kitchen. Later we changed sides so he could install a vented cubicle for his work in fiberglass. It was next to a window that enclosed an exhaust fan, but even so, the fumes filtered into the rest of the loft. Sometimes, if he had one drink after working, he would get instantly high. In those days artists didn't pay much attention to the toxic effects of their materials. The glabrous gray bodies of his truncated pyramid, plinth, wedge, and other finished products made the health risks acceptable. Above us was a metal-stamping factory that operated Monday through Friday from 8 AM to 4 PM and invariably awakened us with the earth-shaking KA-BOOMS of its presses. I lived under this blitzkrieg for the next nine years.

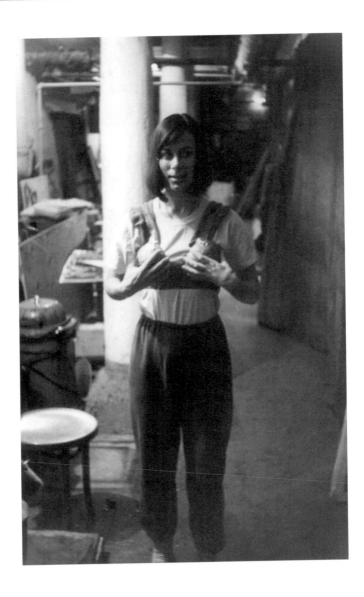

Backstage at the Café au Go Go, December 1964. YR as a "low element" in
a lead brassiere constructed by Bob Morris

12

Implosions

IN DECEMBER 1964 Dick Higgins produced an opera, *Hruslk,* at the Cafe au Go Go. In preparation he asked a number of artist friends to choose a character, costume, and action. On the basis of our responses he devised a script and cast himself as the master of ceremonies. I called my character a "Low Element," and Bob Morris fashioned a lead brassiere as costume. I asked Dick to introduce me with "The Low Element attempts to hoist herself on her own petard," upon which I tried to lift myself up off the floor by grasping my hands behind my knees, finally exploding with a prolonged yell. Since I spent most of the evening backstage, I remember Roy Lichtenstein as a spear-brandishing centurion and not much else.

Much of the noodling around I had done in Düsseldorf worked its way into *Parts of Some Sextets,* a 43-minute dance for ten people and twelve mattresses. *Sextets* contained a gamut of moves from "dancey" to simple hauling of mattresses and hurling of bodies upon them while my voice intoned a reading of excerpts from the eighteenth-century diary

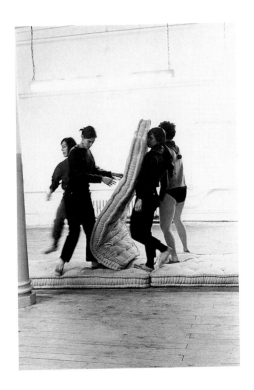

of William Bentley, a New England minister. The elephant story was his, beginning with "Went to the Market House to see the elephant. The crowd of spectators forbad me any but a general and superficial view of him. . . ." The ostensible use of the mattresses—for hauling and reconfiguring the space—was only a part of my intention. Very much on my mind were the immanent meanings—sleep, sex, death, illness—which I hoped would lambently surface via the taped readings.

The dance took eight weeks to learn. For the first four weeks we rehearsed four times a week; after that, two or three times a week. It proved to be dry, plodding work, partly due to the length and repetitiousness.

Rehearsal of *Parts of Some Sextets* (1965). YR, Lucinda Childs, Sally Gross, and Judith Dunn. Photo: © 1965 Al Giese.

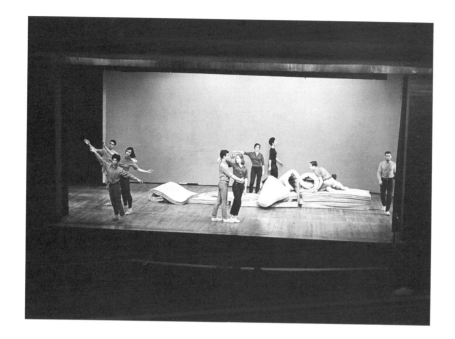

Also, since there was no "organic" or kinesthetic continuity and the hundreds of cues were words that occurred every thirty seconds in the taped reading, some of us found it extraordinarily difficult to learn and ended up memorizing them by rote, like multiplication tables or dates in history. An essay I subsequently wrote about this dance contained a paragraph that has since come back to haunt me:

NO to spectacle no to virtuosity no to transformations and magic and make-believe no to the glamour and transcendence of the star

Parts of Some Sextets, Wadsworth Atheneum, March 1965. Steve Paxton, Deborah Hay. YR, Tony Holder, Lucinda Childs, Sally Gross, Judith Dunn, Robert Rauschenberg, Robert Morris, and Joseph Schlichter. Photo by Peter Moore. © Estate of Peter Moore/VAGA, NY, NY.

image no to the heroic no to the anti-heroic no to trash imagery no to involvement of performer or spectator no to style no to camp no to seduction of spectator by the wiles of the performer no to eccentricity no to moving or being moved.

That infamous "NO manifesto" has dogged my heels ever since it was first published. Every dance critic who has ever come near my career has dragged it out, usually with a concomitant tsk-tsk. The only reason I am resurrecting it here is to put it in context as a provocation that originated in a particular piece of work. It was never meant to be prescriptive for all time for all choreographers, but rather, to do what the time honored tradition of the manifesto always intended manifestos to do: clear the air at a particular cultural and historical moment. I hope that someday mine will be laid to rest.

March 1965 was a tumultuous month. I shared a concert at Judson with Bob, had a solo evening at the Wadsworth Atheneum (invited by curator Sam Wagstaff), and was part of an evening at the Allbright Knox Museum in Buffalo. The crunch came after *Life* magazine covered the Buffalo concert, which had been arranged by Jill Johnston for a big arts festival there. Lucinda Childs performed her beautiful solo, *Carnation;* I presented a slightly abbreviated version of my magnum opus *Terrain* from 1963; and Bob premiered his *Waterman Switch,* a powerful enigmatic tribute to da Vinci and androgyny, in which Cindy wore a man's suit and hat and Bob and I wore baby oil. The *Life* spread showed a large full-color picture of Cindy's solo, a black-and-white photo of Bob and me locked in a tight oily embrace, and not even a mention of my MAGNUM OPUS! Ten years later I still felt the sting. To make matters worse,

the performing experience itself had been unpleasant. The audience—fresh from a cocktail party—was the rudest, drunkest, most loutish I had ever appeared before. Egged on by my shrink, I lowered the boom. Either Bob had to get out of my field or I had to get out of his life. With surprising good grace he eased himself out of "my field." We did one more tour together, to Scandinavia in the fall of 1965, and for the remainder of our relationship Bob no longer performed or made theater work.

Near the end of the Buffalo performance of *Waterman Switch,* as we completed our slow walk along the wooden tracks while locked in our "tight oily embrace," Bob dripped liquid mercury down my side from a vial he had been holding. At a post-performance party, after getting very drunk on tequila, I suddenly became violently ill. Bob took me to the bathroom and stayed by me as I alternately vomited and shat out my guts. The combination of the mercury and booze probably did me in. I was very moved by his solicitude. Not that I wasn't capable of the same when the need arose. Before going to Europe in 1964 he had come down with a high fever. I spent two days administering aspirin and changing his drenched sheets as he became more delirious. I finally called my doctor and filled a prescription for antibiotics. His temperature gradually returned to normal. It's quite likely I saved Bob Morris's life. He had picked a blister on his arm, which had resulted in septicemia. His turn would come soon enough to save mine.

There were additional consequences of the *Waterman Switch* affair. The piece was performed in our joint concert at Judson, following which, in response to the "nude dancing," the national organization of Baptist churches came down hard on Howard Moody, Judson's radical minister, and "excommunicated" the church. Howard didn't seem too perturbed by this. He certainly did nothing to curtail subsequent dance events. In those years nudity was even more disturbing to the establishment than it is

today, perhaps because there was so much of it in the downtown art scene. Oldenburg, Yayoi Kusama, Robert Whitman, and others were baring women's—rarely men's—bodies. Steve and I had performed in G-strings and pasties (for me) in our collaboration, *Word Words*, in 1963. Word of *Waterman Switch* evidently reached the TV networks. When a representative of a midnight talk show invited me to be a guest, I declined. The prospect of having to talk about "nude dancing" was not in the least attractive, especially since I had not choreographed the dance in question.

The most outlandish event of 1965 took place prior to our Scandinavian tour, in London, where I presented a solo concert at the Commonwealth Institute. It was produced by Michael White, who was also responsible for the Cunningham debut the previous year. Just prior to a pre-performance press conference, White advised me, "You know, the more outrageous you can be the more publicity we'll get." I didn't know what he was talking about until the tabloid reporters and photographers who had gathered in the theater kept badgering me about "nude dancing." They were even more salacious and persistent than the guy from the talk show in New York. It was useless to try to distract them from this topic by insisting that *Waterman Switch* was not my dance and would not be on the program. Finally, in utter exasperation, I ran outside the theater and around the block, grabbing their camera cases and climbing over cars, with about a dozen men in hot pursuit. Bob, who was waiting outside in a doorway reading a newspaper, was astonished to see the ragtag group hurtle past.

Upon returning from our Scandinavian tour, I resumed work on a new solo, calling it *The Mind Is a Muscle, Part 1*, a title that announced the first section—later called *Trio A*—of what would eventually be an evening-length dance for six people. I worked doggedly every day, accumulating tiny bits of movement. By the end of the year I was teaching it

t wait for tonight!

CHARLES GREVILLE

n the group of startled Pressmen, rowling like a mad dog.

Then she picked up cameras and equipment and started running through the treets, dumping camera cases in dustbins, laying hide and seek behind walls, unning up the back of parked cars and imping off their roofs.

"It was my way of demonstrating my rustration with you all," she explained.

Tonight, anything could happen.

ey's ld

r of course

hrough ic and photo-

iphs is /eiden- are 36 i notes glossy Francis igazine r de-

recious ll who dite of s and d keep their

non -

But the pictures freeze a fast-moving bit of time (the Julie Christie film "Darlin " is another segment of it), much as Toulouse-Lautrec's sketches caught the turn of the century Paris cafe life.

There are the inevitable names — Jean Shrimpton, Andrew Oldham, John Lennon, Mick Jagger, Brian Epstein.

Loftier

There is pop artist David Hockney, hat designing, boutique owning James Wedge, fashion designer Gerald McCann, actor Michael Caine, interior decorator David Hicks.

There is Chrissie Shrimpton, models Sue Murray and Celia Hammond, Rudolf Nureyev—plus a few remoter, loftier figures of the period

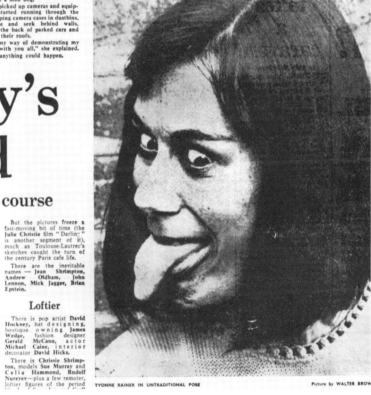

TYVONNE RAINER IN UNTRADITIONAL POSE

Picture by WALTER BROW

267

YR playing Einstein for the London tabloids, 1965

Robert Morris and YR in Copenhagen, 1965. Photo: Hakon Nielsen.

to Steve and David Gordon for a Judson concert the three of us would share in mid-January.

Trio A was basically a four-and-one-half minute solo performed simultaneously but not in unison by three people. It was the only dance of mine to be documented in film and thus survive in its entirety. At this early performance by me, Steve, and David, Alex Hay threw about a hundred three-foot wooden slats one at a time from the choir loft. They landed with a merciless regularity for the nine-minute duration of the dance (*Trio A* executed twice) and by the end formed a pile on one side of the sanctuary floor. During one performance a man in the first row

Studio photo: YR in *Trio A,* 1965. Photo: Zachary Freyman.

First performance of *Trio A,* Judson Church, 1966. David Gordon, YR, and Steve Paxton. Photo by Peter Moore. © Estate of Peter Moore/VAGA, NY, NY.

picked up a slat, placed a large white handkerchief on one end and waved it around in a gesture of capitulation as if to say, "Uncle! *Basta!*" Years later I learned he was the painter Sherman Drexler. Mine was not the only work on this program that offended. Among other pieces, Steve presented *Section of a New Unfinished Work, Augmented* for part of which a recording of excerpts from the Army-McCarthy hearings emanated from a small speaker tied to his head. The writer Ted Castle, an audience member, wrote me a disgruntled letter:

> When Paxton left the room to let the tape play, the audience had no longer anything to do, no reason to behave as audiences do, nothing to command its attention. Young ladies became mildly hysterical, people looked around and bit their nails. I was quite interested in the tapes though, and I was annoyed that I couldn't hear the words very often because of the recording or crummy speakers or an over-taxed machine.
>
> (Letter from Ted Castle, January 11, 1966)

In addition to his wonderful *Mannequin Dance,* David performed a solo in his BVDs, into which he spat. To leave the sanctuary audience members had to brave walking across the performance space, which quite a few of them did during his number. On top of this, Bob Morris singled out David for a blistering pan in a subsequent *Village Voice* review. David claims it stopped him cold from choreographing for the next five or six years.

 Bob Morris's regard had an entirely different effect on me. It was the light from *his* eyes that first illuminated my achievement as I described the making of *Trio A*. This may have taken place in Monte's, or maybe the San Remo, in the Village, over double vodka martinis in the

Steve Paxton's *Section of a New Unfinished Work, Augmented,* 1966. Photo by Peter Moore.
© Estate of Peter Moore/VAGA, NY, NY.

David Gordon's *Mannequin Dance* (1962), Judson Church, 1966. Photo by Peter Moore.
© Estate of Peter Moore/VAGA, NY, NY.

winter of 1965–66. I watched his expression change from polite attention to intense appreciation, even wonderment, as I described the details of creation. I was saved.

One would have thought that I had by this time received enough recognition from critics and peers to bolster my fragile ego, but that recognition seemed to have no cumulative effect. It was as though each time I made something I had to start from scratch to be convinced once more of my worth. Thus the feeling of being saved—momentarily—by "the light from his eyes." The following spring we had a confrontation over my self-effacing ways. Bob suddenly roared at me, "I hate false modesty!" I was so upset that, after leaving him a note, I hopped on the next TWA flight to San Francisco and my brother's safe haven. Belle offered the insight that Bob's attraction to me was based on my ambition, not lack of it. After five days I returned home. The warring components of my character—assertiveness, modesty, confidence, self-effacement, arrogance, "niceness"—were to produce unsettling repercussions, not only for me but for those around me, for many years.

The Mind Is a Muscle was presented at Judson in May of 1966 as a forty-minute work-in-progress. Performed by Becky Arnold, Bill Davis, Barbara Dilley, Peter Saul, David, Steve, and me, it contained four of the six sections that would constitute the finished dance. The slats made their appearance in the last section, now titled "Lecture," a special version of *Trio A* tailored to the balletic talents of Peter Saul. While teaching it to him, I stuck in a pirouette or jump wherever possible. Following the Judson show we all went to Max's Kansas City for dinner. Mickey Ruskin, the owner of the place, to my surprise and delight, sent a bottle of champagne to our table.

Ruskin, after consulting with painter Larry Poons and other artists for decorating ideas and a name, had opened Max's Kansas City on Park

Avenue South in December 1965. Basically a steak house—for $1.65 it offered a steak dinner and all the dried chick peas you cared to eat—it featured a fish tank containing barracuda and walls covered with paintings and reliefs of up-and-coming and arrived minimalists. It became the favorite watering hole of all the latest bicoastal art world luminaries. Bob Morris and I hung out there at least once a week. The people we saw the most were Don and Julie Judd, Robert Smithson and Nancy Holt, and Carl Andre and Rosemary Castoro. Max's was the main point of convergence.

In August 1966 Bob and I took a two-week auto trip to Maine. We went canoeing and hiking and slept beside mosquito-infested lakes or in rustic cabins. We climbed Mt. Katahdin, the highest peak in the Northeast, and made camp for the night. For months afterward Bob regaled our friends with the tale of my having lugged cans of cat food instead of tuna fish up and down the mountain. From my point of view, those two weeks fled past us. Later I couldn't remember a single argument, not even the kind of maneuvering for brief privacy that people do when they are together constantly. It seemed impossibly idyllic. Looking at those two weeks against the backdrop of later events, I was at a loss to understand the nature of his feelings. I felt like a fool thinking about it—deceived and humiliated. But I also felt a deep sadness. There was no denying my own happiness and sense of completion at the time. I wondered if he had ever felt such things in my presence, for even a single moment. Bob would later tell me that Barbara Rose asked him, "Where were you when I was giving birth to your child? After all, I did it for you." At which, he said, he hit her across the face. As it turned out, he was with me in Maine, dissembling to both of us.

MY FIRST PHYSICAL implosion was now in the making. Billy Klüver was organizing *Nine Evenings: Festival of Theater and Engineering,* a series of collaborations between artists and Bell Laboratory scientists to take place in the fall of 1966 at the Armory on Lexington Avenue and 25th Street. The artists besides myself were Cage, Rauschenberg, Childs, the Hays, Paxton, and Fahlstrom. My collaboration with physicist Per Biorn was called *Carriage Discreteness,* and my two evenings would be shared with John Cage, the first one on October 15. As the opening date of *Nine Evenings* drew near, it became apparent that the technicalities of the venture were overwhelming for everyone. The massive platform that contained John's electronic gear had rolled over and severed the hundreds of cables that would transmit internal and external sources of sound. Everyone was enlisted in the time-consuming task of scraping and splicing wires. At the same time I was assembling hundreds of objects that were to be moved either electronically or by my performers, ranging from a single sheet of typing paper to six mattresses and two fifty-pound Otis elevator weights. For a week before my October 15th performance I became Per Biorn's errand girl, going back and forth to Lafayette Street to buy motors, transistors, circuit boards, and other paraphernalia required for the programming of the remote controlled "events" in my piece. The work went on day and night. I hardly slept. On the evening of the performance I sat with my walkie-talkie in the remote balcony overlooking the 200 × 200-foot performing area like a sultan surveying his troops on a vast marching field. (The choice of this imperial position has been a source of much subsequent embarrassment for me. Why couldn't I have allowed the performers to move the objects in any way they pleased? After all, the piece was about "the idea of effort and finding precise ways in which effort can be made evident or not." But no, I had to exercise my controlling directorial hand.)

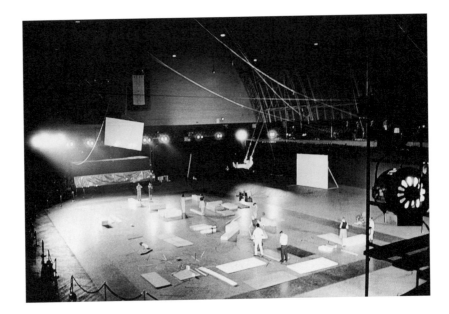

The walkie-talkies didn't function. Nothing seemed to be happening. The audience, primed by the publicity that had touted the festival with all the fanfare of a Ringling Brothers Circus, became restive and began to clap in a hostile rhythm. Rauschenberg suddenly appeared on his hands and knees at my feet to tell me that the electronic events weren't working. (I later learned that they had been programmed backwards.) Finally all I could do was instruct the performers to move the objects at random. My piece was a fiasco; John's seemed to go off okay. A few of us unwound at Max's Kansas City afterward. I ate two big lamb chops. From lack of sleep and stress I was in a zombie-like state. I hardly slept

Carriage Discreteness (Steve Paxton on the swing) "Nine Evenings: Festival of Theater and Engineering," 1966. Photo by Peter Moore. © Estate of Peter Moore/VAGA, NY, NY.

that night, and toward morning when I got up with a stomachache and sat on the toilet, my abdomen suddenly swelled with such pain that I began to pass out. My cries awakened Bob, who bundled me into his bathrobe and called Bob and Steve. Steve carried me down the steep stairs and the four of us took a cab to St. Vincent's hospital. I remember treading with my hands like a cat against Rauschenberg's legs in the back seat; I remember all of them screaming at the cabbie to go north up 7th Avenue against the one-way traffic in order to get us closer to the emergency entrance; I remember Rauschenberg carrying me from the cab, gasping, "Oh my god, oh my god." I weighed a good 140 pounds. The next thing I remember is lying on a gurney and projectile vomiting black liquid into a basin held by a nurse standing five feet away from me. Then I was in a ward, again vomiting while a group of interns stood at the foot of the bed. I heard one of them exclaim, "What could she have eaten?" "LAMB CHOPS!" I screeched from the semi-comatose depths of my nightmare. No one seemed to be doing anything for me. I was in agony. "PLEASE DON'T LEAVE ME LIKE THIS!" I screamed at them.

Dear Yvonne:

Hello: what color are your hospital walls?! Do you face them from your bed/and/or/chair, or a window? I don't really know what news I should be telling you from the outside . . . Backstage, at the Armory, there was a blackboard, with a report on your condition "Yvonne is improving" . . . just like one of those Hollywood movies about the life backstage, all the chorus girls crowding around the blackboard! The show must go on! Your show went very smoothly, I thought!

Mickey Ruskin almost blamed your illness on his food— when you ate supper there!

(Letter from Julie Finch Judd, November 2, 1966)

Bob Morris reorganized my dance and took my place in the second performance, which, I was subsequently told, went well. On the second day I was operated on. Adhesions, stemming from an appendectomy at age eleven, had caused a blockage at the end of my ileum and in adjacent blood vessels. I had gangrene and peritonitis. The resident surgeon cut out four feet of gangrenous small intestine and reconnected what remained to my transverse colon, leaving a "blind loop" of ascending colon. The procedure was called an "end-side ileo-transverse colostomy." (A gastroenterologist once told me that President Eisenhower was the only one she had ever heard of with a similar intestinal arrangement.) They gave me a fifty per cent chance of surviving. I remember the levitating feeling from a morphine injection. I remember being in intensive care and my surgeon slicing into my upper arms to make "cut-backs" for blood pressure and heart monitoring and muttering, "You have to be an anal-compulsive to do this kind of work." I remember Deborah Hay and Viola Farber at my bedside. I was so weak I couldn't find my voice.

In my early 30s I was in an intensive care unit after passing the critical stage of a serious illness. Theresa, the Puerto Rican day nurse, was trying to haul me out of bed and into a chair for the first time. I was so weak my legs wouldn't support me. As she struggled, I felt an inexplicable contempt for her. Some days later, after I had been transferred to a ward, my neighbor in the adjacent bed spoke admiringly of Theresa. When she had been in intensive care, Theresa had cared for her "like an angel."
(*Privilege*, 1990)

278

I survived. I was convalescent for the next six months, not able to do much. I remember being hailed on the street by some hooligans with,

"Hey skinny!" a form of address I had never encountered before. During this time I saw Michael Snow's *Wavelength* at Anthology Film Archives on Wooster Street. Thinking I knew what the "minimal" film was about I went downstairs to pee and missed the dramatic death of Hollis Frampton in the middle of it. For years afterward I never understood what people were talking about. I went to the Judson gym twice a week to work out and practice a frail and light *Trio A*. On February 2, 1967, I performed *Trio A* as *Convalescent Dance* at Hunter College for *Angry Arts Week*, a series of exhibitions and performances mounted to protest the Vietnam War. Bob and I marched in some of the big New York antiwar demonstrations during this period.

In April my intestinal demon struck again. This time adhesions had sprouted at the site of the previous "anastomosis," where ileum had been attached to colon, resulting in blockage of my jejunum. Since no blood vessels were involved, they simply "liced," or disentangled, the adhesions—if they are cut out, more grow in their place like the mythical Hydra's heads—and freed up that portion of my gut. I developed a high fever. They put me in the "ice blankets," where I rattled and shook all night long, the torture finally coaxing my temperature of 107 degrees back to normal. A shorter convalescence followed. However, this was by no means the end of my gut tribulations.

In May 1967 an administrator for the Harkness Ballet invited me, Steve, Lucinda, and Trisha to be interviewed by Rebecca Harkness, who was looking for new choreography for her company. We were ushered into a wood-paneled, sumptuously furnished parlor to meet a throw-back to World War II womanhood, from spectator pumps to ratted coiffeur. We described our ideas, including Steve's *Satisfyin' Lover* and my *We Shall Run*. Mrs. Harkness was predictably shocked. "How can you expect these dancers, who have spent their whole lives training for the classical

ballet," she expostulated, "how can you expect them to do nothing but walk and run on the stage?!" We didn't get the gig, but had she lived, Mrs. Harkness might have been equally shocked to have seen some of these dances staged thirty-five years later during Mikhail Baryshnikov's dive into 1960s' dance.

Around the same time a young woman from *Harper's Bazaar* came to our loft to interview me for a special issue of the magazine called "100 American Women of Accomplishment." In response to her question, "What do you value most?" I replied "Being a part of one's time." When the issue came out, Lady Bird Johnson was number 1 in a full-page photo, and I was number 100 in a photo the size of a postage stamp on the last page. Beside my picture was the misquote, "Using one's time well."

IN LATE JUNE 1967 I am on a plane bound for Rome, where I will catch a train to Spoleto. I have been invited to perform in the festival there. I am once more in a state of barely controlled terror. I sit with a bunch of young Italian-American men from Little Italy, all returning to the old country to visit relatives. There is much flirting and wise-cracking. One of them, to the knowing winks and innuendoes of his companions, offers to take me under his wing. He is the only one going on to Naples by train. Without its having to be spoken, I know the quid pro quo: In return for my sexual favors he will help me, using his rudimentary Italian, to purchase a ticket for a Spoleto-bound train. It seems a fair enough deal. My overwhelming and irrational fear of being stranded, abandoned, lost in a strange country, is assuaged. He and I arrive at a pension a block from the train terminal, one of many in the neighborhood that cater to just such needs of tired or horny travelers. We take turns bathing in the bathroom down the hall, have sex in the sagging double bed—not very pleasurable for either of us—then dress and walk to the station, where he buys my ticket, steers me to the proper platform, and says good-bye. We don't exchange our New York phone numbers.

I sit in a compartment, the only woman with five working-class men who all look like distant relatives. I manage to impart that my father came from a town near Biella. "Ah Biella, tre bella." The train begins to climb into the foothills of the Apennines. Every time it goes through a tunnel there is total blackness and I feel a hand on my knee, and when the train exits, so does the hand.

In Spoleto I take a room with a family. I learn to my chagrin that all the Festival wants of me is a five-minute dance when I have brought an hour-length *The Mind Is a Muscle* for two dancers, myself and Bill Davis, who is to arrive two days later. The evenings are very strictly

Chapter 12

Implosions

281

arranged: At 6 PM you go to the modern dance concert in the tiny theater; at 7 PM you go for cocktails; at 8 PM you see the grand opera in the grand opera house; and at 10 PM you eat dinner. I am determined to present my whole opus, and they agree that Bill and I can go on at 6:55, and those who so desire can leave for their cocktail hour. Following a dramatic reptilian solo by choreographer Manuel Alum, we start at 6:55, and, sure enough, the theater empties out at 7 PM, leaving five people who have come just to see my work, John Weber and his wife, Annina Nosei, John's eight-year-old daughter, and several of their friends. Afterward we go to dinner where we eat trout broiled on an open hearth. It is one of two memorable meals in Spoleto. The other is in a mountain-top restaurant on our last night. I eat an unbelievable pasta carbonara. Bill and I see *Don Giovanni* with Henry Moore sets, a stunning spectacle. The town is awash in large divas in splendid couture sailing through the streets followed by acolytes. It's all reminiscent of a Fellini movie.

Bill and I flirt and pet a bit. I love talking with him; for me, the flow of language always produces desire. Nothing more comes of it. After all, he has lived with his dancer companion, Albert Reid, ever since college. Besides, the very traditional families with whom we are staying make it very clear: no visitors of the opposite sex.

On my return to Rome, Annina and John take me to Ostia Antica on the outskirts of the city, where we watch a Greek play in an outdoor amphitheater. I remember the full moon, the ancient stones, and the *cothurni* of the chorus more than the play. I visit Annina's family villa in Ansedonia, north of Rome. The village is by the sea, and we walk interminable steps cut into the cliff to reach the water, which is the color of verdigris, the view breath-taking. We dine at a local outdoor pavilion where rich beautiful people gather with easy grace, their light bubbly voices floating on the limpid air. They all look like movie stars. In fact, I

meet Bernardo Bertolucci. He is 27 years old. *Before the Revolution* is behind him, *The Spider's Stratagem* ahead. He reclines languorously on the patio. Their velvety Italian spills from their mouths. Everything seems silky, languorous, and easy in the Tyrrhenian sun.

I stay in Rome several more days and eat shrimp salad for lunch in a trattoria. The next day I begin to feel odd. Returning to New York for only a few days, I depart for Aspen, Colorado, where Bob is in residence at a summer arts program, along with Claes Oldenburg, Roy Lichtenstein, and Les Levine. I feel stranger and stranger, attributing my lassitude to the altitude. Two weeks go by. We are staying in a cabin six miles outside of town beside a torrentially noisy river. I feel weaker and weaker and am having shits that smell like a chemical factory. I play tennis with Bob. He grows impatient with me when I can hardly run after the ball. I make an appointment with a local doctor for the following day. In the middle of the night I wake up with a familiar pain, not as explosive as the first or second time, yet unmistakable. I wake Bob and we dress and get into the car; he drives while I lie on the back seat. I try to calm him as he begins shouting and pounding the dashboard. We are let into the small local hospital. A doctor is called. He arrives, a very nervous orthopedic surgeon, used to dealing with broken legs, not this. Bob and I are both talking at once, desperately intent on filling him in on my medical history. He tells us to shut up and tries to get a tube down my throat that will extract the contents of my stomach. After several attempts he succeeds, then sedates me, or maybe he sedates me first. He also puts me on an IV. There's no way I can be treated in this hospital. I will have to be flown to Denver, but a plane can't fly out of these mountains until daybreak. I don't know how much time elapses. Finally I am wheeled out of the hospital. I see all our friends at the entrance: Claes and Patty, Roy and Dorothy, Les and Otsuko, who is a nurse. The next thing I remember is

being lifted on a stretcher into a small plane. Otsuko and Bob are coming with me. The plane takes off. The early morning sun streams through the windows and warms my face. It is the most glorious scene I have ever beheld: the deeply shadowed peaks and valleys, the sun as I have never felt it. It is like an LSD high.

At St. Joseph's Hospital in Denver, Otsuko stays by my bedside, removes my tampon, makes me comfortable. Due to the medication I am not in pain, but I am in trouble. I meet my surgeon, Dr. W. L. Reimers, a forty-ish handsome guy who keeps me sedated, unlike the New York doctors who withheld pain medication because they wanted "to see what's happening." Otsuko disappears. I never see her again because she and Les Levine split up shortly thereafter.

I am prepared for the operating room. There Reimers and his anesthesiologist, both of them well-built men over six feet tall, stand chatting with me, leaning casually against some cabinets and in no particular hurry to start their work. After a few minutes Reimers says to his colleague, "Well, shall we begin?" The two of them lift me onto the operating table as if I'm as light as a feather. I feel I am in good hands. Reimers later writes, "Exploration at this time revealed a 3 to 4 foot segment of gangrenous bowel in the upper jejunum. This was resected with an end-to-end anastomosis and obvious contamination of the abdominal cavity."

Something is wrong. A week later in the middle of the night, still bed-ridden, I have to pee and call for a nurse's aid to help me onto a bedpan. As I raise my hips I feel a searing pain in my diaphragm. They immediately sedate me. An X-ray reveals a subphrenic abscess that must be drained in another major surgery. Reimers assures me it won't be painful. I wake up from the surgery in agony as they are wheeling me into the recovery room. I scream and revile him for lying to me. The sur-

gery is not entirely successful. He has removed my left floating rib in the process, but the infection continues to fester. Nine days later he operates again and drains the cavity. I am placed in some kind of isolation room where someone comes every half hour to turn me from one side to the other. To be moved or jostled or touched is excruciating, but it must be done. Bob visits and stands at a distance, dressed in hospital scrubs, booties and mask. I am finally returned to the ward. I have a new room-mate, a young Pawnee woman from an Oklahoma reservation who is suffering from ulcers. Her Anglo husband visits almost everyday. She tells me they are quite well off, as there is oil on the reservation and the drilling profits are distributed among the tribe. Bob also visits every day. He is staying with his younger sister, who, with her husband, runs a dry-cleaning business in Denver.

By now I am addicted to Demerol. Every night I wake up in sheets drenched with sweat. A male nurse on the night shift patiently changes them, turning me from side to side as he pushes the fresh dry sheets into place. The food is terrible and I have no appetite. I also have a low-grade fever that doesn't change. Ivan flies in from Berkeley. He jostles the bed accidentally, and I call him a slob. Roy Lichtenstein visits and gives me an annotated copy of *Alice in Wonderland* with the original drawings. Stan Brakhage comes to visit and advises me, "Now, Yvonne, you really have to put your mind to figuring out why this has happened three times in a row." No doctor seems to know. No one knows why some people develop adhesions after surgery and some don't. Adhesions seem to have very low status as subjects of research. (I doubt if they know any more now in 2004 than they did thirty-seven years ago.) One doctor would commiserate, "You're one of the most unfortunate young women I've ever met." When I ask Dr. Reimers if there are a lot of adhesions in my abdomen, he rolls his eyes.

After three weeks in the hospital I am released. Weak as a fly and down to 107 pounds (from my accustomed 140), I lie about Bob's sister's house for a week—Bob has already returned to New York—until Donna tells me my presence is disrupting their lives. I have taken their hospitality for granted, too absorbed in my own abysmal condition to be sensitive to theirs. After one last visit to see Dr. Reimers, who gives me the name of a New York gastroenterologist, I am driven to the airport by Donna's husband, Bob Caudle, who then pushes me in a wheelchair to my departure gate. The last time I see him is as the plane is leaving its berth. He is watching through a window in the waiting area.

Some details of the people who came to my aid during this time are riveted in my memory: Otsuko's gentle face as she bends over me; Dr. Reimers's red shantung short-sleeved shirt as he removes my stitches; Bob standing in his scrubs watching me in the isolation room, later at my bedside, reading aloud from Bertrand Russell; the tub of Cool Whip on Donna's kitchen table; Bob Caudle's small figure behind the air terminal window as my plane backs away from the jetway. With the exception of Bob Morris, I never see any of them—nor eat Cool Whip—again.

Improvisation, Washington Square Galleries, 1964. YR and Jill Johnston. Photo by Peter Moore.
© Estate of Peter Moore/VAGA, NY, NY.

13

Divertissement

IT IS TIME to pay tribute to Jill Johnston, the inimitable champion of the Judson Dance Theater. I wrote the following for an issue of Les Levine's newspaper, *Culture Hero,* all of it devoted to just such a tribute in 1968:

1,500 words about JJ! Good God (I've done 8 already), it would be hard for me to write that many about me. I shall just have to try to run off at the mouth nonstop, no niggling, no erasing, no adjustments, no getting the record straight, no trial by jury in other words: a rough approximation of the style of JJ herself. Indeed. Stopped dead, whew. I can't remember where I first met her—sometime between 1959 and 1961. It says a lot about me that at that time I was picking up on people who were picking up on me, so my first conscious memory of her was at a dance concert at the 92nd Street Y, probably one of those deadly dull affairs that everyone went to

because of the general dearth and just to keep up and because we dancers had only just begun to take the first faltering step in trying to connect up to western civilization (those of us in our twenties in the early sixties) or certain aspects of it. We hadn't yet realized that the 92nd St. Y was a cemetery, that venerable repository of cranky ladies in Mexican jewelry and sagging boots with wizened faces not getting old with good grace in the audience, and crazy ladies on the stage eking out their private agonies, fantasies, and deprivations in the name of all that is or was holy and aesthetic. Their raptures, ecstasies, and agonies even then or maybe especially then turned me off or turned me on to my own holy mission. Unbeknownst to me I was well on my way to joining their ranks. So I met Jill at this concert with Sally Gross, I forget whose concert it was, Jill evidently had just written something about me in the *Village Voice* because I remember thanking her and she acknowledged my thanks—something about there being no need for it and it was all very formal. The nonverbal part of this contact remains the clearest part of the memory because it was something that reoccurs periodically in my irregular meetings with JJ and at times drives me up the wall: It was the way she looked at me, the gaze very intent, the expression indicating detachment, calculation, and bemusement. People with pale eyes always make me uncomfortable. I guess that is why I have a habit of looking at people's mouths during conversation; too many people in the world have pale eyes (and the Word is easier to deal with than whatever it is in them there eyes. Hmm . . . I'll have to think about that). In a strange way I have come to value that detached gaze of JJ's. It has come to mean, "Now there's a creature as strange as I am." I know very well it could mean anything or nothing at all, but what it sometimes does is stop

me cold in my presumption that everyone in the world is as franti-
cally engaged in the pursuit of sanity and rationality as I. (Is this
about her or about me? I am managing to churn it out if not in a
manner that I thought I might.) Jill's early role in relation to me, that
of self-styled PR-lady, unfortunately incurred a debt that I feel un-
equipped to repay in mind. My hindsight for the details of her life
is very much blurred by self-involvement and intense ambition. I re-
member lots of loft parties, which we undoubtedly attended together,
and in the peripheral vision of my mind's eye I see her gyrating madly
somewhere in the vicinity of my gyrations. Our party craziness over-
lapped for awhile. Mine died or withered or something long before
hers did; I guess hers never did: it was simply that those big loft
bashes gave out. People got tired, splintered, smaller scenes prolif-
erated. I remember Jill lying on people's laps in a Volkswagen bus
singing at the top of a drunken voice those British-American revolu-
tionary songs: Prince Charlie, King George, and all that, and we
ended up at the old Dom now the Electric Circus and Jill leaning over
me and not getting the response she wanted saying, "Oh Yvonne,
you're impossible." She always claimed that Bob Morris ruined me.
I could tell her only much later in fact quite recently about how much
I helped him out in that area. Now that I think about it, a lot of things
coincided or overlapped in our lives—JJ's and mine. Her entry into
dance writing and mine into dancing. And our natural disasters or
disasters de la guerre. One potent memory is me lying low in the crit-
ical ward of St. Vincent Hospital, my then shrink by the bed helping
me to open an envelope containing a feisty salutation from Jill in the
St. Vincent psycho ward. I got out before she did that time. As far as
I know we each had three official "dissolutions," mine within a much

shorter time span. I have come to consider mine breakdowns; I suspect she has a more transcendental view of hers, that they were breakups. Maybe because her ass is higher than mine. I entertain for this moment the quaint notion that people with low-slung asses have their feet on the ground. Of course by the fact of my own brief sojourn at Bellevue and also through direct observation while there, this notion cannot be entirely confirmed. The diet in mental institutions is not conducive to the maintenance of a high ass. (Notwithstanding that Jill emerged unscathed on that score.) Since I lost a lot of weight while there, could it be that The Ass Also Rises? Foo. Keep it light, keep it light. One last foray: Jo Baer says that high asses are challenging. She ought to know.

I get very mad at Jill when she repeats something I say in her column or when I find out she's mad at me through reading the vv. She avoids direct communication. That's her trouble, that's my trouble, that's everybody's trouble. End sermon. Sorry Jo. Now I am remembering a dance that Jill and I actually really and truly did together at a place called the Washington Square Gallery around 1964. That gallery was something else: Ruth Kligman ran it; there apparently had been a huge bundle invested in it, it was four or five floors (no elevator!), the investment most conspicuous in the plushiest office I'd ever seen sitting like a throne atop a short balustraded berugged flight of stairs off the ground floor. You could tell the place was doomed as soon as you came in the door. The dance was to be a collaborative improvisation full of spontaneous determination and indeterminacy and chancy randomness. (O world, forgive my perpetuation of these semantic pods of unnatural thought.) It was agreed that we would each do our thing. I forget what we called it. Jill

had some muciz *[sic]* she wanted to use: Bach, Purcell, Monteverdi. She fortified herself with frequent guzzles from a bottle of vodka during the hour before the performance, making the professionals who were sharing the program somewhat uptight. Now there again my memory blurs: I really can't say what she did in that performance; I hardly can say what I did. Well let's see, I did some cathartic-type rolling around on the floor (I had very strong thighs then), coming up on the knees, falling back, also some rushing toward the front row of audience and flinging myself into a lap (one lap belonged to Larry Kornfeld, maybe another was David Bourdon's; did this several times). Jill and I converged at several points. I saw her waving around on the balcony, maybe hanging over the railing and I rushed over and tried to chin myself on the railing. Another time she was standing with her legs spread and I may have dived thru or twined around them. It was a time (early sixties, definite Halprin-Forti influence on improvisation) when if you saw someone's legs spread you dived thru. What else was there to do with someone's spread legs? Jill later said that she was very surprised at my trying to "relate" to her; she had really never expected anything like that. I have another image of Jill, perhaps not solely from this dance, of her doing her slow-motion giant behemoth thing, arms akimbo, head tilted to the side, face screwed up in intense concentration, torso ever-so-heavily revolving from side to side. She was always making a lot of people indignant, but a lot more people (and I secretly) admired her for it—like when she and Bob Morris did a thing at the Pocket Theater the previous year and flooded the stage. I didn't see the piece because I was on the same program and had to get into a G-string for an appearance in a Jimmy Waring extravaganza that followed their thing. Suddenly everyone

was screaming about the water, how we'd all break our necks "out there" ("out there" means stage), and she was dead drunk on top of it to boot. The Jilly Bean had struck again. Oh, and then for awhile there were some sad scenes when JJ became an impresario and set up out-of-town concerts for some of us. I remember a particularly dismal one—perhaps it was the last—at Fairleigh Dickinson University involving Jill, me, and David Gordon in what I think was his last performance of his own work. There were five people in the audience. Becky Arnold was there seeing me for the first time. (Becky now dances with me.) Jill had a terrible time; the microphones didn't work; her lecture didn't carry. It was just after a blizzard. The vw that had picked us up at the station had skidded into a brick gatepost, shaking us up quite a bit, then as soon as we got going again, it skidded—very slowly, dreamlike—into an oncoming car. Jill got shaken around the worst—front seat next to driver. Banged head, scraped knee, sprained finger. I guess all that was before the performance. Remembering this gives me the shakes; I know one shouldn't tour in the winter in a car, and I just got thru doing it again. Suicide.

Suddenly my 1,500 words have taken on a melancholia. I can't pretend that in the last ten years Jill and I have not been thru painful times. Though I laugh at some of those times, it is not so easy with others. But it is true that many of the unpleasant experiences we shared now definitely seem funny. Even your last *vv* column, Jill. And how about last fall—me sitting around after my most recent operation and you dispossessed of a home—the two of us getting up every morning, mooning over coffee cups, and fiercely engaged in a contest of who has more reason to be miserable. As usual I was determined to win. I must admit that your strategies baffled me. Perhaps it was a draw.

My life has now emerged along a different facet. I haven't seen you since that peculiar dinner at the Cookery—martinis, Gibsons, and chicken salad—when you kept me in stitches with the first ten pages of your memoirs, and later I watched you get into your mother's walrus-car with the left side all bashed in. I hope you too have turned a corner.

If this isn't 1,500 words then I don't know what is.

Dressing room shenanigans, Billy Rose Theatre, February 1969. David Gordon, Jennifer Tipton, YR, Heywood Becker, Susan Marshall, Frances Brooks, Steve Paxton, Judy Padow, Becky Arnold, Douglas Dunn, Fredric Lehrman, Frances Barth, Barbara Jarvis, and Rosemarie Castoro

14

Prelude to Melodrama

WHILE I WAS still in St. Joseph's Hospital, Bob Rauschenberg flew out to Denver to visit. I was very moved that he had come all that way in spite of a bad cold. Upon my return, since Bob Morris was going to be busy with teaching and preparing for exhibitions, and our loft was full of fiberglass fumes, Rauschenberg offered a room in his Lafayette Street building for my convalescence. Deborah Hay came over every day to care for me. Deborah always seemed to be preternaturally cheerful and upbeat; she certainly contributed to making my situation bearable. I was still very sick, having to sprint to the bathroom every couple of hours either to vomit or shit. Food either refused to stay down or raced through me. I was eventually admitted to New York Hospital, where I stayed for a month while undergoing countless tests to determine why I still had a fever. It was finally determined that I had contracted hepatitis from a blood transfusion in Denver. It seemed to be going away; my temperature was down, and my strength was returning.

Bob Morris brought my Wollensack to the hospital so I could record myself reading Dr. Reimers's letter to my NY gastroenterologist.

I had been invited to present work on a "Choreoconcert" at the New School in October and asked Becky Arnold and Bill Davis to perform "Mat" from *The Mind Is a Muscle* to the accompaniment of my reading. The absent choreographer was thus invoked in her diseased particulars while the robust dancers went through their athletic paces with two mats and two twelve-pound dumbbells.

Upon being released from the hospital, still convalescent and underweight, I worked with Becky and Bill, having them "learn" my watery-legged movement as I shakily negotiated running, crawling, getting from a chair to a high stool and back down again. After the first session I got

Becky Arnold and Bill Davis rehearsing *Mat*, The New School, 1967. Photo: Julie Abeles.

the idea of a staircase with two stairs the exact height of the chair and stool and wide enough to accommodate two people climbing at the same time. The next day June Ekman, whom I had met in 1960 at the Halprin workshop and who had been an active participant at Judson, told me about a dream she had in which she couldn't figure out why Becky, Bill, and I were having so much difficulty climbing a staircase with tiny steps. As a result I widened the staircase and added two tiny steps at the top. Bob built and carpeted the contraption and put it on wheels so that it could be moved around. It was ultimately incorporated into *The Mind Is a Muscle* as "Stairs," a trio for David, Steve, and me.

"Stairs," a section of *The Mind Is a Muscle*, Anderson Theatre, 1968. David Gordon, Steve Paxton, and YR. Photo: Julie Abeles.

NEEDLESS TO SAY, our sex life was pretty much disrupted by all this illness. I remember undressing my skeletal body, standing over Bob as he lay in bed, and lamenting, "I feel so weak and ugly." He in turn was afraid of hurting me. My withdrawn presence also embarrassed him when collectors visited to look at his work. The loft was totally open at this point. The only place I could hide was on a mattress behind a low bookshelf at one end of it. Bob eventually built an enclosed office for me. For the next three months I did a lot of sitting around in our red leather armchair from the Salvation Army, doing next to nothing, until he couldn't stand it anymore and berated me. I was regaining some of my weight and seemed relatively healthy, so he didn't see any reason for my indolence.

I slowly got back to work. *The Mind Is a Muscle* was premiered in its entirety at Brandeis University on January 12, 1968, later presented in New York at the Anderson Theater on 2nd Avenue in April. Peter Saul was unavailable for either production. I was stuck. I had grandiose fantasies of Jacques D'Amboise appearing at the end from nowhere to do a bravura *Trio A*. Next in line in my fantasy dance was Merce Cunningham. I became obsessed with this idea and eventually proposed it to him at a party. He laughingly declined. I finally did it myself in tap shoes—minus the balletic furbelows—with the slats shot in from a ladder in the wings and with a wooden grid that filled the proscenium space descending in the middle of the solo. It stayed down for one minute, then ascended out of sight. I had the same ambivalence about decor that I had about music: It shouldn't hang around too long, and the more grand the effect, the briefer the appearance. I still think it would have been a stunning—if anticlimactic—ploy to have one of those great dancers appear at the end of the evening.

John Erdman, then an undergraduate at Tufts, and some fellow students attended the Brandeis performance. When he and his companions emerged from the auditorium and one of them pointed toward the

men's room, it was as though they had never seen that gesture before. The performance "opened my eyes," he said. The external world of everyday activity—illuminated by my "pedestrian," or task-like chore-ography—shimmered with a new reality. John subsequently dropped out of school and came to New York to study and eventually perform with me, also becoming a close friend. The dance reviewer for the *Boston Globe* panned the concert, disdaining our "slack bodies." I have a feeling she meant mine in particular, which was still underweight and, with its protruding, postsurgical belly, not very trim. Three New York perfor-mances followed at the Anderson Theater in April in a series shared with Deborah Hay.

January 14, 1968

Dear Yvonne:

I thought a good deal about your "ballet" when I came home last evening . . . before I say a word about my "thoughts" let me tell you that what you are doing is remarkable! Whatever "difficulties" there may be in your work for audiences, feel certain that no other young choreographer (that I know of) is going as *far* or as seriously into the unknown as you are. The work is quite unique, but for rea-sons which I suppose are all but impossible to verbalize, or take apart, or demonstrate through critical analysis. . . .

For me what I saw yesterday was the most extreme Realism I had ever seen in dance . . . When I first saw *The Mind Is A Muscle* I was impressed at that time with the lyrical onrush of movement— at times, almost rhapsodic in its celebration of the bodies' (the dancers') release of energy/and/or containment of energy. Yester-day what I seemed to be experiencing was quite different. At the moment the little film of a foot gently nudging a ball came on, my

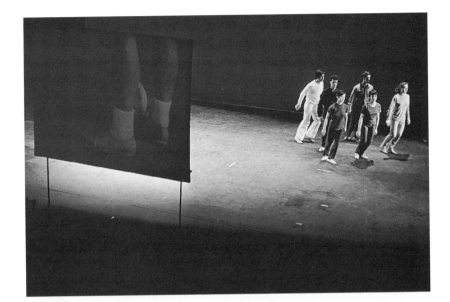

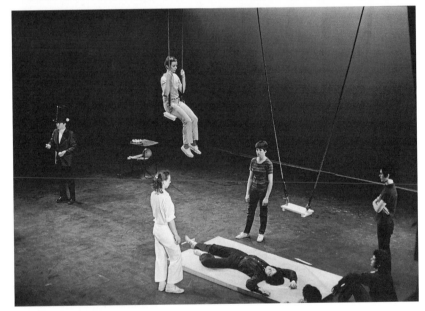

302

"Film," *The Mind Is a Muscle,* Anderson Theatre, 1968. David Gordon, Bill Davis, YR, Steve Paxton, Gay Delanghe, and Becky Arnold. Photo by Peter Moore. © Estate of Peter Moore/VAGA, NY, NY.

"Act," *The Mind Is a Muscle,* Anderson Theatre, 1968. Harry de Dio, Barbara Dilley, Gay De-langhe, Steve Paxton, Becky Arnold, Bill Davis, David Gordon, and YR. Photo by Peter Moore. © Estate of Peter Moore/VAGA, NY, NY.

reaction was to see the whole "ballet" as a form of "preaching": "This is what the body is about." The body is cool, or it sweats; it cannot ignore gravity, best give in to it. The body leaps; it falls down. We can balance ourselves, but only for a moment or two. The body gets tired. It gets dirty. It gets short of breath. . . .

All of these things and more are in your work. But can you understand my kind of shocked awareness that a dancer and choreographer has set out to "teach" the public what the Body is all about? I have a tendency to reject didactic art, though this is silly. A good deal of the art I admire *is* didactic (Tolstoy, Courbet, Kafka, Rodin, Morris, Judd, to name a few). Yet it has created a problem for me since I have always gone to the dance simply for pleasure, a sweet dear "kinetic response." The kind of dancing I most enjoy is basically sexual and alluring.

The questions your art proposes are very hard to face. Should the public be asked to face them? The answer of course is a resounding "Yes!" But, my dear Yvonne, I hope you are prepared to accept the fact that they may kick like hell. . . .

Once again let me congratulate you on your total devotion to truth in The Body. Few artists have this degree of courage.
(Letter from John Bernard Myers, then director of the Tibor DeNagy Gallery, New York)

In February Bob traveled to Amsterdam and Paris for several one-man shows. His letters are chatty and descriptive—about the museum people and collectors he was meeting and the complications of delays in shipping and installation—and end with affectionate sign-offs. There is a note of frustration in a letter dated February 17, 1968, in which he expresses a wish to get out of New York and complains that our life in the

city is only about work: "All we do is work." The depth of that immersion becomes clear in an incident that occurred while driving upstate on a deserted two-lane country road on our way to visit Eugene Goosen, the dean of the Hunter College Art Department (where Bob was working on his Ph.D. thesis on Brancusi). We were each silently engrossed in our own thoughts, he fantasizing about sculpture, I, in the passenger seat, about choreography. Suddenly something was happening. Seeming to move in slow motion, the car was careening to the left, finally coming to rest facing the opposite direction in the other lane. The only sound I heard was my own voice moaning, "Oh no, oh no, oh no." Bob had taken a curve too fast and to avoid hitting a tree had sharply turned the wheel. We were lucky. There was no traffic in the other lane.

In June 1968 Bob began teaching a sculpture course at the University of California at Berkeley. While waiting to sublet a house in San Francisco, he stayed with Belle and Ivan in Berkeley. Our tensions were beginning to be examined openly. From New York, I wrote to him:

Bob:

I must tell you how I feel. I was very upset after talking to you tonight. . . . What really bothers me is that you may be entertaining the idea of an affair with Meredith. Unless you have made up your mind as to what you want to happen between us (and I doubt very much if this is so) I must ask you to use some discretion and not do it. Aside from the fact that I would lose a friend, it would provide such fertile ground for fresh wounds and complications that I don't think I could ever make an honest commitment to you again. Your concern for Meredith's welfare is admirable, but your efforts to manipulate Belle sound very peculiar to me. Do you really want to subject Meredith to that oppressive household? If you're so concerned about her

why don't you put *her* up in the hotel? Do you need an excuse to go somewhere else to live until the house is available? I think you're being deceitful with everyone, including yourself.

I'm not going to apologize for this diatribe unless you ask me to. It's part of my new policy of saying what I think. I have had enough of your fanning my jealousy of Barbara all these years. I think it is time to object to objectionable behavior. If you are going to go places with female friends now that you are 3,000 miles away that is your business, but when you fish for reactions from me on the telephone in telling me how much you enjoy yourself in the company of these ladies, then it becomes my business. It upsets me and angers me. If you were in New York and we were trying seriously to work things out I would ask that you discontinue your relationship with Barbara Rose, but since you are in Calif. and we can by no stretch of the imagination be described as trying to work things out, I can only tell you I am angry and resent your behavior.

To defend myself: If I were in California I would be enjoying myself too, but being in NY I work. The obvious moral is that as long as one is in NY one works. Staying a whole bloody year in NY we start blaming each other for not being able to enjoy ourselves. Just try me! You owe me a vacation: We never did go to Antigua. . . . Write, sweetiepie, and save on the phone bill. I love to get letters, especially from you, while talking on the phone is a pain in the behind. Bill Copley— The Letter Edged in Black—is paying me $200 to use some facsimile pages from my notebooks. One of my students wants private lessons in *Trio A.* He says he's really getting to understand what it's all about now—even more than when he saw all three concerts! Pretty soon they'll be shining my sneakers!
Love from indignant [signed] Yvonne

In his response of July 8, 1968, Bob denies that he is involved with anyone, makes some devastating assessments of my brother's family, and castigates me for my self-righteous use of the words "honest commitment," adding, "You never used the word commitment to me once, let alone again, but your casual statements about backing out were flung in my face time after time." He was right about the last bit; early on that was often my way of dealing with the rough patches.

7-16-68

Bob:

Sorry about the delay. I just received your letter today. It arrived last week but the mailman put it in the wrong box—some floor that's been on vacation. . . .

I've been spending time with my psychologist, dentist, teaching, and just this week started rehearsing with Becky to get together material to show this agent in Boston in about two weeks. The therapy hurts so it must be good for me. She's insisting I deal with things that Schimel with his pollyanna-ego-building techniques managed to help me avoid. After a certain point with him any kind of self-criticism was put into its proper place as being a part of my history of compliant self-denigration. Somehow in the process of becoming "stronger" I have acquired a lot of techniques for keeping myself distant, inaccessible, superior, condescending, "formidable," as you and others have put it. In making any reference to "commitment"—self-righteous or otherwise—I want you to know that painful as the thought may be of our recent and future being, right now I feel committed to finding out what my contribution has been with the hope that this will have some positive effect on our relationship. This sounds like a smug pat

formulation and doesn't really take into account what I feel, but it's what's happening.

Had crab gumbo at Rauschenberg's the other night with couple dozen people. He heard from Ed Schlossberg who says you're a wonderful person. Bob is madly in love with a young (24) Israeli who runs a gallery in Amsterdam. Looks a little like Jerry Malanga. Bob's definition of Love: a condition wherein one feels beautiful. No comment on that at the moment. Simone getting ready to take a 10-day cruise with her folks. Bob came back from Europe and what with the extra 5 hours, loss of sleep, and extra 5 hours of boozing he smashed a glass into his forehead. It looked like 3 or 4 stitches. Went up to Walter Gutman's to see Mike Kuchar's film biography of Walter. It was sensitive beautiful and vulgar like their best work, Walter's peccadilloes right out there in all their glory. I ought to expose my belly and its implications in that way. Some beautiful footage of one of his girls getting the plaster treatment from George Segal and some close-ups of bareback riding and tigers down in Florida. It's called "Unstrap Me."

You know what? I absolutely adore teaching. I'm conducting very precarious classes in that I'm not always completely prepared and they can observe my thought processes. . . .

How does it feel not to "think much about working"? I want to come out there and not think much about working too. I'll probably have to do a bit of thinking about my brother and mother.
Love, Yvonne

I had changed my shrink and was now going to Magda Denes, a Gestalt psychologist. I had also taken over the course that Deborah Hay

had started at the School of Visual Arts, which she called "Approaches to Performance." (I still use this title for courses in film and video.)

In successive exchanges our long-suppressed resentments continued to ratchet up. A letter from Bob in which he examined his distrust of women was detailed and convoluted, casting me as the punitive maternal figure and his paramours as providers of pleasure. In a letter dated July 26, 1968, he spelled out what he wanted from me, though he thought it might be too much to ask—hostility and love rather than judgment and condescension—at the same time confessing to having manipulated me for his own ends.

(I have to tell myself at this point what I loved in this man: his boundless energy and curiosity; his ability to appreciate small mundane urban things, like gratings, corners, cast-off objects; a kind of stolid determination and ingenuity in exploring unfamiliar terrain, both artistic and theoretical, his melancholy face, his sensitivity. Does one have to articulate such thoughts or do they become apparent in everyday interactions, through gesture and look? Did I assume too much or was he simply not receptive? Was I really so parsimonious with look, gesture, and word? Was I fulfilling Bob's expectations of the worst rather than the best in myself? His letters sometimes express love. Since my replies have vanished from Bob's files, the few carbons that remain in mine suggest only the rising storms or the floodgates of anger that had remained closed for so long.)

He went on to express his wish to integrate pleasure *within* our relationship rather than outside and ended casually, reporting that Meredith had been staying at his place but now had found an apartment and that he had learned a lot from her. He again proffered a sharp appraisal of Belle and Ivan. My reply shut him out:

I can't say [your letter] clarified much for me in that it didn't seem to say anything that I didn't think you knew already . . . all that Freudian analysis is sheerly descriptive and causal and as such isn't really any of my business. It may be interesting but I don't know how it concerns *us* and our *feelings*.

I didn't want to know that he had "learned a lot" from Meredith, and I didn't want to read his caustic opinions of my family. His reply of July 27, 1968, was immediate and shrill. If I knew all these things before, he wrote, why hadn't I told him? My telling him that his insights were "none of my business" was just more evidence of my not wanting to deal with him. He said he wanted to spend the rest of the summer alone.

I had been reading all the letters to Magda, my new shrink. A veil was about to be torn away. I began to remember bits of conversation with Bob and others that indicated that Barbara Rose was not his only lover.

I rented a car so Becky and I could get up to Boston to audition for an agent. We drove back on a Sunday. I dropped Becky off and returned the car to the Hertz garage on East 12th Street. I walked to the back of an empty parking lot on the same block and sat down on a wooden beam. It was a hot day. A well-dressed man passing by saw me and approached. He said he was going to a Democratic fund-raising event, would I like to come? I started to take off my clothes. He said, "Oh no, don't do that, don't do that," and fled. I took off all my clothes, folded them neatly and placed them on the plank beside me. There were some people sitting on a front stoop across the street. Within five minutes a police car with its siren wailing pulled into the parking lot. Three cops got out and proceeded to ask me questions and hustle me into my purple miniskirt and brown blouse. I refused to talk or look at them. They went through my

purse. One of them said, "There's fifty dollars in here." Another said, "Not here, Jack, people are watching."

They took me to Bellevue, where I sat in a waiting room facing two of the policemen. One of them said, "If I shot off my gun I bet she'd look up." I was still silent, eyes downcast. A doctor finally examined me. As he took blood pressure, then shined the beam of a small flashlight into my pupils, I started to cry. Memories of all the handling I had endured during my many bouts of illness flooded over me. But I still refused to speak. I was taken to the women's psychiatric ward. From information in my address book they contacted Rauschenberg, who called Bob in California. He got on the next plane and showed up at Bellevue within twenty-four hours. Which was exactly what I—albeit unconsciously—wanted. All I was conscious of was the necessity to do something just short of destroying myself. It was a highly effective maneuver. My guilty partner came to my rescue.

For the three days I was in Bellevue the daily regimen was exactly the same: Get out of bed around 7 AM, assemble in the community room; eat breakfast of hard boiled egg, white toast, orange juice, and coffee; swallow a dose of thorazine; lie around on the benches in a stupor because we were not allowed back in the wards until bedtime. I saw a psychologist who told me that unless I started to speak I would not be released. A young black adolescent befriended me. She said she was in there because she swallowed safety pins and that "they won't let you out of here unless you start talking." When Bob showed up he said, "I don't care if you never talk again, but they're not going to let you go until you do." I started to talk. Most of the inmates were black or Puerto Rican. I listened to some of their stories. A middle-aged woman confessed, "I was so afraid, so afraid." I didn't think any of them were any more crazy than I was, just afraid and angry.

(A young Puerto Rican woman in a hospital robe faces camera)
Digna: The head honcho here asked me to name the presidents of
the U.S., beginning with the current one and working backwards.
Of course, he refused to speak Spanish. So I named a few presi-
dents: Kennedy, Eisenhower, Truman, Roosevelt, Hoover. Then I
got stuck. And guess what? *He* finished the job. He went all the way
back to Lincoln. He was very proud of himself. Imagine! A history
lesson from the head shrink of Bellevue Hospital!
(*Privilege*, 16mm, 1990)

After three days I was released into Bob's care and walked out into
the hot glare and clamor of New York streets. Bob returned to San Fran-
cisco with me in tow. I was ashamed and chastened, did a lot of crying,
felt very confused, unmoored. He was gentle and careful with me. But it
was painfully clear to both of us that we had reached a gulf of irrecon-
cilability. When we returned to New York at the end of the summer,
by mutual agreement he found a loft in Little Italy and moved out of
Greene Street. I spent November 1968 in residence at Goddard College,
teaching and making a dance for thirty students called *North East Pass-
ing*. Bob's correspondence during this period reveals depression and am-
bivalence. He compares himself unfavorably to me and accuses himself
of wasteful behavior, says he is at loose ends, not able to work, laments
the changing nature of his work, which makes him feel disoriented. Still
later his mood changes; he pulls back and becomes more accusatory,
complaining of feeling sexually rejected by me and living with the fear
that I am not interested in him physically, pointing to my obsession with
my own body. He claims that he had started lifting weights to improve
himself for me, in reaction to which I accused him of being vain, that the
affair with Barbara Rose was based on her pleasure in him physically. He

accuses me of accepting his withdrawal from me, which he took as further evidence of my lack of interest.

These vacillations between admiration and resentment continued, seasonally played out in reconciliations and separations. I went along for the ride, you might say, dancing to Bob's drumbeat. At the beginning of the summer of 1969 I began to walk some of my belongings down to his loft as we made tentative moves toward living together again. I even went to a Park Avenue obstetrician to see if my surgically ruined abdomen might sustain pregnancy. The guy's cold-blooded recommendation was "Why don't you find another profession and another husband?" (Although we had never legally married, I presented myself as Bob's wife when the need arose.) I had never had any inclination to have children and was in his office only to comply with Bob's fantasy, but nonetheless I felt like throwing the heavy glass ashtray on his desk at his head. By the end of the summer I was walking my possessions back to Greene Street after some violent arguments along the same old lines: I reproached him for his infidelities, and he justified his actions by accusing me of not loving him. I remember throwing a glass at his head and missing. For the next three years we gravitated toward and away from each other in predictable patterns until I enacted the coup de grâce that put an end to my involvement with Bob Morris—and almost my life.

BETWEEN 1968 AND 1970 my work moved along in overlapping stages. I devised a format variously called *Performance Demonstration,* or *Performance Fractions,* or *Composite,* which would include fragments from old work plus slides, sound, and whatever new movement ideas engaged me. I also began to think about the teaching process itself as a possible form of performance. During *Performance Demonstration* at the Performing Arts Library at Lincoln Center in the fall of 1968, I began to teach Becky Arnold *Trio A* while fifteen people executed various tasks around us, sometimes jostling us as they walked back and forth putting down and picking up books. The surrounding activity harked back to *Dialogues* of 1964 when Paxton, Hay, and Holder bumped into the women as they ran on and off the stage.

Rose Fractions was presented in 1969 during a two-week dance festival at the Billy Rose Theater. My programs of February 6 and 8 were of epic proportions, incorporating fifteen dancers—both trained and untrained—film and slide projections, swaths of paper and rubber, books, fluorescent lights, a monologue on snot by Lenny Bruce, an aspic fish on an aluminum platter, "people walls" and other formal configurations, packages, *Trio A* performed by five nonprofessionals in silence followed by five professionals to the Chambers Brothers' "In the Midnight Hour," the premiere of Deborah Hay's *26 Variations on 8 Activities for 13 People plus Beginning and Ending,* and my own *North East Passing,* which, although my favorite part of the evening, may have been superseded by the sensationalism attendant on the screening of a porno film I had borrowed from Steve Paxton for the second night. The program ended in a Hades-like image: the stage suffused in red light emanating from visible suspended florescent tubes, a "people wall" of ten performers slowly walking in a row from stage right to stage left while emptying ten bags of kitty litter, the contents of which by the end completely covered the

stage. The dust from this activity drove the spectators in the three front rows out of their seats and drove the stage hands and Don Redlich, whose concert followed mine, to distraction. The crew's subsequent mopping of the floor created a surface of sticky mud due to the clay in the kitty litter, almost impossible to get rid of.

Picture this (from the spectators' point of view): To the right of the proscenium arch is a film of two nude figures—Steve and Becky—executing simple maneuvers with a large white balloon in a white living room (in Virginia Dwan's Dakota apartment) furnished with two white sofas and rug. To the left of the proscenium arch is a projection of a

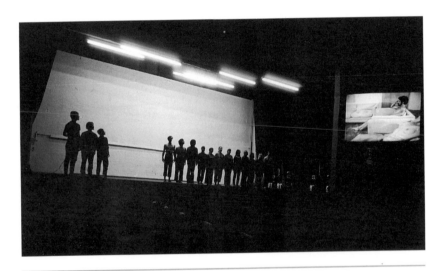

Section of *Rose Fractions* (rehearsal), Billy Rose Theatre, January 1969. Photo by Peter Moore. © Estate of Peter Moore/VAGA, NY, NY.

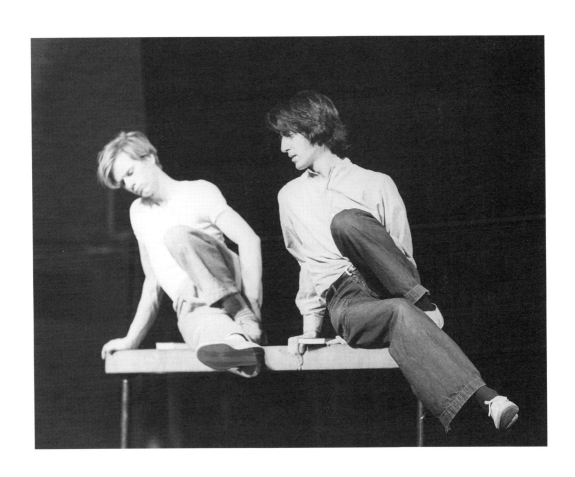

Douglas Dunn and Fredric Lherman in *North East Passing*, Billy Rose Theatre, 1969. Photo by
Peter Moore. © Estate of Peter Moore/VAGA, NY, NY.

heterosexual "blue movie"—a scratchy print, probably shot in the 1940s—that looks "dirty" in every sense, down to the man's dirty fingernails. Downstage is a row of a dozen people facing the audience and moving their ribcages laterally back and forth. At stage right are three performers: Barbara Dilley and Steve are doing something I don't remember while I stand at a microphone and recite Lenny Bruce's *On Snot*, which begins, "I'm going to tell you the dirtiest word you've ever heard on stage. It is just *disgusting*. . . . It's a four-letter word, starts with an 's' and ends with a 't'. . . ."

The porn film played until a hysterical house manager ran backstage and ordered it turned off. Lighting designer and stage manager Jennifer Tipton held him off as long as she could but finally had to capitulate. I saw people walking out at this juncture on both nights, though I did not show the offending piece of art at the premiere. Unwilling to risk the management's cancellation of the second performance—my desire to get my work shown as widely as possible trumped my zeal for challenging prudery—I had made the decision to screen the film solely at our final performance. If only for a few minutes' duration, the audience would be exposed to these contrasting functions and representations that, when seen together, might turn the notion of obscenity on its head. Secretion, movement, nudity, and play, from the everyday to the contrived and hilarious. In this context the moving ribcages became as "obscene" as the pornographic display, the porn as funny as the *Snot* recitation. On the first night I substituted *Hand Movie*, a close-up of my hand filmed in 8mm at St. Vincent's Hospital by Bill Davis when I was first taken sick. Come to think of it, the performance of my fingers, rubbing and caressing each other, if one put one's mind to it, could be seen in the Billy Rose context as erotic, if not obscene, and, in any case, comic.

The mainstream critics, to no one's surprise, were not amused. Clive Barnes devoted two successive Sunday *New York Times* pans to

Rose Fractions despite the fact that he purportedly fell asleep through most of it and left early. His first review, titled "Blue Movies? Ho Hum," chided the Ford Foundation for sponsoring such a disgrace. Frances Herridge's *New York Post* piece, "The Avant-Garde Is At It Again," decried my

> relentless defiance of everything conventional in theater and dance. . . . Her *Rose Fractions* was performed last night in sloppy street clothes—mostly jeans and sneakers, without benefit of hair brush or makeup, sets, wing curtains, or music. *[She too must have left early; "In the Midnight Hour" accompanied* Trio A *at the end of the evening.]* And the choreography consisted mainly of walking or running, aimless repetition, without grace, logic, style, sequence, virtuosity, or meaning.

I was elated. The battle lines had been drawn. The *Times* also published some ardent letters of defense, including one from dance critic Jack Anderson. I was not the only object of calumny. Meredith Monk's and Twyla Tharp's evenings also drew vituperative complaints from reviewers.

My experiments with teaching during performance continued in March 1969 at Pratt Institute in Brooklyn, where I presented another *Performance Demonstration,* and—in programs shared with Canadian artist Glenn Lewis—in *Performance Fractions for the West Coast* at the Vancouver Art Gallery, Mills College, and an abandoned theater in downtown Los Angeles. In all three cities I taught the opening phrases of *Trio A* to groups of thirty people. However, it was in the Pratt program that I became conscious of the exhilarating implications of this new mode of performance for my own group. The Pratt *Demonstration* was the genesis of *Continuous Project-Altered Daily,* a title inspired by an earthwork of that name that Bob Morris altered every day during its installation at the Castelli Warehouse in Harlem by rearranging the rods, shards and

other objects imbedded in a pile of dirt. I envisioned an ongoing process with six performers that would encompass a gamut of activities performed along a continuum of imperfection and polish and that would drastically change its shape with each performance. What was beginning to interest me was the possibility of producing spontaneous behavior within a formal setting. Twyla Tharp was investigating rehearsal behavior by videotaping it and then having her dancers learn and set their gestures as predetermined choreography. I was after something else. Not fully rehearsing material meant that we would have to talk about it during the performance itself. Our ad hoc interactions would be seen beside more conventionally polished material. Oddly, in the ensuing months, as our everyday behavior began to be exposed during the various gigs that accrued to "Yvonne Rainer and Group," something strange and unforeseen began to occur.

I was working with an extraordinary group of performers. Steve Paxton, Barbara Dilley (then Lloyd), and Douglas Dunn had already danced with Cunningham. David Gordon had honed his sensibilities with Jimmy Waring in the late 1950s and early 1960s and had passed through the crucible of Judson Dance Theater along with Steve and me. And Becky Arnold had been dancing with me since 1966. All of them except Douglas had weathered the two-year odyssey of *The Mind Is A Muscle*. Previously submerged in the Minimalist style and discipline of my work, their distinct and forceful individual characteristics had hardly been exploited or revealed up to now. Steve's wry equanimity, Barbara's mischievous intelligence, Doug's quickness and humor, and David's verbal acuity were straining at the bit offstage, waiting to enter. (Becky's quality of disciplined consistency was already in evidence throughout her association with me.) *Continuous Project-Altered Daily* would open a door for those colorful entrances.

Basically, CP-AD was constructed of interchangeable units of material, some very elaborate and requiring the whole group, other units being solos, duets, and trios that could be executed at any time. Some units could be performed by an indeterminate number of people. The sequence of events—unlike that of *The Mind Is a Muscle*—was determined by the participants during the performance itself. The complexities—and dangers—of loosening my directorial grip became apparent in the succeeding months during performances at the University of Illinois–Urbana-Champaign, the University of Missouri–Kansas City, Amherst College, and during a summer residency at the American Dance Festival–Connecticut College.

In retrospect it is easy to discern, harder to describe, the euphoria that ensued following those early concerts of CP-AD, especially the one in Kansas City in November 1969. It was here that the phenomenon of "spontaneous behavior" really erupted as a viable mode of performance. At one point the whole group was "thrashing" across the space in a spasmodic cluster. Barbara had donned one of the "body adjuncts" that had been constructed by Deborah Hollingworth as optional costume accessories (feathered wings, a lion's tail, a global hemisphere, a "hunchback"). Catching sight of her in the hunchback, which she had inserted under her t-shirt, I burst out laughing. She met my eye and also began roaring with laughter as we continued traveling. Never, I repeat, never had I seen anyone—or experienced myself—laughing so heartily during a dance performance. It was an unbelievable release and high. As for the spectators, some thought the performance was "only for us," while others were more appreciative. I was banking on the hope that watching performers laugh spontaneously might be infectious.

One strategy for producing the kind of spontaneity I was after dropped in my lap when Steve was unable to be in residence with the rest

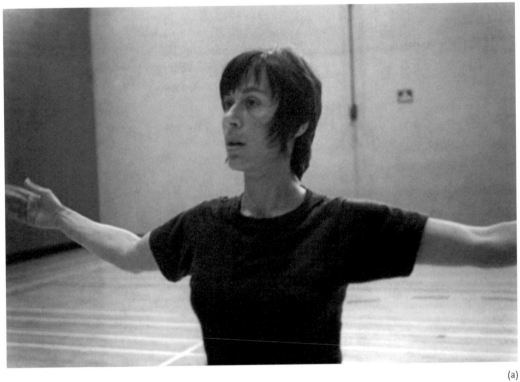

(a)

Working on *Continuous Project-Altered Daily*, Connecticut College, summer 1969. (a) YR. (b) YR and Barbara Dilley. (c) Douglas Dunn.

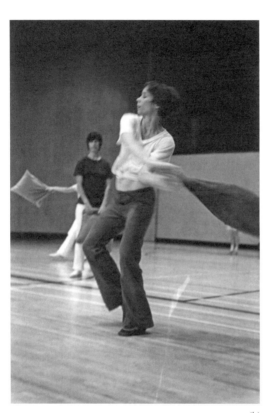

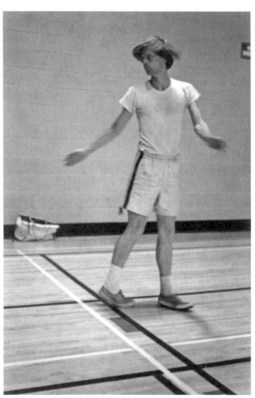

(b)

(c)

of us at Connecticut College and when he and Barbara started teaching outside of New York. This meant that I could continue working with the smaller group and, at the same time, send Barbara and Steve separate instructions. For instance, at one point I sent them drawings of Isadora Duncan with the instruction to interpret them in a duet at any time during an upcoming performance. I could also rely on their presence and responses—now encouraged and expected—as spectators when the group next converged for a concert. In other words, since I didn't schedule a rehearsal of the whole group prior to any given show, neither segment of the group knew what to expect from the other. What resulted from this ploy came under the category "surprises."

A more serious side of the process necessarily entailed a great deal of soul-searching and agonizing on my part about control and authority. It seemed that once one allowed the spontaneous expression and responses and opinions of performers to affect one's own creative process—in this respect the rehearsals were as crucial as the performances—then the die was cast: there was no turning back to the old hierarchy of director and directed. A moral imperative to form a more democratic social structure loomed as a logical consequence. What happened was both fascinating and painful, and not only for me, as I vacillated between opening up options and closing them down. My correspondence with Barbara and the rest of the group is revealing. Excerpts follow:

Monday, November 10, 1969
Dearest Baba:

I am lying in Bob's house *[his loft on Mulberry Street]* feeling very chilled. Maybe I am coming down with the cold I have been

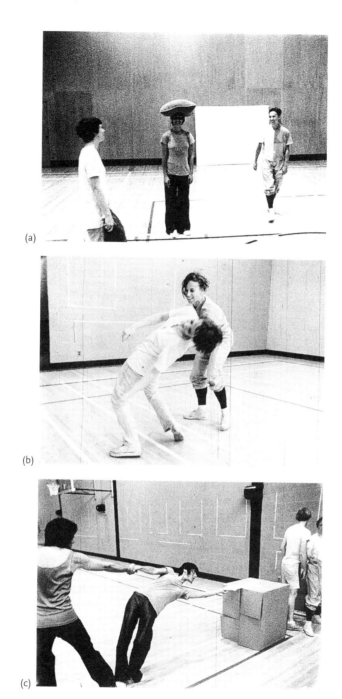

(a)

(b)

(c)

323

Connecticut Rehearsal, a 16mm film by Michael Fajans, Connecticut College, summer 1969.
(a) Barbara Dilley, YR, and Becky Arnold. (b) Barbara Dilley and Becky Arnold. (c) David Gordon, YR, Douglas Dunn, and Becky Arnold.

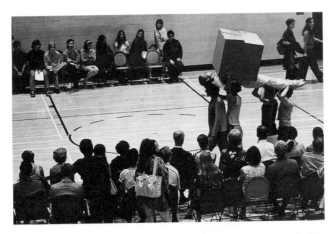

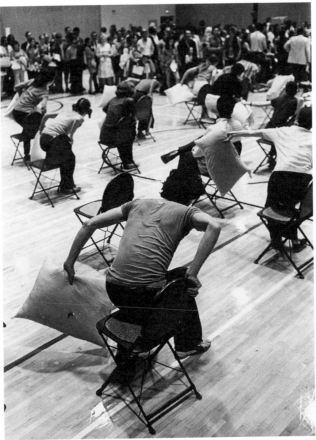

Performance of CP-AD during *Connecticut Composite*, Connecticut College, summer 1969. Becky Arnold on our heads. Photo: Ellen Levene.

Performance of *Chair/Pillow* by students, Connecticut College, summer 1969. Photo: Ellen Levene.

staving off for the last week. Lots of vitamin C and ginseng going down the hatch.

I have so much to say to you. Talked to your friend and mine D.G. for three solid hours on the plane (as I guess you did with S.P. after we left). He with his characteristic sensitivity clued me in to what happened between you and me—which neither of us got to adequately before saying good-bye. . . .

I have this huge trust in you and Steve. In writing out those instructions for the two of you I had absolute faith that however you figured them out I would be pleased and tickled. In other words I am at a point—a dangerous one—where I take certain things for granted. When I saw you rehearsing in the afternoon the thing I am lamenting took place: I saw; then I thought "o yes, of course, that looks just like I thought it would; *they couldn't have done it any other way*! There is nothing to say (criticize) about that." Blast me! There I stood with my steely gaze brazenly taking credit for what *you* had done. Wow!

Forgive me, dear friends. As my affection and esteem for all of you grow I am forced to examine these vestiges of parsimony and control. We cannot take anything for granted anymore—I in relation to your achievement and you with respect to your own. What the two of you did in Illinois was nothing short of phenomenal, and considering that you had to disregard my instructions in order to do it, well—my mouth hangeth open, my mind does boggle, I almost don't believe, but I have seen the glory. . . . The phenomenal quality of your accomplishment also characterized the whole experience for me. The words I keep thinking of to describe it come perilously close to current psychotherapeutic clichés: reality of encounter, responsible interaction, truthful response. To put it in a more personal way: I got a glimpse of human behavior that my dreams for a better life are based

on—real, complex, constantly in flux, rich, concrete, funny, focused, immediate, specific, intense, serious at times to the point of religiosity, light, diaphanous, silly, and many leveled at any particular moment. As David said—the complexity of and differences in the quality of the experience of each one of us in that situation at any given moment balance out and prevent the domination of any one person's involvement. Yet at the same time there is a consistent seriousness of response in the best sense—whether it be giggling, scowling, or reflective—that unifies the whole thing. We are totally and undeniably *there* . . . I am ready to accept total freedom of "response." At this moment I have trepidations about allowing people to "alter" my material or introduce their own. BUT . . . I give permission to you all to do either of these *at your own risk:* that is, you will risk incurring the veto power of me or other members of the group, *in performance*) I do not want to know about such intentions prior to performance). In short, I reserve the right—and I confer upon all of you the same right—to be true to my/your responses in performance—be they enthusiastic or negative—bearing in mind the *natural precedence and priority of my material.*

A letter from Barbara fleshed out the details of the "KCMo" show. Excerpts follow:

I remember the breathlessness of the lifting section, first with you and then with Steve in your place. A concentrated hunk of weighted material, and then the end version—it became a condensation of history. I remember your Martha Graham story and

your voice rising, and I got worried you were going to talk about whether she ate cock or not and Steve starting to read on the other mike and changing the atmosphere. I remember the opening bars of the Chambers Brothers and doing *Trio A* slow, very slow, and Steve joining me and then fast, with and against Steve's tempo. It was sheer delight. I felt sexy, moving through material I know that slowly. I remember you . . . grinning at the pleasure we had. Oh, and the wings. I remember watching the pillow solo and then during *Trio A* the wings would sometimes flap in my face. The literary images, the dream images, the animal images . . . I remember talking to you in the hotel, before, "stoned," and you said I was always wanting to get someplace and that I should just be where I was— and only there—and that was what happened in the performance. I remember standing around waiting to start the run-thru, and you were talking and then you turned and said, "What are you waiting for?" and Doug saying what I had been doing, which was waiting for you! I remember the pleasure of the huddling in the rolls and Steve coming down on me with his self-conscious silly grin. And I remember being out of it thru Becky's solo, then toward the end seeing her so totally there with that changed and changing body of hers . . . *[Becky was pregnant.]* I remember the box improvisation with David. What a pleasure! And David teaching me *Here Comes the Sun [the dance].* Felt natural and relaxed about learning in front of people. Was it then Steve put on the *Satie?* What a surprise. What a glorious feeling to do that as solo and duet at the same time. Like two people floating thru the clouds together and occasionally touching . . . Then the pillow duet with Steve and the bit with you and David and the pillows. So smooth, so full of comic surprise.

It was still the beginning. Barbara, the most restless of the bunch, had already floated the idea that they might introduce their own stuff in performance. I wasn't ready for that big a leap. We had one more show, in the gymnasium of Amherst College on December 12, before I followed Bob Morris to the University of California–Irvine, where he was teaching during the winter quarter of 1970. I spent days composing another long letter to the group:

The typewriter in use is perched on a desk just inside a plate glass door giving out on a 3rd floor "penthouse" balcony opposite three 4-story eucalyptus trees beyond which is unadulterated (to the eye) Pacific Ocean. Last night we heard hooting on one of the trees and discovered an owl sitting up there, a strange fat feathered raccoon-looking creature, snowy white, hooting plaintively; perhaps he was lost.

In rereading the newsletter written after the KCMo performance I find that I basically have little to add other than defining certain "strictures" that might make that projection more possible and/or operable. My main reservation about the Amherst gig was that we were operating on the assumption that anyone could depart from the basic structure (meaning *my* material) on an individual basis at any time. When you get 6 people exercising this option—well, I kept being reminded of early Judson "random" activity. Actually all it takes is for one or two out of the six to detach themselves from a group activity and then suddenly the whole thing becomes diffused when the remaining people set about keeping themselves "busy." Actually Amherst was so different from anything I could or would have thought of making that I am still sort of astonished and blown by it. It put into very clear relief the particular nature of my concise and orderly way of arranging things. What I would like to try next time is

a system which would produce both the unevenness and diffusion of the Amherst performance *and* the concentration and tight focus of a lot of my imagery. (My memory may not serve me well, but one of the few "highly focused" moments in the whole performance was the duet by Steve and Barbara doing their Duncan bit.) A dispersed "look" over a prolonged period becomes a drag, and I am no less dragged at the thought of the tight-ass look of the beginning of CP-AD (where Doug gets hoisted) dominating the evening. I hate to say it, or I almost hate to say it, but I really do seem to be about variety, changes, and multiplicity. Not necessarily contrast, but rather a spectrum of possibilities in terms of spatial density, types of performance (rehearsal, marking, run-through, teaching, etc.), and perhaps most important of all: durations and sequence. I'm nothing if not a two-bit entertainer.

On to a revision of the statute of limitations: I have changed my mind about how much of my stuff can be performed solo. I mean there are either clear-cut solos or unison and group situations. This greatly cuts down on individual options during a break: for instance, the *Here Comes the Sun* one-legged balance routine must be done with 3 to 6 people (except where Baba and David do it together with the box); also the chair-pillow bit must have a minimum of 4. (Since it was originally conceived for 30 I still consider it a group routine.) What I am trying to get at is a situation where we will exercise more responsibility toward each other. A mechanical way of doing this is to cut down the number of solitary activity possibilities; this will result in one's having to enlist the cooperation of others when initiating a break.

VETO POWER: No one exercised it. As Doug said, he looked around and saw everyone having such a good time doing their thing that he didn't have the heart to interfere even when he wanted to

make a change. I think I should repeat, or re-emphasize: In the event of a conflict of will concerning duration of elements in the sequence prescribed prior to performance, the wish to continue or repeat has priority over the wish to break. Similarly, the wish to return to the PRESCRIBED SEQUENCE has priority over prolonging a break. This is beginning to sound a bit doctrinaire, but the Amherst performance introduced a whole new "wrinkle" that at this point, as far as I am concerned, only muddles the situation.

And so I tried to dot the I's and cross the T's, arrive at some kind of rapprochement between my coveted formal ideas and the new bewildering terrain of group input and freedom. "The work gains in 'kinky behavior' while losing in unity," I wrote even while relishing the distance we had traveled in expanding the definitions of "performance" and "rehearsal" and shrinking the distinctions between the two. "Teaching" was now a very small part of the whole phenomenon. For the fall performances of 1969, in addition to the various props—cardboard boxes, a white screen, a five-foot wooden pole, pillows, folding chairs, foam rubber mat—I had asked for several standing microphones at which the dancers might comment on what was going on. In the same letter I wrote:

The ambiguities and cross-purposes of live presence vs. apparent behavior vs. implied intention conveyed by specific source material vs. unconvincing performance: It all adds up to a kind of irony that has always fascinated me. When I say "How am I like Martha Graham," I

imagine that my *presence* is immediately thrust into a new performance "warp" (in the minds of the spectators). From that moment on people are forced to deal with me as a certain kind of *performer*, someone who is simultaneously real and fictitious, rather than taking me for granted as a conveyor of information (simply because I'm talking half-way rationally). Or do I overestimate the evocative power of that name? Similarly I feel that the tension that is produced from not knowing whether someone is *reciting* or *saying* something— pushes a performance back and forth, "in and out of warp."

Steve had further comments to make in a letter postmarked February 1, 1970:

> Amherst was more personally disorienting than KCMo . . . Arrived having decided not to do anything extra—having discussed the possibility with you and having consistently gotten uptight and cautious and reserved consent, didn't want to make a move not eagerly anticipated. But pushing flying let me join Barbara in *Trio A* and to put on the "Satie soup spoon" [*Trois Gymnopédies*]. Enjoyed that—an organic way to that area of freedom implied and resisted so far by all.
>
> A couple of problems: Warm-ups: *Need* to have group warm-ups and training in catching bodies in mid-air. I'll do what I can by myself from now on, but wow! such a sore back . . .
>
> The self-conscious quality of most of the discussions for or at the audience. It seems to me that all, including you, are uneasy with the mikes. It would be groovy if they were capable of picking

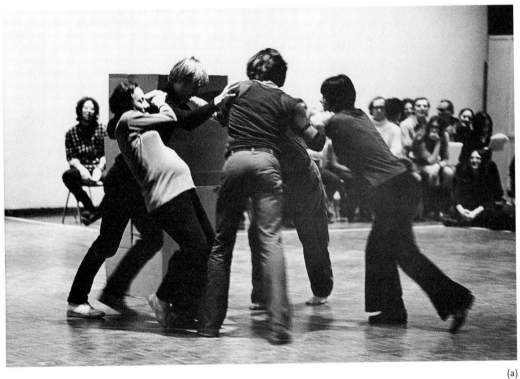

(a)

CP-AD at the Whitney Museum, April 1970. (a) Becky Arnold, Douglas Dunn, David Gordon, and YR. Facing page: (b) Becky, YR. Photos by Peter Moore. © Estate of Peter Moore/VAGA, NY, NY.

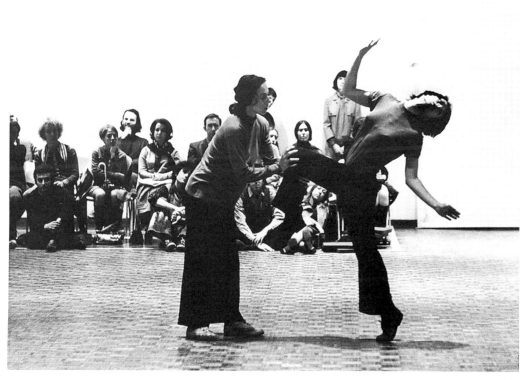

(b)

up random verbiage but they aren't. This has to be addressed. From all of us casually super-skilled bodies these tense and defensive voices come out. It is a good vibe-killer.

I have never used rehearsals much to get into material. One place seems as good as another and finesse is odious. But I guess I do rely on them for firming in my head my feelings re: co-dancers and the humor involved in our undertaking. What substitute is possible with the company spread out like oleo on bagels? How to make our performance inter-connections floaty and unthought? And how to fall in love with each others' work without a chance to see it, even in performance? I miss seeing us dance.

Continuous Project-Altered Daily culminated in three performances at the Whitney Museum in the spring of 1970. As the audience straggled in to the open space that was encircled by folding chairs, I was engaged in teaching new material to the rest of the group, now comprising Steve, Douglas, Barbara, David, and seven-months-pregnant Becky. The program stated that "the audience is invited to go to any of the three performance areas at any time" to view films as well as the live show. On one night *The Incredible Shrinking Man* was screened, on another *The Night Walker* with Barbara Stanwyck and Robert Taylor. Also shown was a 16mm documentation of an early rehearsal of CP-AD by Michael Fajans (*Connecticut Rehearsal*).

Following the first Whitney performance some of us convened at St. Adrian's, the bar beneath the Broadway Central Hotel that now vied with Max's Kansas City as the latest art world hot spot. Sitting at a table with David and me, Bob Morris carried on about the "unnecessary" amount of talking during the show and how it distracted from what we were otherwise doing. I totally agreed with him. Configurations like

"Group Hoist," which we had previously mastered, now appeared unfinished and rough. Why did we have to act as though we were still in rehearsal with stuff that we knew so well? The permission to "behave spontaneously" was like a contagion, spreading over the whole endeavor. The following night, hoping to contain some of their vocal exuberance, I conveyed these thoughts to the whole group.

At one point during the show David and I put pillows on our heads to begin an improvisation. I swung my arm and knocked his pillow to the ground. He then swung his arm and whacked me on the side of the head with such force I thought I would pass out. He immediately held me and I recovered my composure. Later he told me that he was enraged by my censure of the group's growing sense of freedom. After giving them free rein, I was now trying to lock the horses back in the stable.

It was obviously too late. The die was indeed cast. By the end of 1970 we had invited in three new members—Trisha Brown, Lincoln Scott (aka "Dong"), and Nancy Green—and were calling ourselves the "Grand Union." ("Rio Grand Union" was used for nonprofit status so as not to conflict with the supermarket chain.) There was still a rocky road ahead on the way to becoming a completely autonomous improvisational group. In a 1983 interview Douglas Dunn reminisced:

> Suddenly we didn't know where we were. We knew Yvonne was no longer leader, and we didn't know anything else. For a while even the group numbers were amorphous. . . . It wasn't clear who Grand Union was going to be at first. There was a kind of shuffling period, when people were deciding whether they wanted to be there if Yvonne wasn't leading. Then as she became no longer the leader there was the question of, could we all deal with each other, enough to continue in a group?

Another complication was that public awareness lagged behind the changing identity of the group. Invitations to perform continued to come to "Yvonne Rainer and Group" rather than to the new entity, a situation that took another year to rectify. A number of people have documented GU performances via photos, interviews, and transcribed memories. My own memories of the two years in which I was involved with the GU have blurred into one extended tapestry of nonchronological moments in a number of different spaces:

Steve asks someone in the back row of the theater to raise his hand and asks another person in the front row to keep a flashlight trained on that hand. The flashlight is passed from hand to hand toward the illuminated hand in the back row until it reaches its destination. Delicate Trisha hoists strapping David horizontally and pretends to ram him headfirst against a metal column as he belts out a Broadway musical number. We all fade away and watch Nancy dance a ravishing solo to Ravel's *Bolero*. Trisha and Douglas attempt to enact an anatomically impossible duet as they illustrate my reading of a mock pornographic text. A student amateurishly plays a Chopin exercise over and over as David reclines on his side on top of the upright piano and I stand on his hip while belting out "I want a girl just like the girl that married dear old dad." With the audience seated on two sides of a gallery space, I lie on my back across the laps at one end and ask the spectators to pass my body over their laps to the other end. As Valda Setterfield "receives" me, she says, "I don't understand why you're so heavy, Yvonne; all I ever see in your refrigerator is celery." I cart a mattress up the aisle of a theater and ask the spectators to pass it forward over their heads toward the stage. They cooperate in completing the task.

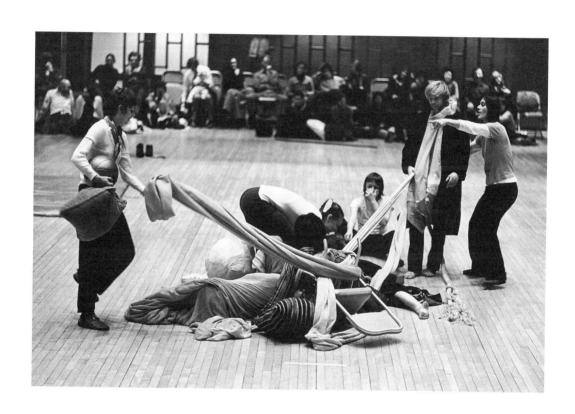

The Grand Union, Loeb Student Center, NYU, January 1971. Nancy Green, Becky Arnold, Barbara Dilley, Douglas Dunn, YR, Steve Paxton (in tubular fabric, from which he emerged nude). Photo by Peter Moore. © Estate of Peter Moore/VAGA, NY, NY.

During this period some of us continued to show our individual work in various venues. Steve screened a seventeen minute version of Robert Fiore's *Winter Soldier* on a wall of the Whitney Museum while Richard Nonas and Jeffrey Lew, seen in silhouette in front of the image, hung upside down from the ceiling like bats. David made *Sleepwalking,* a group version of his 1962 *Mannequin Dance.* Barbara continued to work with her "Natural History" group. Trisha staged her startling *Man Walking Down the Side of a Building.* I presented WAR, a piece for thirty people, in a space adjacent to that in which the Grand Union was simultaneously performing. Following a trip to India, I enlisted the GU members to play "gods" in *Grand Union Dreams,* a theater piece that also involved a dozen others who played "mortals" and "heroes." In my *Numerous Frames* for about fifty people at the Walker Art Center in May 1971, the performers entered sequentially in twos and threes and uttered single lines. (I remember an exquisite young Jessica Lange saying, "I'm not afraid to die, but I don't want to.") By the spring of 1972, after I had completed my first feature film, the strain of having to be spontaneously inventive proved too much for me. I couldn't perform without getting stoned on grass. After a few ambivalent "hiccups"—which provoked David into challenging me, "Are you in or out?"—I opted out. David, Steve, Barbara, Trisha, Douglas, and Nancy carried the Grand Union to 1976, when it disbanded. I unfortunately missed, only heard about, many of their most brilliant moments.

Street Action, Greene Street, 1970

15

Protest, Performance, Puppets

IN MAY 1970 the United States invaded Cambodia. The ArtWorkers' Coalition was making demands on the major art institutions to broaden their exhibition policies to include more women and artists of color. The on-going antiwar movement and the killing of students by the National Guard on U.S. campuses brought in a fresh wave of concerned artists. The AWC meetings I attended were sprawling, unruly affairs, with contesting voices yelling for inclusion in the organization's publicity materials. One heard the repeated refrains "and blacks," "and women," and "race and gender," demands that goaded the consciousness of us white newcomers—and the white male-dominated art world—into taking notice of previous moral and ethical blindness. One such meeting took place at the Museum of Modern Art. A woman got up and reviled curator Kynaston McShine for including too few women in the current show and then only those who were attached to male artists. I was one of those women. Although I didn't have an art work in the exhibition, the catalogue contained a statement I had written. It was the first time I had to

confront the fact that my career, insofar as it encountered the art world up to that point, may have owed something to my being with Robert Morris. It was distressing, not because the assessment was necessarily accurate, but because I was being aligned with the agents of exclusion. I was forced to start asking myself some questions: Where did I stand, whose side was I on? All of a sudden I was cast as a product of privilege rather than the "unaligned outsider" I had always imagined—and preferred—myself to be. Anarchism had not prepared me for this.

Another meeting took place in the Loeb Student Center of New York University. Before a disruptive crowd of around 300 artists a young activist named Poppy Johnson delivered an incendiary diatribe against art galleries and loft dwellers. She riffed on the word "white." White, white walls, white art, white skin, etc. She herself had a pale white complexion, long blond hair, and a cherubic mouth. She looked like Alice in Wonderland. Bob Morris was also on the stage, trying to chair the meeting and calm the chaotic proceedings. Suddenly Dorothea Rockburne was whispering in my ear, "Bob wants you to come up there. He needs help." When I got to the stage, faced with a sea of disgruntled faces, I shouted in high performance mode, "Look, if we can't get it together today, in five years we'll all be in concentration camps!" I don't remember the outcome of the meeting, but some strategizing must have been worked out because my next memory is of sitting with a hundred others on the steps of the Met and preventing museum goers from entering the front doors while we demanded that the museums shut down for a day to protest the war and also initiate a day of free admissions. After several hours a Met worker appeared at the top of the steps with free coffee and muffins. Everyone rushed to partake. And we were all invited to a grand banquet celebrating the opening of the next exhibition. I remember

attending and exchanging barbs with composer David Amram, a lover from a dozen years before who was providing live music for the event. I accused him of being co-opted—a case of the pot calling the kettle black. It was I who felt thoroughly co-opted sitting in the huge banquet hall, eating lobster, caviar, and pâté scooped from the groaning buffet tables. I left early, quite disgusted with myself and everyone else. (But wonder of wonders, something had been accomplished. Today most museums can boast of an admission-free day.)

The newly mobilized antiwar fervor of that spring and fall generated a great deal of activity, comparable to "Angry Arts Week" of 1967, during which I had performed *Trio A* (as *Convalescent Dance*) at Hunter College to raise money for activist groups. In the spring of 1970 I was teaching at the School of Visual Arts. As a final project I invited my students and some friends to participate in a street action to protest the Cambodian invasion. In three columns, wearing black armbands and with bowed heads, we slowly snaked our way through the streets below Houston Street in swaying formation. The inspiration came from the movement of the factory workers in Fritz Lang's *Metropolis.*

In November Jon Hendricks invited me to do something at the opening of the "People's Flag Show," an exhibition at Judson Church mounted to protest the government's prosecution of gallery owner Stephen Radich for showing the work of sculptor Mark Morrell, which was alleged by the prosecutors to be a "desecration of the flag." It was a huge show, open to anyone who contributed an art work using an American flag or its image. Jasper Johns, Leon Golub, Faith Ringgold, and Kate Millett were among those who submitted work. I invited five dancers who knew *Trio A* to perform it with me nude, with five-foot flags tied around our necks. We were Barbara, Steve, Nancy, David, Lincoln, and myself.

Street Action, YR, Douglas Dunn, and Sarah Rudner in the front row

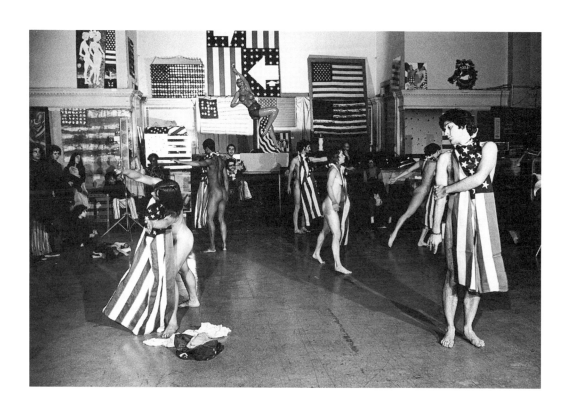

Trio A With Flags at the opening of the People's Flag Show, Judson Church, 1970. YR, Lincoln Scott, Steve Paxton, Barbara Dilley, Nancy Green, and David Gordon. Photo by Peter Moore. © Estate of Peter Moore/VAGA, NY, NY.

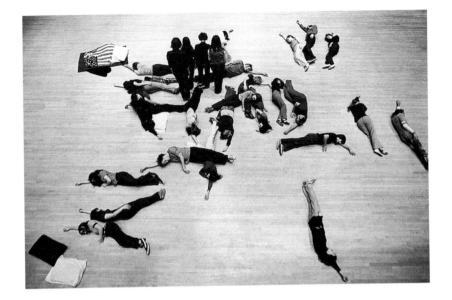

A more ambitious—and specifically antiwar—dance was WAR, performed by thirty people at Douglass College and New York University in the same month. During the performance Norma Fire, the narrator, read descriptions of military maneuvers from news reports and classics like *The Peloponnesian War.*

Ten days after the opening of the Flag Show "Yvonne Rainer and Group" were involved in a controversy at the Smithsonian in Washington, D.C. Our sponsor, on seeing a rehearsal of Steve dancing the nude/flag version of *Trio A* in front of their immense tattered nineteenth-century flag, refused to grant him permission to do it during the actual

WAR at Loeb Student Center, November 1970. Photo by Peter Moore. © Estate of Peter Moore/VAGA, NY, NY.

performance. We held a meeting and deliberated whether or not to refuse to go on. Barbara was all for threatening to pull out. Steve, in his characteristic conciliatory way, suggested that he do it clothed, with flag, and then open up a discussion with the audience and tell them what had transpired. We, and our sponsor, agreed to that plan. A lively interaction with the young audience followed, during which we discussed the issue of censorship and institutions and, of course, the war.

Recently Steve sent me his latest ruminations on the event:

You mentioned to our sponsor that you were going to show *Flag/Trio A*, and she requested that you not. Just before rehearsal you sidled up and said that the Smithsonian had nixed it. In my customary belligerent and insubordinate way, I said I would do it anyway. It was only a rehearsal, and you had arranged for the Washington half of the performers to watch us NYers in your work as appreciation for their participation.

It was rather late in the evening. All was going well. I walked out onto the cool marble floor and tied a flag around my neck, undressed behind it, and began *Trio A*.

From approximately fifty feet away, the clack of tiny heels on stone. *Trio A* is so composed as to avoid eye contact with the audience, so I had only a glimpse of the source, a beautifully dressed (possibly Gucci) and determined woman followed by two tall beautifully besuited gentlemen.

She asked me to stop. I ignored her. She grappled with me (I was on half toe, arms swaying back and forth, gaze averted). So I stopped and told her she was censoring "art." She replied that she was maintaining decency. I pointed out that within the halls of the Smithsonian were nudes in other mediums, and flags with, for

instance, Theodore Roosevelt's portrait where the stars should be. Meanwhile I was fumbling with the flag-knot which was very tight; but finally I released it. I draped the flag over her arm.

The beautifully dressed officials and the naked dancer, arguing in the middle of a large stone hall, formal and immaculate, lights focused on the argument, and in the gloom around the performing area, the gaggle of performers watching, and in the gloom surrounding the Smithsonian, Washington, D.C., the seat of the government supposed to protect our constitutional freedoms, slumbered.

Other NY performers came out onto the floor, including you, trying to cool the argument, and in support, the custodian joined in too, supporting his boss. He began arguing from behind, and I turned and answered him. David Gordon laid his hand on my arm and murmured, "That is an argument you do not wish to have." He was right. I left the floor and put on my clothes.

Flag/Trio A is balanced precariously between overt symbolism (artist visible behind our nation's symbol—protected? Vulnerable but for the flag? Not fully seen because of the flag?) and insolence (icon tied to a social taboo).

I noted that to delaminate the two, this woman revealed my nudity to 'protect' the flag. Only, was there any desecration involved? If nudity in the Institution was the issue, no one was nude until the 'censorship' occurred.

It was not rightous censorship. It was wobbly, just-in-case censorship. The dance and its costume are merely juxtaposed.

Politicians and others wishing to be identified as American regularly appear in front of a flag. Why is it censorable if the flag is in front of the American? Why is a representation of the nude body

OK, while in another art the nude body cannot be seen as a representation? Or is it that I am Scots-Irish, not a Pole?

At any rate, disloyalty was in the eye of the beholder. In a sop to those times, the Institution had invited the NY dancer who had been termed the High Priestess of the Avant-Garde, and then struck a blow for conventionality, eliminating one of her images. This is an insidious form of censorship; not reasoned, only occurring to erase possible ambiguity.

Flag/Trio A is admittedly very high on the scale of ambiguity at first view. By the end, when the flag has not been desecrated, when no outrage has happened, when the (sacred) symbolism has not been challenged by the purely abstract movements of *Trio A*, one might logically say that this was reflexive censorship. Even at its most potentized, when the flag is seen as drenched in the blood of the defenders of our American way of life, we are left to ask ourselves whether this dance achieves any desecration or is the most patriotic of acts. The Smithsonian chose to stop the show, not even viewing the whole dance. *Flag/Trio A* is entirely innocent but provoked a classic confrontation.

BOB MORRIS WAS now embarked on another on-again, off-again affair, this time with Poppy Johnson, the rabble-rousing activist from the Art-Workers' Coalition. (Did Alice in Wonderland entice herself, or was she enticed, into the despised white-walled loft of the successful artist?) My 1970 correspondence file has disgorged an undated letter from him to me in which he repeats his plaint about the lack of physical touching in our relationship. He analyzes our situation in terms of gender stereotyping: In my work I exhibit female qualities of spontaneity and sensitivity and his work is about power and strength, while in our private lives the reverse prevails. He points to my "male" independence and lack of needs and his "female" needs for attention and affection.

Outside of letter writing he was openly discussing his ambivalences with me. Following an event at Jones Beach by Joan Jonas, Bob drove me home in his new white Porsche. He talked about how Poppy represented youth and the future, while I represented familiarity and the past. I wish I could report that I responded in an appropriate fashion: "Good God, I'm only 36. What *is* the matter with you, man? Shit or get off the pot. In fact, I've had enough, I'm out of here." Alas, I was still hooked. I said NOTHING. The game was winding down to its near fatal conclusion. We were like puppets in malevolent hands.

In January 1971 the Grand Union performed at Loeb Student Center in a benefit for the Black Panthers. Bob was there and afterward was complimentary. I had become involved with Jeffrey Lew, the *enfant terrible* of 112 Greene Street. Younger than I, Jeffrey was an ebullient, bushy-haired artist, the product of a traumatic childhood who always seemed to land on his feet. His wife, Rachel, and the late sculptor Susan Harris and her rock-musician boyfriend had bought and renovated the whole building, making its ground floor available for performances and exhibitions. The Grand Union made an appearance there at least once. Vito

350

Acconci performed a threatening act at the bottom of the basement stairs. Blindfolded and brandishing a baseball bat, he dared anybody to approach him. Fernando Torm, a former professional concert pianist who had studied with me, presented a surrealistic event involving a grand piano and heavy chains. Jeffrey's and Rachel's loft was the site of innumerable parties, or I should say, people just hung out there all the time. One could always count on getting high there on various substances. According to Jeffrey there were also orgies, but I could never be sure if he was trying to impress me. He thought I was beautiful, brilliant, and uptight. Rachel knew and didn't seem to mind our affair, although I didn't quite believe that either. Rachel, Suzie, and Carol Gooden started Food, the restaurant on Greene and Prince that lasted into the 1980s.

In late January 1971, Jeffrey and I were about to fly to Kathmandu. I had received a grant from Experiments in Art and Technology to travel in India for a month to attend performances of dance and the Kathakali (the classical theater of India) and keep a journal of my observations. I spent the evening before leaving at Jeffrey and Rachel's place. Everyone was laughing and carrying on at the spectacle of the two of us, a most improbable couple, about to go off together: the flaky, starry eyed tyro and the intense mature careerist. Kathmandu was our first destination. The recollections of India in the following chapter derive from the diary I kept during my travels.

YR in Kerala, 1971

16

India and After
(*Denouement*)

ON THE DRIVE into Kathmandu from the airport, the first assault on our senses was a powerful co-mingling of smells: excrement and incense. After a few days I felt I had to get out of there. The combination of extreme poverty—children squatting over their white diarrhea in the street—wealthy tourists, and stoned hippies was unnerving. The foreigners who had been traveling for a long time seemed inured to the poverty. A young guy from Yorkshire who was cycling around the world, on the last leg of a two-and-a-half-year odyssey, talked about money and the Yorkshire pudding he yearned for. I was especially irritated with Jeffrey, who was wandering around in ganja heaven. Feeling a little guilty, I said goodbye and headed for Madras, where I would meet up with American composer David Reck and his photographer spouse, Carol. David was spending a year in Madras studying Indian music on a Guggenheim Fellowship.

I missed my plane connection in Benares, spent seven hours in the beautiful pastoral airport, sitting outside with the head administrator,

drinking tea, watching crows and children, and inhaling the spicy fragrance of flowers. At one point while walking down an adjacent road, I offered a child some peanuts I was munching from a bag. Almost immediately I was surrounded by a swarm of children, shrieking, clutching, reaching into my bag. I reversed my direction, shook my head vigorously, "No, enough," and relinquished the bag. An older boy held them back. He was very intent, looking into my face, saw my fear perhaps. They gradually dropped away. I walked back to the airport very shaken, crying. Naive, rich American just taking a pleasant amble in the countryside.

Finally my plane came in at 10 PM. I boarded and was invited by the steward to join the captain, or rather, he extended the invitation of the captain to watch the takeoff from the cockpit. I was the only woman aboard. On arriving in Calcutta at midnight, I learned that the airport lodging facilities were filled up. A young worker took me in hand, saying, "Don't worry, we'll take care of you. You don't want to sleep in the hotel. Too expensive. You can sleep right in the airport. Everyone does it, and it won't cost you anything." I discovered that for all the VIP attention I had gotten in Benares, they hadn't made a reservation for me on the morning Calcutta–Madras plane. On asking if I would get a seat I was told, "Yes, yes, you have bad chance," spoken with the familiar ambiguous vertical wagging of the head. I slept between two chairs that night. When I woke up the next morning, the whole place was filled with shrouded recumbent forms. Couldn't tell heads from feet. My ankles, where my bare feet jutted from clogs, were full of mosquito bites. I didn't feel afraid here. They were all curious about me, but I felt no menace. It was as though I was from Mars and there was nothing I could do about it. In the absence of the possibility of being anonymous, it was

a relief to be myself and be acceptable, though alien. It was definitely a new experience.

In Madras I settled into the domestic routines of David and Carol, sleeping in my bedroll on the roof of their little house, awakening every morning to the cawing of crows and children singing in a nearby school. David was recovering from a bout of hepatitis but felt well enough to start planning a trip to Kerala to attend some Kathakali events with me and his friend, Jim McConegee. He introduced me to his Tamil teacher, Mr. Chellum, a small erudite man, conversant in seven or eight languages, including English and German—age hard to determine—head shaved except for a tuft in back, dressed in a long white dhoti and orange shawl. I accompanied him by bus to his home in Mylapore, where we were going to observe the evening worship in the Mylapore temple. From the bus, he pointed out various things to me, like the cinema. I asked him if he goes to the movies. "Yes," he smiled enigmatically, "sometimes." The bus was fairly crowded, mostly with men. The smell was strong and sweet. When we alighted, we walked down a street lined with vegetables and fruits. Mr. Chellum was very curious to know which ones I was and was not familiar with. We got to his house, three tiny rooms with stone floors and old wooden furniture. Huge brass vessels stood by the door full of water. There seemed to be bureaus, but no closets. A clothesline was suspended over the bedding on the floor and materials were draped over it. What at first seemed to me like a hovel was, on reflection, probably quite luxurious by Indian standards.

Mr. Chellum's wife, Sita, was bustling in the kitchen, which was chock-full of pots and vessels and, like David and Carol's kitchen, bare of furniture. There was no sink, just a cold water spigot near the floor over a drain. Sita squatted on the floor to make coffee for us. "She knows

four languages," Mr. Chellum said proudly, "and writes for a journal." He went into the bedroom and returned sniffing something like snuff and blowing his nose in his shawl. He then took me outside to a small temple immediately adjacent to his house. I was beginning to see a scheme of things in these temples. Each one was really a temple complex. The main gate consisted of huge doors decorated with row upon row of bronze nipples extruding from them. Then inside four, five, or six shrines varying in size, housing images of deities at the end of corridors. We did not go into any of these. Mr. Chellum explained them all to me outside.

I was impressed again with the casualness of it all. People of all ages doing all kinds of things in the courtyard: children playing, following us about, people worshipping in various ways—walking round and round a pillar, touching foreheads to ground in front of a shrine—Mr. Chellum loudly lecturing to me, in the middle of which he too touched his two hands devoutly to his forehead. A man followed us around pointing to various events for my benefit, hoping to horn in on what he seemed to think was Mr. Chellum's lucrative territory. A cluster of women, sitting huddled at the entrance to a shrine, observed us dispassionately while chanting in unison. Stopping in front of a shrine, Mr. Chellum explained that this deity represented "the midway point between form and no form." And there inside on a platform was a red shrouded blobby thing. Under another pavilion was a representation of the movement of the planets. People walked round and round it. There was a stable for cattle and a pen for peacocks. From a gold-plated, twenty-five foot high flag staff a static representation of a billowing flag was frozen in a permanent breeze. Each temple had one of these. Mr. Chellum proudly pointed out the gold.

It all reminded me of Coney Island—gaudy, sleazy, flung about, noisy. Yet it seemed to work better. It was not a place that people escaped

to. It was all part of their daily experience. At dusk a priest came out and blew a long horn and played drums. Then another priest—bare chest, short white dhoti, white stripes across forehead—came out with a tray holding fire, flowers, and ashes. He sprinkled ashes in peoples' out-stretched palms and they smeared their foreheads with them. Mr. Chel-lum did likewise. Then suddenly he seemed in a hurry to get away. It was all over. During the short tour I became very fond of this gentle man.

THE TRAIN FROM Madras to Trichur in the state of Kerala was my initiation into third-class travel in India. The three of us—David, his friend Jim McConegee, and I—slept in a tier of three wooden berths. I slept well, even while having to wake up every half hour to change position. I couldn't help wondering how the Indians did it, with so much less flesh to pad their bones. Following the three-day theater and dance festival in Trichur, I took a bus with Jim to Guruvayur, a town on the sea with a famous temple to Krishna. The buses here roar down these narrow roads like demon monsters, playing chicken with oncoming vehicles. We rented bicycles in the town, rode three miles to the Indian Ocean, past thatched roofs and more modern squarish bungalows painted yellow, pink, or blue with wrought iron gates and filigree woodwork under the roofs. A polyglot mix of Victorian colonialist legacy and Bauhaus design. At the ocean we found a fishing community—thatch-roofed huts huddled close together with the usual candy store array of goods in jars: biscuits, plantain chips, sodas in half-filled bottles. On the shore were large, round-bottomed, canoe-shaped boats. The beach stretched for miles. At first we were surrounded by kids who insisted on getting into our photos. On the way back we stopped for a rice meal and were joined by the owner and several locals. Such encounters followed a pattern: We explained where we were from, what we were doing here, how long we would be here, and when we came here. And because their English was not that good we repeated the same things two or three times. Once the ice was broken, it seemed they simply liked sitting around with us. I was beginning to tire, was actually coming down with something. The owner kept ordering more beer, then some hot salted fried fish, very tasty. He wanted us to stay longer and come visit him, in fact stay at his house and meet his family. We had to decline repeatedly, politely, and firmly.

That night I began to get a fever. As I was dropping off to sleep I suddenly felt it was very important to wake David up (the three of us had been sharing a single room) and tell him that the first night we were there I had dreamed that someone had come in and made me sick. Later I dreamed that someone came in and put garlands of flowers on each bed so that there were three mounds of flowers in the room. It seemed to me a death image, though flowers were used in worship here.

The next day I went to the local doctor. She made me say ah, looked in one eye, listened to my chest with a stethoscope, asked me if I was allergic to any drug, and promptly wrote out a prescription for an antibiotic. The new witch doctor cure, it promptly fucked up my gut. We had now come to Cheruthuruthy, where the Kathakali had its school. I began to panic and then caught myself. Somehow I knew I was not going to get my lethal thing. If I was going to be sick it would be the way Westerners usually get sick here.

One evening I saw the dusk in a very auspicious place. A ghat on the river, a broad sluggish flux with as wide an expanse of dry shore on one side that probably got flooded during monsoon. Off to the left was the pedestrian-vehicle bridge, way to the right a train bridge. As the light faded, the sounds and movements became isolated and enhanced— pure sensation. The women slapped their wet saris against the wet rocks. A red toy train whistled across the bridge. A bus crossing the other bridge was now in silhouette, each passenger clearly outlined against the still-bright evening sky. A cut-out bullock-drawn cart trundled across. Bicycle bells. Slap, slap, soft murmur of women. Flat water changing color, darkening, losing reflection. Automobile lights moving across the bridge. Tears came. Slap, slap, slap.

We are now on a train moving toward Conanur, thence to a small town—Alikode—to see a two-day festival in which the Kathakali will

take part, I look down at the passing countryside that slopes away from the tracks: a huge patch of coconut halves, washed and drying by a river, white trousers and dhotis spread flat on the ground. Four hours on the train. Four-and-a-half more hours on two buses to Alikode. Then we start to climb up a dusty road to the site. We can look back at the village ringed with mountains. There are now five of us, including two more Americans: Julie, a serious student of Kathakali, and a young guy with beautiful open face and giggle. We will be the only Westerners. As we start walking with our assorted duffle bags, knapsacks, bedrolls, shopping bags, we laugh at the prospect of an Indian Woodstock. We get picked up by a panel truck loaded with boxes of rubber sandals headed for one of the stalls. The site consists of one long road with stalls on either side selling coffee, bangles, bananas, religious pictures, peanuts and biscuits, rubber sandals, dishes and pots, among other sundries. At the crest of the hill is the temple, a rough affair with a kind of corral, then a roofed pavilion, then to one side the inner sanctum housing the deity. *Puja* (worship) is going on as we arrive. The drums are going and there is a bedizened, caparisoned elephant standing in the corral. A big sloping field stretches down to the stage where the performance will take place.

The stage is made entirely of bamboo. Thick bamboo poles support it, and crisscrossed matting forms the walls. We are incredibly dirty and are told about a "tank" where we can bathe. The only trouble with bathing in India is that women have to be pretty well covered. So I go in in my clothes, figuring I'll wash clothes and body at the same time. The water is very green and silty. Afterward I change into a sari I have bought in Shoranur. A group of local ladies and children gather about staring as Julie tries to instruct me in proper draping of my first sari. She finally asks one of them to help me. There ensues lots of fussing and pulling and

giggling. I am finally in it, very uncomfortable and self-conscious. The women and children think the whole operation hilarious. We have dinner in a large hutch halfway up the hill from the tank. It is a delicious rice meal provided free for the performers and entourage by the local maharaja who has sponsored the whole festival. For two days we will eat here.

The performance begins about 9:30. Before that there is singing, I think by children, but I don't pay too much attention. I feel that I should save my concentration for the all-night marathon to come. I go back-stage to observe the preparations. The performers lie two at a time on their backs on bamboo mats. Specially trained makeup men apply the paint upside down, that is, sitting with legs spread and the head of the performer between. The beards are very carefully built up in ridges with strips of paper, gauze, and a white paste-like substance. Since the performance goes on for so long, the ones who appear later get made up after it has started. They don't seem to mind our coming and going backstage. Everything is very relaxed, informal. They don't do any special preparation or warm-up.

They do three stories a night. The stories are mostly episodes from the long epics of Indian mythology—the *Ramayana,* the *Mahabharata.* Someone said that there are 150 stories in the *Ramayana,* and it would take as many days to do them all. The first story on this night is about Nala, a once great king doomed to exist as an ordinary man after a serpent sent by a jealous god bites him. The old performer playing Nala—Kunjan Nayar—does a one-hour solo recapitulating his story. The rhythms of the drums and cymbals heat up. Now I could see what great performance really is like in this form. The younger ones wiggle their eyebrows, turn up the corners of their mouths and do a few more things, and that's about it. But this guy actually projects *emotion.* His cheeks

vibrate, he seems about to cry, he looks startled, he looks afraid, he looks puzzled, he looks proud. But all through extremely small changes in particular parts of his face. Watching his face is like watching changing weather while on LSD. A moving panorama of human feeling.

The second night the musicians in their "overture" really go wild. Someone is taping it, and I sense something is afoot. The maddalam player seems very fidgety and nervous as they get started. Then—BAM!—they are into something: chendra and maddalam facing off, pushing each other to cathartic heights of pure rhythmic energy, sometimes the gong player giving a cue for a fresh rush, sometimes one of the drummers. BAM! They are off again. Then it dies down for a bit, and I am afraid it will stop. Then POW! the big maddalam guy (with a sixty-pound drum strapped around his hips) starts flailing away, his bare torso pulsing, arms straining from the shoulders, right-hand fingers sheathed in plaster sleeves rattling against one end, and open left hand making another sound on the other side, making it sound like two drums. And the chendra man throws down one of his sticks and pounds with one hand and one stick, his head vibrating so fast it is a blur. Relax a little, slow down—no, no, no—don't stop now. Rattle rattle rattle plaster cast fingers rattle rattle BAM! flail. One of the cymbal players dropping the heavy brass plates together and just letting the top one lie around on the underneath one so that it clangs and vibrates deliciously. It goes on for twenty minutes. I hate when it ends.

The energy in that audience was unbelievable. I doubt if anyone left before the end. You might see someone nodding out now and then, but they stayed. Young and old. An old toothless man sat next to us both nights, head bundled against the chill, blanket around his shoulders, gaze riveted on the stage, mumbling and chanting to himself. He was really in

there. It meant more to him than a moment's entertainment and escape from his life. And something other than what opera is to Westerners.

Back in Cheruthuruthy, I was getting a little hung up. Felt run down, so small things were bugging me—my pen running out of ink and having difficulty getting another one in the tiny town. Julie and I were banished to a rustic little house next to the rest house, which had been taken over by some cinema people. It had running water and that was all. No toilet or shower. We could get along without a toilet and shower in the house; the real hassle was that there were windows on each side, that is, wooden shutters that had to be left open for air and light, and they were right off the ground, so we were in a fish bowl again.

Mr. Vasudavan, a writer, took us to an American couple who were living about five miles from Cheruthuruthy. She was a sociologist doing research on comparative customs in Kerala and Madras, and he was a linguist. She told us about the Theyam, the untouchables whose rituals involve drinking chicken blood, sitting on hot coals, also dancing. Afterward we went to Vasudavan's house, met his old mother, wife, two daughters, and brother. We sat on the porch. The old lady was doing something to dry red peppers, squatting way down on her haunches, legs doubled up like a hinged yardstick, laughing toothlessly. Vasudavan was one of those people who can live comfortably in two worlds. Very well informed and worldly in Western terms, also tied to his roots, his family, his village, his Nambuteri caste and customs. Julie and I did a version of Kathakali that made everyone roar with laughter.

The next night we saw another all-night Kathakali performance. Very difficult to focus on it—crushed like sardines sitting on the ground, and they kept coming in, threading their way in order to sit beside friends and relatives. You started out with legs crossed and ended with

knees tucked under your chin. Excruciating for back, hips, and buttocks after twenty minutes. I couldn't think of anything except my aching ass. This performance site was out in the sticks. We walked a half-mile from the road around dusk—full moon already up. Then, since it wasn't to begin until 10 PM, we walked about a mile to Ramancutti's house, one of the great old actor-*ashans* (teachers) with the troupe. Along the earth mounds that separated the rice paddies we picked our way through the gathering night. The tall palms became more and more silhouetted. The moon brightened. Fantastic evening. The house had no electricity. They carried kerosene lamps from room to room. A rice meal was served by four statuesque women in elegant saris, several of whom spoke very good English. Very charming, hospitable people. I wasn't sure who they all were, but obviously all related—loads of children, a man of fifty who stayed close the rest of the night with a flashlight, and an old toothless grandmother who went back with us and sat next to me for much of the night resting an arm on my leg or shoulder. We returned to this house at daybreak. The same people "hanging out"—laughing, talking, drinking tea, eating rice iddlies, cooking, wandering in and out of the house. No one going to bed, neither the old nor very young. After staying up all night, I was really pooped.

I was beginning to have doubts about being a tourist. I hadn't gone to India on a spiritual quest. I went because of the opportunity, a passive reason. Now after four weeks, I questioned why. If I was a tourist then I should see a few more things and then return home. I couldn't stay in Cheruthuruthy any longer. To live in that proximity with a village and maintain the distance of a tourist seemed indecent. I admired Julie's perseverance with the language and in making contacts, however limited. "I am going, you are laughing. It is good," and the like. I stood back and let her work. But I was not at this point committed to any greater degree of

involvement. Yet not being involved also drained energy, made me feel self-conscious, even guilty. I was here for my own enrichment. In some indirect way the tourist-voyeur lives at others' expense. One way to deal with this Marxist-Puritan discomfort was to keep moving.

On my return to Madras, I made a solo excursion to Mahabalipurum, then to Kanchipuram, two seaside towns south of Madras. Vishnu, a young guide, attached himself to me. We rented bicycles and went out to the "Tiger Cave," a big boulder on the shore out of which is carved a shrine and huge bas-relief heads of tigers. One morning I got up at 5 AM after going to bed at 9. Around midnight there had been a commotion in the corridor, lots of people bedding down, hacking and coughing as if in a TB ward. When I stumbled out of my room the next morning, I had to step over bodies. The same glut of sleeping bodies sprawled on the front stoop downstairs. I wondered if the proprietor charged them rent. A lot of people live that way here. Bathe in the ocean, sleep anywhere. How do they eat? Vishnu was one of the more affluent. He said he is paid by the government, although he was obviously going to hit me for something (8 rupees).

The moon roars eastward thru the paling night
Seeking its peaceful just end
As the sun advances a cloudy dawn
Before thrusting up from the floor
of the Bay of Bengal.

365

A temple to Siva, right on the sea shore. I kept being reminded of Stonehenge and those sight lines. A portal, a tank, a gate, a shrine. A vertical opening, a watery opening, a cleft opening, a doorway. Lots of preliminaries before you get there. Inner sanctum, outer rectangles, tank,

portal, rectangular mound in the middle of the tank. None of these remained in use or completely intact. The different kinds of architecture existing side by side were astonishing.

How much more interlocking, overlapping were history, everyday life, fact, myth, superstition, daily worship in this country than anything I knew about. In India the earthly and divine are all mixed together. Dung in the cathedral; idols at eye level, the ephemeral and eternal, peeling paint and granite elephants that will last thousands of years; unsaintly deities; hurdy-gurdy temples; monkeys and peacocks and the midway point between form and no form. Could I shave my head, smash coconuts on the Shiva Lingam, get ashes smeared on my brow, walk in circles around the deity? In the temple used for worship here monkeys played in the tower, red-faced unafraid monkeys. Mama, Papa, Auntie, Baby. Shaven-headed devotees offered both monkeys and deity bananas, coconut. A woman swept. Again I wept.

I left Madras for New Delhi toward the end of February and stayed in the local YWCA. Aside from several music and dance events I attended at the Sangeet Natak Academy (a richly appointed MoMA-like museum and concert venue), I found my three days in Delhi to be an interesting nightmare. Weakened from persistent diarrhea, I was now desperate to go back to NY. With too many Westerners, Delhi was a huge hustle. What first hit me was the incredible din in the heart of the city—far worse than New York—and the effort of crossing the streets. You jump—or else! The squalor of the YWCA, a cross between an Oliver Twist workhouse and Bellevue, was dispiriting. I met two pinched young women at the Y, one from New Zealand, on her way to London to work, the other from London headed for Australia. Both of them were traveling by bus—eighteen days across Asia Minor and Europe! All they talked about was penny-pinching and avoiding getting gypped. Constant complain-

ing about the service, the difficulties, the Indians. I didn't mind the "Indian way" until I decided to come home. Funny how I fell right back into my American compulsion for expediency, efficiency, quick results following a decision. At first, I had adjusted very quickly to the different sense of time and energy-output. It was all very curious, and I was in no hurry. Now the pressure of only three days in which to see Delhi, buy gifts, gather information, attend cultural events—plus dealing with a queasy gut—was too much. I could hardly wait to get on the plane.

I wandered thru Old Delhi on a Sunday. The men (couldn't tell whether they were Muslim or Hindu) really jostled hard. They had a trick of holding arms at full length by their sides. Then as they jostled you they could get an extra feel on the thigh or—if skillful—the crotch.

I visited the studio of dancer Maya Rao. The "new" choreography put me to sleep with its literalness, but their skills were impressive. They were all competent in Bharata Natyam, Cuttack, singing, drum, and several knew Yakshegana. Satya Narayan showed me some Cuttack. I had never seen such fast footwork. The atmosphere of the place was very friendly. When they asked me to show them something, in my black pants outfit, vitamin pills and change falling out of the vest pocket, legs wobbly from la turista, I churned out *Trio A* in the 10 × 8 foot space. Afterward they applauded, and Sonar Chand commented that it seemed to be about "human frustration." He explained what he meant, but I didn't get it. His kinetic memory was unbelievable. In talking about *Trio A* he all but danced the whole thing out.

During one of the concerts in Delhi I was delighted to recognize several ragas that I had heard in Madras. The singer was from Mysore.

LIKE SO MANY Westerners, I returned home in a state of extreme culture shock. In a deep funk, I was flooded with contemptuous feelings toward my culture, entertained fantasies of giving up my profession and going back to school to study marine biology or nursing, and gained fifteen pounds while eating my way through countless jars of peanut butter and immersing myself in Jung's *Memories, Dreams, Reflections,* Miguel Serrano's *Jung, Hesse: A Record of Two Friendships,* and Colin Turnbull's *The Forest People.* One result was a theater piece, *Grand Union Dreams.* Another was an unsent letter from me to Bob Morris:

I would like to release you from your relationship with me. I seem to have some kind of power over you, or you invest me with it—it doesn't matter which. I wish to withdraw that power. . . . The veils are falling away: Penelope waits for Odysseus. Odysseus dallies. He dreams: Scylla and Charibdis, the Cyclops, Sirens, Circe, etc. He invents them all so as to postpone the inevitable. He forgets what Penelope looks like. Penelope forgets what he looks like. They both exist on a cushion of memories. He can't go home and he can't not go home; she can't close the door and she can't not close the door.

His dreams embody his dread, but in the dream he knows that he dreams and chooses not to awaken. Bob, wake up. Go home or don't go home. YOU CAN BE HAPPY WITH EITHER ONE OF US IF YOU SO CHOOSE BUT YOU'VE GOT TO CHOOSE.

My decision not to send the letter is telling. Mythologizing our mutual thralldom could only have exacerbated my psychic paralysis. We

had a brief reunion and reconciliation at a conference in Seattle in the spring of 1971 and agreed to meet up in San Francisco that summer. The Grand Union was scheduled for a gig at the Walker Art Center in Minneapolis at the end of May. From there Barbara Dilley and I were going to Vancouver for some workshops and then on to the Bay Area. While in Vancouver I received a letter from Bob Morris. The gist of it was that he needed to be alone for a while and was going to Europe by himself. I wrote to Magda Denes, my shrink:

Dear Magda:

I am enclosing a letter from Bob. I have re-read it enough and have no more need of it. I am wary of "revelations," especially when they are expressed with unnecessary hurt ("No ease of touching"). I received the letter like a karate-chop to my neck. I am glad that this time it was so quick and not drawn out (although he extends the possibility of a future: "I will one day want to tell you about it"). What I am forced to confront—and in a more agonizing form than before— is how without the certainty of Bob in my future, my life turns to shit. Bob has played a dominant role in my fantasy life all this year. I know now that to entertain such a fantasy any longer would be crazy. He has come to represent some kind of security: He would always love me and protect me. When I was with him I could "pretend" I had an autonomy I never felt. Now I exist in the world with my terrors, which seem to grow with familiarity. Certainly they don't abate. All I can do is decide moment by moment how to make myself comfortable. Work out with Barbara, take a steam bath, smoke dope or don't smoke dope, play with Barbara's son, 8-year-old Benjamin, or avoid him (his problems make me very anxious), work on my workshop

plan which starts in a few days. Somehow it all goes back to my rela-
tionship with my brother. Whenever I come west my brother (in my
fantasy) is looking over my shoulder commenting on my "growth."
Why can't I live for myself? Why can't I like myself? . . . I don't have
sufficient grip on myself to distinguish fantasy from reality right now.
All I see is how fucked up I am.

Barbara and I had bought a secondhand vw bug in Minneapolis,
which we drove to Vancouver. Subsequently I drove it down the coast to
San Francisco while she stayed a little longer in Canada. At the border I
was pulled over by the U.S. customs people. After all, I looked like a hip-
pie; in fact had just hidden a piece of hash in my brassiere, which the
customs woman's body frisk did not detect. On searching the car they
found marijuana seeds all over the floor. I talked my way out of a po-
tential pickle by claiming that I had bought the car secondhand and
hadn't cleaned it up, which was half true. There were many joints rolled
in that car before and after we bought it. Other members of the Grand
Union were converging in San Francisco. Barbara, Lincoln, Douglas,
and I would live in a spacious airy house on Potrero Hill that belonged
to a friend of Belle and Ivan. David was staying with Valda and their son
Ain in Berkeley, where she was dancing with Merce.

The painter Nancy Graves was also in San Francisco, in residence
at the San Francisco Art Institute. She and I had become friendly in New
York while we were with our respective partners, Richard Serra and
Morris. She reminded me of when we first met: at a dinner I had made
for them in Bob's loft. She was impressed by the way I had pulled it off.
(I made meatloaf.) Nancy was never much of a cook. It was probably our

ill-fated liaisons with problematic male artists that first drew us to each other. In my vulnerable and depressed state that summer I felt that Nancy had adopted me. She introduced me to her flamboyant friend Joan Chase, who made light shows for rock bands. Joan had a great mane of bleached blond hair and walked around North Beach with a huge shaggy white wolfish dog. One evening she drove the three of us in her big white convertible (sans dog) over to Sausalito for dinner. After consuming three bottles of wine we staggered out to the car. Nancy crawled into the back seat and promptly fell asleep. On the Golden Gate Bridge Joan kept sticking her head out of the window and vomiting. I was too soused to be alarmed.

I was miserable. Belle later told me they could recognize that I was in a bad way but didn't know what to do about it. I felt estranged from the Grand Union members and mooned about the Potrero Hill house compulsively eating everything in sight. I was also fed up with them for behaving like irresponsible children and not observing the rules of the house, like not mastering the burglar alarm code, which resulted in the alarm going off at all hours of the day and night when someone came home. In August we gave a performance on the roof of the Art Institute. Barbara had asked Nancy to paint designs on her nude body prior to the performance. Totally stoned, she walked in that "costume" along the top of a high narrow wall that bordered the terrace. If she had fallen, it would have been all over. Leo, my eleven-year-old nephew, built a small enclosure around me with cardboard and wood, which I then burst out of. Ivan too got into the act, as did Valda and Ain.

In late August or early September I returned to New York, where I had a class to teach at the School of Visual Arts. One day, while walking on Madison Avenue near the Whitney Museum, I ran into Barbara Rose. She announced that Bob Morris had gotten married to Poppy Johnson

and gone to Europe with her during the summer. I was stunned. During the next few weeks I sank into the throes of depression and suppressed rage. I wrote to Bob and told him to get the rest of his stuff out of my loft or I would throw it out. When he came by I stayed at the far end and refused to speak to him. At night I began to walk in my sleep, sometimes finding myself at an open window many yards from my bed. Or I woke up screaming "NO, NO, NO!" from a nightmare in which unknown "they" were trying to get in through the window. The only way to get rid of "them" was to wake up. A dancer friend, the late Jani Novak, who was staying over one night, was awakened by my screaming and rushed into my room to hold me. During the week I managed to keep myself together through teaching, therapy with Magda, and occasional sessions with Grand Union members. But on weekends I would fall apart and frantically call Magda. Her advice was invariably, "Call a friend, go to a movie."

John Coplans, the new editor of *Artforum*, arrived from Los Angeles in the fall. He invited me to a dinner party for the LA art dealer Irving Blum, Leo Castelli, and a few others in his Upper East Side apartment. The dinner had been prepared by a pretty Japanese American assistant of Blum's. She also served the various courses to the seated guests and, after serving, sat down at the far end of the table to eat with us. We were the only women present, and I was the only artist. The conversation—one smarmy piece of gossip after another, mostly about successful women in the art world—began to disturb me. Finally I couldn't take it anymore and said to the cook, "Do you always have to put up with this kind of talk when you cook for them?" Before the poor girl could answer I excused myself from the table and headed for the door. Catching up with me, Coplans opened the door with a courtly flourish, and I sailed through. I had barely finished the first course, a serving of honeydew melon, for which, to my mortification, I had started to use the improper

utensil, a spoon instead of a fork and knife. A few weeks later, seeing Leo on the street and still astride my righteous high horse, I blatantly snubbed him. Years later Coplans admitted that when he first took on his new job and was green in the ways of New York social protocols, he had made a grievous faux pas in his selection of guests. This incident, though not contributing to my downward emotional slide, was definitely en route.

A more pertinent contributing factor was my enrollment in a course on Indian music being taught at the New School by David Reck, my friend from Madras. Full of composers and musicians, the class was conducted at a very high technical level, far beyond my musical comprehension. In my depressed state it was a throwback to that early failure when I dropped out of U.C. Berkeley.

I BEGIN TO foment a plan. I call three doctors—my gastroenterologist, my gynecologist, and a GP I have visited once or twice. I tell them I am working very hard and am having trouble sleeping. Can they prescribe something for sleep? They all comply. I wait for the prescriptions to arrive in the mail. I tell no one. I visit Magda early in the week. I tell her nothing about my plan. The word "suicide" has never come up. I have an improvisation session with Douglas and David on Thursday and say nothing. I am on automatic pilot. The last prescription arrives on Friday, October 15, 1971. I have already had the previous two filled in different pharmacies and I go to a drug store in the Village to attend to this last one. I then walk to the supermarket at Houston and Bleecker and buy cat food, kitty litter, and a banana cream pie. My cat, Harriet, has recently given birth to a litter of four kittens. I make sure they have plenty of water and food and the cat box is clean. I eat a slice of the pie, then swallow the contents of the three vials of sleeping pills with water. I lie down in the middle of the loft on a piece of felt left by Bob Morris. I wait. Nothing happens. I am wide awake. I get up and get another vial. This one contains bella donna to slow peristalsis and will probably save my life. I swallow the entire contents, then lie down and instantly black out.

JANI HAD A key to my loft with the understanding that when I taught on Mondays at Visual Arts she could use the space. She didn't always come, but on this Monday she did. Finding me unconscious in the middle of the floor—not in the enclosed bedroom, which she might not have looked into—she called a friend who then called an ambulance from St. Vincent's Hospital. Bert, who ran the freight elevator, told me later that I was green when they rolled me into the elevator on a gurney. In St. Vincent's ER a resident took one look at me and plunged a tube into my chest to take over my breathing and also pumped my stomach. All the stuff I had ingested hadn't yet reached my small intestine, where it would have been absorbed and done me in. But I was still unconscious. I woke up on Thursday, six days after having tried to end my life.

It was not a sudden awakening. For what seemed an eternity I was trapped in my coma, aware of being handled, turned, and manipulated, aware of voices, clamor, bright lights, but unable to move or speak. It was a nightmare, full of terrifying hallucinations. I was pinned to a wall, in a jungle with pygmies; there was loud drumming; there was no way out. I must have awakened for short periods before the ultimate awakening because once I found myself sitting up with a mask over my mouth and nose, hunched over some contraption that was forcing me to breathe. David Gordon told me later that the doctors didn't know whether I had suffered brain damage. When I was finally fully awake, I was immediately transferred to a ward, where a social worker came to see me. In response to her questioning I told her that I had been having nightmares and was walking in my sleep, and that I must have gone into the street and been hit by a car. She didn't buy this absurd explanation. "What about the empty vials of pills found on your drain board?" And then I remembered. The hospital's diagnosis was OD, not suicide attempt.

Ivan showed up—he had been there from the beginning—then tons of people: friends, students, Magda. Trisha came and threw herself into my arms as I lay in bed. We both dissolved in tears. Hollis Frampton brought a tiny hand-cranked viewing machine and some silent films to thread into it. He offered to become my "film guru." Pat Catterson, who had taken over my class at the School of Visual Arts, performed *Trio A* with her students on the 12th Street sidewalk three stories below my hospital room. The nurses asked, "With so many friends, how could she have done such a thing?" I heard that Bob Morris had been coming to the hospital every day while I was unconscious, but now there was no sign of him, and I was relieved not to see him. I had finally washed the man out of my hair, but I had a long row to hoe before reaching an understanding of what I had done.

The most immediate repercussion of my act was a deep decubitus ulcer, or bedsore, on my tailbone from having lain in one position for so long. Every day a doctor scraped a little of it away as I yelled in pain. They finally listened to my entreaties and gave me a hefty shot of Demerol a half hour before his daily visit. After about six sessions in which he scraped it down nearly to the bone, he was done. The emotional aftermath lingers to this day. With Magda's help I began a long torturous investigation. Two questions arose that I have never satisfactorily answered for myself: How could I not have given a single thought to the hurt I would bring to the people who loved me? And how could I have let myself be taken over so completely by this singular obsession? What I discovered was that suicide as a means of escape had been a viable option throughout my life when I was depressed, angry, or felt rejected. Always lurking in the recesses of my mind, ready to lure me into its net, it was a constant, if recessive, companion. My task now was to monitor the instant it hove into view. Nip it in the bud, wrestle it down to its origins,

376

deal with the event, however trivial, that triggered its intrusion on the stage of my consciousness. Over the next ten years Magda sent me to a series of specialists who prescribed various drugs for depression—Tofranil, Elavil, Nardil, and lithium—the precursors of the current serotonin reuptake inhibitors. Each produced side effects that were intolerable. Lithium, the last of them, was prescribed by a private clinic housed in an Upper East Side mansion where the clients sat around the waiting room talking like chemistry Ph.D.s. Once a month I went up there, had my blood tested for toxicity, and spoke for five minutes with a psychologist. What they didn't tell me was that when taking lithium in hot weather one should drink at least three quarts of water a day. On the hottest day of 1980 I went down to Washington, D.C. to attend a massive labor demonstration and didn't drink a drop all day. On the bus back to New York the muscles in my back began to twitch, and when I got home I slept for the next sixteen hours. Upon awaking I immediately went up to the clinic to get a blood test and, sure enough, I was toxic. I went off the stuff cold turkey and told the five-minute shrink I was leaving. He said, "You'll be back." He was wrong. I've never taken antidepressant drugs again and in the intervening years have not had a debilitating depression. They say you can outgrow these things.

Under a cloud of depression, does one decide to commit suicide or is one driven to it? For some years after, Ivan—in denial about how close I came to death or serious injury—would say, "If you had really meant to kill yourself you would have washed down the pills with a fifth of bourbon." To which I would respond, "If I had thought of it I would have done it." Would have bought a bottle of Jack Daniels rather than that banana cream pie. But I've never liked the taste of liquor, so it didn't occur to me. Or if I had "really meant" to do it, why didn't I barricade myself in the bedroom instead of lying in the middle of the floor, where

Jani could easily find me, or do it on Tuesday instead of Friday? Can't answer these questions. The exchange with my brother is chilling in the way it places a moral onus on intent, as though anything short of a "successful" suicide is proof of flawed moral fiber. What else underlies the questions we ask of Marilyn Monroe's death? Was it an accident that she died? Did she really mean to do it? Or did she just want a little relief from the loneliness of that Saturday night? Would we respect her more if she had marched into oblivion resolute and determined?

Without taking undue credit, I can claim a certain amount of determination, but if it was based on a decision, this was not articulated as "I want to die" or "I am going to kill myself." If I could have given my impulse words, they might have surfaced as "I don't want to be here; I don't want to have to feel this rage and pain." If I had been able to form these words I might have averted the near-disaster. It was this suppression and lack of words that fed my engine of self-destruction, its blind, mute, headlong drive.

As for Robert Morris, his marriage to Poppy Johnson didn't last long. (I must confess to a lingering satisfaction, although I wish neither of them ill.) I've run into him twice in the last thirty-five years, both encounters amicable. The word "erasure" comes to mind. A life can be so easily erased. Almost erasing mine may have been a successful strategy for erasing a man from my life, but I don't recommend it. I was extraordinarily lucky. Almost needless to say, but not quite, suicide has definitely lost its power over me. When it very occasionally raises its head, I am instantly on the alert.

He presses his face and chest against the wall.
He gives way, without shame, to a fit of uncon-
trollable sobbing.

(Slide projection, *This is the story of a woman
who* . . . , 1973)

17

<p style="text-align:center">Feelings Are Facts</p>

A SMALL COMPONENT in my decision to knock myself off in the fall of 1971 was a nearly depleted bank account and what I thought were no future prospects for income. I had conveniently (for purposes of suicide) forgotten that I had applied for a grant from the National Endowment for the Arts in September. Early in 1972 the $10,000 grant came through, which did much to swell my depleted spirits. It was the second big grant I had received, the other a Guggenheim Fellowship in 1969.

Another decision, in this case far more productive and less traumatic, did not take place overnight. One might say I eased out of dance and into filmmaking over a three-year period, 1972 to 1975. There were several circumstances that facilitated this transition: economic freedom was certainly one. Also meeting the French cinematographer Babette Mangolte, who had come to the U.S. in 1970 and was being exposed to the New York avant-garde by her friend and mentor Annette Michelson, the noted film historian. Through Babette I would learn the nuts and bolts of film production and editing. Prior to this felicitous convergence

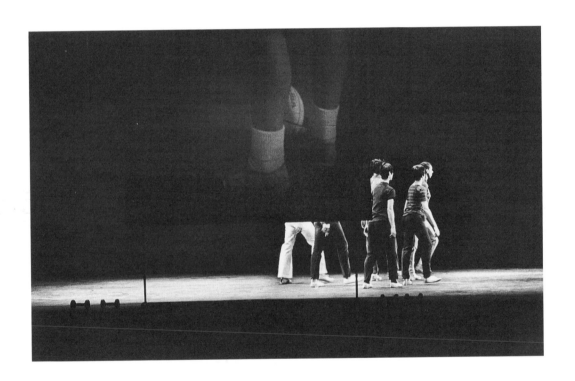

"Film," *The Mind Is a Muscle,* Anderson Theatre, 1968. Photo: Julie Abeles.

I had made five or six short, minimalist ("boring," I enjoy adding, half-facetiously) films between 1966 and 1969, most screened in conjunction with dance concerts. In the "film" section of *The Mind Is a Muscle* of 1968 a screen, raised to a height of three feet, was placed downstage center. Upon it was projected *Volleyball*, a ten-minute film of my legs repeatedly walking into the frame to meet a volleyball that was rolled into the frame from different off-screen angles. The traveling live dancers occasionally converged behind the screen, thus creating a dramatic contrast between their human-scale legs and those in the much larger projection. The ostensible subject matter of these early films was space and time.

Specific film references appeared in my dances as early as *Terrain* of 1963 with a movement resembling Jean Paul Belmondo's death lurch at the end of Godard's *Breathless*. There was also a configuration called "M-Walk"—first seen in *The Mind Is a Muscle,* and later in *Street Action* and *WAR* of 1970—that was based on scenes from Fritz Lang's *Metropolis.*

In *Continuous Project-Altered Daily* of 1969–70 and *Grand Union Dreams* of 1971 a 6 × 7-foot white screen was a prop manipulated by the dancers, and Jack Arnold's *The Incredible Shrinking Man* was projected in a space adjacent to the live performance at the Whitney Museum.

But there were even earlier sustaining influences that nudged me toward filmmaking, not the least of which was my longtime immersion in all kinds of film culture: the emotional power of Hollywood melodramas and European art films seen from a very early age, plus the films of Maya Deren, Andy Warhol, and Hollis Frampton—particularly *At Land, Henry Geldzahler,* and *Poetic Justice* respectively—viewed in the 1960s and early 1970s. Against this multifarious backdrop of Vigo, Renoir, Cocteau, Dreyer, Pabst, "women's weepies," and the formal strategies of the avant-garde, I intuited that I was venturing into a mother lode of possibility.

"Diagonal" from *Terrain* ("death lurch"), Judson Memorial Church, 1963. YR, Trisha Brown, and Albert Reid. Photo: © 1963 Al Giese.

Continuous Project-Altered Daily during *Connecticut Composite*, Connecticut College, 1969. Barbara Dilley, David Gordon, and Becky Arnold in background. Photo: Ellen Levene.

Although by the late 1970s feminist film theory would provide a different kind of support for these interests (vis à vis a critique of the so-called "male gaze" in Hollywood films of the 1940s and 1950s), it was the return of the women's movement itself—coinciding with the devastation of my love life and enraged near demise and recovery—that ultimately catalyzed my transition from moving body to moving image. Busy with "my brilliant career," I had hardly taken notice of the gathering tumult of feminist voices. As a white, unconsciously ambitious artist, oblivious to art world sexism and racism and ensconced in dancing (a socially acceptable female pursuit), I started reading the

Grand Union Dreams, Nancy Green (standing, center), Lincoln Scott squatting behind Douglas Dunn and Valda Setterfield lying on their sides, and James Barth and Epp Kotkas resting on suitcase. Photo: Susan Horwitz.

angry experiential writing in Robin Morgan's anthology *Sisterhood Is Powerful* and the fiery polemics of Valerie Solanas's *Scum Manifesto* and Shulamith Firestone's *Dialectics of Sex*. I had never thought of myself as belonging to an oppressed group—nor privileged one, for that matter—especially as I began to achieve recognition. Hadn't I gotten a Guggenheim before Bob did? Wasn't he always encouraging me and taking pride in my success? Hadn't he said that he hated "false modesty" when I tried to claim I wasn't ambitious?

Excerpts from Firestone's analysis of romantic love still read with a burning clarity:

> Thus "falling in love" is no more than the process of alteration of male vision—idealization, mystification, glorification—that renders void the woman's class inferiority.
>
> However, the woman knows that this idealization, which she works so hard to produce, is a lie, and that it is only a matter of time before he "sees through her." Her life is a hell, vacillating between an all-consuming need for male love and approval to raise her from her class subjection, to persistent feelings of inauthenticity when she does achieve his love. Thus her whole identity hangs in the balance of her love life. She is allowed to love herself only if a man finds her worthy of love.

Hot stuff! I extracted what I needed to fuel my nascent feminist fury. But Firestone's recasting of Freud and Marx and Solanas's apocalyptic vision did more than galvanize my outrage. Their writings, and those of a welter of other feminists, gave me the impetus to begin examining my experience as a woman—that is, a person positioned in the social hierarchy of patriarchy—but also gave me permission to think of

myself as an intelligible and intelligent participant in culture and society rather than the over-determined outcome of a lousy childhood that had previously dominated my self-perception. In a sense, I began to come of age reading this stuff.

On returning from India early in 1971, I was thinking about combining narrative, biographical bits—not yet my own—with dance-like images and formations. *Grand Union Dreams* of that year was an elaborate pageant that dealt with myth, anthropology, and Jungian psychology. The performers, divided into "gods, heroes, and mortals," read or recited texts excerpted from the writings of Miguel Serrano, Colin Turnbull, and Jung, in no particular narrative order. In a section titled "The Heroes Reveal Themselves" James Barth and Epp Kotkes walked decorously about while he said to her, "I am sorry, but you have arrived at an awkward moment. We were supposed to have gone on vacation yesterday, but my wife was stung by a bee, and we have had to postpone our trip. Everything is topsy-turvy here." In another section titled "Mortals' Meetings" two or three performers at a time emerged from a clump and stood or sat in random relationship while wearing felt bibs upon which were crocheted roles, such as "mother," "friend," "lover," "enemy," "wife," "leader," "other woman," etc. Given the literary sources and the magisterial pace, the event was at once pontifical and child-like. Nevertheless, it was *Grand Union Dreams* that initiated an ongoing investigation of strategies—as yet very rudimentary—for creating characters and telling stories in unconventional ways.

In January 1972 the Grand Union was in residence for three weeks at Oberlin College, conducting workshops and preparing for performances. It was there that Steve Paxton began to work with a group of male students on "Contact Improvisation," the form that since then has been taught and practiced throughout the world. I worked on a forty-five

minute theater piece for forty students called *In the College*. I had brought two books with me: Vladimir Nizhny's *Lessons with Eisenstein* and the scenario of G. W. Pabst's 1928 silent film, *Pandora's Box*. I had never seen the Pabst film, which was not yet in distribution in the U.S., but was riveted by the luminous production stills, especially of Louise Brooks. (On the way back to New York from Oberlin I saw the film at Eastman House in Rochester in a private screening that Annette Michelson, who knew archivist James Card, had arranged for me.) *In the College* was a collage of group maneuvers and texts—spoken and projected—in some instances excerpted from these two books. Two "narrators," Jani Novak and Mary Overlie—flown in from New York on the day of performance—stood at a microphone on one side of the stage and ad-libbed "interpretations" of what they and the audience were seeing for the first time. At one point all forty performers lay down in a row on the apron of the stage and watched a three-minute film that consisted solely of titles. Some of these were taken from *Pandora's Box*: "Our affair is the talk of the whole town. I'm ruining my career!" "As agreed, then, you'll come to see me tomorrow." "I'll dance for the whole world but not in front of that woman!" "If you would only come with me. Wouldn't you like to come with me?" Other quotes were recycled from *Grand Union Dreams*: "Emotional relationships are relationships of desire, tainted by coercion and constraint; something is expected from the other person, and that makes him and ourselves unfree" (from Jung). Each quotation was a separate shot. The *Pandora's Box* quotes were also the basis for a series of live tableaux enacted by a male and female student. I asked them to interpret each quote with a static pose. When they had produced about thirty of them, I asked them to perform the sequence as fast as possible. It became a silent Mickey Mouse melodrama, or live flip book. A section called "Lulu" was also a series of *tableaux vivants,* in this

388

case based not on language, but on the production stills reproduced in the Pabst scenario.

At another point in *College* a huge corrugated metal door slowly rose at the rear of the stage while a slide was projected on the left side of the proscenium arch. The slide read, "A man who has not passed through the inferno of his passions has never overcome them. They then dwell in the house next door, and at any moment a flame may dart out and set fire to his own house. Whenever we give up, leave behind, and forget too much, there is always the danger that the things we have neglected will return with added force." Through the opening beyond the

"Lulu" from *Lives of Performers* (16mm, 1972). Valda Setterfield and John Erdman

stage could be seen the cluttered workshop of the theater department. This text too was recycled Jung previously used in *Grand Union Dreams.* I thought it a very funny and apt juxtaposition: "the inferno of his passions" and the unformed materials of a future theatrical production residing "next door."

In the next several years I would grapple with the challenge of representing and fictionalizing the inferno of my own passions. Some of the questions I had begun to ask myself are contained in a letter I wrote to art historian Nan Rosenthal following a screening of *Lives of Performers* at the Collective for Living Cinema in January, 1973:

I had started to talk about how as a dancer the unique nature of my body and movement makes a personal statement, but how dancing could no longer encompass or "express" the new content in my work, i.e., the emotions. And you had supplied me with the word "specific": Dance was not as specific, meaning-wise, as language. There is another dimension to all this that excited me no end when I thought about it: Dance is ipso facto about *me* (the so-called kinesthetic response of the spectator notwithstanding, which only rarely transcends that narcissistic-voyeuristic duality of doer and looker); whereas the area of the emotions must necessarily directly concern both of us. This is what allowed me permission to start manipulating what at first seemed like blatantly personal and private material. But the more I get into it the more I see how such things as rage, terror, desire, conflict, et al., are not unique to my experience the way my body and its functioning are. I now, as a consequence, feel much more connected to my audience, and that gives me great comfort.

The implications of this change as they concern art and the avant-garde must be most complex . . . For example, is there some connection and/or polarity between formalism/alienation/human-ism? Or indeterminacy/narrative? Or psychological content/the avant-garde? Or am I creating straw men? Obviously I have some ideas on all this myself; it just seems too early to get into it.

In fact, I was already "into it," up to my eyeballs. By 1972 the above questions were key to thinking about rendering the shards of my own life into art. From my present vantage point I can conjure a slightly different gloss:

"Feelings are facts," an adage of the late John Schimel, my psychotherapist in the early 1960s, became an unspoken premise by means of which I was able to bypass the then current clichés of categorization popularized by McLuhan—"hot," "cold," "cool," etc. Ignored or denied in the work of my 1960s peers, the nuts and bolts of emotional life shaped the unseen (or should I say "unseemly"?) underbelly of high U.S. Minimalism. While we aspired to the lofty and cerebral plane of a quotidian materiality, our unconscious lives unraveled with an intensity and melodrama that inversely matched their absence in the boxes, beams, jogging, and standing still of our austere sculptural and choreographic creations.

In hindsight, if I ruminated at all over Dr. Schimel's "feelings are facts," it would have seemed unassailably obvious that facts are best conveyed by writing, print, and reading. I had already utilized spoken language in my early dances: "The grass is greener when the sun is yellower; the grass is greener when the sun is yellow" were two lines uttered

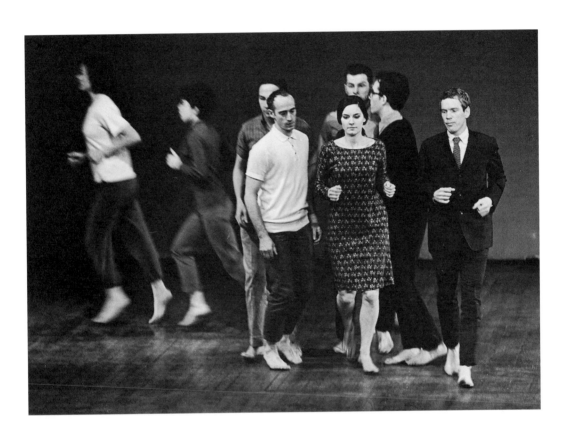

We Shall Run (1963), Wadsworth Atheneum, Hartford, Conn. 1965. YR, Deborah Hay, Robert
Rauschenberg, Robert Morris, Sally Gross, Joseph Schlichter, Tony Holder, and Alex Hay.
Photo by Peter Moore. © Estate of Peter Moore/VAGA, NY, NY.

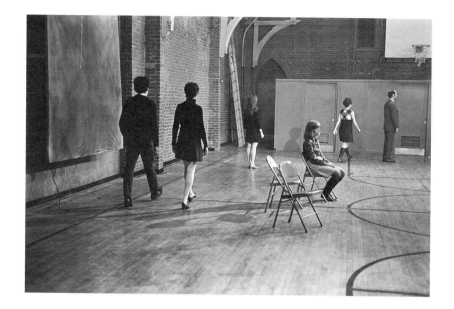

toward the end of *Three Satie Spoons* of 1961. *Terrain* of 1963 contained two "Talking Solos" with autobiographical stories by writer Spencer Holst, recited during a sequence of unrelated movement phrases.

By 1972 my own Sturm und Drang had catapulted me into a new terrain of representation. Having survived my various physical and psychic traumas, and emboldened by the women's movement, I felt entitled to struggle with an entirely new lexicon. The language of specific emotional experience, already familiar outside the avant-garde art world in drama, novels, cinema, comic books, and soap opera—and *inside* the avant-garde in the work of, for example, Roy Lichtenstein and the Kuchar

Satisfyin' Lover, choreographed by Steve Paxton, 1968. Photo by Peter Moore. © Estate of Peter Moore/VAGA, NY, NY.

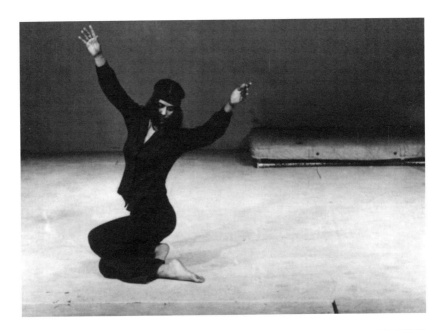

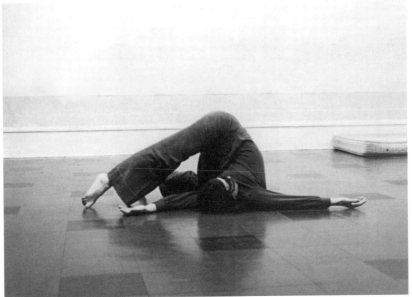

Second section of *Three Satie Spoons* (1961), Theatre for the New City, March 1973. YR

Third and last section of *Three Satie Spoons* (1961/1973). YR

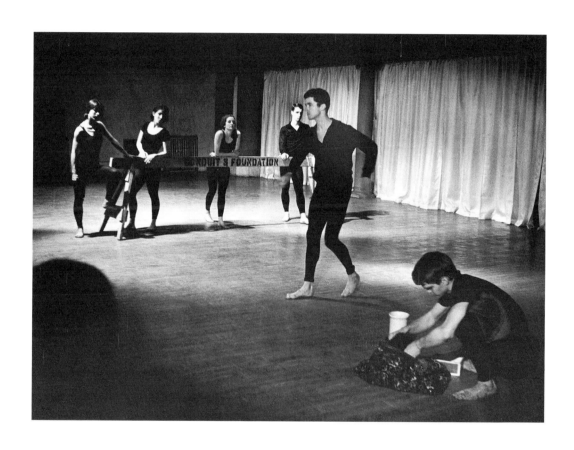

"Talking" and "Sleep" solos from *Terrain,* Judson Church, 1963. YR, Judith Dunn, Trisha Brown, Steve Paxton, Bill Davis, and Albert Reid. Photo by Peter Moore. © Estate of Peter Moore/VAGA, NY, NY.

brothers—promised all the ambivalent pleasures and terrors of the experiences themselves: seduction, passion, rage, betrayal, grief, and joy.

Although my transition from dance to film was relatively swift, it took me over twenty-five years to move from "performer" to "persona" and make halting—and ambivalent—use of the conventions of mainstream narrative film—character, plot, exposition, verisimilitude, shot/reverse shot, and most problematic: credible, or professional, acting. A more concise way of putting it would be: It took me twenty-five years to allow my unformed personae to scream at each other or shed tears. My performers would utter, but not convincingly appear to own, the words they spoke, thus creating a situation that, though not always deliberately cultivated, was fine by me. At the beginning of that period, however, printed texts, coupled with *tableaux vivants* or simple tasks, seemed sufficient to represent emotion. Print, especially, seemed to say it all.

Here I must interject a slight anomaly: In a recent conversation, Valda Setterfield reminded me that the first thing I asked her to do at her first rehearsal of *Grand Union Dreams* in 1971 was to "trudge in a circle around the room wringing my hands while wailing and shrieking." Red in the face and dripping with sweat, she completed the task, upon which I matter-of-factly remarked, "That's not quite it, but let's go on." "It" must have been the memory of my mother at her wit's end, wringing her hands and bewailing her quarrelsome children. I seem to recall that some form of "it" appeared in the final performance of *Grand Union Dreams*.

The snail-like pace of this trajectory was not without reason and precedent. The concerns of 1960s minimalist sculptors were bolstered by the writings of Merleau-Ponty, Roland Barthes, and Alain Robbe-Grillet. The latter's *For a New Novel* was especially important to me. Its critique of the nineteenth-century novel's full-blown descriptions of character and story was a revelation. To describe "what cannot be seen," like inte-

riority, psychological causality, and—yes—feelings was, according to Robbe-Grillet, obsolete.

> Reality would no longer be constantly situated elsewhere, but *here and now,* without ambiguity. The world would no longer find its justification in a hidden meaning, whatever it might be; its existence would no longer reside anywhere but in its concrete, solid, material presence; beyond what we see (what we perceive by our senses) there would henceforth be nothing.*

The notion of "concrete, solid, material presence" would have been troubling for the more conservative dance critics of the 1960s, who saw our lack of theatricality as a lack of artifice altogether. One of them foreclosed, in all seriousness, "Someday there will be a real murder in one of Yvonne Rainer's dances." Another asked, "Why are the Judson dancers so dead-set on just being themselves?" Without going into an extended examination of the ontological contradiction in such a perception—there's a way in which "being oneself" is quite impossible, especially in front of an audience—I will confine myself to the simpler assertion that we refused to transform ourselves into dramatic or mythical personages. Taking a leaf from Barbara Rose's seminal 1965 essay, "ABC Art," in *Art-Forum* (that in her words "unwittingly . . . initiated the vogue for minimal art"), I laid out my own depositions for what I called "postmodern dance" (long before "postmodernism" became a catch-all buzz word for everything from art and culture to war). Just as Donald Judd's "specific objects" and Robert Morris's "unitary forms" had replaced illusionism

* Alain Robbe-Grillet, *For a New Novel,* trans. Richard Howard (New York: Grove, 1965), 39.

with nonreferential forms and monumentality with human scale, so postmodern dance would replace fictional character and technical virtuosity with "neutral doing,"* task-like activity, and human—rather than heroic—scale. If on occasion I indulged in a modicum of characterization—either imitating crazy behavior seen on the subway (*Ordinary Dance*) or pretending to be out of control (*Three Seascapes*)—these "episodes" were always formally bracketed as disjunction and incongruity, to be preceded or superseded by the usual deadpan abstraction or task. The terms, or formal conditions, of my new world of "emotional facts" would at first also remain tied to the disjunctive and aleatory procedures which had laid claim to my earliest development as an artist via the ideas of John Cage and Robert Rauschenberg. On the one hand, this mindset can be characterized as a refusal of narrative and fixed meanings and a deep distrust of the "telling" and shaping strategies of fiction and history. On another, it can be seen as a refusal to differentiate events, thus running the risk of trapping the spectator in a chain of unlimited interchangeability.

It was the latter view that made me begin to reassess my previous paratactic strategies of "radical juxtaposition" (another Sontag term) as I inched toward film via multimedia theater pieces that incorporated slide projections, texts, bits of narration, and dance. But at first, Robbe-Grillet's proscriptions against "depth" and "what cannot be seen" did not seem contradictory to my newfound preoccupation with the specifics of emotional life, both my own and those that jumped from the pages of

* I must here refer to Carrie Lambert's observation (with which I concur) in her essay "Other Solutions" (*Art Journal* [Fall 2004]: 52): "The lack of race consciousness by white artists during most of the 1960s, which would have allowed whiteness to go unremarked . . . points to the blind spot of the period's focus on the body as a neutral, phenomenological entity rather than a socially defined one. . . . [N]eutrality was already internally compromised in Rainer's work of the 1960s."

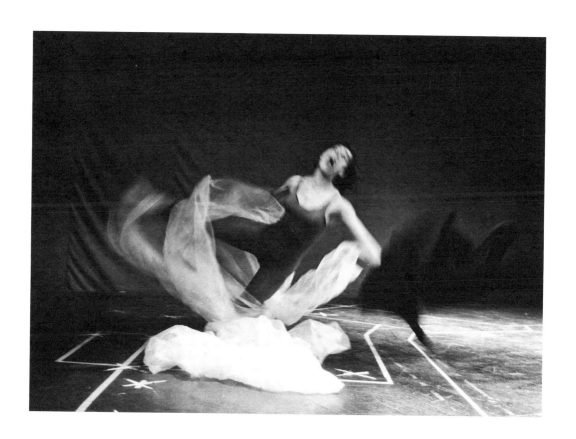

Final section of *Three Seascapes* (1961), Stage 73, 1964. YR. Photo by Peter Moore. © Estate of Peter Moore/VAGA, NY, NY.

Pandora's Box. Dr. Schimel's "feelings are facts," far from violating the interdictions of the *Nouvelle Roman* and the Minimalists, coincided with my previous techniques for handling props, movement phrases, and bodies, that is, as objects that could be endlessly reorganized and manipulated in space and time. Objects and facts were conterminous, subject to identical disjunctive, nonnarrative procedures.

It was no coincidence that my transition to film production was marked by yet another change in focus. The production of different registers of meaning in dance via "unlimited interchangeability" of bodies, objects, and texts would, by my third film (*Kristina Talking Pictures,* 1976), give way to the production of different registers of meaning around specific social/political issues. Treating bodies as objects—for example, having men and women engage equally in the work and effort of lifting each other interchangeably with lifting boxes (as a polemic against classical balletic partnering in which women are "wheel-barrowed" around and hoisted like ethereal creatures devoid of weight and mass)—would be replaced by a critique of the *objectification* of women in Hollywood films.

Even after I introduced a different category of objects, however, in the theater pieces that preceded each of my early films—a gun, suitcase, and letter, for instance, replacing the boxes and balls of my dances—I used them for their melodramatic or narrative *connotations* and not for specific functions that might further a plot or argument. Just as the mattresses of *Parts of Some Sextets* (1965) and the pillows in *Continuous Project-Altered Daily* (1970) functioned as both objects to be carted around, "cushioning" devices, and avatars of sleep, sex, illness, and death, so too the suitcase in *Grand Union Dreams* was used as a "body-supporting device," its immanent everyday meanings of departure and separation remaining static and recessive. And my instruction for the use of the gun in the theater piece of 1973, *This is the story of a woman who . . .,* was that it never be pointed at anyone or fired.

401

Parts of Some Sextets, Wadsworth Atheneum, Hartford, Conn., 1965. Robert Morris, Lucinda Childs, Steve Paxton, YR, Deborah Hay, Tony Holder, Sally Gross, Robert Rauschenberg, Judith Dunn, and Joseph Schlichter. Photo by Peter Moore. © Estate of Peter Moore/VAGA, NY, NY.

To deal with feelings—however factual—was such a novel enter-
prise that I had to find justification in literary criticism for what felt like
clichéd and stereotyped expression. It was Leo Bersani's observations
about cliché that offered me the support I needed.

> Cliché is, in a sense, the purest art of intelligibility; it tempts us
> with the possibility of enclosing life within beautifully inalterable
> formulas, of obscuring the arbitrary nature of imagination with
> the appearance of necessity.

(Slide projected during *Inner Appearances*, 1972)

Continuous Project-Altered Daily, Whitney Museum, 1970. Steve and Barbara. Photo by Peter
Moore. © Estate of Peter Moore/VAGA, NY, NY.

Connecticut Rehearsal, a film by Michael Fajans, Connecticut College, 1969. YR and Becky

Grand Union Dreams, Emmanuel Midtown YM-YWHA, May 1971. Trisha Brown on ball, Fernando Torm in box. Photo: Susan Horwitz.

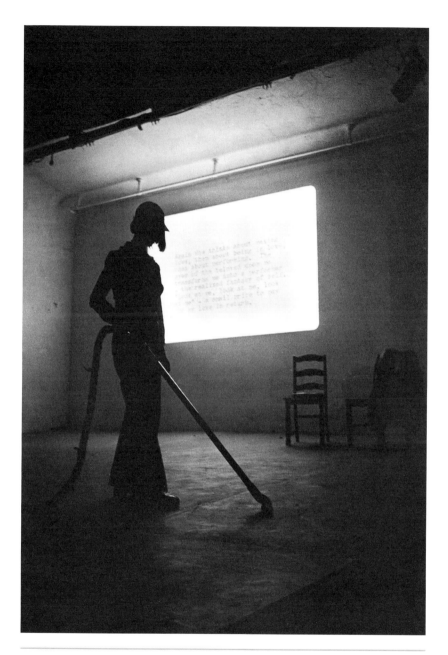

Inner Appearances (1972), Theatre for the New City, 1973. Photo by Peter Moore. © Estate of Peter Moore/VAGA, NY, NY.

On returning to New York from Oberlin I worked on assembling texts for a solo called *Inner Appearances.* In this dance a solitary performer, initially myself, dressed in casual pants and shirt and an old-fashioned green printer's eye shade, alternated everyday actions—from slowly and meditatively vacuuming the floor of the performance space to turning off the vacuum cleaner, lying down on a mattress, or standing, apparently lost in thought. Behind the performer on a white wall appeared a sequence of projected texts dealing for the first time with autobiographical material, now fictionalized and passing for the inner thoughts of a female protagonist, designated by third person pronouns. The first projection was from *Lessons with Eisenstein,* which provided me with a "ready-made" character via the eyeshade and following text:

> The face of this character is a fixed mask. We shall have her wear an eye shade to reveal her inner and outer appearance. The eye shade hides the movement of the upper half of her face, but the lower half, where the tongue works, stays visible. She must function with a face of stone and at the same time reveal her characteristic dissembling. (Slide projection during *Inner Appearances,* 1972)

The above is a paraphrase, extracted from a description of a film workshop conducted by Sergei Eisenstein in which he discussed how Balzac represents Mademoiselle Michonneau in *Le Père Goriot.* The paragraph seemed to encapsulate perfectly both dilemma and solution of the narrative conundrum. If the unmoving human facial exterior gave up neither interpretation nor meaning, thus belying human interiority—"The idea of an interiority always leads to the idea of a transcendence," wrote Robbe-Grillet—then the "inner and outer appearance" of

a performer could be nudged toward a *semblance* of coherence and sense by very minimal means indeed.

In an epiphany, I appropriated Eisenstein's eye shade and text and proceeded to deploy the standard form of anecdotal third-person narrative writing to create a sequence of memories, events, and feelings. Though the slide sequence itself was a kind of inventory of disconnected story fragments, the "she" of the slide projections was consistent, and the individual paragraphs were coherent. Furthermore, the spatial and temporal contiguity of performer and texts created a unity, but would, hopefully, produce not a verisimilitude of character and history, but something in that vicinity, something provisional and surprising, even unsettling, perhaps something that might call into question what narrative traditionally accomplishes. In the words of Hayden White, "narrativity . . . arises out of a desire to have real events display the coherence, integrity, fullness, and closure of an image of life that is and can only be imaginary."*

In the embarrassing wars around prospecting for proxies of experience, I was ever on the lookout for strategies that would evade the siren calls of that desire and its unacknowledged, or unconscious, acting out. Operating somewhere between ambiguity and Bersani's "appearance of necessity," between the seductions of cliché and frustrations of disjunction, I would confront my spectators' addiction to the pleasures of their vicarious tumults while providing a liberating alternative. For me, Pauline Kael's famous declaration, "Only in the movies can you send your mind away," was like a red cape thrown out to the bull. *My* tactics would do the opposite: restore and invigorate the spectator's critical faculties!

* Hayden White, "The Value of Narrativity in the Representation of Reality," *Critical Inquiry* 7, no. 1, (1980), 5–27.

John Cage's famous story comes to mind here, about studying with Schoenberg, to whom he confessed that he had no feeling for harmony. "He then said that I would always encounter an obstacle, that it would be as though I came to a wall through which I could not pass. I said, 'In that case I will devote my life to beating my head against that wall.'" In my case, lacking a "feeling" for plot and character, the essentials of traditional narrative, I have devoted much of my career to banging my head against that wall—with no expectations, I should add, of gaining entrance to a narrative mainstream, but rather to wrestle with its prescriptions.

Paradoxically and a little naively, I rejoiced in the potential of "text-as-image"—read simultaneously and communally, in the dark, by the theater audience—to induce a frisson similar to the effect of a mono-logue delivered by a great actor. Print, because it was eschewed by tradi-tional theatrical practice, would "defamiliarize" the clichés of emotional excess and make them fresh. The words, isolated from a social or character-driven context, and coexisting with a task-involved figure, would in and of themselves cause a quickening in those who read them in the dark-ened theater. Or so I hoped.

Events of the past rose like waves and, battering against her mind, threw it into a wild commotion of shame, grief, and joy.
(Slide projection during *This is the story of a woman who . . .* , 1973)

408 There was no denying I wanted to have my cake and eat it too.

Other influences during the 1960s were the work of Richard Fore-man, the Living Theater (where I saw Brecht's *A Man He Is a Man* and *In the Jungle of Cities*), and Ronald Tavel and his Ridiculous Theater Company, all clearly infused with Brechtian notions of alienation and distanciation. John Vaccaro's direction of *The Life of Juanita Castro* for

Tavel's company, which I saw around 1965, left an indelible impression. Vaccaro sat in the first row of a Tenth Street gallery and gave directions to his performers, who stood in a row, facing the audience. "Juanita, tell Raoul you love him," at which Juanita turned to Raoul and deadpanned "Raoul, I love you." It was both hilarious and touching.

So I embarked on bringing versions of these techniques to the representation of episodes in my own checkered past, events that would be fictionalized through narrative fragmentation, incongruous text/image combinations, and uninflected delivery of lines designed to invoke but not replicate the familiar rhetoric and role-playing of love, disaffected and otherwise. These were my guidelines when I assayed a first 16mm feature film in 1972 called *Lives of Performers.*

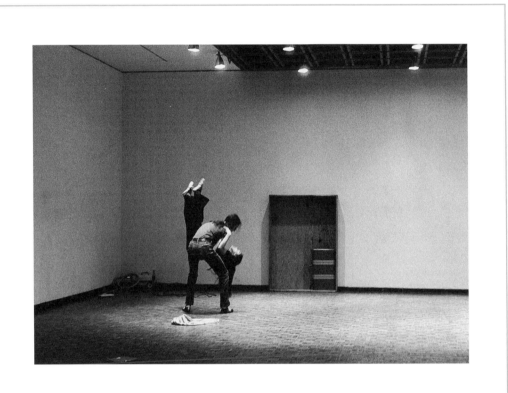

Performance, Whitney Museum, April 1972, James Barth and Epp Kotkas. Photo: © 1972 Babette Mangolte.

18

Lives of Performers

WHILE IN RESIDENCE with the Grand Union in Oberlin early in 1972, I met Peter Way, an unemployed classical scholar with whom I became involved when he came through New York shortly after my return. Fragments of that relationship would show up in my theater and film work of the next few months. For instance, toward the beginning of *Lives of Performers* my voice-over plus those of Shirley Soffer and Fernando Torm discuss the image of a photo of Fernando in a wooden box bracing his body against a suitcase.

> *(voice-over)*
> *Shirley:* And there's Fernando in the box . . .
> *Yvonne:* . . . with suitcase. Why does Fernando have the suitcase? Is he going away or has he just arrived? Why is he in the box with the suitcase? Is he trying it out as a body-supporting device? And what is in the suitcase? Dirty socks?
> *Fernando:* The complete works of Aristotle in Greek.
> (*Lives of Performers,* 1972)

Peter Way's traveling companion was indeed the "complete works of Aristotle in Greek." An intense, small-boned, handsome guy around thirty, Peter had a reserved, rather halting manner. He was not a scholar to whom translating Greek and Latin came easily. But he was stubborn, determined to achieve and maintain fluidity, and worked at it almost every day to prove to himself that he could do it. He had taught classics as an adjunct at college level, but was now out of work and intending to spend some time writing at a friend's cabin in New Hampshire. He was around during the next couple of months as I prepared two different programs—one at Hofstra University and the other at the Whitney Museum, both called *Performance*—and finished shooting and editing a rough cut of *Lives of Performers* with Babette Mangolte. Peter was a great support to me—emotionally, sexually, and practically—as, in a still fragile state of mind, I struggled in therapy with the implications of my suicide attempt and in my work with unaccustomed materials. He designed and built a long wooden desk for me and listened sympathetically as I read him parts of a script that was evolving out of my memories of our flirtations in Oberlin. Sort of like Joseph Losey's *Romantic English Woman* without the third character. "You have a unique voice," he commented. This was both surprising and encouraging, as my plainspoken writing seemed both ordinary and clichéd to me. He also proved to be a life saver when he repaired Babette's 16mm camera during the *Lives* shoot. When Peter left for New Hampshire, we exchanged detailed and sometimes passionate letters describing our respective situations. Years later he returned all of my correspondence, whether out of pique or in appreciation of the ways in which I was transposing my experiences into art, I may never know. In any case, these letters, from which I shall occasionally quote, have provided me with many memory prods. I last saw Peter around 1980 on his return from China, where he had spent three years teaching Greek and Latin in a remote province.

RUTH BARNES, WHO studied with me between 1969 and 1971, recently described the first dance class she attended in my studio on Greene Street: "When I came in, Yvonne was lying on the floor. When everyone was assembled she went into a closet and came out with a huge garbage bag, which she emptied. After fifty green tennis balls *[I remember them as red rubber balls!]* tumbled out, she said, 'Get to work.' And that was the class. I've never seen adults so intensely involved in such serious uncompetitive play."

Those classes, which ended in the spring of 1971, were an odd mix of people and ideas. The lessons ranged from lying on the floor for an hour while listening to my taped voice reading instructions for systematically focusing on parts of the body, to movement improvisations to Indian ragas following my return from India. I was also trying out the formations and movement configurations that would become part of future dance work. I had placed a can at the door to receive weekly contributions, but I never made more than $10 from a single class, though attendance sometimes reached as many as fifteen to twenty. On top of the small monetary return, a number of expensive art books disappeared from the bookcase near the door. Most of those who attended the classes had little or no dance training, but all were involved in the downtown New York art scene in one way or another and were avid followers of Grand Union performances. Some of them participated in my large group extravaganzas: WAR and *Street Action* of 1970, and *Grand Union Dreams* of 1971.

Shirley Soffer was one of the participants in a workshop I conducted in my loft in the summer of 1970. Shirley lived a block from me with sculptor husband Sasson and two children, Simeon and Sarah. In the early 1950s she had studied painting at Brooklyn College, where she knew David Gordon as a fellow student in an art history class taught by Ad Reinhardt. In keeping with the times, Shirley deferred to Sasson's career, running the household and working full-time as secretary to the

president of Basic Books. There she met Bill Davis, who was designing book jackets part-time while dancing with Merce and me. It was he who told her about *The Mind Is a Muscle* at the Anderson Theater in the spring of 1968. Regarding that performance, she has written, "I was transfixed by what I saw, then transformed. From that moment my life began to change." She has described working with me as a "process of inter-change." Which indeed it was. In the workshop I asked the students to bring in their dreams, and it was one of Shirley's that I used as voice-over in *Lives of Performers.* Over an image of eight-year-old Sarah bouncing a ball with a cat lying behind her, we hear Shirley reading her dream:

> I had a dream about a wall. The wall is not concrete or metal; it is steel mesh like the fence in a schoolyard. I climb the wall and it feels terrific. I'm stretching my body as I climb, feeling the pull on my legs and arms as I reach the top and climb over. I enjoy going down the other side. What I like about this wall is that I have no fear of being locked out or locked in. I can always get in or out by climbing, by my own physical nimbleness and agility.
>
> On the other side I find that I am in a schoolyard, which is, in fact, the schoolyard of the school across the street from the house where I was born. . . . It is a beautiful spring day. I run around freely, the wind blowing in my hair. I am happy, bouncing a large volleyball. . . . I have an enormous sense of great physical well-being, of a stretching and toning up of all my limbs and the back of my neck. When I wake up I am really happy. I remember that I have caught a glimpse of something alive and free within me.

I also used Shirley's family photos. Interweaving photos from Babette's and Shirley's family archives with writing about my own and others' ex-

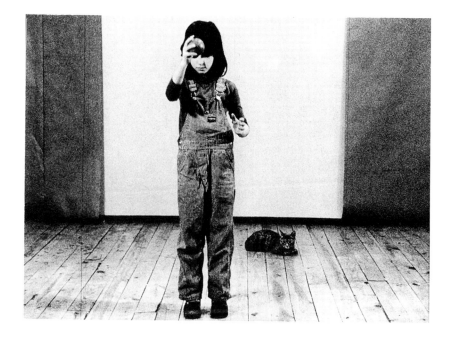

periences created a semblance of authenticity, or Bersani's "appearance
of necessity," while blurring distinctions between real life and fiction.
Shirley was an enthusiastic "victim" (her term) of my appropriations.

John Erdman also gravitated to my studio after seeing *The Mind Is
a Muscle*. Gangly and delicate, John was definitely not a stereotypical ro-
mantic lead, the role I assigned him in *Lives* and later in *This is the story
of a woman who . . .* and *Kristina (for a . . . Novella)*. Nor were Fernando
Torm's Latin lover and Valda Setterfield's femme fatale the result of type-
casting. If these three—and Shirley—evolved into characters in my work,
it was by dint of their idiosyncratic presences and my unconventional

415

Lives of Performers (1972). Sarah Soffer and "Harriet"

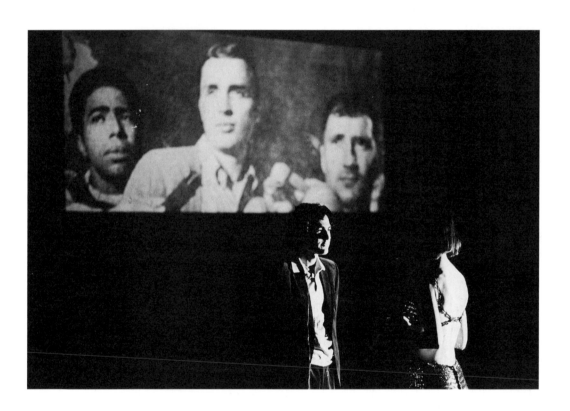

Kristina (for a . . . Novella), 1974. Returning Vietnam veterans, John Erdman, and YR. Photo:
© 1974 Babette Mangolte. All rights of reproduction reserved.

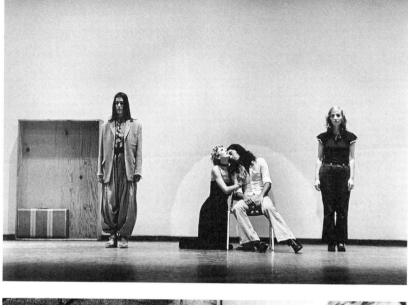

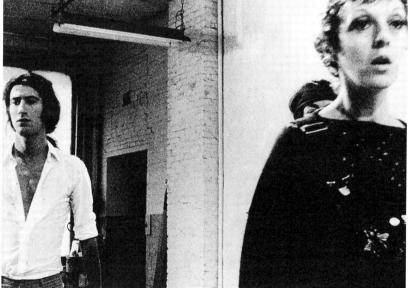

Performance, Whitney Museum, April 1972. YR, Valda, Fernando, and Shirley. Photo by Peter Moore. © Estate of Peter Moore/VAGA, NY, NY.

Lives of Performers (1972), Fernando Torm and Valda Setterfield

use of them. I should also give them all credit for their intuitive understanding of what I was about, even at those moments when I hardly knew myself. Neither Shirley, John, nor Fernando had dance or acting training. John had been an undergraduate at Tufts; after moving to New York, he enrolled in General Studies at Columbia University to avoid being drafted into the Vietnam War. Fernando was a Chilean visual artist, originally a professional concert pianist who had studied with Claudio Arrau. He had a relative high up in Allende's government who had died in the coup. Fernando in particular identified with his quasi-character. During a sequence in *Lives,* as we see him crossing the studio carrying a suitcase, his voice ad-libs, "Here come Johns [sic] to pick up Fernando. They are going to take the train to Chile." This elicited much laughter from the rest of us, which is also heard on the soundtrack. For Fernando the iconic suitcase was invested with more specific—and sinister— meaning than we were willing to acknowledge at the time.

Valda Setterfield was not a participant in my classes or workshop but appeared in *Grand Union Dreams* and the work that followed. A spectacular performer born in the U.K., where she trained in ballet, Valda was a member of the Cunningham Dance Company from 1964 to 1974. I had known her and her husband David Gordon since the early 1960s, when I danced with them in Jimmy Waring's company. After seeing Nazimova's *Salome* at the Elgin Theater in 1971, I was inspired, uncharacteristically, to make a solo for Valda that evoked the sinuous seductiveness of Nazimova's *Dance of the Seven Veils* while exploiting Valda's lithe elegance. The costume for the dance, a long, dark green velvet gown, came out of Valda's own closet. The solo contained several extreme backward stretches for the torso. During one of the performances, having slithered her arms out of the shoulder straps, Valda arched back to such a degree that her breasts popped right out of the dress.

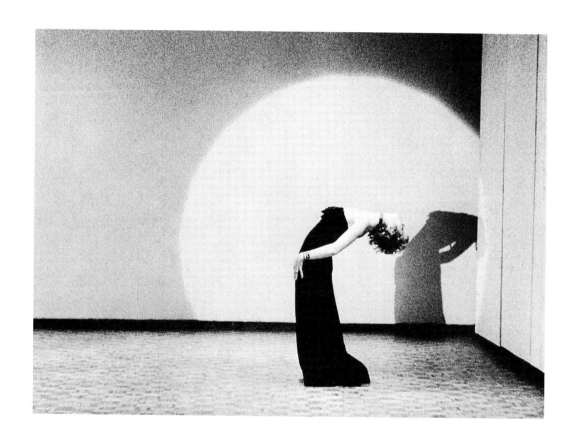

"Valda's Solo" in *Performance*, Whitney Museum, April 1972. Valda Setterfield. Photo: © 1972
Babette Mangolte.

Valda's Solo appeared in a series of programs organized by Jimmy Waring called "Dancing Ladies" at Westbeth between March 23 and 27, 1972. I was also scheduled to appear in the series with my vacuum cleaner piece, *Inner Appearances*. My irritation with Jimmy for what I considered a demeaning title was exacerbated by the pressure of my deadlines for the Hofstra and Whitney shows and finishing *Lives* with Babette.

Excerpt from letter to Peter Way, dated March 27, 1972:

Forgot to mention the two performances at Westbeth. Ugh! Torturous nights waiting around to do my turn & get the applause. Am now very drunk. Went to Chumley's with Nancy Graves, John Erdman, & a friend of Nancy's. Drank two big bottles of wine. Tonight was supposed to do *Satie Spoons*, & Phil Corner tried the piano beforehand. The pedals didn't work. Awful piano, so it was canceled. You cannot imagine the CALIBER of the dances on these programs. TIME CONTINUES TO STAND STILL in the dance world. Women with their twisted fantasies continue to come out for curtain calls with the most elaborate inflated visions of largesse and noblesse oblige even when the audience applauds in a sardonic and condescending manner. Mr. J. Waring complained about my curtain call the first night—said it was too casual, and would I please make it more separate from my dance. I remember that the last time I performed for or with Jimmy Waring—maybe 6 years ago—I said this is the very last time. Nostalgia for the mud. I don't need it! The *Times* reviewed the first night. Said my piece was a live feminist tract. Yes, I guess that's understandable. It's about a woman and about an activity that is now being identified closely with woman's oppression (housecleaning). As I said to one woman [actually Edith Stephen whom I took my first class

with in 1957] who said, "It seems to be about Women's Lib." I replied, "No, I think Women's Lib seems to be about some of that.". . .

I think of you every half hour, maybe more frequently. Maybe I think of you constantly. It is hard to say. I see the flicker of your eyelids as you glance at me—"check me out"—as we make love. I keep my eyes on your face, or my eyes are closed. Pointblank I love you . . . dear Peter, Yvonne

PS: I am glad you are 31 and not 38 or 40. I am not altogether glad I am 37.

I had by now gone far enough out on my own limb, both politically and aesthetically, to be annoyed with Jimmy's campy sensibility. So it didn't occur to me to be appreciative of the fact that he liked my dances enough to present them in his series or of his graciousness in including an irascible note I wrote for the printed program:

Political utterances do not come easily to me. The title of this program, however, cries out for comment. It may be that prior to the sixties the designation "lady" denoted respect—with occasional exceptions which did not exempt "ladies" from also being "tramps." Recent explorations into the subject have cast doubt on whether such differentiations were ever anything more than a means of keeping women in a particular static relation to men and to each other. Five years ago I might have appreciated the humor and quaintness of "Dancing Ladies," but in a time when more and more women are struggling for a sense of individual dignity in ways that are new and

unsettling, such a title is—at best—anachronistic in its ignoring of that struggle and—far worse—condescending, perhaps even a shade obscene when viewed with the photo on the flier. I would hope that times have really changed: from voyeuristic sex object to parody to autopsy. Perhaps at some future time nostalgia will again be a pleasurable luxury.

Still, I feel that my umbrage at the title was justified. By 1972 Jimmy should have known better; he could have had more sensitivity to women's issues. Camp can be a political/critical tool, but it easily tips over into preciosity and kitsch. I wouldn't call Jimmy's own work kitsch. He was too canny and sophisticated in his appreciation and use of popular culture as manifested, for instance, in vaudeville and Laurel and Hardy movies and Fanny Brice routines. But I felt that in his role as an impresario, Jimmy was condescending. I thought it was inappropriate for *my* work to be presented under his patronizing umbrella, no matter that one of my dances, *Valda's Solo,* had been inspired by a supreme example of kitsch.

Viewed from our present moment, we can enjoy and feel superior to the mannered self-consciousness of Nazimova's dance. *Valda's Solo* took on kitschy overtones in its ingratiating loveliness, enjoyable for that as well as for its nostalgic allusions. In contrast, when Mikhail Baryshnikov performed the solo thirty years later in khakis—in a forty-minute dance called *After Many a Summer Dies the Swan,* which I choreographed for his White Oak Dance Project—with the whole gown strapped in front of his body, he became a figure of androgyny and, as such, an implicit assault on sexual orthodoxy. Still later, in 2002, when I

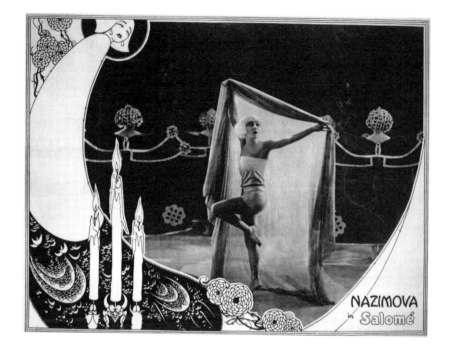

transposed his live solo to a videotape dealing with the clash of art and politics in the waning years of the Austro-Hungarian Empire, a new possibility for the dance emerged. A title (from Carl Schorske's *Fin-de-Siècle Vienna: Politics and Culture*) superimposed over Misha's performance reads:

423

> Themes of androgyny, homosexual reawakening, erotic liberation, and male fear of impotence all met with charges of indecency and immorality.
>
> The Ministry of Culture withdrew its support.

Lobby card: Alla Nazimova in *Salomé,* ca. 1923. Billy Rose Theatre Collection, The New York Public Library for the Performing Arts, Astor, Lenox, and Tilden Foundations

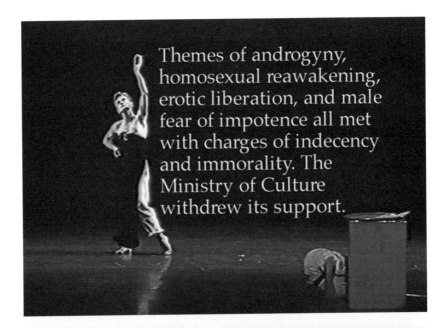

Themes of androgyny, homosexual reawakening, erotic liberation, and male fear of impotence all met with charges of indecency and immorality. The Ministry of Culture withdrew its support.

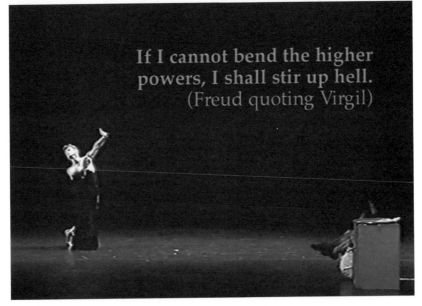

If I cannot bend the higher powers, I shall stir up hell. (Freud quoting Virgil)

After Many a Summer Dies the Swan: Hybrid. Mikhail Baryshnikov performs "Valda's Solo" as Michael Lomeka executes backward somersaults behind the box

After Many a Summer Dies the Swan: Hybrid. Mikhail Baryshnikov and Michael Lomeka

Valda's Solo, in this, its final incarnation, had now mutated from its original artsy elegance into a decadent object of censure by the Viennese Ministry of Culture. The critical potential that the original lacked was also realized in a successive title supered over another point in Misha's performance:

> If I cannot bend the higher powers, I shall stir up hell.
> (Freud quoting Virgil)

I didn't intend, with the above digression from "Dancing Ladies," to cast a shadow over *Valda's Solo* as it was originally choreographed and danced, but rather to raise some provocative questions regarding the unstable hermeneutics of camp and kitsch. Can the enjoyment of camp be the product of both nostalgic sentimentality and critical appreciation? Can a kitschy dance represent both a longing for what was and a call to "stir up hell"? I would like to think that *Valda's Solo* in its later materialization answered both of these questions in the affirmative.

IN MARCH 1972 Valda performed the solo in *Performance* at Hofstra University. This event was also memorable for the absence of Fernando, who for some reason or other was unable to attend. At the beginning of the evening I asked for a male volunteer from the audience to replace him. A young student came forward, and during *Valda's Solo* he and I stood backstage while I gave him instructions and sections of script that he was to read at various points in the program. We spoke into a microphone, so our conversation was amplified for the audience. He even performed in the up-ended wooden box that had been a prop in *Grand Union Dreams*. He did very well, although in appearance he could not match the long-haired hippie brio of Latin lover Fernando.

John Erdman's absence from another version of *Performance* at the Whitney Museum a month later resulted in my taking his part. John had been struggling through the entire shoot of *Lives of Performers* with an undiagnosed infection and was hospitalized just before the Whitney show. On the afternoon before the evening show, Valda, Shirley, Fernando, and I, with the technical help of composer Gordon Mumma, recorded the soundtrack for the film without him. We watched the edited silent workprint in private and muddled through our assigned pages of script. It was the first time that the three of them were seeing the results of their work. Shirley especially was spontaneously vocal in her responses. At one point she exploded, "I look like an old-fashioned movie star!" I edited that and other unscripted remarks and laughter into the final soundtrack, including my instructions to them. That evening, during the actual performance, Gordon Mumma again recorded our reading, now catching the occasional laughter of the spectators as we, and they, watched the film, which was complete except for *Valda's Solo*, which Valda performed live. I now had two soundtracks from which to choose for the final cut of *Lives*.

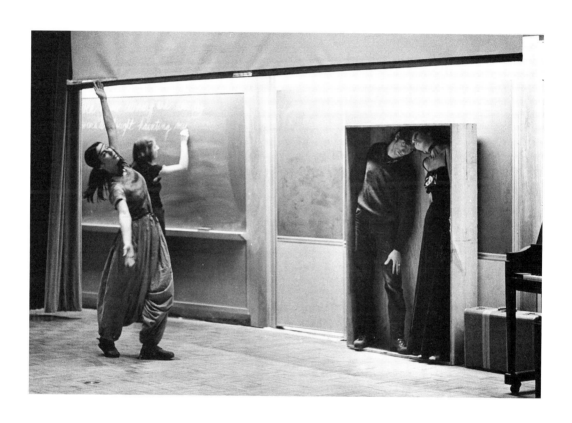

Performance, Hofstra University, March 1972. YR, Shirley, "proxy" Fernando, and Valda. Photo by Peter Moore. © Estate of Peter Moore/VAGA, NY, NY.

Lives of Performers begins with a rehearsal of a unison dance—
Walk, She Said—for John, Shirley, Valda, Fernando, and me, plus
dancers Epp Kotkas and Jim Barth, two of the "Heroes" from *Grand
Union Dreams.* Despite all the tensions from my deadlines, Valda's doing
double duty rehearsing with me and Merce at the same time, and John
obviously unwell, Babette came through with flying colors. Trained at a
famous technical school in Paris (the "Vaugirard," or École Nationale de
la Photographie et de la Cinématographie), she coolly and expertly ma-
neuvered her 16mm Arriflex. Although we worked closely during most
of the shoot on framing and camera movements, Babette made her own

Lives of Performers. Shirley Soffer

well-chosen decisions during the dance rehearsal, leaving me free to go about the business of choreographing a unison walk in complex floor patterns that twisted and turned about the space as our upper bodies moved in opposition or consonance with the direction of our feet. The soundtrack in this section is somewhat rough due to our lack of lavaliere mikes and the roar of the badly "blimped" motor of the camera. Babette and the sound man warned me about this but I had too little experience, too little time and money, and too much else on my mind to pay attention or correct the situation.

What I most clearly remember about the *Lives* shoot is the "Lulu" sequence, the series of *tableaux vivants* at the end of the film that is based on production stills from *Pandora's Box.* It was a long day of shooting, but it went like clockwork. Fernando and Peter Way had painted the brown paper backdrop black, and Babette changed the lighting to create a somber chiaroscuro ambiance that matched that of the published stills. While we set up for one tableau, those involved in the next studied the relevant photograph that would be the template for the following shot. Without much to work with or any guidance from me, John and Fernando exchanged jacket, vest, cap, or tie to approximate their characters in the photos, while Valda and Shirley appeared in the clothing they had worn throughout the film—Valda's gown and Shirley's black pants and short-sleeve top that would mark them in my mind as "femme fatale"/ "other woman" and "betrayed wife"—not that one can figure out which one is "betrayed" or who is betraying whom in the film—and in Shirley's mind as "polished gem" and "diamond in the rough." We were all riding high on this new adventure in cliché.

Following an early screening of *Lives of Performers* at the Collective for Living Cinema, an experimental downtown screening venue, a member of the audience remarked that the film was a "pessimistic view of

love." From my formalist perspective, this was a surprising response. How could anyone ascribe a Weltanschauung to this patchwork quilt of disconnected, ironic takes on representations of amorous misadventures? Another response along these lines came from Simone Forti. "Why didn't they just go to the beach?" she grumbled. Simone had no patience with depictions—however underground—of domestic travail. (I don't know if she ever saw my second feature, *Film About a Woman Who . . .* , in which "they go to the beach.")

More recently, artist Simon Leung commented wistfully, "The film is remarkable in the way it reveals a real community." I found this equally astonishing. We had no community in the sense in which he meant it and I experienced it in my Judson days. In *Lives* we constituted a group of dance students, one professional dancer, and a choreographer, all of whom had assembled for a very brief period to execute a series of fabrications: of alleged romantic entanglements no less than our performances and cheap imitations of performances. True, the representations of our lives as performers and lovers were both real and fictional, deliberately confounded by our addressing each other on the soundtrack by our given names. But far from the appearance of a community, I thought, the film might conceivably be seen as a documentation of shabby loft living and downtown 1960s fashion (with the exception of Valda's chic gown).

And yet, for all that, there may be something genuinely "communal" that seeps through the contrivances and narrative disruptions of *Lives,* or perhaps is revealed *because* of the narrative disjunctions. Because the melodramatic moments and references are so discontinuous and schematic, what remains is the spectacle of a group of people intensely involved in a kind of *work,* in the task of performing. We are performers whose commitment to our work is palpable in the film. In the

sense that we share the work of performance—and the work of perfor-
mance is foregrounded—I can understand how we might be perceived
as a "real" community beyond the boundaries of the film.

In any case, I continue to love *Lives of Performers* and everyone's
work in it. And community or not, it is very definitely unlike any film
I've made since.

My films can be described as autobiographical fictions, untrue confessions, undermined narratives, mined documentaries, unscholarly dissertations, dialogic entertainments. Although my subject matter may vary from film to film, I can also generalize about intent and purpose: To represent social reality in all its uneven development and fit in the departments of activism, articulation, and behavior to create cinematic arrangements that can accommodate both ambiguity and contradiction without eliminating the possibility of taking specific political stands, to register complicity, protest, acquiescence with and against dominant social forces—sometimes within a single shot or scene—in a way that does not give a message of despair; to create incongruous juxtapositions of modes of address and conventions governing pictorial and narrative coherence so that the spectator must wrestle meaning from the film rather than lose him/herself in vicarious experience or authoritative condensations of what's what.

And lately, after rereading Monique Wittig's *The Straight Mind*, I've been thinking that my films, to some degree or another, can be seen as an interrogation and critique of "straightness," in both its broadest and most socially confining sense: Straightness as a bulwark, as protection, as punitive codes against deviations from social norms that define and enforce the parameters of sex, gender, race, class, and age. Straightness as it pops up in psychoanalytic theory no less than at the breakfast table; straightness that clouds the liberal imagination congratulating itself on its tolerance; straightness that kills, cripples, and curtails the lives of gays, Lesbians, blacks, women, the poor, and the aging; straightness that equates strength with bloodshed. To be continued . . .

(Statement, November 16, 1990)

Epilogue
(*as Prologue: 1973–*)

"WHY STOP NOW?" My filmmaker friend Su Friedrich admonishes me, "What about all the wonderful filmmakers you met in the '70s and '80s?" I don't say, "Like you, for instance," or that the memoir so far hasn't said a word about my friendship with Su and other filmmakers who have been important to me. I argue that the point at which I left dance and became a filmmaker seems a logical place to end the book, and besides, two books on my films have already been published.* She reminds me that my professional life up to 1972 is less than half the story. I have to agree. Later, with myself, I continue the argument: it's also true that as more and more of my private life went into my films, such transposition, though fictionalized, reduced my need to reconfigure it elsewhere. Another deterrent to dealing in a comprehensive way with the last thirty years is the decrease of documentation in my files—including letters and even notebooks—that might spur memory. By the late 1970s long-distance telephone calls and postcards were replacing lengthy personal

433

* *The Films of Yvonne Rainer* (Bloomington: Indiana University Press, 1989); *Essays Interviews, Scripts* (Baltimore: Johns Hopkins University Press, 1999).

434

Robert Rauschenberg, Jill Johnston, Ingrid Nyboe, and YR, ca. 1980

Niece and nephew, Leo and Ruth, in the Pyrenees, 1982

435

Ivan, Audrey Goodfriend, and Belle, ca. 1990

YR , Martha Gever, Block Island, 1992

correspondence—Ivan and I stopped writing letters around 1980—and by the late 1980s short e-mail bursts became yet another disincentive to spend time writing long letters. Furthermore, during this same period, the contents of my files increasingly deal with the details of my "business"—screenings, lectures, teaching, and the like.

And there's something else: Sturm und Drang makes a better read than a stable life. As noted earlier, my demons eventually quieted down. If this book has been—in a major way, if not entirely—a chronicle of a struggle and ultimate accommodation with them, then any further variations on the "living with" side of things could only be anticlimactic. Nevertheless, egged on by Su and Lynne Tillman, I am willing to make some concessions toward filling out the years 1973–2004—with regard to both private and professional life—by way of some unsystematically arranged notations and ruminations. To begin:

About twenty-five years ago I compiled a list called Shameful Conditions and Occurrences:

> To live alone.
> To arrive at a social gathering alone.
> To go outside in clothing not suited to the weather.
> To say something that can be traced to someone else.
> To have nowhere to go Saturday night.
> To have no interest in Jacques Lacan.
> To have no friend with a summer cottage.
> To have no family.
> To be dirty, to smell.
> To have no interest in people.
> To be gossiped about.
> To be sexually betrayed.
> To be ignorant of current popular music.

To be disloyal to a friend.

To gossip.

To become middle aged.

To lose one's youthful beauty.

To be enraged.

To be inordinately ambitious.

To have more money than your friends.

To have less money than your friends.

To not understand what is said to you.

To not recognize someone.

To forget a name.

To lose one's powers.

To go down in the world.

To have misfortune befall one.

To be bored with one's friends.

To be thought of as superior to what one knows oneself to be.

To discover what one thought was common knowledge about one-
self is not so.

To discover that closely guarded information about oneself is com-
mon knowledge.

To have less knowledge than one's students.

The dispirited humor of the above inventory probably originated in the dissolution of a relationship with "my last man" around 1980 and the beginning of ten years of celibacy. Through most of the 1980s, in close friendships with a number of younger lesbians, determined not to enter into any more ill-fated heterosexual adventures, and already show-ing up at Gay Pride parades, I was calling myself a "political lesbian." In 1984, as we stood outside Film Forum, artist/activist Martha Rosler in-troduced me to Martha Gever, the editor of the film and video magazine,

the *Independent.* She and I remained professional acquaintances and theater buddies, occasionally flirting, until 1990.

That summer Ruby Rich, then head of the film and video section of the New York State Council on the Arts, was celebrating her birthday with fifteen friends in the garden of an Italian restaurant on Lafayette Street. I had just learned that I was the recipient of a MacArthur Fellowship and decided to blow a few hundred dollars on Ruby's party. Toward the end of the meal I quietly left the table and settled the bill with our waitress. When the guests began to bestir themselves to pay, I informed Ruby, sotto voce, about my windfall. "I know," she grinned impishly. At the other end of the long table the waitress was telling Martha Gever, in response to her inquiry about the bill, "But you paid!" Martha and I, two white middle-aged women sporting short hair and glasses, were indistinguishable to her. It was a portent of things to come.

Several months later, something—it's hard to say exactly what—gave way that allowed me to overcome my fears and make a leap into intimacy.

Doris: Mildred and I had been theater buddies for a few years. One day she called me up and invited me to the Clit Club, said she was doing "field work." I said I would think about it. I was scared. And then I read an essay by a student of mine, an essay about sexual identity, which culminated in a peculiar daydream. . . . She was so torn between women and men that instead of one fantasy, she would produce this weird amalgam of mix 'n' match bodies, heads, and genitals. After reading that I thought, "Hey, this isn't my story. I know what I want. I want Mildred." So I immediately called her up and we made a date. The first thing I noticed was that she was wearing the socks I had given her.

(*MURDER and murder*, 16mm, 1996)

438

There ensued a tempestuous affair. I was fifty-six years old and euphoric about becoming a lesbian. Martha, younger than I but nonetheless a veteran in such matters, was my bemused mentor in matters social and historical. We're still together in what may well be a rest-of-life union. Lesbian identity has taken its place, or backseat, in the everyday negotiations and pleasures of domestic life, the still unfolding skirmishes in the public sphere around gay marriage notwithstanding.

I was visiting the Bay Area when Belle died in the early morning of January 19, 1998. For the previous four years she had been yoked to a tank that delivered ever more oxygen to her compressed lungs in a losing battle with scoliosis. As Ivan and I sat on the end of the bed beside Belle's still warm body, I suddenly felt cold and said, "Would you mind if I close the window?" Ivan got up and closed the window. At that moment I was visited by an unexpected thought: "It's all right to close the window. Whatever remained of her has already left." I don't think of myself as a religious person, though I am aware that the practice of art might be called the religion of atheists. Unlike my father, who called himself an agnostic, if push comes to shove I would rather be known as a resolute irreligious atheist, which means, among other things, that I have no belief in the existence of a soul or in life after death. There may be many things—the universe, the interconnections of mind and body, the communication of animals—that scientists still know little about, but I do not believe that it follows from such "unknownness" that a higher power has organized the order and chaos of the world and cosmos. So it

was not anything that might pass for religious belief that produced the odd visitation in my mind that morning.

I neither saw nor sensed anything leaving Belle's body. What left her body was a final breath, witnessed by Ivan, and what passed through my mind at the moment he closed the window was cultural baggage. I still grieve for her at unexpected moments.

HAVING JUST PASSED my seventieth birthday (2004), I realize, as I wait in line to see an afternoon screening of the Alexander Payne film *Sideways,* that I hate old people. They're so slow and cranky and bewildered and anxious. They come out of the movie and stop in their tracks right in front of you and can't figure out where to go. They can't get settled; they have to pee all the time like little children; they're always taking umbrage at trivial things; they don't understand simple directions; they can't remember anything. I see it coming; I have passed the divide; I am on my way. Complex logic eludes me; figuring the tip is a major undertaking; my mind wanders as I watch the depressing evening news; the rules of any system beyond traffic lights and the washing machine seem baffling and grotesque. And when I have agreed to change—my computer, my habits, my home—I am filled with an inexplicable rage.

I find external targets for my fury while arguing with myself whether it is better to stick my head in the sand or read the papers every day and get upset. Destroy the city to save it for democracy; a two-year-old Fallujan in a hospital bed with one of his legs blown off; a dead child lying in the street, clutching the headless body of an adult; an emergency health clinic blasted to rubble. As I face old age, I face four more years of a president who has no capacity for rational thought, compassion, or empathy and an administration that will do anything to stay in power and further its apocalyptic agendas. A group of thugs who lie through their teeth while smirking mischievously.

440 Ivan phones. "I'm losing my memory," he reports flatly. In previous phone calls he has repeatedly and vigorously announced that he has Alzheimer's, as though he was proud of it, or at least glad to have a definitive explanation for his deteriorating mental capacity. Struggling with denial, I invariably protested, "No, Ivan, my understanding is that you have a condition that may or may not lead to Alzheimer's." But this is different. A trace of sadness and foreboding in his voice.

For half of my life I adored my older brother. He was my model, my sounding board, my idol. Though I no longer have that relationship to him, his present circumstances are nonetheless very distressing to me. Filled with guilt and dread I am unable to respond, and change the subject. Our mother suffered with Alzheimer's for fifteen years following our father's death. Living in the Bay Area, Ivan—with a great deal of support from Belle—had taken on the lion's share of responsibility for her care. When I last saw Mama in the nursing home six months before she quietly died in her sleep, she was in a vegetative state, shrunk to half her normal size, riddled with bed sores, her arthritic hands coiled like claws around washcloths. At her bedside, to her vacated presence, I sang all four verses of "'Come little leaves,' said the wind one day, 'Come o'er the meadows with me and play,'" a song she had sung for us throughout our childhood. It ends with "Soon fast asleep in their earthy beds, The snow laid a coverlet over their heads." In a more recent phone call Ivan sounds cheerful and determined. He is keeping track of everything on the wall calendar in his kitchen. He has crafted an intricate curving handrail for a staircase in Ruth's flat. *He's* doing okay. For the time being, I have a respite from my brother-worries.

IN JANUARY 1975, several months after my mother died, I stayed in Berkeley at Ivan and Belle's house for several weeks prior to a teaching stint at the California Institute of the Arts in southern California. Burrowing into the family matrix, I celebrated Ivan's forty-fourth birthday, played with Ruth and Leo, my niece and nephew, and, with Ivan, scattered Mama's ashes on an isolated slope of eucalyptus trees in Tilden Park. She had taken so long to die that, when she finally did, I hadn't given it much thought. Several days before I was to leave the safe haven of my brother's house and drive down to Los Angeles with Ruth, who was in her last year at Cal Arts, the loss of my mother and my imminent departure for a new and strange environment hit me like a ton of bricks. Convulsed in tears I sat beside Ivan on the edge of my bed while he held and tried to comfort me. "I want to be her," I wailed, pointing at Keisha, the family dog lying at our feet. A sheltered beast, untouched by terror and sorrow.

SOME NONSEQUITURS, THINGS I had forgotten until reminded of them by others or by my notes and letters of thirty years ago (I kept carbon copies of some of my correspondence): (1) I saw Stephen Tropp's eye-opening *Poems for the Theater I and II* in 1961, not 1964. And his *Poem* with the accordion-folded screen, behind which someone was loudly knocking and against which a silent film of waves breaking on a shore was projected, had big polka dots painted on it. (2) Around 1970 Bob Morris told me I should be making films. (3) In *This is the story of a woman who . . .*, after sitting lost in thought for a few minutes during a monologue by Shirley Soffer, I suddenly exploded with "FUCK YOU!" to no one in particular, then looked around in bewilderment as though I didn't know where I was. Startled, Shirley broke off her soliloquy (about a performance she had presented at an upstate New York boys' school), then continued. Both behaviors had been scripted.

My 1973–74 files are filled with appreciative letters from those who saw this multimedia event. Stefan Brecht, Bertolt Brecht's son, wrote,

> [*This is the*] *story* . . . struck me as an eminently humane work of art—Tennessee Williams' work has the same simple quality requiring courage, but the recipe for Rainer's species is different: by an intelligent comprehension, take self-pity & passion, aggrandize them into compassion, save them from sentimentality (of which some accused this show), make the insight inoffensive by humor, f. inst. gentle irony, & take care to eliminate traces of bitterness, but keeping the pain. It's a love story & a moving & truthful physiology of love.

Brecht's long essay went far toward confirming my hunches.

The late 1970s through the 1980s are indelibly marked in my memory by the rise of feminist and postcolonialist filmmaking, as well as the

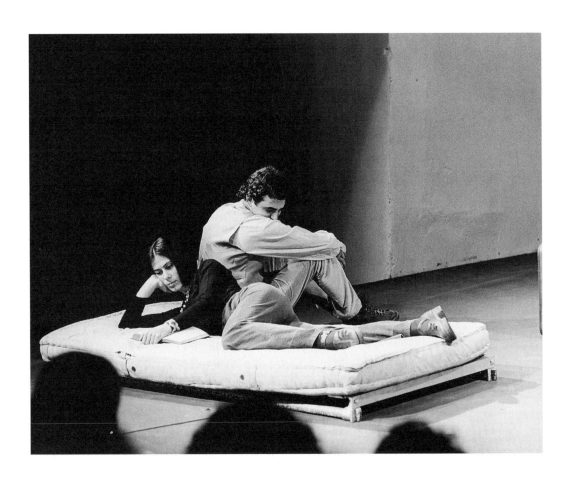

This is the story of a woman who . . ., Theatre for the New City, 1973. YR, John Erdman. Photo:

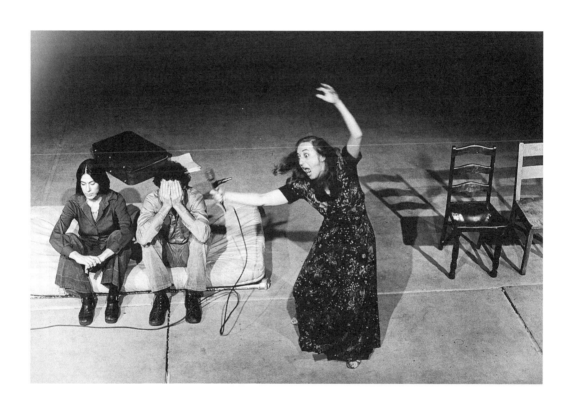

This is the story of a woman who . . . , Theatre for the New City, 1973. YR, John Erdman, and Shirley Soffer. Photo: © 1972 Babette Mangolte. All rights of reproduction reserved.

preparations for and realizations of my own films, with increasingly longer time lapses between them: 1974's *Film About a Woman Who . . .* , 1976's *Kristina Talking Pictures,* 1980's *Journeys From Berlin/1971,* etc. At the end of 1974, upon the completion of *Film about a Woman Who . . .* (like *Lives of Performers,* shot by Babette Mangolte), I wrote to Jonas Mekas, " . . . in the working out of *Woman Who . . .* I decided to abandon the prime strategy that characterized *Lives,* namely, the treatment of emotional torment as if it belonged in an absurd "trade manual" of cliché. And, as a consequence, I took on the risks that I knew would be incurred by moving in closer to that content."

My writing has repeatedly posed these "risks"—and what I perceived as the attendant necessity of "moving in closer" to narrative conventions ("the embarrassing wars around searching for proxies of experience")—in terms of my own ambivalence. Teresa de Lauretis expatiated the possible reasons for my "suspicions" of narrative in a complex essay in her book *Technologies of Gender.** Taking a feminist tack, she points to the contradiction in feminists' desires for the authorial voice of narrative "when those notions are admittedly outmoded, patriarchal, and ethically compromised" and to the necessity for "a critical reading of culture . . . and a [feminist] rewriting of our culture's 'master narratives'"—a more analytic version of my mantra, "having my cake and eating it too." Writer Audre Lorde once said something like, "You can't dismantle the master's house using the master's tools." By the late 1970s I would have rebutted, "You can, if you *expose* the tools."

Some people have called my early films "pre-political" and "pre-feminist." Nevertheless, *Film About a Woman Who . . .* became a focal point

* "Strategies of Coherence: Narrative Cinema, Feminist Poetics, and Yvonne Rainer," *Technologies of Gender: Essays on Theory, Film, and Fiction* (Bloomington: Indiana University Press, 1987), 107–126.

for more than one brouhaha in the feminist film theory wars of the late 1970s and early 1980s. The battles raged over issues of positive versus negative imaging of women, avant-garde versus Hollywood, distanciation versus identification, elitism versus populism, documentary versus fiction, transparency versus ambiguity, accessibility versus difficulty, and so on. I sometimes found myself fending off partisans from both sides of the barricades.

A deep depression gripped me during the shooting of *Kristina*, triggered by the loss to Hollywood of my preferred cinematographer a week before production was to begin (not Babette, who had already shot a portion of it and with whom I had a mutual agreement not to work

447

Film About a Woman Who . . . (16mm, 1974). Shirley Soffer and YR

John Erdman and Babette Mangolte during shoot of *Film About a Woman Who . . .* Photo: ©
John Erdman.

Shirley Soffer and YR during production in YR's loft. Photo: © John Erdman.

together for awhile). The depression dissipated by the time the shoot was mercifully over and I started editing. On a visit to New York Sally Grieg came to my midtown editing room and remarked, "This looks like the real thing!"—a reminder for me and a shock for her that my ship had long been launched. After cutting in the last bit of soundtrack at the end of *Kristina,* I called my friend Mark Rappaport and declared, "I feel like I've just delivered a baby." He caught the next train uptown to take a look and made some valuable suggestions for the final cut.

Kristina premiered at the 1976 Edinburgh Film Festival. It was there that I met Laura Mulvey and Peter Wollen and where I was on a

Kristina Talking Pictures (16mm, 1976). Blondell Cummings

Kristina Talking Pictures, Ivan Rainer and YR. Photo: © 1972 Babette Mangolte. All rights of re-
production reserved.

panel—"Narrative Film and the Avant-Garde"—with Peter, Manuel De Landa, and Simon Field. I remember Paul Sharits declaring from the audience, "All films are narrative," an assertion I viewed as a desperate maneuver on his part to shimmy his own paratactic work in under the emerging experimental narrative umbrella (designated "The New Talkie" by Noël Carroll to characterize the essay films of Wollen/Mulvey, Straub/Huillet, and others). Afterward I toured the Scottish Highlands with Ruth, Ruby Rich, and her then boyfriend, Gunnar. The sweep of mountains descending into the lochs was a welcome antidote to the intensity of the conference. On the way back to Edinburgh I discovered that my flight to West Berlin, where I was to begin a year's residency under the DAAD (Deutscher Akademischer Austauschdienst), was scheduled for the previous day. Arriving in Edinburgh, I dashed around and managed to replace my ticket, then took a cab to the airport with Ruth. She flew back to Amsterdam, where she was studying music and would live for the next thirteen years (eventually marrying a Dutch palynologist and returning to San Francisco). I went on to West Berlin.

The DAAD set me up in a large pre–World War I apartment in a building still pocked with World War II bullet holes on Nikolsburger Strasse, a few blocks south of the Kurfurstendamm. It had been vacated by an art historian who, blacklisted by the *Berufsverbote* (the law that forbade government employment to political radicals and members of the Communist Party), was now living and teaching in Paris. The shelves of the apartment were lined with the publications of the *Rote Fanne* press, including the complete works of Lenin and Stalin. During the height of the Cold War, with acts of violence by the Red Army Faction still taking place in other parts of West Germany, West Berlin was teeming with foreign artists of all kinds, brought to the city to enhance its aura of a glittering capitalist mecca. Cynthia Beatt, a budding British

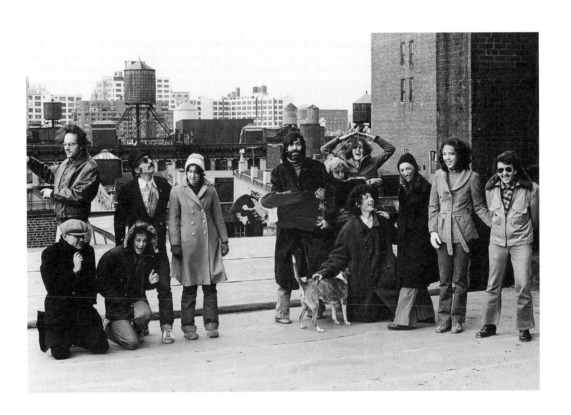

Wintry NYC rooftop greeting to me in Berlin, 1976. Jim Barth, John Erdman, Sasson Soffer, Lucinda Childs, Sarah Soffer, David Gordon, "Ginger," Valda Setterfield, Trisha Brown, Ain Gordon, Shirley Soffer, Nancy Katsin, and Ron Clark. Photo: © 1972 Babette Mangolte. All rights of reproduction reserved.

filmmaker then living with German filmmaker Rudolph Tome, became my friend and guide. I spent hours every week at the Arsenal, the funky showplace for experimental and historical film culture on Welserstrasse, a ten-minute walk from my apartment. One night, on emerging into the tiny lobby at the end of a screening, I encountered several very perturbed Arsenal workers. Told that a man had made off with the cash receipts during the show, I asked naively, "Did he have a gun?" "Oh no," replied Alf Bold without missing a beat, "We're not that advanced yet."

I met filmmaker Ulrike Ottinger and her flamboyant girlfriend Tabea Blumenschein, and in the summer of 1977 played a disillusioned artist in Ottinger's *Madame X,* which was shot on an old showboat/ galleon on Lake Constance. I took up with an eccentric poet whose father had been high up in the Wehrmacht. The native Germans I met were mostly bi- or trilingual, all born just before or during World War II, and, to one degree or another, all bore psychological scars bequeathed by their parents' lives under the Nazis.

Upon returning to New York in 1977 I started working on the script of *Journeys From Berlin/1971*, making use of observations, readings, and experiences accrued during my year in Berlin. ("1971" in the title was an obscure reference to the year of my suicide attempt.) A year later, after several months of rehearsals with Annette Michelson for her role in *Journeys,* we both landed in New York hospitals, I with another gut implosion that required surgery. The shoot, which was to be produced by the British Film Institute in London, was postponed for a few months, finally taking place in the spring of 1979. It was an unusually arduous one. Annette and my British friend Ilona Halberstadt, who played shrink to Annette's analysand in the film, were both left intellectuals—the one a Trotskyite, the other refusing definition. They started out friendly and ended up at loggerheads. During one of the endless waits in the

Whitechapel Gallery for a new lighting set-up to be completed, I sat beside Peter Sainsbury, my BFI sponsor, and groaned, "I hate film production." I longed for the editing room, where, alone and free of the frustrations and complications of the shoot, I could finally sink my teeth into the material.

Another part of the *Journeys* shoot took place in the bed/living room of Peter Wollen and Laura Mulvey on Ladbroke Grove. They had generously contributed their mantelpiece as a site for the numerous objects and photos referred to in the script, from a pile of steaming spaghetti to Rosalind Russell and Ulrike Meinhoff. One of the objects was a rowboat that had been carted up the stairs and placed in front of their fireplace. Laura reported waking up in the middle of the night, gazing—as if in a dream—at the ghostly craft looming at the foot of her bed.

The 1980s were full of incident: Invited by Joan Braderman, I started attending meetings of No More Nice Girls, a group of fifteen or twenty women engaged in abortion rights activism. With pillows under our black skirts, linked by heavy chains, and bearing banners and placards with slogans like "NO MORE FORCED LABOR," we paraded in mass demonstrations in New York and Washington, D.C., to protest challenges to *Roe v. Wade.*

I was blown away by the films of Charles Burnett, Julie Dash, Helke Sander, Rabina Rose, Ana Carolina, Marguerite Duras, Chantal Akerman, Sally Heckel, Sally Potter, Marlene Gorris, Valie Export, and of Isaac Julien, John Akomfrah, Martine Attila, and others coming out of the black British film collectives. I became deeply engaged with the feminist and postcolonial polemics swirling around such work at conferences and screenings. I joined the board of the Collective for Living Cinema, a struggling experimental screening venue in Lower Manhattan, which finally collapsed in 1989, a victim of exhausted funds and internal dissensions.

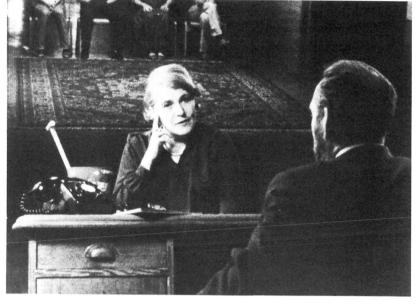

Journeys From Berlin/1971 (16mm, 1980). Annette Michaelson and Gabor Vernon

Journeys From Berlin/1971. Vera Zasulich in photo on mantelpiece

The shooting of my fifth film, *The Man Who Envied Women,* was marked by the coming together of cinematographer Mark Daniels and my French production manager, Christine Le Goff. They evidently hit it off while working on the film, Mark eventually moving to France to shoot documentaries and live with Christine. I still derive a certain satisfaction from their union, as I had up to then felt that working with me could not lead to professional advancement or personal fulfillment beyond the immediate situation. Just as I had to start from scratch every time I launched a new project, I was sure that a Rainer film was a comparable dead-end for those associated with it. So you can imagine my surprise and satisfaction when I discovered their liaison.

Following a screening of *The Man Who Envied Women,* a well-known feminist who subscribed to Lacanian psychoanalytic theory asked me why I hadn't made a film about a woman. I was flabbergasted, having been under the impression that I had done just that. But she, taken in by the title and the prevailing physical presence of the male character, had discounted the pursuing, nagging, questioning female voice on the soundtrack. She didn't understand that I had taken Laura Mulvey's critique of Hollywood films—in her ground-breaking essay, *Visual Pleasure and Narrative Cinema*—literally, and that by staying out of sight—beyond the reach of "the male gaze"—my heroine could maintain her dignity and avoid being caught with her pants down.

Privilege, my sixth feature, brought a special array of problems. How could I in good conscience, as a white middle-class woman, portray working-class people of color, especially men? The script drove me half crazy to the point where I was ready to give up filmmaking and go back to school. The cultural schisms and negotiations along racial lines in the late 1980s were impassioned. I felt I was in a minefield: one false move and the jig was up. After seeking reactions to the script from a

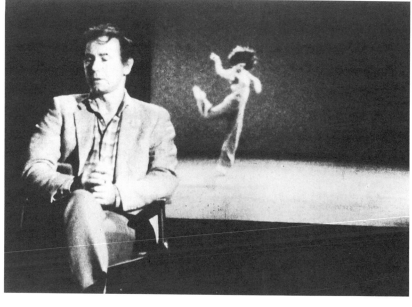

The Man Who Envied Women (16mm, 1985). William Raymond with Trisha Brown, performing her *Watermotor* in a film by Babette Mangolte

Privilege (16mm, 1990). Gabriella Farrar, Dan Berkey, and Alice Spivak

number of friends—video artist Joan Braderman was especially helpful, coming up with the idea of the Carmen Miranda get-up for one of the characters—and after many anguished sessions with Nathan Stockhamer, my therapist since the early 1980s, I slogged ahead. Mark and Christine, by then living together on the Lower East Side, again lent their production savvy. Jenny, my white liberal protagonist (played by Alice Spivak), became a somewhat cantankerous and defensive character in her dealings with her black interviewer, Yvonne Washington (Novella Nelson), who was written as the truth sayer and conscience of the film. In the process Brenda, Jenny's white lesbian neighbor (Blair Baron), was given short shrift. As Geeta Patel observed after seeing *Privilege,* "One subjectivity always seems to be foregrounded at the expense of another." The film received mixed—and not entirely predictable—assessments from assorted friends, academics, and critics, black and white.

MURDER and murder of 1996 was another story. The diary I kept of the interactions between Martha and me in the early days of our domesticity was a virtual cornucopia. I set about transforming it into fiction: sharpening the dialogue, rearranging and whittling events, casting myself as the drag puppeteer/master of ceremonies. Kathleen Chalfant and Joanna Merlin played Mildred and Doris, two battling dykes who finally bore only a passing resemblance to Martha and me, with the exception that the Doris character was diagnosed with breast cancer and lost her left breast to surgery, which is what happened to me in 1993. (No recurrence as of this writing twelve years later.) The sets for *M & m* were the result of my having seen an installation by Ilya Kabakov at the Pompidou Museum in Paris and a collaboration with production designer Stephen McCabe. They veered from the funky realist disarray of Doris's cold-water flat to the "radical juxtapostion" of McCabe's inspired boxing ring, its canvas floor stenciled with cancer statistics.

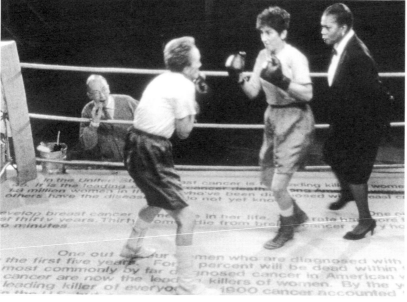

The set for Doris's apartment in *MURDER and murder* (16mm, 1996). Photo: Stephen McCabe.

MURDER and murder. John Hagan, Kathleen Chalfant, Joanna Merlin, and Novella Nelson

As I sat in the editing room for six weeks lovingly toiling over my MURDER footage on the Steenbeck, I sensed it would be the last time I edited a film in this manner, perhaps the last time I would make a feature film. I had received my share of once-in-a-lifetime big grants; the awards program for individual artists formerly administered by the National Endowment for the Arts had been wiped out; and I was in the last group to receive grants from the American Film Institute. Getting M & m off the ground had been a killer: To fill key crew positions I found myself interviewing NYU graduates who had never heard of me and were asking questions like, "Have you ever made a feature film?" I couldn't see myself going through this kind of indignity again. Peter Wollen once said to me, "They let you make five." Before the whole cultural and economic climate in the U.S. changed for the worse for low-budget narrative filmmakers, "they" let me make seven.

After traveling the usual rounds of film festivals with MURDER and murder, I settled with relief and deep satisfaction into writing poetry for a year, during which time a semester of teaching at the School of the Art Institute of Chicago saved me from the tedium of writing grant applications. Following is a poem from a series of about thirty (I have no idea of their value; they have never been published):

Flamingo Lodge, FL

The heavy air
the shrill call
the unseen bird
the piercing reeds

I am as heavy
with foreboding
impervious to the light
as the sound
of one palm frond scraping

"Oh, that's just another pelican"

Thoreau said,
"If I could,
I would worship
the parings of my nails."

In 1992 choreographer Sally Silvers asked permission to perform
Mat from *The Mind Is a Muscle* on a Movement Research program at
Judson Church. She taught it to herself using a description in my first
book *(Work: 1961–73)*, and the result was a fair approximation of the
original. (For some reason I was not around to fine-tune it or see the
performance, but I have seen a video of it.) That same year Sally Banes
invited me to present *Trio A* on a "Serious Fun" Festival at Lincoln Cen-
ter. Uncertain of whether I was still able to do it, I taught the dance to
dancer/choreographer Clarinda MacLow, daughter of the late poet Jack-
son MacLow. These two events launched my reentry into dance. Subse-
quently I helped a French group, Quatuor Albrecht Knust, reconstruct
surviving fragments of *Continuous Project-Altered Daily;* I taught Sally
Silvers *Three Satie Spoons;* Clarinda and I taught *Trio A* to twelve dancers

who performed it nude with American flags at Judson Church in a revival of the version that had been seen at the opening of the 1970 People's Flag Show.

Upon answering the phone toward the end of 1999, I heard a heavily accented male voice announce, "This is Misha Baryshnikov." "WHO?!" I nearly peed in my pants. He was inviting me to make a dance for his White Oak Dance Project. After a few seconds of hesitation, I accepted the invitation. I hadn't made an original piece of choreography for twenty-five years, but, assisted by Pat Catterson, who had studied with me in 1969 and was still going strong, I raided my icebox, pored over old notebooks and vintage photos, choreographed some new material, added death-bed pronouncements of famous and not-so-famous people, to be uttered by the dancers, and came up with a thirty-five minute mélange that I called *After Many a Summer Dies the Swan.* The reference to *Swan Lake* and Misha's proverbial—now abandoned—classical background was of course intended, although the phrase originated in a Tennyson poem and had been used by Aldous Huxley to title his 1939 novel about Hollywood. The six-week rehearsal period in Misha's studio on the White Oak Plantation in northern Florida was exhilarating. I love working with dancers. They know exactly what they can do and why they are there. They are accustomed to hard work and the limited material rewards that it brings. Misha worked his tail off along with the other five: Raquel Aedo, Emily Coates, Rosalynde LeBlanc, Michael Lomeka, and Emannuèle Phuon. *Swan* toured various venues in Florida on a program of dances by Mark Morris and John Jasperes before being presented at the Brooklyn Academy of Music in June 2000.

Jack Anderson complained in his *New York Times* review that the dancers looked like glamorous models, a far cry from the scruffiness of the original performers of my work. In photos of *Continuous Project-*

Altered Daily of 1970 the six of us, dressed in loose fitting clothing and, in the case of Steve, hirsute with uncombed hair and beard, certainly bear little resemblance to the sleek White Oak troupe. The later bunch, especially the women, were accustomed to showing their bodies, in keeping with the contemporary daily summer attire of nondancers. "Street clothes," which I had asked for, had an entirely different meaning for this generation of dancers. And I could hardly have asked Misha to grow a beard and not comb his hair. (On further thought, maybe I could have!) It never occurred to me at the time, just as I had never thought to make us more glamorous in 1970.

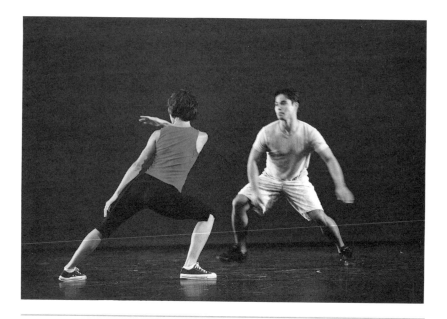

"Facing" from *Trio A Pressured,* Brooklyn Academy of Music, 2002. Rachel Aedo and Michael Lomeka. Photo: Stephanie Berger, © 2005.

In May 2000 I appeared on an evening called *Martha @ Mother,* a variety show organized by the 6-foot-5 Graham impersonator, Richard Move, in a tiny funky club on West 14th Street. Richard and I had worked out a script for "Debate 2000," in which "she"—in exaggerated Graham makeup, bun, and fancy gown—interviewed me butched up in a tuxedo. The dialogue included priceless bits remembered from my days at the Graham school, like, "When you accept yourself as a woman, you will have turn-out," delivered by Richard's Martha with no-holds-barred hauteur. On the same program Baryshnikov danced *Valda's Solo* on the tiny shelf of a stage. Two years later I joined Richard for *Martha at the Pillow* for "Debate 2002" at Jacob's Pillow in Massachusetts. To entertain the cast and crew between shows, I devised—with the aid of Stacy Dawson and Patricia Hoffbauer—a ten-minute send-up of the show, which contained lampoons (of Move's lampoons!) of classic Graham works like *Lamentation* and *Frontier*. In the latter piece ("I believe you call your dances 'pieces,'" "Martha" had intoned disdainfully), performance artist George Sanchez, who, with his long black hair and brown complexion, looks like a pre-Columbian hunter, doodled around with a sawhorse while I read a screed on manifest destiny. ("This dance is called *Manifest Destiny.* Again, I would like to impress upon you that I finished this dance two weeks before Martha Graham's *Frontier!*") I can honestly say it was just about the most fun I've ever had in my life. The cast and crew bellowed with laughter, Richard loudest of all.

464

Richard also contributed to a collaborative video edited by Charles Atlas, called *Rainer Variations,* in the course of which I attempt to teach "Martha" *Trio A*. As expected, she resists my corrections and goes her own way with florid sweeps and grand flourishes. At one point I lose patience and growl, "Oh stop farting around, Martha. This isn't Medea's dance of revenge!" The rest of the tape is an amalgam of clips from my

films and faux interviews in which I am alternately played by myself, Richard, and Kathleen Chalfant as we enact parts of a conversation that originally took place between Gregg Bordowitz and myself. *Rainer Variations* was part of a traveling exhibition that originated at the Rosenwald-Wolf Gallery in Philadelphia in the fall of 2002 and included *After Many a Summer Dies the Swan: Hybrid,* a half-hour video that combines fragments of the White Oak dance and texts dealing with the clash of art and politics in fin-de-siècle Vienna. While editing it at the Wexner Center facility in Columbus, Ohio, I discovered the wonders of the Avid editing system. After editing *Swan* on the Avid with a technician, I doubt—ruefully—that I will ever be able to go back to the old-fashioned Steenbeck.

Since 2002 there have been more revivals and reconstructions. My old warhorse *Trio A* still has legs, as does *Chair/Pillow* from *Continuous Project-Altered Daily*, both of which have now been Laban notated. I have a fantasy about a new piece of choreography, for four women, set to Stravinsky's *Agon.* The women approximate some of the moves from the Balanchine classic. Somewhere in the middle of it a horde of people rushes from stage right, each brandishing a fork or sharp knife. Screaming, they pour across the stage and disappear into the opposite wings.*

For some years after 1975, the year I stopped performing and choreographing—my head still awash in movement images—I would jokingly offer Trisha ideas for choreography. The images receded in the intervening years as I became involved with scriptwriting. I don't know what this relation/opposition between words and body means or portends. As I returned to dance in the 1990s I stopped writing poetry. And

* As of summer 2005 I have abandoned this idea, although work on the dance continues.

now again movement language is superseding verbal language. I tell my-
self, "Don't worry. The mind works in mysterious ways, even stranger
than the body." The body declines, the mind continues to extrude lan-
guage. I look forward to the perambulations of both—mind and body—
in the next decade. It follows, then, that this epilogue can be read as
another prologue.

Name Index

Note: Page numbers appearing in *italics* indicate illustrations.

470